THAT SINGULAR PERSON
CALLED LEAR

BOOKS BY SUSAN CHITTY

The Diary of a Fashion Model
White Huntress
My Life and Horses
The Woman Who Wrote *Black Beauty*
The Beast and the Monk
Charles Kingsley and North Devon
The Intelligent Woman's Guide to
Good Taste
The Puffin Book of Horses
Gwen John
Now To My Mother
That Singular Person Called Lear

THAT SINGULAR PERSON CALLED LEAR

A Biography of Edward Lear,
Artist, Traveller and Prince of Nonsense

Susan Chitty

ATHENEUM
1989
NEW YORK

Atheneum
Macmillan Publishing Company
866 Third Avenue, New York, N.Y. 10022

Library of Congress Cataloging-in-Publication Data
Chitty, Susan, Lady.
 That singular person called Lear: a biography of Edward Lear,
artist, traveller, and prince of nonsense/Susan Chitty.
 p. cm.
 Bibliography: p.
 Includes index.
 ISBN 0-689-11897-X
 1. Lear, Edward, 1812–1888—Biography. 2. Poets, English—19th
century—Biography. 3. Artists—Great Britain—Biography.
4. Travelers—Great Britain—Biography. I. Title.
PR4879.L2Z6 1989
760'.092'4—dc19
[B] 88-19737 CIP

Macmillan books are available at special discounts for bulk purchases
for sales promotions, premiums, fund-raising, or educational use.
For details, contact:

Special Sales Director
Macmillan Publishing Company
866 Third Avenue
New York, N.Y. 10022

10 9 8 7 6 5 4 3 2 1

Printed in the United States of America

For Jessica

"I see life as basically tragic and futile and the only thing that matters is making little jokes."

Edward Lear's diary

Contents

Illustrations

Introduction

It is a hundred years since the man who wrote "The Owl and the Pussy-cat" died. For that poem alone Edward Lear would be remembered. It has percolated through every layer of our society. What primary school-teacher has not supervised a class collage of the favoured lovers dancing on the sand? The poem has entered our folk tradition. It has become a nursery rhyme. Other poems of Lear's are only slightly less familiar. "The Dong with a Luminous Nose," "The Pobble who has no Toes", and "The Courtship of the Yonghy-Bonghy-Bò" were all to be heard on the radio last year. A BBC correspondent recited at length from "The Akond of Swat" after visiting the present Wali of Swat.

Lear as a water-colourist is not known to such a wide public, although his landscapes now fetch high prices. The history of his rise to favour as an artist in our time is strange. During the Second World War a Lear could be picked up for almost nothing. I remember my stepfather, Tom Hopkinson, going out to buy one and coming back with a couple for ten shillings. This was in part because the market in Lears had been flooded by Gertrude Lushington's auction, in 1929, of the pictures she had inherited from her father, Franklin Lushington. The post-war revival of interest in Lear, the artist, undoubtedly owes much to Vivien Noakes, whose biography, *Edward Lear: The Life of a Wanderer*, came out twenty years ago (it has reappeared twice, slightly revised). Before Miss Noakes's biography there had been only Angus Davidson's, *Edward Lear: Landscape Painter and Nonsense Poet*, in 1938.

My justification for producing a third biography is as

x

follows. Much more is now known of Lear's immensely complicated personality, and in particular of his homosexuality. The great love of his life (and the one that caused him most unhappiness) was for the young Franklin Lushington whom Lear did not meet until he was thirty-six. Few people have heard of Frank, but even fewer of Venables, a new and sinister figure. George Stovin Venables was the lover of Frank's elder brother, Harry, and contrived to destroy any chance Lear had of happiness with Frank. More, too, is known about Lear's extraordinary relationship with his Albanian man-servant, Giorgio, and of the boy, Hubert, with whom Lear fell in love at the end of his life.

My own interest in Lear goes back a long way. As a child, like Lear's friend Mrs Bunsen, I disliked the limericks with their illustrations of gluttons with caverns for mouths. But I did like a tinted lithograph of the great auk with a fish sliding down its beak. It hung in my parents' dining-room in Kensington, and my sister and I especially enjoyed its black webbed feet visible beneath the water. Nearly forty years later, on weekly visits to the library at Harvard, I became aware of Lear's water-colours, guaranteed to bring on an attack of Eurosickness. But my most intimate contact with Lear came in 1976. When travelling across Europe with my family on donkeys I came upon Lear's *Albanian Journal* and was immediately enthralled. This man had lived the life I was living. He knew about perilous paths and badly roped baggage, about the friendliness of peasants and the hostility of authority, about wetness and coldness and darkness. And, what was better still, he could see the funny side of it all. It was then that I decided to write a book about Lear.

Biographers of Lear must, however, beware of being seduced by Lear, the traveller. Lear spent the greater part of his life travelling, and any book about him is in danger of degenerating into a travelogue. My policy has therefore been to enter into the details of a journey only occasionally, and to write fully about one journey in particular. This journey Lear made to Arcadia with Franklin Lushington the year he met him, 1849. I have chosen this journey because it formed a turning-point in Lear's life. The sources for it are sparse: two long letters written by Lear to his sister, Ann, and a

few anecdotes contributed by Frank to *Macmillan's Magazine*. Fortunately, however, Lear labelled and dated the two hundred drawings he made on the trip. (These Greek drawings were considered by Philip Hofer the finest he ever made.) Also he referred back to the visit to the Peloponnese frequently in the *Albanian Journal*. I made two visits myself to the area, travelling some of the northern Peloponnese on foot.

My chief manuscript sources for the rest of the book have been Lear's copious letters, particularly those to his sister, Ann, and his diary, which commences at about the time that the Ann letters cease, in 1858. Mention must be made of Lear's spelling and punctuation, both of which were sometimes odder than he intended. I have revised these in places for the sake of clarity.

Acknowledgements

I would like to thank particularly for their help in Greece, H. E. Jeremy Thomas, British Ambassador in Athens, and his wife, Diana, who showed me the Embassy Lears and lunched me in the loggia; Fani-Maria Tsigakou, Keeper of Prints & Drawings at the Benaki Museum, Athens, who worked so hard in the basement that she would never come out to lunch; Lambros Eutoxias, founder of the City of Athens Museum, who showed me the Lear illustrations to Tennyson in his bedroom; Theocritus, the guest master at the monastery of Voulkano, who gave me a night's hospitality in spite of cries of "*Diavolo*" from passing peasant women; Moiz Molho, bookseller and publisher of Salonica who informed me about Mount Athos during three lonely weeks in his city; and Yorga of Zaloróu and her donkey, Spita. In England and the United States, Dr David Michell, a descendant of Lear's sister Sarah through the Gillies family, and his wife, were most generous with Lear reminiscences and memorabilia and have given me permission to quote from Lear's letters to his sister, Ann; John O. Waller, of Ohio State University, who shared with me twenty years of research on the Lushingtons of Park House; Matina Raymond, who spent two years doing what she could for my fast-fading modern Greek; Master Ben Cooper of Copthorne, who directed me to Tennyson's hat at Carisbrooke Castle; Susan Gates, of the Tennyson Research Centre, Lincoln; and Thomas Hinde, my husband, who regimented both the footnotes and the author. Also countless others including Nicholas and Ann Bagnall, Susan Benn, the Rev. Patrick Burt, Stephen

Clarkson, Mr and Mrs Maldwin Drummond, Elsie Donald, Mr and Mrs Patrick Leigh Fermor, Silas Glossop, F. Montgomery Hyde, Susan Hyman, Jane Lushington, Betty Messenger and Derek Webley.

The following institutions also gave me help: Somerset County Record Office, Taunton; the Tennyson Research Centre, Lincoln; Somerset House; the Bodleian Library; the Reading Room and the Print Room of the British Museum; the Victoria and Albert Museum; the Houghton Library; the Liverpool City Library; the Liverpool Public Record Office; the National Library of Scotland; the National Library of Wales; the London Library; and the Radcliffe Science Library, Oxford.

The author and publishers are most grateful to the owners for permission to reproduce the pictures, and also to the following people who allowed us to reproduce the Lear drawings in the text: page 64, Trustees of the British Museum; p. 195, J. J. Farquharson, Esq.; p. 201, Miss Prescott and the late Col. W. Prescott; p. 212 and 236, Somerset Record Office; p. 263, National Portrait Gallery.

PART I

ARCADIA 1849

1

Franklin Lushington 1849

Edward Lear met Franklin Lushington in Malta in 1849, and the life of neither man was the same afterwards. Lushington was a golden youth of twenty-six. Lear was ten years older, an established painter of landscapes and author of the recently published *Book of Nonsense*. He had been forced to change ships at Malta, an island of which he had a poor opinion. To add to his annoyance, on his arrival he had immediately been clapped into quarantine. The fact that he had visited Malta twice the year before and knew just about everybody who was anybody[1] made no difference. In the Lazaretto on Quarantine Island he had to stay for four days.

Frank Lushington was on Malta in a semi-official capacity. His older brother, Harry, was Chief Secretary to the Government there, immediately under Richard More O'Ferrall, the governor. He was heavily engaged in introducing a new penal code to the legislative council. Lear had probably met Harry on his previous visits to Malta, but Frank had only recently arrived. Upon his release from the Lazaretto, Lear was swiftly summoned to dine at the Villa Giuseppe. This was Harry Lushington's residence. It was a magnificent house, standing two miles north of Valletta on Msida Creek. By custom the senior officials on Malta lived in rural splendour outside the cramped capital. O'Ferrall himself lived a little further inland at San Anton Palace, "one of the nicer houses in Europe". At the Villa Giuseppe flowers spilled from the courtyard down to the cliffs and great Mediterranean pines gave patches of shade.

Conversation at a Lushington dinner-table was frequently

in Greek. A school-friend of Frank's once observed that they were "as much at home in the language of the Greek dramatists as if it was their native tongue".[2] It could be said that the Lushington boys had been not only exclusively but excessively educated. They were of a class which supplied its sons with one tool only, the classics, to prepare them for one profession only, the law. Their father had been a judge in Ceylon and their great-uncle, Lord Ellenborough (1750-1818) Chief Justice. When the eldest of Frank's brothers, Edmund, became a professor of Greek at Glasgow, Tom, another brother (there were four) accused him of degenerating into "a useless annotator".[3]

In company Harry tended to eclipse Frank. "Ah! how his sweet and delicate face and voice . . . come back," said Bradley, a school-friend. "A glorious fellow," said Francis Garden, who had put him up for the Cambridge Apostles.[4] Yet it was Frank, the younger brother, who drew Lear's attention on that night of 1 March 1849. Frank, too, had been an Apostle (ten years after Harry) along with Tom Taylor (the popular dramatist), Henry Maine (the constitutional historian) and Arthur Hallam. The last two had been exceptionally close friends of his. He, too, was now a fellow of the old college, Trinity Hall. But he had also won the coveted Chancellor's Gold Medal for Excellence in Greek Composition, which Harry had failed to do.

Frank was a troubled young man, and Lear was good with troubled young men. Frank had reason to be troubled. His young life had been tragic. His father had died when he was fourteen, and his mother, in his arms, when he was eighteen. After that his home was never again to "know cheerfulness". Perhaps, after dinner, the two men took a turn on the terrace. Beyond the twinkling lights of Valletta was darkness. Four hundred miles into the darkness lay the Peloponnese, "land of the free and cradle of the brave" (they had both been brought up on Byron). Perhaps it was then that they took the decision to go to Greece. It was not typical of Frank to act on the spur of the moment. He had all the caution of a lawyer, and, like all the Lushingtons, considered abroad to be "overpuffed".[5] Nevertheless, the Patras steamer was in the Grand Harbour

"with her screws turning", and two days later Frank and Lear sailed away in her.

It would be pleasant to imagine the two men approaching Greece on the deck of the packet, watching Missolonghi glide by, on the left, under a full moon. In fact they "had a most abominable voyage – not that the weather was bad at all, but the Locust steamer is such a nasty little thing", Lear explained in a letter to his very much older sister, Ann. "One never has a moment's rest from rolling and pitching."[6] Ann was always concerned about her brother's health. He had very nearly died of malaria in Greece the year before. Fits of feverish shivering still returned at three-weekly intervals, indeed one of these occurred the day after he arrived in Patras. He fended off the "persecutor" by taking "quinine pills without end". On the day of an attack he increased the dose to ten or twelve pills, washing them down with a large amount of cream of tartar. Ann sent diet sheets which he largely ignored. There were more exciting things to think about.

The Peloponnese is like a three-fingered hand that hangs off the bottom of Greece. Mountain ranges march up each finger towards the wrist and in the high centre is Arcadia, a land of plateaux, chasms, vanishing lakes and underground torrents. Mounting a sketching expedition in such a country was no light affair and by now Lear was a sufficiently experienced traveller to know what to leave behind. A few books, however, were essential. He carried with him the original 1842 edition of John Murray's *Handbook for Travellers in Greece*, but his bible was Martin Leake's *Travels in the Morea*, in which the colonel described with military precision journeys he had made before the War of Independence (1821–32), when Greece was still under Turkish rule. But these books were only a fraction of those he had read before he left home. According to Frank, before visiting any country, Lear, "studied every book he could lay hands on that would give him . . . information as to its physical characteristics and its history. . . . He knew what he wanted to see and followed it up with energetic determination." He was a valuable and delightful fellow-traveller, provided your tastes were "in unison with his own".[7]

Their first task was to hire a dragoman. Andrea Vrindisi,

though old and fat, entered Lear's service with "the usual testimonials". He was somewhat rheumatic and inclined to fall from his horse, but husbanded judiciously the strength that was left to him. He spoke ten languages, including Italian, could memorize paths through the wildest and most dangerous terrain, mollify with bits of paper the most tiresome city officials and create a home for his masters wherever they chose to draw rein. For this he charged the usual rate of £1 5s. a day.

The three men and four hired horses set off eastwards, along the Gulf of Corinth. They planned eventually to make a roughly circular tour of the gulf in an anti-clockwise direction. Like all travellers with oriental guides, they left Patras at a gallop, which they preserved until well out of sight of Andrea's friends. Andrea was a splendid figure in front, wearing the traditional Greek peasant costume of baggy trousers and a tasselled cap, his great white moustaches flying in the wind. The luggage bounced on the pack-saddle and Lear no doubt bounced on his, a bulky Turkish affair with a high peak, unreliable string girths and awkward shovel stirrups. He vowed in future to bring English stirrups.

On horseback Lear and Frank made an oddly contrasted couple. The Fellow of Trinity Hall sat his horse like the son of a country gentleman that he was. Lear sat his like the son of a Holloway stockbroker, which he was. He had ridden a horse for the first time only seven years earlier. (A well-connected friend, Charles Knight, had given him a few lessons in the Frascati area near Rome.) Both gentlemen wore tweed cutaway coats and a casual version of the topper known as a "wideawake". This, John Murray declared, was "the most respectable and respected travelling costume for an Englishman throughout the Levant". Lear's spectacles were his chief problem. He was short-sighted and had been obliged to wear thick lenses in circular wire frames from boyhood. These travelled slowly down his nose with the motion of his horse, misted over in wet weather and were often swept away altogether by overhanging branches.

By the end of the first day they had reached Vostizza (Aiyon), and turned south into the mountains. They aimed to circle Mount Helmos by the southern route, after a pause

at the great cave monastery of Megaspilion. By the third night they had reached Kalavrita. At sunrise next morning Helmos glowed like a live ember for several minutes, and Lear and Frank hurried out with stools and little seven-by-ten-inch pads, leaving Andrea to load, and quarrel over the bill. After two hours they had scrambled over two passes. At the top of a third they were met by an amazing sight. Far beneath them, gilded by the setting sun, lay a great sheet of water. It was Lake Phonia. Beyond it were mountains still white with winter snow. On the right was a spur of Mount Kremosi, cleaving the water like the prow of a ship. Lear never knew why mountain lakes moved him so deeply. Peaks and precipices were "fearfully exciting", but a lake represented peace and security, almost the encircling arms of a mother. He had made the acquaintance of some good lakes in Albania the year before; indeed, he had claimed that a day by Lake Peupli had been the best in his life. Phonia was no disappointment.

Lear was now surely in love with Frank. At the beginning of the tour he had told Ann that he was "an amiable and talented man, to travel with whom is a great advantage to me as well as a pleasure".[8] By the end he had discovered that Frank had a sense of humour to match his own. Frank often recounted with delight the occasion near Lake Phonia when Lear sat down on a cow. It was dark and he supposed it to be a bank "but an instant grunt and heave convinced him of his error, as a dark bovine form suddenly rose under him and tilted him into the mud".[9]

"Mr Lushington," Lear declared, "has been so constantly the most merry and kind travelling companion . . . he draws as much as I do, and we only complain that the days are too short." It was "the most delightful tour I ever made. Everything has been so fortunate and pleasant that the time has gone a great deal too quickly Altogether I do not know when I have enjoyed myself so much."[10]

Lear almost certainly wrote of his more intimate feelings for Frank in his diary, but all the volumes before 1858 are lost. Looking back many years later, he made a significant comparison between Frank and an earlier friend, the young Danish painter, Wilhelm Marstrand. "Dear gentle good clean Marstrand . . . [we] used to be always together . . . Marstrand

6

was the Franklin Lushington of those days: and I dare not think of them".[11] Frank, who eventually married, was less inclined to commit his feelings to paper, but it was from this time that he admitted to "a lifelong intimate friendship with Lear".[12]

The two friends spent as long on three legs drawing the lake next day as they had on four the day before. Frank came to know Lear's method well. First he would pace the area, seeking the most suitable place from which to sketch. Then he would seat himself upon his three-legged stool and, having raised his spectacles to his forehead, quiz the view for several minutes through a monocular glass that he kept in his breast pocket. Only now was he ready to select one from among his three sketch-books of different sizes and convey to paper the view before him "with a rapidity and accuracy that inspired me with awestruck wonder".[13] "Nothing could have induced him to give his landscapes any effect of form, colour, light, shade or other detail that did not actually belong to nature", Frank wrote.[14] He quoted the eminent geologist, Sir Roderick Murchison, who said he could always tell the geology of a country from one of Lear's sketches.

Frank, a keen amateur artist, sketched beside him. It was during these hours of intense concentration that he probably came to know Lear's face. The wide myopic eyes peered timidly from behind the protecting lenses. The lips were full and sensitive. (Lear did not wear a beard at this time.) By midday Lear had drawn Phonia several times from the shore. He wrote the time on each sketch, as was his custom, and added copious notes on the colour of the lake, such as "dark blue, snowy edges" and "very deep lilac". The frequency of these notes to himself always increased with happiness. On that day, 13 March, Lear achieved the astonishing total of seven detailed sketches. He varied the foreground by moving his position, but always there was the lake, with the mountain spurs running out into it to form secret bays of happiness. Little did he guess that one day the lake would be no more. It would drain away through one of the swallow holes beneath the mountains, home of Pluto and Persephone.

If Lake Phonia had witnessed the commencement of Lear's and Frank's love, the Plain of Messene in the south, near

7

Kalamata, saw its flowering. 22 March 1849 was like a wedding day. One day of rain had brought forth flowers innumerable. "No one can form any idea of what the spring is in Greece," Lear wrote to Ann.[15] "It is difficult for you to realize that the whole earth is like a rich Turkey carpet. As for Lushington and I, equally fond of flowers, we gather them all day like children, and when we have stuck our hats and coats and horses with them – it is time to throw them away and get a new set." And so the two English gentlemen, knee high in flowers, walked through the land of lost content. Portly Andrea mopped his brow and rested in his saddle. He was glad of a break, but had the milords gone complete *trelithi* (crackers)?

After three weeks in the Peloponnese the two men travelled to Athens together and on through Attica, following the well-worn tourist route to the mountains of Delphi. Though Lear admired the rugged beauty of the Roumeli (northern Greece), he looked back with nostalgia to the Morea (the Peloponnese). "All this scenery is very magnificent, but I prefer the plains and gentle scenes of the Morea." Was it possible that it was Frank, and not Greece, that was changing? Lear had hoped to continue the journey with him into Albania. Frank made excuses. First he said he must go back to Malta, then to England. Other men had become alarmed by the intensity of Lear's affection. On 22 April they arrived at Patras, having crossed the Gulf of Corinth by boat and so completed their circuit. Here Lear saw Frank on to the steamer for Malta. By good fortune the Austrian steamer, *Elleno*, arrived on the very day after Frank's departure. Lear and Andrea embarked for Albania, going by way of Corfu. The six happiest weeks of Lear's life were over.

PART II

THE BEGINNING 1812–37

2

Childhood 1812–27

Those three weeks in Greece had been the happiest in a life that had not always been happy. Lear remembered his childhood as a period of darkness and rarely referred to it. The facts were simple enough. He was born in 1812, the twentieth (and penultimate) child of a London stockbroker, Jeremiah Lear, living in a large eighteenth-century house, Bowman's Lodge, in the village of Holloway, near Highgate. His mother was understandably tired by the time he was born and he was largely cared for by his sister Ann who was twenty-two years older than he was.

Ann had a sister, Sarah, three years her junior. These two could be said to hold the posts of captain and lieutenant in the Lear family. Then came Mary and Eleanor, born ten years later (after many infant deaths). They were the subalterns. After them came the corporals, Jane, Harriet, Cordelia and Florence, gradually promoted from the ranks as they left the schoolroom. By the time Lear was a year old, there were still three infants in the nursery: his brother Charles, aged three, himself and Catherine, the final child. These three little people were the troops, disciplined by Ann, Sarah, Mary and Eleanor, assisted by Jane, Harriet, Cordelia and Florence. So, for little Edward, it was the monstrous regiment of petticoats, layer upon layer of them. He also had two much older brothers, Henry who was sixteen and Olivier who was twelve at the time of his birth. He saw little of them for they were young bucks about town by the time he was old enough to be conscious of them. And then there was Fat Frederick who was nine when Lear was born.

Lear's earliest memory went back to the age of three. Ann had scooped him from his bed, grabbed one of his blankets and taken him into the front garden from which there was a view over London. The black chasm was alight with cascading showers of stars. Napoleon had been defeated at Waterloo. Unfortunately Wellington's victory was a signal for disaster for Jeremiah Lear. His name appeared on the Stock Exchange Register of Defaulters, as owing over £2,000. Almost everything had to go. The carriages and horses were sold (the stables still stand) and Bowman's Lodge let. Lear was given into the charge of Ann and moved with her into rooms. Rescue was fortunately at hand, for Jeremiah was evidently a trusted man in the City. His problems at the Stock Exchange were solved by one William Smith, Junior, paying 2s. 6d. in the pound to his creditors, and his personal debts were settled by a loan of £1,000 from a bank.

Afterwards, the return to Bowman's Lodge was not as happy as it should have been. All the good furniture had been sold and what remained had been rained on. The tenants, who had been Jewish, had always opened the window when there was a thunderstorm "for the easier entrance of the Messiah".[1] For Lear there was a worse disaster than that. He now found himself completely rejected by his mother. We know little about Lear's mother, whose maiden name was Skerrett. Unlike his father she was of gentle birth, being descended from Northumberland stock.[2] Her marriage to Jeremiah was frowned on by her family, perhaps because of the disparity in their ages (he was thirty-one and she was nineteen) but more probably because of the disparity in their social standing. Jeremiah was decidedly "trade". The Lears had been London sugar refiners for two generations, and before that they could trace their lineage no further back than to a butcher living at Gillingham in Dorset in the seventeenth century. Jeremiah and Ann married at Wanstead in Essex, some distance from the homes of either. No member of their families signed the register. This is all we know about the early life of Ann Skerrett.

Lear felt his mother's rejection of him deeply. The bitter self-hatred that grew from it was with him for the rest of his life. How much he longed for the love of a conventional

mother and father can be seen in his satire on Tom Moore's "Oft in the Stilly Night",[3] written when he was a very young man.

> I slept: and back to my early days did wandering fancy roam
> When my heart was light
> And my 'opes were bright
> And my 'ome a 'appy one
>
> When I dreamed as I was young and hinnocent
> And my art vos free from care
> And my parents smiled on their darling child
> And breathed for his [spirit] a prayer.

By silly spelling Lear disguised this ballad as a funny one, but it was not funny. There were no golden fields and flowers in his childhood. Only the great dark house with bare floorboards. It always seemed to be night in those rooms, for the trees grew close against the back of the house. In one of them Lear had his first epileptic fit. He had already seen fits. "How I remember my sister Jane's epileptic attacks! How! Child as I was then and quite unable to understand them."[4] Jane was thirteen when Lear was born. She was the oldest of the corporals, coming immediately after Eleanor. She did not survive to adulthood.

There are two kinds of epileptic fit, *grand mal* and *petit mal*. In a *petit mal* attack, now known as a "subtle seizure", the burst of electrical activity in the brain is so brief that bystanders are often unaware that the subject has had a fit. In *grand mal*, the victim may drop to the floor and will certainly suffer muscular spasms. When he recovers he will have no recollection of what happened to him, will feel mildly confused and inclined to sleep. Lear did not suffer from "drop" attacks. He usually received some sign of an impending fit, probably only a few moments before it happened. There are many kinds of warning, not necessarily the *aura epileptica* (or flashing lights), but sometimes a ringing in the ears or an itching in the palms. All his life he managed to keep his fits secret. "It is wonderful," he wrote, "that these fits have never been discovered, except partly apprehending them before-

hand, I go to my room."[5] In his diary Lear marked with an "X" the days when he had a fit, adding a figure from one to ten beside it. These figures may have indicated the degree of severity on some private Richter scale, or they may have indicated the duration of the fit.

Lear was deeply ashamed of his epilepsy. Ann was responsible for this. She told him that "The Demon", as he always called his attacks, came to little boys because they played with themselves. In spite of this dire warning, Lear found it impossible to exercise self-control. "Every morning, in the little study when learning my lessons, all day long and always in the evening and night."[6] One night Harriet, now fifteen, was put to sleep with him in his room. "The strong will of sister Harriet put a short pause to the misery, but very short. How well I remember that evening!"[7] One can imagine Harriet, amply nightgowned, leaping from her bed to do her duty. She had followed her older sister Mary into strict Evangelical Christianity. Only towards the end of his life did Lear begin to suspect that there might be no connection between masturbation and fits. After recording one more fit in his diary he wrote, "As yet it seems the 'self-control' is not worth much."[8] Lear was also convinced, as were most of his contemporaries, that epilepsy would lead to deterioration of the brain and early death. He had, after all, seen his sister Jane die. This view is no longer held. There were, of course, no barbiturates in those days, but Lear was fortunate not to be dosed with laudanum like Tennyson's brother.

After "The Demon" came "The Morbids", Lear's word for a state of nostalgic despair, based on the certainty that everything which was good and beautiful was lost beyond recall. These attacks began at the age of seven. The more beautiful a sight or an experience, the deeper was likely to be the resulting blackness. It was in the last year of his life that he recorded the memory of his first attack of the Morbids. It occurred on a rare occasion, when his father took him, as a boy of six or seven, to a fair near Highgate. There was a "performance of gymnastic clowns ... and a band. The music was good, – at least it attracted me: – and the sunset and twilight I remember as if yesterday. And I can recollect crying half the night after all the small gaiety had broke up

– and also suffering for days at the memory of the past scene."[9]
The "Never, no more" gong, so familiar in the Nonsense
Ballads, had sounded for the first time. For the rest of his
life Lear was in love with yesterday.

Around this time the small boy was taken to Margate by
Ann, for the sea-water cure. But even at that innocent resort
monsters lurked. Years later Lear reminded Ann of "the hawk
Mr Cox had, and the colliers disbarking coal at the pier, and
the windmills, and the chimney sweep you so cruelly MADE
me walk round and round to be sure he was not smoking!
. . . My imperfect sight in those days, ante-spectacled, formed
everything into a horror!"[10] As a child Lear hardly knew
truth from fantasy. Throughout his life he persisted in pro-
moting some extraordinary falsehoods about his family. The
family name, he declared, was from the Danish Lør. And
he always insisted that his father had gone to King's Bench
Prison for four years after his bankruptcy and that Mrs Lear
had daily brought him "a full six-course dinner, with all the
delicacies of the season".[11] At the same time he suggested
that his sisters had been sent away as governesses and four
of them had died from unaccustomed privations. This was
nonsense. Most of the corporals did eventually die as govern-
esses, but when they were older.

Something happened to Lear when he was nine that he
did *not* exaggerate. On Easter Monday, 8 April, 1822, he
was almost certainly sexually abused by a young man called
Frederick Harding. When Lear heard of Frederick Harding's
death in 1871 he underlined his name in his diary. "It is just
50 years since he did me the greatest Evil done to me in
life, excepting that done by C: and which must last now
to the end – spite of all reason and effort." Frederick Harding,
at the age of nineteen, had just left his regiment and was
staying at Bowman's lodge.[12] It was he who painted a minia-
ture of Lear's father.[13] "C" has not been identified. He may
have been Lear's older brother, Charles, although this seems
unlikely.

Of the pleasanter aspects of his childhood Lear spoke little.
He did not mention the evening gatherings round the piano
in the drawing-room, over which his father presided, splen-
didly attired, according to his sister Sarah. Sarah described

the girls as exceptionally tall and handsome. Every night they dressed in high-waisted white dresses with blue bows, in the style of the Empress Josephine.[14] Nine beauties of assorted sizes so attired must have been a memorable sight. They sang the popular ballads of the Irishman, Tom Moore, and Lear grew up knowing many of these sentimental ditties by heart. He also learned to play the piano. The four boys presumably took part in all this, but, strangely enough, Lear never mentioned a single one of his four brothers. Henry, Olivier, Frederick and Charles were ignored as if they had never been. Henry and Olivier admittedly left home young, shamed by their father's bankruptcy. Henry attempted to make money the quick way, while Olivier joined the army. When the one was accused of forgery and the other deserted, both left the country. Fat Frederick, however, seems to have been a jolly enough figure. He used to chase Ann around the room for calling him a "Norfolk Biffin", because, like the apple, he suffered "constant increase in circumference".[15] Charles and Frederick both eventually emigrated, but under respectable circumstances. Frederick went to colonize America and Charles to convert Africa.

For the first twelve years of Lear's life his education was supplied entirely by Ann, with a little help from Sarah (the clever one). Ann was a thoroughly nice young woman (and not without suitors). She had a sense of humour. She also put up with being teased by her youngest brother, both for her spelling and punctuation and for her fear of creepy-crawlies. Many years later Lear wrote, "Should you like me to send you a green frog by the next parcel? Or a tortoise?" He shared her terror of dogs, the smaller the worse.[16] At Bowman's Lodge, one of the best downstairs rooms in the house was set aside as a painting-room or studio. Jeremiah Lear appears to have been interested in art. In his palmy days he had owned some excellent paintings. The girls had been brought up to make water-colours of flowers and they passed on their knowledge to their brother, although drawing was more commonly taught to girls than to boys in those days. (The painter, Thomas Uwins, only learned to paint by observing his sister's drawing master at work.) One of the earliest Lear water-colour drawings preserved is of a geranium

which he painted for Eleanor at the age of sixteen. It is a highly competent piece of work.[17] Eleanor was by then Mrs Newsom and living at Twickenham.

Across the hall from the painting-room was the schoolroom. Scripture must have had a prominent place in the curriculum. Ann was a deeply committed Christian and would have insisted on a knowledge of the Bible stories. She was broadminded enough, however, to see that Edward had an almost equal knowledge of the myths of Ancient Greece. The fashionable educational manual of the early years of the nineteenth century was Maria Edgeworth's *Practical Education.* Edgeworth was a disciple of Rousseau and believed that independence and self-reliance were the qualities most to be encouraged in children. They must be taught to discover the natural world for themselves. In the moral tales, bad deeds were punished in kind. Thus Rosamund, who squandered her money on the chemist's jar full of purple liquid, must wear her old shoes until her toes came out at the ends.

Like all romantic young ladies of her age, Ann was deeply afflicted with Byron. She communicated her enthusiasm to Lear who became intimately acquainted with long sections of Byron's poetical autobiography *Childe Harold*, particularly the Greek section. He was much moved by Byron's death at Missolonghi, remembering years later "the small yard . . . when I used to sit . . . in the cold looking at the stars, stupefied and crying" on hearing of the event.[18] He had been eleven at the time.

It was at this age that Lear started school, having first acquired a pair of spectacles and commenced the "post-spectacled era". He never made a single reference to his school. Presumably it was not much more than a dame school round the corner, teaching reading, writing and arithmetic. Certainly it did not offer the Greek and Latin available to his social superiors. Nor do games or gymnastics seem to have been taught. Lear used to complain that he "never had any chance of manly improvement and exercise", as a boy.[19] There is a silhouette portrait of Lear at about this age showing a rather chubby face, thick hair and a somewhat piglike snout. The mollycoddled boy in spectacles could hardly be expected to attract anyone but bullies. In fact he did have one friend,

a boy called William Nevill, the son of a close neighbour, who was to prove a friend for life. But at least there was now "beloved Sussex" to escape to. Sarah had married Charles Street, a banker, and gone to live at Arundel. The story of Sarah's marriage was a strange one. One day Jeremiah Lear was walking in the City when he saw a nameplate with his name on it. He introduced himself to the man inside and the two families became friends for life. At the other Jeremiah Lear's grand home in Sussex, Sarah met her future husband. Sussex was a revelation to the young Edward Lear. He was enchanted by the beauty of the South Downs at Arundel, where dark clumps of trees have been clipped into shape by the wind, and sudden deep valleys appear at the walker's feet. A favourite walk of the Street family was to the top of Bury Hill from whence the valley of the Arun spreads far and wide. Lear did not have to walk alone. Nearby at Peppering House, Burpham, he met the Drewitt family, whose sons and daughters became close friends.

When Lear was fourteen and a half he was ejected from Bowman's Lodge and "thrown out into the world without a penny!"[20] Jeremiah Lear had decided at the age of seventy to retire, and had bought a small house in Gravesend where there was room only for his wife and one of his daughters. Upon Florence fell the privilege of being an unpaid companion and nurse for the rest of her parents' lives. Ann, who had inherited a small income from her maternal grandmother, Florence Brignall Usher, must go elsewhere, and Lear went with her. Looking back, Lear never considered that he had had an education. "I was brought up by women and badly besides."[21] Yet at other times he thanked God "that I was never educated, for it seems to me that 999 of those who are . . . have lost all before they arrive at my age and remain, like Swift's Stulbruggs, cut and dry for life".[22] He was a passionate admirer of *Gulliver's Travels*.

3

Parrots 1828–32

It is pitiful to contemplate the fate of a boy of fourteen and a half turned upon the streets of London to make his living with no other qualification than an ability to draw flowers and butterflies. Such work was suited only to the decoration of fans and screens, traditionally the occupation of consumptive ladies working in cellars. Lear undertook it, and also work of an even more menial kind, the colouring of book illustrations necessary before colour printing. These monotonous tasks were performed in one of the attic rooms Ann had rented off Gray's Inn Road. Lear also made "morbid disease drawings for hospitals".[1] The Canadian landscape painter, Fowler, who knew him four years later, vouched for Lear's circumstances in his autobiography, and spoke of the "uncommon queer" drawings the boy used to sell for ninepence to stage-coach passengers in inn yards.[2]

It was probably during this period that a carriage wheel ran over Lear's legs, leaving his knees, he claimed, deformed (but mercifully still serviceable). At times he must have felt like abandoning the struggle. It was but a short walk to the river and a permanent solution. The painful memories of those days were with Lear till the end and turned up in his final autobiographical poem, "Uncle Arly".

> Like the ancient Medes and Persians
> Always by his own exertions
> He subsisted on those hills :—
> Whiles – by teaching children spelling, –
> Or at times by merely yelling, –

Or at intervals by selling
"Propter's Nicodemus Pills"

This period of poverty cannot have lasted more than a year
and a half. Lear was not without connections and he started
to give drawing lessons at houses in St James's Square and
Cavendish Square. By the time he was sixteen his ability to
draw birds had developed. As a boy he had been given a
small album, no bigger than a modern paperback, with pages
of different colours. The album, now in the National Library
of Scotland, was so precious that at first he hardly dared deface
it. He merely decorated the first and last pages with cut-out
paper butterflies stuck on pencilled twigs. This was probably
done in his schoolroom days. Now, more sure of his powers,
he painted an exquisite pheasant, barely two inches long and
yet with every feather distinct; also several tits and finches
no larger than bees. By comparison with these miniature
birds, the early butterflies looked primitive indeed.

Now Lear acquired his first patron. Mrs Godfrey Went-
worth was a person of some influence, for her father was
Walter Ramsden Fawkes, one of Turner's patrons, and a keen
amateur zoologist. Mrs Wentworth was enchanted by Lear's
little birds, and introduced him to Prideaux Selby, the ornith-
ological artist. In gratitude, Lear "respectfully and gratefully"
rewarded her with a flock of tiny finches on squares of paper
no larger than Christmas cards. Prideaux Selby, with Sir Wil-
liam Jardine, was at work on his *Illustrations of British Ornitho-
logy*, which appeared in nineteen instalments or folios between
1825 and 1839. The fashion for enormous books of bird
engravings had started in the eighteenth century, but in
those days the birds had been foreign. Now, as scientific clas-
sification advanced, naturalists were observing more closely
their native birds. In 1820 the great Audubon began to cata-
logue and draw all the birds of North America. Selby was
undertaking a similar work in Britain, and he offered Lear
work when the boy was barely sixteen. Selby's style of draw-
ing was bold and innovative, and under his influence Lear's
birds grew large and lively. Soon he ceased to be treated
merely as an apprentice. He was given credit for his work.
The water-colour study for the Great Auk, which appeared

in the seabird section, was signed both by Lear and Selby.[3] Lear always spoke of Selby as "very kind", and he remained in touch with his family long enough to know his grandson more than thirty years later.

Lear had worked for Selby for barely two years when he had the surprising effrontery to embark on publishing an illustrated bird book of his own. It was to be a book of parrots. He planned a limited edition, in fourteen folios, to be issued serially, and to be entitled *Illustrations of the Family of Psittacidae, or Parrots*, the first English book, he claimed, ever to be devoted to a single species.[4] The book was remarkable in another way, for Lear was the first to work consistently from live models. Furthermore, most of Lear's parrots were of "Species Hitherto Unfigured".[5] Three were subsequently named after him, Lear's Macaw, *Anodorhynchus leari*, Lear's Cockatoo, *Lopochroa leari*, and the Tabuan Parrot, *Platycercus leari*. By a fortunate coincidence Lear's interest in parrots coincided with the opening of the Zoological Gardens at Regents Park. On 16 June 1830 at a meeting chaired by Lord Stanley, President of the Zoological Society, Lear was given permission to make drawings of the live parrots at the zoo, and to study the stuffed ones in the zoo's museum at 33 Bruton Street. Lord Stanley also lent Lear some of the parrots from his private menagerie. So did various society ladies including the Countess of Mount Charles. Parrots were fashionable birds at the time.

Lear's parrots were well received. The following letter, written on 26 November 1831, said all that the most ambitious young artist could hope to hear. It came from William Swainson, a zoologist who had studied under Audubon.

Sir, I received yesterday with great pleasure the numbers of your beautiful work. To repeat my recorded opinion of it, as a whole, is unnecessary but there are two plates which more especially deserve the highest praise; they are the New Holland Palaeornis, and the red and yellow Macaw. The latter is in my estimation equal to any figure ever painted by Audubon, for grace of design, perspective, or anatomical accuracy. I am so particularly pleased with these, that I should feel much gratified by possessing

a duplicate copy of each. They will then be framed, as fit companions in my drawing-room to have by the side of a pair by my friend Audubon.

The Red and Yellow Macaw is indeed a masterpiece. It is in fact mostly blue, and its long, ever-diminishing tail reaches to the bottom of an Imperial folio page. (All Lear's parrots were life-size, another of his innovations.) The glory of the Red and Yellow Macaw was a shawl of yellow feathers spread across the upper part of the wings. With the keeper's help (in slightly lifting a wing) the parrot was persuaded to display this astonishing golden fan spotted with emerald green. Lear's method was to make a series of sketches each traced from a previous drawing, and each more elaborately coloured than the one before. In all but the final study, much extraneous material would appear on the page, such as sketches of other birds or even caricatures of bystanders. Particularly pleasing is a rotund citizen, hands in pockets, gaping up at a Rose-ringed Parakeet, whose mental capacities appear a good deal greater than the man's.[6] Lear had also developed the habit of writing notes to himself on his sketches. Messages like "soft frill of feathers" or "rather too pink", or "rather too deep" appear. The finished water-colour of the Red and Yellow Macaw conveys the softest frill of neck feathers Lear ever achieved. Layers of red, almost tangible, rise from the neck to the hood. The reptilian eyes stare malevolently from the wrinkled white cheek.

Throughout 1831 drawings of parrots spilled over the floor of the room in Gray's Inn Road. Lear wrote to his life-long friend, Charles Empson, a botanical artist:

> should you come to town, I am sorry I cannot offer you a home *pro tempore* (pro trumpery indeed it would be) . . . for unless you occupied the grate as a seat, I see no possibility of your finding any rest consonant with the safety of my Parrots, seeing, that of the 6 chairs I possess, 5 are at present occupied with lithographic prints. The whole of my exalted upper tenement in fact overflows with them, and for the last 12 months that I have so moved, thought, looked at, and existed among Parrots – that should any transmigration take place at my decease I am sure my soul

would be very uncomfortable in anything but one of the *Psittacidae*.[7]

The lithographic prints Lear referred to were the next stage in the process of book production. The Red and Yellow Macaw was to lose less in reproduction by lithography than it would have done by other methods, because Lear could control it himself. With the more conventional methods of engraving, or wood engraving, the original had to be transferred to a block by a professional. With lithography the artist was able to do the work of transferring to the stone himself. The final print of the Red and Yellow Macaw appeared facing the wrong way. This was because, for this book, Lear traced directly on to the stone. He was not familiar with transfer paper, and in a letter of March 1833 to Arthur Aitken, thanking him for a gift of some, he wrote, "I understand nothing of that part of the art of Lithography – I have taken it to Mr Hullmandel."[8] Charles Hullmandel was the famous lithographic printer of Great Marlborough Street. In his studio Lear could inspect each pull and make alterations on the stone before the final printing. It was at a party in Hullmandel's studio that Lear saw Turner for the only time in his life. Turner sang a comic song and according to Lear closely resembled a pig.

The parrot book was never completed. Lear ran out of money for production costs when he had finished twelve of the fourteen folios, and only forty-two parrots appeared. He blamed subscribers who forgot to pay. The list was headed by Mrs Wentworth, followed by Lord Stanley, who honoured their promises. "To pay colourer and printer monthly I am obstinately prepossessed, since I had rather be at the bottom of the River Thames than be one week in debt," Lear told Empson. "I have just nine and twenty times resolved to give up parrots and all and should certainly have done so had not my good genius, with vast reluctance, just nine and twenty times set me going again." He referred presumably to Mrs Wentworth. Finally it became impossible to find money "to procure food and pay for publishing at once", and the work ceased.[9] Ann received a presentation copy of the book on 15 April 1832, inscribed "With sincere

regards, E. Lear".[10] The twelfth folio bore the inscription,

Under the Patronage of
And dedicated by permission to
THE QUEEN'S MOST EXCELLENT MAJESTY.

The queen, of course, was still William IV's Queen Adelaide. Lear's *Parrots* is now a very rare book. The drawings were erased from the stones after the original edition of a hundred and seventy-five had been printed. "The expense is considerable of keeping them on," Lear explained. This did not prevent the parrots from being pirated by a Frenchman called Saint-Hilaire five years later. Several of the plates in his book on parrots were direct copies from Lear's, though in some cases reduced and revised. There was an occasional mention of Lear in the text, but never on a plate. It is to be hoped that Saint-Hilaire grew fatter on *Perroquets* than Lear did on *Parrots*. There were, however, other rewards than money. As Lear philosophically pointed out to the learned Sir William Jardine, "the speculation... so far as it made me known brought me employment."[11] It also brought him associate membership of the Linnean Society. Lear remained a Linnean for thirty years, until he was asked to resign since he did not any longer "communicate science".[12]

Now began Lear's long and not always happy association with John Gould, who had bought the remaining copies of *Parrots*. Gould himself was only thirty at this time. He was a self-made man, the son of a Dorset gardener, and lived at 20 Broad Street, Golden Square. While working as a taxidermist at the zoo he had taught himself zoology and had been promoted to the post of curator of the stuffed birds at 33 Bruton Street. There he decided to publish a book entitled *A Century of Birds from the Himalayan Mountains*. The book had been as successful financially as Lear's was a failure. After this came the famous five-volume *Birds of Europe*. To make drawings for this, Gould took Lear abroad for the first time on a tour of European zoos. As soon as they arrived in Amsterdam, warmed no doubt with Dutch gin, Gould persuaded Lear to sign a contract to work for him for six years. "At Amsterdam," Lear wrote, "we laid the foundation of many subsequent years of misery."[13] Lear had plenty of time to

repent at leisure while they toured Germany and Switzerland. Sharing a stage-coach with Gould gave him an opportunity to discover how little he liked him. "In spite of a certain jollity and bon-hommie, he was a coarse and violent man... ever unfeeling for those about him."

Gould had one particularly dishonest habit, that of signing his name under other men's (and women's) work. He longed to be an artist, but only his wife, Elizabeth (an unsung genius) could draw. He had claimed her work as his own in the past, now he claimed Lear's. In the preface to *Birds of Europe* he wrote,

> perhaps I may be allowed to add that, not only by far the greater number of the plates of this work, but all those of my "Century of Birds"... have been drawn and lithographed by Mrs Gould from *sketches and designs by myself*, always taken from nature. The remainder of the drawings have been made by Mr Lear whose abilities as an artist are so generally acknowledged that any comments of my own are unnecessary.

Enraged, Lear noted his own drawings in his copy of *Birds of Europe*, now at the Houghton Library. When Gould died fifty years later, he was still not forgiven. "He owed everything to his excellent wife and myself, – without whose help in drawing he had nothing."[14] The birds that Lear claimed as his own were indeed outstanding, and outstanding among them were the large ugly ones. Lear saw into the soul of the raucous raven, the oracular owl and the preposterous pelican. There were times, he declared, when he felt that he was becoming a bird and he didn't particularly mind. The fantasy was with him for the rest of his life. Yet as a young man Lear's emotions were not entirely directed towards birds. With adolescence came a vague universal longing for something or someone. Sunsets were inclined to bring it on, and a particular sunset, seen from the Downs at Bury Hill when he was seventeen, inspired a poem. It was such a beautiful sunset that he still remembered it forty years on. "O Sussex! And what a sunset."[15]

When the light dies away in a calm summer's eve

And the sunbeams grow faint and more faint in the West
How we love to look on till the last trace they leave
Glows away like a blush upon modesty's breast.

So when grief has made lonely and blighted our lot
And her icy cold chains o'er our spirit has cast
Will not memory oft turn to some thrice hallowed spot?
That shines like a star among years that are past.

Lear wrote this poem in the multi-coloured album, choosing
a pink page. It was clearly written under the influence of
Thomas Moore, the Irish balladeer. He even attempted to
draw the view from Bury Hill in the album: the great wide
valley of the Arun framed in a U-shaped fold of the Downs.
The drawing was abandoned in disgust. Several Italianate
castles on imaginary lakes were more successful. At this time
Lear also wrote a couple of poems about Greek temples in
the style of Byron.

It is not known who, if anyone, Lear was in love with
that summer of 1829. Certainly one of his earliest surviving
comic poems, "Miss Maniac", was written for Eliza Drewitt
of Peppering House. Lear had treasured memories of the mill
at Peppering since he first came to Sussex at the age of eleven,
and perhaps of Miss Drewitt too. But "Miss Maniac" was
not a love poem. It was another Thomas Moore parody.
Miss Maniac was an unmarried mother who went mad
because she had been abandoned by her lover. In her anguish
she cried:

> Oh – thou who falsely – darkly lured
> My frail fond heart astray
> Then left me like a broken flower
> Alone to waste away.

To make quite sure Miss Drewitt did not take him seriously,
Lear illustrated each couplet with a drawing in the style of
Cruikshank. (These are his earliest surviving humorous draw-
ings.) The Drewitts regarded Lear as a lovable eccentric. "My
Sussex friends always say that I can do nothing like other
people," he wrote to Empson.[16] At seventeen he had already
formulated his lifelong principle: deflect ridicule by being
ridiculous. Another Sussex girl to whom he wrote several

long letters was Fanny Coombe, a friend of his sister Eleanor, but they were in no sense love letters.

Lear's male friends in Sussex were more worldly. One was George Lear, the youngest of the three children of the other Jeremiah, at Batworth Park. George was a wealthy young man, recently articled to a solicitor in Gray's Inn. By coincidence Charles Dickens was a clerk in the same office as George and described him in *The Pickwick Papers* as "the articled clerk who has paid a premium . . . runs a tailor's bill, receives invitations to parties . . . who goes out of town every long vacation to see his father, who keeps live horses innumerable".[17]

Also about this time Lear was introduced to Lord Egremont of Petworth, Turner's patron. Petworth was twelve miles from Arundel and Lear knew its Capability Brown park well. He knew even better Turner's hazy light-suffused watercolours of that landscape. He had read *Liber Studorium*, the book that Turner had produced ten years earlier with examples of "Landscape Compositions".

In 1831 Lear moved to larger and more respectable rooms at 61 Albany Street, on the east side of the Zoological Gardens. A member of the Linnean Society could hardly perch in an attic and invite distinguished patrons to roost in the grate! Ann came too. She had little choice. At the age of forty, with an income of only £50 a year, she had not much hope of marriage and none of a career. It is evident that their financial roles had been reversed. Lear was now supporting Ann. They did not always agree. Ann remained a curiously ingenuous and childlike creature all her life. Lear was ashamed to take her out in society. She had no taste in dress. Her clothes were at the same time garish and shabby. With nine sisters, Lear took an interest in female apparel, and he made Ann the occasional present of a muff or a shawl. She infuriated him by putting these away because they were "too good to wear".

At the age of twenty-one Lear was not all that presentable himself. Fowler saw him as "tall, not handsome, and rather ungainly in figure".[18] Lear concurred. He drew himself for Empson, commenting, "this is amazingly like. Add only that both my knees are fractured from being run over which has made them very peculiarly crooked, that my neck is singularly

long, that I have a most elephantine nose, and a disposition to tumble here and there, owing to being half blind, and you may very well imagine my tout ensemble."[19] What Lear lacked, or thought he lacked, in looks, he made up for in charm. Although he confided to Empson that he was very little used to company or society, Fowler found him "very agreeable and genial in manner". Certainly he had the art of being all things to all people. His charm was particularly potent with older women. But it was not older women that Lear sought.

Two of Lear's friends, William Nevill and Bernard Senior, were in town. "Bern" (Lear rarely contracted people's names) was now working in the same solicitor's office as George Lear. He was one of the few people who knew that Lear suffered from fits. It is possible that he was a fellow-epileptic. He was certainly a bad influence. He introduced Lear into low company, and as a result Lear, according to himself, "contracted every sort of syphilitic disease".[20] What he meant by that will never be known. He was, as usual, exaggerating. Until 1910 syphilis was an incurable disease destroying heart, liver and brain within twenty years. Lear probably referred to gonorrhoea, a much commoner disease. This could be cured even in Lear's time, with arsenic and mercury, in a matter of weeks. The main reservoir of gonorrhoea was, and still is, the prostitute. It is not so well known that gonorrhoea is even more common among male than female prostitutes.

Knowsley 1832–37

It was at Knowsley that the Nonsense began. Lear went there first in 1832 to draw Lord Stanley's private zoo. Lord Derby, Stanley's father, was still very much in charge. He was the famous "little Derby" who established the horse race and popularized the bowler hat. Now in his eighties, he was as lively and popular as ever, sharing his home with an actress and several married sons and their families. "Dear old man!" gushed Lady Shelley. "His love of society and good cheer made his guests as happy and merry as himself. He constantly bantered the young ladies... about their lovers, which, though not always in the refined modern taste, so evidently proceeded from... a natural kindness, that no one could possibly have been offended."[1] Knowsley lay between Liverpool and Manchester, and still survives just beyond the suburbs of Liverpool. It is almost as large as Buckingham Palace and just as ugly. A mews as big as a royal one housed a quantity of horses. A large part of the Stanley family day was spent riding these, that is to say the part that was not spent shooting. There was also, of course, the menagerie.

Lear's arrival at Knowsley was not propitious. The station fly from Hayton swept speedily past the entrance portico and deposited him at the servants' door. There he was informed by the steward that he would be dining at the housekeeper's table. It was a moment of profound disillusion, and he persisted in referring to himself for the rest of his life as a "dirty artist". In fact his sojourn on the wrong side of the green baize doors was brief, thanks to the Man of Tobago. The Man of Tobago was a character in a collection of limericks.

There was a sick man of Tobago
Lived long on rice-gruel and sago;
But at last, to his bliss,
The physician said this:
To a roast leg of mutton you may go.

The book had appeared in 1822 under the title *Anecdotes and Adventures of Fifteen Gentlemen*, and was illustrated with woodcuts by the caricaturist Robert Cruikshank, (elder brother of the more famous George).

Lear now started to draw his own illustrations to the Man of Tobago, and to write nonsense verse in the same limerick form. Lear told the story in his own words:

In days when much of my time was passed in a country house where children and mirth abounded, the lines beginning "There was an old man from Tobago" were suggested to me by a valued friend as a form of verse lending itself to limitless variety for rhymes and pictures, and thenceforth the greater part of the original drawings and verses . . . were struck off with a pen, no assistance ever being given me in any way but that of uproarious delight and welcome at the appearance of every new absurdity.[2]

Soon a collection of odd persons engaged in odder activities were finding their way into the albums of the Knowsley young entry, and one of these albums, the Knowsley Album of about 1837, has been preserved. It had originally been a large pattern book, designed to take swatches of dress fabrics, and was formerly the property of a Manchester textile merchant. A scrap of sprigged cotton still adheres to one page.[3] It contains a hundred and twenty-eight limericks.

In the Knowsley Album Lear compressed the limerick into three lines at the bottom of the page. Bold drawings of grotesque characters filled the rest of the page. They had travelled a long way from the more elaborate styles of Rowlandson and Cruikshank. They were simple childlike caricatures, which could be the work of a twentieth-century artist, such as Thurber.

The origins of the limerick form are obscure. The Oxford English Dictionary claims that the name derives from a cus-

tom at convivial parties, according to which each member
sang an extemporized "nonsense-verse", which was followed
by a chorus containing the words "will you come up to Limer-
ick?" Certainly it was Lear who popularized the form and
who must therefore in some sense be held responsible for
the disreputable rabble it has spawned. Even Tennyson wrote
dirty limericks. So did Swinburne, Browning and who knows
who else. The limerick is normally a vehicle for wit and relies
on a final punch line. This was the case in the "Tobago" limer-
ick. In Lear's limericks the last line was a version of the first.
This produced an undertone of fatalism.

Victorian children delighted in these poems because they
were anarchic. They were the antithesis of Maria Edgeworth,
whose stories were instructions in disguise. Lear's "Old Per-
sons" were not like people you had ever met. They had beards
in which birds could nest, heads as small as buttons, chins
as pointed as pins and legs of impossible length. Their conduct
was "strange and unmannerly". They slept on top of tables,
ate underneath them, ran up and down hills in their grand-
mothers' gowns and expressed their anger outrageously. The
ladies were no better:

> There was The Young Lady of Russia,
> Who screamed so that no one could hush her.
> Her screams were extreme,
> No one heard such a scream,
> As was screamed by that lady of Russia.

And Lear's obsession with noses was, to say the least, cur-
ious. The Old Persons had monstrous noses, some of them
curling like elephants' trunks, others providing a perch for
birds.

> There was a Young Lady whose nose,
> Was so long that it reached to her toes;
> So she hired an Old Lady,
> Whose conduct was steady,
> To carry that wonderful nose.

The Freudian significance of these noses can be easily guessed.
Lear considered his own inordinately large.

Strangest of all in the limericks is the presence of "They",

a Kafkaesque concept if ever there was one. "They" form
an anonymous chorus. Sometimes they merely express disap-
proval from the sidelines. Sometimes they go horribly into
action. They smashed the old man with a gong, and also
the old man of Whitehaven. But "They" were not always
responsible for the world's sorrows. The note of fatalism is
sounded to a greater or lesser degree in all the poems. In
Lear's philosophy the world is a sad place with or without
"They", and there is no remedy. "Will nobody answer this
bell? I have pulled day and night, till my hair has gone white,
but nobody answers this bell!" Lear did not intend the limer-
icks for publication and *A Book of Nonsense* was not to appear
for a further ten years.

On Lear's second visit to Knowsley everything had
changed. The fame of his Old Persons had been disseminated
by the children. Fowler takes up the tale:

> He could not determine whether he was invited as a guest
> at his lordship's table or at that of the housekeeper....
> He took the safest part; he went below and presented him-
> self to his old friend (the housekeeper) but almost immedi-
> ately Lord Derby was heard calling out from the head of
> the stairs leading to the living regions, "Mr Lear, Mr Lear,
> come up here." Up Lear went. And from that moment
> took his place among the society... which he kept with
> ease, all his life.[4]

"Ease" was perhaps a strong expression. The dining-room
at Knowsley was the size of a church and could accommodate
a hundred diners. It was entered through a pair of Gothic
doors that reached to the roof. General Grosvenor is reputed
to have enquired, "Pray are those great doors to be opened
for every pat of butter that comes into the room?"[5] Lear
must have been more concerned about how he would get
out in case of a fit. "Half the fine people of the day" dined
at Knowsley, for Derby had been active in public life. Lear
became a particular favourite of the dissolute Earl of Wilton.
He found the earl "extremely picturesque if not handsome",
dressed in crimson with a black velvet waistcoat "like a por-
trait by Vandyke". (There were many Vandykes at Knowsley
but of more interest were the Claude Lorraines.) "But what

I like about him is that he always asks me to drink a glass of champagne with him at dinner. I wonder why he does."[6]
Not all the guests at Knowsley were friendly. Some were "hard and worldly critters" who "hadn't a particle of taste". If it had not been for the unvaried kindness of the Stanleys, they would hardly have been decently civil to the "dirty artist". The world weariness of the rich Lear found almost as trying as their bad manners. "The uniform apathetic tone assumed by lofty society irks me *dreadfully*" he wrote. At times there was "nothing I longed for half so much as to . . . hop on one leg down the great gallery".[7]

If the Stanleys were kind, so were their relatives, the Hornbys. The Stanleys made a habit of marrying Hornbys. It started when a curate called Geoffrey Hornby took Derby's ill-favoured sister off his hands in return for an exceptional living. Two of the children of that match married Lord Stanley and his sister (who were of course their first cousins). Lear became a close friend of several of the Hornbys. There were the Rev. Geoffrey's two sons, J.J. and Phipps (1785–1867), later to become Admiral Phipps Hornby. There was also Robert Hornby, a fine-looking man and a cousin of Lord Stanley's.

Lord Stanley's zoo (for such it was) was in fact an extension of his father's menagerie and aviary. In 1843 Derby died and Lord Stanley (as I shall continue to call him for the sake of clarity) became the 13th Earl of Derby. It was only then that he was able to develop fully Knowsley's zoo, making it famous throughout Europe. On Mondays, when prominent citizens from Liverpool dined at Knowsley, a tour of the zoo was always included. Lear's task was to provide a record of every specimen in the collection. He was never as much at home with fur as with feather, although some of his studies of animals, such as the tree rat (unidentified) were fine. Many of the animals lived in covered parts of the zoo where the light was poor. He had trouble with a type of turtle called a Trionyx: "Even now only the underside of the Trionyx is what I really like . . . although James Hunt held it up for me two whole mornings."[8] He also mentioned a "cat" that gave him trouble. He probably referred to his strangely formalized presentation of a seated South American leopard.[9]

In the aviary at Knowsley he returned to full strength. Stanley's Crane (*Scops Paradisea*) is of special interest because Lear supplied a landscape behind it, a conventional arrangement of palm trees and mountains. These landscapes began to appear increasingly in Lear's bird pictures. In a letter to Charles Empson he asked for "sketches of South American trees . . . they would be invaluable to me for I often want to put birds on [them]."[10] A book, *Gleanings from the Menagerie and Aviary at Knowsley Hall*, containing seventeen of Lear's large lithographic plates appeared eventually some ten years later in 1846. During the seven years that he worked for Stanley at Liverpool, Lear was obliged under his contract to continue working for Gould in London. *The Birds of Europe* was followed by a book of Toucans, a book of Trogons and a book of Australian birds.

While Lear was working at Knowsley his father died of a heart attack at the age of seventy-six (1833). He had been coming up from Gravesend to attend meetings of the Fruiterers' Company until within a few months of his death. His mother survived, still cared for by Florence, but during this period Cordelia died, and so did Lear's younger sister, Catherine. Both were governesses and perished from consumption. Cold bedrooms, poor food, long hours and no prospects can have done little to encourage them to live. Soon all five of the youngest Lear girls had died. A happier fate awaited two of the older girls. Mary was now Mrs Boswell and Eleanor was Mrs Newsom, and lived at Leatherhead. To her sorrow Eleanor was childless, until Charles brought her a present from Africa.

Charles, it will be remembered, was only three years older than Lear. He had gone to West Africa as a medical missionary where he was reported to be a great favourite with the chiefs. When he nearly died of malaria, he was put on board a ship for England. The captain would not take him without a nurse, so Adjouah, the native girl who had nursed him, was sent too, but Dr Lear honourably insisted on marrying her first. He took her to his sister Eleanor. Family tradition had it that the day after she arrived Adjouah poured the jug of water in her bedroom over her head. She seems to have been a lovable and intelligent girl. Lear was thoroughly embarrassed

by the whole business. He did a series of illustrations for the ballad, "Alice Grey", in which Alice, who was originally the owner of "a brow of spotless white", becomes a black mammy teetering along under a minuscule umbrella.[11] Charles returned to Africa where he shortly died and Adjouah, after three years of education, returned home to become a missionary. Lear continued to write other send-ups of well-known characters in drawing-room ballads of the day, by supplying them with ludicrously inappropriate illustrations. Beautiful young women and their adornments were still the chief butt of his pen. The heroine of "The Mistletoe Bough" was portrayed as an upended whale with a Spanish comb and sundry withered flowers stuck in her hair. The fact that Lear frequently misquoted these ballads suggests that he had sung them so many times that he considered he knew them by heart.

Lear now became interested in life-drawing. In 1834 he seriously considered enrolling at the Royal Academy Schools, for, although he had given drawing lessons, he had never received one. The Academy specialized in teaching the art of drawing from the living model. To prepare for its entrance exam he enrolled at Sass's School of Art in Bloomsbury, but only stayed a few months. He nevertheless was there long enough to meet a fellow-student, William Knighton, who was soon to become an important friend.

There were other signs that Lear's art was developing in new directions. He had continued to spend the summer holidays in Sussex each year since boyhood. This year, 1834, he went in October, and took a sketch-book with him. It was not much larger than a pocket account book, but in it he began to draw landscapes for the first time, or rather houses in landscapes. He drew Peppering House set in its fold of the Downs at Burpham. Then he drew the mill with its ricks and turkeys. (He composed a comic poem about these turkeys for the Drewitts.) The following year he toured the Wicklow Hills with another of the Stanleys, Arthur Penrhyn, later to become Dean of Westminster, and one of the most loved of Victorian churchmen. Arthur's father, the Bishop of Norwich, came with them as far as Dublin. Landscapes now began to predominate over buildings in Lear's drawings. "Wicklow

Head" is a mountain scene in which only a fragment of masonry appears, and even that is partly obscured by a group of very Learish trees.

It seems possible that Lear was taking some sort of tuition in landscape drawing by this time. Daniel Fowler, in whose studio Lear sometimes worked, had been training under James Duffield Harding (1798–1863) between 1831 and 1834. So had his brother-in-law, Robert Leake Gale, also a friend of Lear's. J.D.Harding was, of course, well known as a landscape painter in the rather formal eighteenth-century tradition, and was the author of *The Tourist in Italy*. Lear gave Fowler several sketches signed "Lear after Harding" in the gloomy Harding manner (which he did not entirely admire). He certainly knew Harding. Years later, on hearing of his death, he wrote in his diary:

Ah! J.D.Harding! I could have liked once more to have seen you! Wide apart as we were in all thought, yet you had some astonishingly true and original perceptions; and moreover I owed you for some benefits . . . I had received – not much personally – but much through Gale and Fowler; advantages which I . . . acknowledge the value far more now than then.

The following autumn came the visit to Cumberland and Westmorland. Lear's companion and sketching pupil on this occasion was J.J.Hornby, son of the Reverend Geoffrey, no less than a future Provost of Eton. The holiday was an unusually long one, lasting nearly three months. Lear had been overworking and he was seriously worried about his sight. "My eyes are so sadly worse, that no bird under an ostrich shall I soon be able to see." His intention was to walk over "the whole ground" that Wordsworth had made sacred and to "sketch a good deal" of it. He and Hornby (a muscular Christian if ever there was one) raced each other up "most of the notable fells".[12] The portfolio he brought back gave him the right to put "landscape artist" after his name. Suddenly he knew what was closest to him in life. He had found a family in these hills. "Scawfell Pikes is my cousin," he announced, "and Skiddaw is my mother-in-law". Years later he still regarded landscape features as closer to

him than people. "The elements, trees, clouds, silence...
seem to have more part with me... than mankind,"[13] he
wrote thirty years later. On 27 September 1837 he made a
drawing of the great rock of Crummock which expressed
these feelings. The rock rises, black and fearsome, the lake
is pale, a lonely figure stands upon the road.[14] Lear had seized
the vision that would be with him for the rest of his life.
He had also caught a bad cold.

PART III

ROME 1837–48

5

Rome 1837

There was one thing only wrong with the English landscape. It was wet. The winter after the visit to the Lakes found Lear gasping with bronchitis. By January 1837 he was also suffering from a return of the childhood asthma that always accompanied it. The cure for a weak chest, before the days of penicillin, was to winter in a warm climate if you could afford it, and death from pneumonia if you couldn't. Young William Knighton, Lear's fellow-student at Sass's, was just off to study art in Rome, heavily chaperoned by his mother and his cousins and his aunts. Lear, who was more than a little taken with the young aristocrat, decided to follow him. (Perhaps he was also inspired by the tales of Fowler and Gale who had just returned from Italy.) Lord Stanley and his cousin, Robert Hornby, lent him the money. The six years of servitude to Gould were over. The twenty-five years of partnership with Ann were also about to end. Ann planned to go to Rome with Lear but she got only as far as Brussels where she remained for a year, waiting to be summoned by him when he considered it safe. He never did. Instead he wrote her frequent "long and shambly"[1] letters.

With the letters to Ann the young Lear steps out of the shadows for the first time, startlingly articulate. He described to her his feelings as he greeted the Mediterranean world, knapsack on back. He walked round Lake Como, enchanted. The mountains at Lugano especially impressed him, rising almost perpendicularly from the lake, covered in a mass of crimson foliage. In the foreground were groups of picturesque peasants. The portfolio bulged.

Back at Como he met Knighton as arranged. Knighton was now Sir William Knighton Bart, for his father, also Sir William, had recently died. The title was not an old one. Sir William Senior had been given it some twenty years earlier by the Prince Regent, whose doctor he had been. Subsequently he became Prince George's private secretary and Keeper of his Privy Purse. In these positions he was responsible, during the ten years of George IV's reign (1820–1830), for getting the king out of his chronic condition of debt. The king came to rely on Sir William, but also to resent the power he had over him. "I wish to God somebody would assassinate Knighton," he was once heard to say.[2] In spite of his privileged position and the opportunities it gave him, Knighton took nothing from the King except his baronetcy, and once George had died, he had retired to the country. He was a man of taste, with a keen interest in painting, and it was no doubt for this reason that his eldest child and only son had set out to become a painter. The young Knighton was vastly gregarious. He travelled not only with his family, but with quite a number of Tattons and Russells, who were vaguely related to him, and a Mr Ellis. The whole party appears to have adopted Lear as a kind of pet "and a famous holiday we had on the beautiful lake".

Lear now engaged a shared *vetturino* with Mr Ellis. "I cannot conceive anything more trying than a *vetturino* journey," he grumbled to Ann.[3] The heavy four-wheeler moved at a rate of three or four miles an hour across the endless plains of Lombardy behind a queue of other vehicles, stopping at every ducal frontier for passport formalities. The crossing of the Apennines was more exciting. The carriages, each hauled by eight oxen, crawled to the snow-line, the passengers walking. Suddenly they saw Florence below them, a cluster of red and white amid green hills. The Knightons, Tattons and Russells all turned up again and they had a capital picnic on the top.

Lear planned to stay in Florence until Rome was "quite purified of the cholera that had plagued it all summer", supporting himself by giving drawing lessons. Socially he was off to a flying start with his Knighton escort. As soon as he arrived in Florence the English started dropping cards on

him. In the end it was the autumn monsoon that flushed him out of "the paradise of Florence, water rushing from the marble spouts like cataracts, wholesome only for those whose chests can bear it".[4] The Knightons were heartbroken at his departure. They all gave him presents. One gave him a bag of gingerbread, another a pound of groats for gruel, another a pair of worsted mittens.

William Theed the sculptor offered Lear a seat in his *vetturino* to Rome, assuring him that all the talk of robbers on the road was nonsense. Theed was an old Rome hand. Dennew, a painter, was also of the party, and the journey took "5 mortal days, from 3 am till sunset".[5] Lear was immediately fired by the male beauty of Rome which attracted him more than the female prettiness of Florence. "You should see the Corso," he told Ann, "the immense length of it, the palaces of the nobility enormously high, yet the street itself so narrow". Inside these palaces there were "long galleries . . . interminable stairs . . . but splendid rooms when you get there". The noise of Rome was another matter. Baggage mules went down the Corso "in troops" dodging past the wheels of great beribboned ox-wagons. The horse-drawn coaches of the rich and the hired cabs of the less rich added to the racket and there was a great deal of barging. Lear witnessed a blessing of the horses. "Such kicking and pother. The beasts did not seem to be at all the better for [it]."[6] In the early mornings the racket was increased by a herd of goats and asses driven through the city by a milkman dressed in skins. But there was always the peace of the ruins to retire to. "The melancholy and grandeur of the huge remains is very awful," Lear told Ann.[7] To a certain Mrs Roberts (no doubt a patron) he wrote from the slopes of the Palatine Hill, "Here I sit amid vast masses of antique brickwork . . . I wish I could say I draw . . . [too] extreme is my lizardish enjoyment of the hot sun".[8]

In the 1830s Rome was a city of artists. It was to art what Paris was to be a hundred years later. An artist had two homes, his own and Rome. At the end of the century Baedeker could say, "Rome is still the High School of Art."[9] For the first and last time in his life, Lear became a member of an artistic community. "All the people here are kind and agreeable," he told Ann, "but the artists especially are a delightful set.

Gibson, Wyatt and Theed, Williams, Coleman and Uwins particularly."[10] Of these all but Williams and Uwins were sculptors. John Gibson (1790–1866) was one of the greats. He had studied under Canova. Canova in turn had led the classical revival that followed on the excavation of Pompeii. In spite of his distinction, Gibson was a humble man, "a god in his studio, but God help him out of it", as one of his women students once said.[11] (His liquid white marble nudes can be seen on the stairs leading to the upper floors of the Royal Academy.) Richard Wyatt (1795–1850) was of the same generation as Gibson and a nephew of the architect of lunatic asylums, Thomas Wyatt. Like Gibson he had studied under Canova. William Theed (1804–1891), Lear's companion from Florence, was a man nearer to Lear's age, who was shortly to find favour with the royal family, supplying statuary for Osborne House. He would eventually sculpt "Africa" one of the four monumental groups at the base of the Albert Memorial. The appetite of the Victorians for marble statues was well nigh insatiable. Benjamin Haydon (1786–1846) regretted it in his autobiography. "You fill your homes," he wrote, "with masses of unwieldy stone and allow not one side of your rooms for pictures."[12] The avenues of contorted white figures in Westminster Abbey are a reminder of this passion.

With the help of Theed, Lear negotiated rooms at 39 Via del Babbuino ("Babboon Street to you," he told Ann). It was close to the Piazza di Spagna and therefore to "all the English and all the artists". Lear was delighted with his L-shaped studio on the second floor. It was his first home of his own and he was twenty-five years old. The rooms were about the size of his London ones, but loftier and better furnished, he assured Ann. There was a window opening on to a loggia where were the *commodities* ("begging your pardon"). Lear was a stickler regarding lavatories.

He then outlined to Ann a day in his life in Rome. "At 8.00 I go to the cafe, where all the artists breakfast, and have two cups of coffee [and] two toasted rolls for 6½d. Then I either see the sights, make calls, draw out of doors, or, if not, have models indoors 'till 4.00." (Peasants in local costumes waited all day on the Spanish Steps to be hired.) "Then

most of the artists walked on the Pincio mountain . . . from which sunsets are seen, and at 5.00 we dine very capitally at a Trattoria. After that Sir W.Knighton and I walk to the Academy."[13] The well-loved Sir William had evidently arrived from Florence.

Lear's letters to Ann (who was still living in Belgium) continued to be long and detailed, written at fortnightly intervals. Through them we also for the first time get to know Ann. In his constant teasing and scolding of his sister, Lear was once more a brother rather than a son. "How are your principles? Manners? Money matters?" he enquired on her 58th birthday, adding "Never write a word about politics". If not stupid, Ann was exasperatingly vague. She could seldom even get his address right, having little idea of geography. She thought that Naples was somewhere between England and Rome. "Why you fancied *that* . . . I cannot divine, seeing that it is 3 days journey *beyond* this place."

She lodged with the friendly le Harivel family in the Faubourg du Schaerbeck in Brussels, and made long expeditions into the city and the surrounding areas. Lear drew her setting out on one of these with a basket and an outsize gamp. "I think this is very like you," he wrote underneath. The trouble was that Ann still wanted to come to Rome where Lear now moved in a high level of society. His connection with Sir William Knighton Bart and his introductions from Lord Stanley gave him access to circles normally closed to "filthy artists". Winter was the season when the British aristocracy settled like a flock of starlings upon the city. The Aclands, Hopwoods and Tableys were all vaguely related to the Stanleys. "Indeed I do not know who is *not* here." The young painter accepted invitations to balls which were a nightly affair. Unfortunately he was never much of a dancer, and he soon declared, "I am pretty well sick of those things."[14] The routine of card-dropping and calls was also becoming "as tiresome as London".[15] There were, besides winter visitors, permanent British residents in Rome. One was old Sir William ("Topographical") Gell, author of *The Topography of Rome and its Vicinity*, 1834, a book which Lear warmly recommended in his own book on the subject a few years later. He was a well-known eccentric sharing a neo-gothic

castle on the Pincio with a wealthy friend. The two old bach-
elors also shared "a strong antipathy one for the other".[16]

Society could not be ignored, for its members were his
customers. No self-respecting tourist left Rome unencum-
bered by a picture or a statue, and every artist was expected
to have a showroom to which visitors were admitted during
hours which he announced at the beginning of the season.
The artists' studios were regarded as a tourist attraction:

> Among the characteristics of Modern Rome capable of
> fording the highest interest to the intellectual visitor, there
> are few that offer a greater charm than the artists' studios.
> Travellers in general are little aware of the interest which
> they are calculated to afford, and many leave Rome without
> making the acquaintance of a single artist. In the case of
> English travellers, in particular, this neglect is more inex-
> cusable, as some of our countrymen are amongst the most
> eminent artists of the Eternal city... The instructions to
> be derived in the studios of these gentlemen is afforded
> on all occasions in the most obliging manner.[17]

Since the Roman shops were vastly inferior to the Floren-
tine ones, studio-crawling took up a considerable proportion
of the mornings of persons of quality.

By the end of the winter Lear declared sadly that he had
"done and improved little", but had, however, collected com-
missions for two or three studio water-colours, "so I shall
not starve".[18] The person who commissioned these water-
colours was almost certainly kind Lady Susan Percy, whose
uncle, the Duke of Northumberland, had been one of the
subscribers to the Parrot book. To support himself, Lear also
taught drawing. A young Tatton, who had crossed the Apen-
nines with the Knighton mob, was one of his pupils. He
was lodged conveniently next door to Lear.

Christmas brought with it more distractions. Lear was
charmed by the Neapolitan *pifferari* who went from church
to church serenading the *presepii*, or cribs. They wore tall
black hats, red waistcoats and sheepskins and they blew into
"enormous droney bag pipes". At this season the multi-
coloured clergy were everywhere including cardinals in their
chairs. Priests scurried about and even the ordinary folk

moved fractionally faster although "20 mad bulls would not set an Italian out of a slow walk". There were chestnuts for sale at every street corner, "fine smoking ones. At a halfpenny for 40 you could practically live on them".[19] Lear ate Christmas dinner with the artists at the *trattoria*.

His affection for Knighton was increasing. "We are now very much together," he wrote to Ann in January. Not only did they go together for lessons every evening at the Academy, but on Sundays they took turns in entertaining each other to dinner in their flats. Most precious of all to Lear was a memory of the Colosseum by moonlight with Knighton, "Beyond all conception grand."[20] Suddenly Knighton and all his friends flew away to Naples for the Neapolitan season. Lear was downcast. His sister Florence, who had cared for his parents, now seemed unlikely to outlive his mother. "I thought sometimes of writing," he told Ann, "but the expense would be inconvenient to her." Postage at this time was still paid by the recipient. Lear evidently never wrote to his mother.

Youthful spirits were restored with the return of Knighton in time for the Carnival, a period of several weeks when Italians don fancy dress to celebrate Shrove Tuesday. Lear's ecstatic account of the day is a reminder that he had very little fun as a boy. "Fancy me with a red bodice and green skirt, with a white *scioccatura* which is... the headdress of the common women!" he wrote to Ann. He described the game of "Blow out the *Moccolo*". Everyone hired a coach and filled it with masked friends. "The fun is for everybody to extinguish everybody else's candle, but keep his own alight... nothing is heard but the immense cry of '*senza Moccolo*' the equivalent of 'Howzat'. It is delightful," he wrote, "to creep along behind with a hankie and darken a whole party!"[21] The greater Easter processions six weeks later were the signal for the English gentry to return to their country estates. Lear had worse news than this to announce to Ann. "Knighton is going to be married to a Scotch lady."[22]

Lear's taste for *festas* declined sharply after Sir William left. The trouble was the bangs. He could not understand why the Italians were unable to enjoy themselves without igniting unholy quantities of gunpowder. At one moment, during

the Easter ceremonies outside St Peter's, he thought the whole of Rome was going up in one vast rocket, forum, pantheon, baths of caraculla and all.

The place to escape from noise was the Campagna, the silent, haunted plain that surrounds Rome on all sides. It was the Campagna, "a whole world rolled out flat (not flat but undulating) and bordered with huge mountains" that had attracted his attention on the way to Rome with Theed. He needed constant exercise to control his epilepsy, and here he could walk for miles, meeting only shepherds who were "beyond everything picturesque . . . like satyrs . . . dressed all in goat-skins".[23] Lear rejoiced, too, in the solitary groups of umbrella pines, and in the aqueduct that ran like a thousand-legged caterpillar across the plain. His little drawings of these features for Ann were the equivalent of the snapshots brought home by modern travellers. With the coming of spring the Campagna began to call more imperiously. "I half live there now."[24] The willows along the Tiber were misted with green and the khaki plains spotted white with lambs. When he should have been drawing, he stalked tortoises and porcupines. There were hawks too, and foxes. "Loveliness itself."[25] It was time to join the artistic exodus into the country. After Easter, Lear explained, "everybody runs away and poor dear Rome is deserted."[26]

Civitella 1838–40

"I will now tell you what I mean to do for the summer," Lear wrote to Ann. "I mean to go to Naples with an artist of the name of Uwins – a quiet and good tempered, sensible fellow. Had he *not* been so, I should have gone with *anybody* rather than alone for I know how unpleasant it is to be quite without society."[1] There is some uncertainty about which Uwins this was. Previous biographers have plumped for old Thomas Uwins, RA, painter of genre scenes. Since old Thomas was never in Rome after 1831,[2] it seems certain that Lear's companion was the much younger (and smaller) James, who had arrived in Rome with Frederick Thrupp the sculptor in March 1837, a few months before Lear's own arrival.[3] It was common to confuse the two Uwins even during their lifetimes. Many years later when Lear was living in Corfu, he was informed that *Thomas* Uwins was on his way from Athens. "But this is impossible to me, for old Mr Uwins RA, is 80, and can't go larking up Pentelicus." The visitor turned out, of course, to be James, small and silent as ever, but now heavily bearded. Little James Uwins was a nephew of old Thomas Uwins (who married very late in life and was childless). His father was Thomas Uwins' brother, Dr David Uwins, the physician.

In the spring of 1838 James Uwins hatched the scheme of walking through the mountains to Naples. (It was more usual to take the *diligence* (or stage-coach) through the coastal plain of the Papal States.) In this way they would extend a three-day journey to twenty days. Inevitably the first hill station they encountered in the Sabine Hills was Tivoli. On

top of the 650-foot rock of Tivoli, Lear declared the view to be "the height of landscape perfection". He admired the "beautiful ruins of the Sybils' temple", explaining to Ann, "As the river comes to Tivoli, it is obliged to tumble (with such a noise) *down* the rocks and it is over this chasm that the temple stands." But, truth to tell, he found the waterfall excessively noisy. He preferred the calm of the Villa d'Este's garden. "You come to the upper terrace and are dumb. The most enormous trees – pines and cypresses – are beneath you; long walks of gravel, grass and box – formally cut; fountains by hundreds of thousands, terraces, flights of stairs."

But there was no escape from noise for long. Sunday 6 May was the great feast of the Madonna at Tivoli. A statue of "her ladyship" was brought into town, attended by "sundry children dressed as cherubim (with yellow satin frocks and pink paper wings), long lines of variegated clergy and a band of musicians".[4] Lear, like all Victorian Protestants, received something of a shock from the impact of unmitigated Roman Catholicism. Back in England, Papism was the red-hot issue of the day. The Reverend Charles Kingsley was erupting furiously against Cardinal Newman. Between these two extremes, sat the Broad Church men, and Lear sat with them. He put up with Popish junketings better than some. Thomas Uwins could barely control his indignation against the Roman Church, which, by means of "mummery" reduced its devotees to "degradation and mental slavery".[5] On the whole Lear enjoyed the mummery, and only objected to the racket that went with it. Tivoli could not afford cannons, so its citizens bored holes into the hillside and filled them with gunpowder. The *détonnade* lasted three hours.

In spite of his discomfort, Lear hung on, for he was eager to sketch the peasants who had come to the *festa*. Each village had a different costume: full blue skirts and high heels for the women of Chevara, red, gold and white for the women of Coichara and, best of all, green and red for the women of Albano, whose nunlike headresses, like folded napkins, were "such as you must see to believe the effect of".[6] Peasants were a necessity to Lear and his colleagues. No painting was complete without a group of them in the foreground. Old Thomas Uwins put it well. "Peasants," he said, "enable us

to realise those scenes of history and poetry on which we are most delighted to dwell. A group of society people in modern dress would be a poor substitute."[7]

It was a relief to set off up "the sweet valley of the Anio" (the very river that gushed from below the Sybils' temple) into the wild hills of the Sabines. "Amiable" young William Acland, a Hornby connection, was the third member of the party. He was a person worth encouraging, for his cousin was Sir Henry Wentworth Acland, the patron of Samuel Palmer. Hordes of Victorian tourists eager to visit Horace's farm and willing to believe any lies the locals told them about it were still a thing of the future, and these hills were wild indeed, and their inhabitants uncouth to match. After three days Lear, Uwins and Acland found themselves stranded five miles from a dot on the map called Spiaggia, with night coming on. Lear transcribed a conversation with a peasant of whom he enquired the way:

Lear	How far is it to Spiaggia?
Peasant	Who knows.
Lear	Is it a town or a village?
Peasant	How can anybody tell.
Lear	Are there any inns?
Peasant	I don't live there.

In the event there were no inns and only three houses, but in one of them they were allowed to share a gigantic room with a family and some horses. The food was simple but good, and Lear had learned to eat hard-boiled eggs, formerly his pet aversion. "You remember how I used to like hard-boiled eggs?' he asked Ann. "Now I eat 7 to everybody else's 4 . . . As for fleas, you could have 100 where in England 5 would have done."[8] At the farm at Spiaggia Lear perfected his flea cure. "Strip entirely," he said, "then shake out your clothes well and . . . walk up and down the room bare-footed – presently the creatures settle all over your feet like mites on a cheese and you may kill them by the dozens". It was thus that Lear celebrated his twenty-sixth birthday.[9]

The three young men started to walk every morning before five, while it was still dark, and saw dawn tip the hilltops with pink. These pointed hills now grew "higher and wilder",

each with a "town or a village stuck on its extreme point, many quite inaccessible". Sometimes they could see as many as six or eight towns piled up on distant hills. "To see the peasantry coming down... early, to their work... the mothers carrying their very young children in a pretty wicker cradle on their head" was a fine sight indeed. Lear admired not only the clothes of the Sabine women, but also their figures, "Without their aprons... their shape is perfect... for they carry such weights... on their heads from their youth." It was rare for Lear to mention a woman's shape.

Eventually they reached the busy town of Subiaco, famous for the twin monasteries of St Benedict and his sister Scholastia, in the gorge of the Anio. Ill-luck would have it that the new cardinal of Subiaco was to be inducted to the cardinal's castle that very day. This meant a cannonade. At the best of times Subiaco was not a quiet place, for a selection of the Roman artist colony transported itself thither in May and spent the summer perched like gannets on a rock. There was even "a sort of hotel and *table d'hôte* at which there is plenty of society," Lear wrote with a shudder.[10] (He would have liked the place even less now, for St Benedict's monastery is a world centre of pilgrimage.)

When Lear and Uwins set out southwards for Civitella (they shed Acland at Subiaco) Lear little guessed that Civitella would be one of the most important places in his life. It was a hard place to reach. Even thirty years later, Baedeker recommended a donkey and a guide for the seven and a half mile journey up the valley of the Sacco. Mule roads without a mule, were "fatiguing enough being only rocks forming the beds of torrents and like a flight of steep stairs up and down. The valley we passed I do think the most lovely I ever saw. Claude's pictures give you an exact idea of such spots.... Bye and bye we wound up through magnificent oak forests.... Another tremendous rock staircase brought us to Civitella, the highest village in those parts. Immense ancient walls of solid stone without cement, like Stonehenge... older by many 100s of years than the Romans.... They are called Cyclopian."[11]

Civitella is barely mentioned by Vivien Noakes in her biography of Lear. In her Royal Academy Catalogue she reme-

dies the omission but confuses Civitella with Subiaco. The confusion is understandable. The full name of Civitella was Civitella di Subiaco. The word *civitella* in Italian means "dependent village". Lear was to illustrate both Subiaco and Civitella in his book, *Rome and its Environs*, 1841. The Civitella lithograph (plate 5) he captioned, "The site of an ancient city, 9 miles from Subiaco," thus clearly distinguishing them. Civitella was virtually Lear's discovery. There is no mention of it in Murray's first *Handbook to Rome* (1843), and Baedeker's *Rome* did not include it until 1893. "Civitella," Karl Baedeker wrote, "is a poor village lying on an isolated peak in a barren, mountainous district. Owing to its secure position it was inhabited even in ancient times, but its former name is unknown. The fragments of fortification which commanded the narrow approach on the west side, constructed of large masses of rock, are still visible." Lear and Uwins may have been tempted to linger in the sky dwelling of Civitella, but there was no inn there and it was the custom to walk the extra one and a half miles to Olevano, on a lower hilltop. From Olevano the view of Civitella is loveliest of all, especially at sunset. The village climbs like a crest to the top of the limestone ridge, and stops short at the precipice.

Naples was every bit as bad as Lear had expected. The cheating started long before he reached it. At Monte Cassino the artists hired places in a high-speed *caricola*, but half-way to the city a new driver took over and reduced the number of horses to one! Lear threw himself in front of the remaining horse and argued for an hour. The driver "rushed up and down... and scrunched his hat all to bits" in fury and frustration. In Naples itself things were no better. Sixty thousand of the population had recently died of cholera "but no one can tell the difference". In the market place every woman screamed "muscles [sic] – oysters – baskets – eggs – roses – apples – cherries", while down on the quay every man shouted "a boat, a boat!... to wherever you please!!!" The royal court made just as much noise as its subjects, scampering continually up and down in golden coaches banging on kettle drums. Soon Lear started to suffer from shortness of breath because of "the sulphurous air from Vesuvius and the dust from all the driving".[12]

Feeling ill was not conducive to sociability. He had twenty letters of introduction but does not appear to have distributed them. Certainly there were great patrons of the arts at Naples. Old Thomas Uwins had been flattered and spoilt by the blessed Lady Blessington and his own particular patron Sir Richard Acton, of the Palazzo Acton. Young James Uwins would presumably have had introductions to these two distinguished persons at least. The only member of society whom Lear actually mentioned by name was "little Phipps Hornby", a young officer whose ship was in the harbour, the son of Captain Phipps. Samuel Palmer and his wife Hannah stayed at the Hotel de la Ville de Rome that year. Palmer mentioned that Lear and Uwins were fellow-guests.[13] Lear did not mention Palmer.

At Corpo di Cava things suddenly went right. Corpo was a hamlet at the head of the wooded valley (known as the Cava) overlooking the Bay of Salerno, a long way south of Naples. "Nothing can be so delightful as this place after Naples – the birds singing in the morning and the exquisite air . . . Salvator Rosa studied for many years among the woods of La Cava, and you see numbers of the actual rocks so common in his paintings."[14] There was no *pensione* at Corpo di Cava, and Lear and Uwins rented rooms in a peasant's house for a month. This was to become their summer habit. On the present occasion the arrangement was particularly satisfactory as it was cherry time in the Cava and there are no cherries bigger and juicier than Cava cherries. Lear had the poor boy's passion for fruit. "3 lbs for less than a penny!" he told Ann.[15] He later repented it.

At Corpo there was time to experiment. Here Lear first attempted to paint with oils. He had presumably bought "colours", along with brushes, a palette and thinners in Naples. He started in a small way, making outdoor sketches on paper. Until recently it was thought that only one of these Corpo oil sketches had survived: a detailed study of tree roots.[16] Now two more have appeared in a collection of two hundred Lear sketches. (They were apparently unknown to the organizers of the Royal Academy's Lear Exhibition of 1985.) These were stuck into seven large albums by Lord Northbrook (formerly Thomas Baring) and are preserved at the Liverpool

City Library.[17] Both were painted on 13 June 1838, at Corpo. One was a still life of a glazed jar, a rush broom and a basket. The other, more ambitious, could have graced the lid of any chocolate box. A girl stands in a lane embowered with flowers. In a blue sky cotton-wool clouds await the imprint of cherubs' bottoms.

It was while he was at Corpo that Lear made up his mind about Ann. He had been in Italy for a full year. This meant that Ann had been in Brussels a year also, waiting to be summoned to Rome. At one time he had almost capitulated. Other painters had sisters and wives and mothers in Rome, he told Ann. Now he knew the thing was impossible. He was fond of his quirky old sister, but she was totally unpresentable socially. "I hope you dress as neatly as I taught you to do," Lear wrote, but he knew she didn't. Also she was blissfully unaware of the nuances of social distinction. She once suggested that Lear should board with an English family in Rome called Clark. Lear wrote back "The Clarks are . . . saddlers!"[18] Ann, unabashed, wrote the Clarks a card instead. Even then she got the address wrong. "The Clarks do *not* live in Piazza di Spagna, but Via Babbuino, goosy." Lear was now anxious to get Ann back to England quickly where she could live cheaply with her married sisters or even obtain a post as a companion. Ann, however, like her brother, preferred to be a wanderer, moving from rented room to rented room. It was thus that she would spend the rest of her life.

From Corpo di Cava Lear and Uwins made expeditions on foot (no small feat in July), north to Pompeii and south to Paestum. Pompeii impressed Lear deeply. "Read Bulwer Lytton's book," he told Ann. (*The Last Days of Pompeii* had been published four years earlier.) "You can see the marks the glasses left on the sideboards, the skeletons of the horses still tied to rings in the stables."[19] The excitement of the discovery of the ruins of Pompeii in 1748 was fresh in men's minds and much still remained to be excavated. Paestum was the furthest point south Lear and Uwins reached. Eboli was the village from which one visited its three well-preserved Greek temples. Lear had some difficulty in tearing himself away from Eboli. He was held captive by his landlady. She ordered her servants to lock the door and grab him although he insisted

that Uwins, who had gone on ahead, had paid his share of the bill. "I got up a most particularly outrageous passion," he told Ann. (His fits of rage were a joke between them.) "I don't think you ever saw me in one, but really I inform you I am very awful. I... stormed and acted so well that not only the frightened landlady let go her hold but her very man servants were scared." It was only when Lear rejoined Uwins seven miles along the road back to Corpo di Cava that he discovered that the gentle little Uwins had *not* paid his share of the bill. As Lear's legs were longer he walked back to Eboli. "What a pity," said the landlady, "that such an honest young man should be a Protestant."[20]

Lear and Uwins spent the month of August in Amalfi on the south side of the peninsula that divides the Bay of Naples from the Bay of Salerno. Lear told Ann little about the visit, probably because when he found a *particular* kind of happiness he did not communicate it to her. Years later, in a diary entry for 1862, he spoke of being visited by "*that* kind of happiness" at various times and places in his life, one of them "the first years of Roman and Amalfi life, '38–'39". He made drawings of that astonishing slide of houses into the sea that is Amalfi. From Amalfi, the painters set off for Sorrento, taking the tunnel southwards (clearly visible in Lear's drawings). This coast road, perilous now and more perilous then, was the only way to reach Sorrento, for the peninsula was too precipitous to cross.

Lear's description of the journey back to Rome, this time by the coast road (with robbers) is a miracle of graphic compression, combined with humour. It was surely these letters to Ann that gave him the idea of writing travel books. The two men travelled by *vetturino* but preferred to walk most of the way. The journey became interesting at Terracina. "Immediately on leaving it, commence the Pontine Marshes.... What do you think the 'Pontine Marshes' are like? Why, one straight road, one everlasting avenue, like an arrow, for 40 miles, all the way bordered with the most beautiful trees imaginable.... You see a little round hole at the end like a pin head – hour after hour till you grow sick... Uwins and I... counted 9 vipers... I had a most narrow escape from one... I heard Uwins scream out –

53

which he being usually taciturn, surprised me very much –
I had trodden on one of these creatures – as they bask in
the sun – but on its head! Had I trodden on its tail I must
have been bitten." Alarmed by the experience, Lear took to
the *vetturino*, but that proved no safer. "Getting out of the
Vettura, I threw down a sack – to which I attribute my
being covered with swarms of fleas – as nobody else... suf-
fered as I did. I attempted to draw – but was obliged to
give it up and undress and I actually caught 43 fleas before
I was quite undressed!!! I put their bodies all in a row."[21]
Nevertheless they finally reached Albano and soon after,
Rome itself, "my darling city".

Lear had an attack of what he called gout when he reached
Rome. He decided it was due to the cherries of Corpo and
put himself on a fruit-free diet. Penry Williams soon tempted
him off it with the suggestion that they visit Civitella for
the grape harvest taking a talented young Danish artist called
Wilhelm Marstrand with them. Penry Williams was the
ringleader in most of the undertakings of the English painters
in Rome. He was a man of about forty, full of warmth and
enthusiasm, who had lived in Rome since his middle twenties,
and was eventually to die there. His story was a remarkable
one. Williams's father was a stonemason living in a one-up-
and-one-down house in Merthyr Tydfil. The boy was encour-
aged by Sir John Guest, the local ironmaster, and sent to
Rome, where his studio became a major attraction. His pic-
tures were hung in prime positions in the Royal Academy
over a long period. Forty years after his arrival in Rome,
Penry Williams's studio at 13 Piazza Mignanelli was still on
every tourist's visiting list. He was, Murray's handbook dec-
lared, "without exception the most eminent painter of Roman
scenery and groups of peasantry. No painter in modern times
has better succeeded in reproducing with accuracy the outline
of the distant mountains and the splendid colouring cast by
an Italian sun over the Campagna and the rains scattered
over it."[22] Lear described him as the "1st British painter resi-
dent in Rome", and added that, "he has been always very
good natured to me".[23] Peasant costumes were Penry Wil-
liams's speciality. "The accuracy of Penry Williams's Italian
peasant subjects and the correct beauty of their surroundings

could not be . . . appreciated by those who have never known Italian scenery or any other colour but grey. . . . I owe him most for having introduced me to such places as Civitella."[24] Lear attempted to imitate Penry Williams's peasants in their attitudes of Horatian ease. He failed.

Penry Williams had decreed that they should travel through the bandit country of the Alban Hills. They started with a day-trip to Monte Fortino. Here the heads of five brigands hung in cages over the gate. They had been despatched on the orders "of Pius VII or VIII who cured the country of these pests". The place now seemed to be largely inhabited by pigs. Emboldened by their survival, the three painters decided to risk a night at Segni, "a very curious town where no travellers hardly go as it is not of very good reputation, but Williams having been so long in Italy speaks like a native".[25] Unfortunately a female bandit had survived the Pope's decree and now let out rooms. She kept the party prisoner until they paid her double the usual price, explaining, "English, like quail, do not come twice, we must make the most of them." Penry Williams got his own back on her. He borrowed a mule to carry their goods across the Latine Valley that divides the Alban from the Sabine Hills, and returned it without paying the fee. They passed Civitella, San Vito, Pizziano and Givano, all sublime on their jagged mountains surrounded by chestnuts "and looking over boundless views, most of them exactly like the pictures of Claude (Lorraine) who studied hereabouts". It was probably Wilhelm Marstrand's first sight of Civitella.

Lear finally returned to Rome (after yet another trip to the Sabine Hills, this time with Wyatt and Thrupp) for the winter of 1838–39. He had grown a fine moustache which he cut off when he heard that no respectable Englishman ever wore one. He planned to settle down to work. His landlady had proved an "old hussey". Because the city was bursting with winter visitors she had doubled the rent. He moved to new rooms at 107 Via Felice, not far from the Pincian Gardens, but further from the Piazza di Spagna. His new landlady was a "well known, respectable woman, old Signora Giovannina". He shared her floor of a palazzo with an "eminently respectable" English artist plus wife and mother.

Everybody, he assured Ann, was very *clean*. He had two principal rooms (again about the size of the London ones). The bigger of the two he used as a study (he always referred thus to his studio) as it had three windows. Lear now prepared an exhibition of the oils on paper that he had spent the summer experimenting with. When they were framed and hung ready for inspection by the winter visitors, he declared himself pleased. The studio "stuck all over with my oils [looks] quite grand", he told Ann.²⁶ He continued to produce these oil sketches. "The Temple of Venus and Rome" (1840) was a particularly successful study of a ruin in warm stone shades. It was evidently intended as a present to a friend. Lear signed one of his longer nonsense names on the back:

Mr Abedika
Kratopouoko
Prizzikalo
Kattefello
Ablegorabalus...
Ableborinto phashyph...
Chakonoton the Cozovex
Dossi
Fossi
Sini
Tomentilla
Coronilla
Polentilla
Battledore and shuttlecock
Derry down Derry
Dumps
Otherwise Edward Lear

Scholars have pondered long over this remarkable list of names, and I am indebted to Thomas V. Lange for pointing out that the name Ableborinto phashyph is derived from Aldiboronti phoskyphornistikos, the name of a round game published in 1822. Polentilla is, of course, *polenta*, a favourite food of the painter, crossed with potentilla, one of his favourite flowers, and Derry down Derry (a popular folk-song

refrain) was the pseudonym under which he was to publish his Nonsense.

That winter the water-colours and the oil sketches sold well and during visiting hours Lear's studio looked at times as if a *soirée* ("sorry" to Lear) had hit it. To Gould he wrote that Rome was "more crammed than... since the days of Titus.... The spring came before one knew where one was. You will... possibly fall... off your chair when I tell you that I was enabled to send some of my earnings to my mother and sisters and put by £100 besides for the use of the summer!!!!"[27]

The following summer of 1839 Lear went to Civitella with Wilhelm Marstrand, after making a brief trip north into Umbria with him. Marstrand by now had become an intimate friend, a substitute for James Uwins, whom Lear "missed dreadfully".[28] Marstrand, like Uwins, was small, and "thoroly good and amiable". A self-portrait made at the time shows a broad-cheeked, frank-eyed, very blond young man wearing a curious leather hat.[29] He seems to have been a man of much humour and humanity, judging from the vastly popular sketches he made of Italian street life (his speciality). Particularly charming is a drawing of two children squatting at the window of a pie shop, and another of a mother picking nits from her small son's hair, unaware that he is urinating into the gutter the while.

Lear was to look back on "the long Civitella sojourn" with nostalgia. A sudden fine day in early summer could bring back the memory of it twenty or even thirty years later:

Today there is everywhere a flood of gold and green and blue. This, and the breeze blowing freshly now and then, reminds me of the days in many lands before that knowledge came that tells us we have so little and hope so much.... I do not suppose that kind of happiness can ever come back.... Those *Civitella days of ole*. When one sat from noon to 3 listening to songs coming up from the great silent depths below the rock![30]

Those days "when W. Marstrand and I used to be always together".[31] When Marstrand died, heavy with honours, in 1873, Lear wrote: "I can never see dear, gentle, good, clean

Marstrand more!... he was F[ranklin] L[ushington] of those days."[32]

When he returned to Rome in the autumn of 1840 Lear executed his first studio oil-painting on canvas. The subject was Civitella, and the proposed owner was Lord Stanley.[33] For once hard work does not appear to have raised Lear's spirits. There was a note of depression in his letters to Ann that winter of 1840–41. "Rome is all very beautiful interesting and wonderful... but – it is not England... I am stupid enough to get very homesick fits sometimes," he had told Lord Stanley.[34] On these occasions he begged Ann to write weekly. The "little supper parties" with artists and the day "excursions in the spring and autumn" which had seemed "so very lively and agreeable" only a year ago[35] now failed to amuse him. He even considered getting married, an idea that only occurred to him in moments of deep despair. "I wish to goodness I could get a wife," he wrote to Gould at the end of February 1841. "You have no idea how sick I am of living alone! Please make a memorandum of any lady under 28 who has a little money... and knows how to cut pencils and make puddings."

There was a good reason for all this gloom. Marstrand had departed for a year's study in Munich. After that he would return to Copenhagen to become a professor at, and then the director of, the Copenhagen Academy of Art.[36] Marstrand had left only one footprint in the sand of Lear's life: a pencil-drawing of Lear made at Civitella on 14 July 1840. It showed the young Lear, rarely portrayed. Marstrand never married.

The Abruzzi 1841–45

Lear had now lived in Rome for four years, and had become more than somewhat "foreignized", but the time had come to go home on a visit. He had originally told Ann he would be in Italy only two years. Now he took the fast steamer from Civitavecchia, the port of Rome, to Marseilles, and then the "iron monster" via Lyons and Paris. One of his most important tasks while in England was, as he put it, to run about on railroads and eat beefsteaks in the stately homes of his patrons. These whistle-stop tours would not have been possible before the arrival of the railway train. He now had seven canvases to show, having doubled his production during the months before his departure.

Loiterers at Huyton (pronounced Hayton) Station would have seen a strange sight one day towards the end of July 1841. A lean, beardless gentleman of about thirty, in a state of "high fussiness" was supervising the unloading of a large flat crate. The crate contained the 1840 Civitella, Lear's first completed oil-painting, now ready for Lord Stanley, in part payment of his debt. There was also a painting for Robert Hornby, who had helped finance the visit to Rome. How Lord Stanley received the Civitella we do not know for his diaries were mostly devoted to emu eggs. If Lear had been hoping for a performance similar to that which Lord Acton had laid on for old Thomas Uwins RA in Naples in 1826 he was almost certainly disappointed. Lord Acton not only gave a dinner to celebrate the event but arranged for the poet, Ponta, to read a poem in praise of the painting. This, declared Uwins, was "very agreeable to my feelings".[1] Perhaps the

favour that Lord Stanley granted Lear was a greater one. He permitted him to bring a barrowload of lithographic stones to Knowsley and spend August transferring his views of Rome to them. "I think of publishing some lithography on coming to England to pay expenses," Lear told Gould.[2] The lithography to which he referred was his first book of landscapes, *Views in Rome and its Environs*.

Life was quiet at Knowsley, which Lear declared "pleases me more than all the gaiety in the world". Lord Stanley was "surrounded by his children, grandchildren and nephews and nieces and is really happy. He breakfasts with us after prayers, then about 12 takes a drive with one of his daughters or his sons [and also] myself – after our dinner at 7 he sits with us all." The number of birds and beasts in the menagerie was now "immense ... but I am so thoroughly confined by my lithography as to have little time to see them".[3]

During his visit to Knowsley Hall in the summer of 1841 Lear became intimate with Captain Phipps Hornby. Phipps, a man of fifty-five, was the fifth son of that great progenitor, the Rev. Geoffrey Hornby of Winwick in Lancashire, and his wife Lady Lucy Stanley (sister of the sporting 12th earl). Phipps and Robert Hornby were both first cousins to Lord Stanley and about the same age. Phipps was a distinguished man. He had served under Captain Bligh at the time of the mutiny on the *Bounty*. He had recently been transferred from his beautiful home at the Royal Naval Hospital, Plymouth, to less beautiful Woolwich where he was superintendent of the dockyard. He was married to Sophia, daughter of General Burgoyne.

Captain Hornby may have been grand but he did not lack a sense of humour. Lear drew a strip cartoon for him of his own unsuccessful attempts to keep an appointment with him at the offices of the Woolwich Dockyard.[4] Lear flies from official to official on legs of immense length, entangled in red tape. He makes enquiries of an "intelligent policeman" (a splendid caricature, this), he pursues his "investigations in an earnest and judicious manner" inside a sentry box from which he is rudely ejected, it being occupied, and when at last he finds Phipps's office, it is only to be informed that he has "gone to the basin".[5] Lear and Phipps visited Scotland

together that autumn.

Lear was soon back in London with his precious stones, to see them through Hullmandel's Press in Golden Square. *Views in Rome and its Environs* appeared just before Christmas 1841 under the imprint of Thomas McLean, 26, Haymarket. It consisted of twenty-five folio-sized tinted landscape drawings of which, significantly, only five were of Rome. (What was meant by "tinting" was a buff background permitting white highlights.) No text accompanied the plates, and the book, like the Parrot book, was sold to subscribers only. Lear hoped with this work to cash in on the growing tourist exodus to Rome, and he had planned to draw nothing that could not be reached in a day's ride from the Holy City. There were three drawings of the Campagna and ten of the hill towns of the Tivoli and Frascati areas. But then, unable to restrain himself, he galloped off into the Sabine Hills to draw Subiaco, Olevano and, of course, Civitella. Civitella is fifty-four miles from Rome, the last nine of which, it will be recalled, must be endured on muleback! Nor are the magnificent ruins of Norba, practically on the Pontine Marshes, normally considered to form part of the environs of Rome.

In *Views in Rome and its Environs* we have, encapsulated, all the places that Lear had most come to love in his four years in Rome – the places he most liked to show to new friends. In the Campagna there was Ostia Castle at the mouth of the Tiber where the buffaloes bathe in mud (this was the frontispiece). In the Alban Hills there were the umbrella pines of Frascati, the chasm at Collepardo, the divine volcanic lake at Nemi and the ever-satisfying outline of Val Montone. But Lear always drew best when he moved towards the wilderness, and Civitella on its dizzy height, with the dark trees in the foreground, and the plain and the Tyrrhenian Sea beyond was the most successful of all.

Lear now took lodgings on his own in London. Lacking supervision, Ann had grown more eccentric and dowdy than ever. She was now interested only in the poor. Visiting the needy was a fashionable female occupation and these were the Hungry Forties. Mary Sewell, mother of Anna (of *Black Beauty* fame), headed the brigade. The Sewells moved home every few years and wherever they went, Mary sought out

the most severe cases of misery in the area. Ann Lear also moved frequently, and in each new locality fixed on one or two particularly deserving persons, often favouring the blind. She would then write to Edward for money for a Coal Fund and a Blanket Fund. Lear, too, had a real concern for "those others", whom he referred to as the "coally blanketty people".

While Lear was in London he found time to make a brief excursion to see George and Fanny Coombe at Preston outside Brighton, his old Arundel friends. He drew a "hippopoto-mouse or Gigantick Rabbitte" for Lucy, his god-daughter, now nine years old. Lear spent the last day of October with more children, the grandchildren of Edward and Lady Charlotte Penrhyn at East Sheen. (Lady Charlotte was Lord Stanley's sister.) Instruction seems to have been uppermost in his mind here too, this time in Roman history. Especially popular was "The Tragical Life and Death of Caius Marius", illustrated from "authentic sauces" [sic], who rose from being a shepherd to a Consul-General by doing a lot of fighting and by marrying Miss Julia-Caesar.

Lear came back to nineteenth-century Rome in time to hear the *Pifferaii* playing the Christmas bagpipes once more. Rome was his home. Faithful old Giovannina had kept his rooms for him. Encouraged by the success of his oil landscapes in England, he set about eight more, a number well above his annual average. He wrote euphorically to Gould:

> I am going on very well, which is more than ever I had a right to expect ... I am very glad I took to landscape – it suits my taste exactly, and though I am but a mere beginner as yet, still I do hope [by] staying here to make a decent picture before I die. No early education in art, late attention, and bad eyes are all against me, but renewed health and the assistance of more kind friends than any mortal ever had, I hope will prove the heaviest side of the balance.[6]

Lear was now a recognized Roman artist. He was described in John Murray's 1843 *Handbook for Travellers in Central Italy, including the Papal States, Rome and the Cities of Etruria* as an "English Artist of great promise". Mention was made of "a series of lithographic drawings, lately published in London,

from his sketches, show[ing] his skill in Roman landscape composition".

In the spring of 1842 Lear set out for Sicily. He went with a party that included Sir John Acland, intending only to make a rapid tour of the famous Greek temples on the coast, with a view to returning later. The visit proved sketchier than he had planned, as one of the party was detained by illness for three weeks at Palermo. There was only time to hurtle anti-clockwise round Agrigento, Syracuse, Catania and Taormina, as have so many parties since. Fortunately Lear described the journey in a long letter to Stanley.[7] Because he was writing to a naturalist he emphasized the natural phenomena. There were papyrus thirty feet high in the bed of the River Anapus, the only place in Europe where it grows. At Agrigento rollers flashed "like glittering jewels . . . round and round the old temples" and far above them the eagles hung. Then there was the suspended pig. It was the custom to tether pigs with a rope round their middles along the top of the precipice above Taormina. In spite of this precaution the foolish pig had succeeded in falling over. Lear (and presumably Sir John Acland) rescued it.

It was probably in 1842 that Lear became intimate with one of the grandest families of all. The Dukedom of Sermoneta was the oldest in the Papal States. Lear's introduction to the Sermonetas was probably through Charles Knight. Charles Knight and his sister, Isabella, spent every winter in Rome. Another sister was married to the Duke of Sermoneta. Isabella was a so-called invalid, but only the Victorians could produce an invalid of Isabella's calibre. She was to lie on a couch for seventy years, giving orders to her servants and receiving visitors who were expected to write wittily in her commonplace book.[8] Lear contributed several drawings. A little landscape sketch of the Campagna was particularly charming. It showed a realistic group of pines growing out of the plain. But what is this in the foreground? A lady seal sitting on a gilt chair smoking a pipe? And what is that on the table before her? A decanter labelled Orvieto? Could it be that Isabella had tastes unusually robust for an invalid gentlewoman?

It was in July 1842 that Knight took Lear on a tour of

the Alban Hills, chiefly intended to provide him with some equestrian experience. Perhaps unwisely, Knight lent Lear his own Arab, Gridiron. Gridiron was "far from tame", in Lear's words – not perhaps the best choice for a rider who had barely mastered the principles of mounting and whose seat had by no means reached perfection. Lear persistently rode with his reins too long and his stirrups too short. Going downhill he was inclined to ride "in a pensive manner", that is to say, with his arms clasped round his horse's neck and

his eyes shut. On more than one occasion the gymnastics performed by Gridiron obliged Lear to "change his position for the sake of variety", in other words, he fell off. All these interesting equine incidents were fearlessly portrayed in a series of thirty-three drawings which Lear made for Knight.[9]

The following year, again in July, Lear and Knight, with Gridiron and Iron-Gray, set off on a longer tour, this time to the Abruzzi. The Abruzzi is that wildest and highest section of the Apennines that lies due east of Rome, "as romantic

as unfrequented", the home of wolves, wild boar and bear.
Lear was by now beginning to relish travel for its own sake,
not just as a hardship to be endured in the process of bagging
views. Indeed, this was more than travel, at times it verged
on exploration. "I saw more of that country (by knowing
the language and mixing with the people) than any English-
man has ever done," he boasted to Gould.[10]

The travellers set off along the Via Salaria, the road that
took the Roman Legions over the Apennines to the Adriatic.
At Arsoli, on the second day, they chose the more southerly
road and passed close under Civitella. The travellers took no
guide with them, and no groom to look after the horses and
the luggage. On this occasion, and on several others, they
were benighted and frequently lost as well.

The "long streak of blue that was Lake Fucino" was an
almost uncanny foretaste of Lake Phonia. It, too, was a vast
puddle on the plain that drained out periodically through a
tunnel or *emissario*. The Emperor Claudius had attempted to
drain it by digging a tunnel to connect it with the basin of
the Liri, six kilometres south. He had failed. The next day
Gridiron and Iron-Gray had a day's rest while their masters
went to measure the tunnel's Roman brickwork. That is to
say, Knight did. Lear, "unapt to make researches in the bowels
of the damp earth", greatly preferred reclining in the bright
sunshine. "A herd of white goats blinking and sneezing lazily
in the early sun, their goatherd piping on a little reed, two
or three falcons soaring above the lake, the watchful cormor-
ant sitting motionless upon its shining surface . . . I can recall
no scene at once so impressive and beautiful," wrote Lear.[11]
Somewhere beneath its waters slumbered the ancient city of
the Marsi. Lake Fucino had once sunk so low that the founda-
tions of the city had been seen, and statues of Claudius and
Agrippina been recovered.

There was only one thing wrong with Lake Fucino. There
were too many fish in it. Lear loathed "crabs, bream, barbel",
and declared, "Argentina were the only fish I could ever
eat without fear of choking". In spite of six years' exposure
to foreign food, he still had something of the pernickety child
in him. The best meal of the whole trip was served to him
by a prince at Antroduco: "And what did we not see when

these covers were removed! A positive plain English looking roast leg of mutton, in all its simplicity and good odour. There were plain boiled potatoes too."

But it was time to leave the enchanted lake and continue east. The plains of the Abruzzi were largely inhabited by sheep. The famous *pifferari* played their bagpipes here, "hour after hour in the summer days, an accomplishment of indescribable romance". They also knitted stockings. Now Lear and Knight started to climb towards the Gran Sasso (the highest peak in the Apennines). It was a grim area and the people were as inhospitable as the terrain. In Civita di Penna the only stable available was "so cold and damp that Iron-Gray was instantly taken ill". The next day Gridiron went lame. The path by now was almost vertical. They laboured all day and reached the pass at nightfall, looking down on "a wild chaos of mountain tops . . . a dark purple world . . . immensely below". They arrived at Villa Santa Lucia two hours after dark, and even here there was only one bed between the two of them. They tossed for it and "it fell to me, and directly afterwards fell under me, having but three legs. Knight lay on a small table. At dawn a crowd of 'little chanticleers' ran out of a corner, jumped on the recumbent Knight and proceeded to crow!"

Knight had only agreed to come for a ten-day circular tour to give Lear a chance to reconnoitre, and when the ten days were up Lear was sorry to see him and "old Gridiron" depart. "To be sure," he wrote, "it is better to be alone than in company with a gambler, or a caviller about farthings, or one who is upset by little difficulties, or – what is worse perhaps than all – one who regards all things with total apathy." Charles Knight had been none of these. But the lone traveller had certain advantages. He was forced to seek companions among the natives and, free of an English audience, he could risk making a fool of himself. This Lear managed to do at Antrodoco Spa. "I did as everybody else did after supper, namely sang songs and played on the guitar perpetually, and was consequently pestered for '*un aria Inglese*' every five minutes afterwards during my stay. Two widows from Aquila, the local town, were incessant in their requests for 'Ye Banks and Braes' but 'Alice Gray' had the greatest number

of votes".

Antrodoco was a place of extraordinary charm for Lear, and he lingered some days to draw the entrance to the gorge. The gorges of the Abruzzi fascinated him, and he did some fine free water-colour drawings of the Gorge of Antrodoco, the Bocca di Castelluccio, and the Gorge of Anversa. Beautiful they might be from without, but the narrowest of these gorges were ghastly places within. Daylight never reached the bottom of some of them. Lear only once ventured inside one. It was cold, dark and silent, and he realized in the gloom that he was not alone. There were women, wretched bent old women, grey as the rock face, gathering driftwood. "Whatever brought you here?" he enquired. "Whatever would *you* be doing in such a place as this?" was their only reply.

Tagliacozzo, across the mountains from Antrodoco, was celebrating its centenary and Lear could not refuse the invitation of the *Intendente*, an official of great importance, to accompany him over the mighty pass, "a work of Titian or Giorgione ... in purples, blues and golds". The preparations for departure were prolonged. The average Italian horseman was nearly as incompetent then as he is today, and the art of loading baggage animals had by no means been mastered. "How much string was required to tie on irregular articles of baggage! And how many times all the horses, mules, asses, baggage, grooms, guides and spectators were involved in the wildest confusion, by some freak of 1 or 2 ungovernable quads!" Lear by now considered himself something of an expert on horses. He was appalled at the wretched brutes the dignitaries were expected to bestride. The Secretary and the Judge were both on "very forlorn-looking mules", Prince Giardinelli was on a leading rein and his "sweet little 10-year-old daughter", Donna Caterina, had the choice of two equally revolting animals "with no tails and eyes a long way out of their heads", known as Pomeranian ponies. Lear was fortunate to have a nice black, but sat somewhat unevenly all day after losing his stirrups down a precipice. Soon "most of the party were complaining bitterly of fatigue and not the least sympathising with my admiration of the views".

The *festa* at Tagliacozzo was worth it all. Ladies almost as

old as the centenary resurrected themselves from mothballed castles and came to the opera in the fashions of the last century, one flaunting "a rose coloured satin bonnet – 4 foot [in] diameter, and a blue and yellow fan to match". At the Palazzo Mastroddi there was a banquet for sixty guests and not enough ladies to go round. Lear, however, managed to get in among them, being a foreigner, while judges and generals and even the great Don Romeo Indelicato had to sit together "unilluminated by any of the lights of creation".

Simple kindness awaited him also in the home of a lord of the manor, Don Antonio Ferrante. Again it was the lady, Donna Maria, who charmed him most with "the quiet self-possession and simple friendliness typical of the Abruzzese notablity". In a land famous for barbarity Lear was amazed to meet civility far greater than that to be found in the cities. Among male members of the nobility Lear seemed always most in sympathy with the captive sons and heirs doomed to imprisonment in some mountain-locked domain. Donna Maria's son, Don Manfredi, was one of these. He walked several miles with Lear on the day of his departure, in order to unburden himself. His older brother had become a Jesuit, leaving him with the inheritance. "We're like wolves, closed in these mountains," he complained.

Towards the end of his tour of the Abruzzi Lear returned to spend an idyllic four days on Lake Fucino, this time with the Tabassi family at the castle of Celano. In the evening the townspeople would pay calls on the family, and ask to see the *pittore Inglese's* drawings so that they might try to recognize their own houses. There was one drawing they asked for regularly. It showed the lakeside church of Santa Maria di Luco. Instead of dangling straight, the bell rope hung in a loop, disappearing out of the left-hand side of the picture. They all knew that it went through the bedroom window of the sacristan who lived next door. The laziness of the sacristan was a local joke. On one of Lear's last evenings at the castle of Celano there was an earthquake during dinner. "I felt myself suddenly shaken forward in my chair, till my nose nearly touched the table. Some novel domestic arrangement of the servant, shaking everybody into his seat, said I to myself ... but the moment after ... various people

screaming '*terramoto*' ran wildly into the room". When Lear looked from his window that night the lake was once more a still line of silver. Little did he guess that within thirty years there would be no Lake Fucino, just as there would be no Lake Phonia. By 1873 an English engineer, Hutton Gregory, had succeeded in draining the lake through a tunnel, similar to the Roman emperor's, but longer.

Lear was greeted on his return to Rome by news of his mother's death at Dover. Aged eighty, she had died of "general decay", according to the death certificate. She was barely mourned by him. He had enquired after her only very occasionally in his letters to Ann, and he never sent an affectionate message. Once, years later, he found a photo of her in a box, and returned it, referring to it in his diary as "Mother", in inverted commas.[12] Now he confined himself to ordering a mourning suit from his tailor and, after the customary week's delay, wearing it. (Those who wore mourning dress immediately after the death of a loved one were suspected of having been measured in advance.) Now he felt he positively must invite Ann to Rome for a winter season. Storm clouds were gathering on the horizon of his paradise. "Though no war will probably break out as yet – two or more years will possibly upset everything," he told Ann. He planned to visit England in the spring of 1845, and would be able to accompany her home. The letter of invitation to Ann, written on 27 August 1844, is a memorable one:

I hope you will dress *very* nicely – (although we shall both be in deep mourning) ... Your drawback would be the want of society, for a few months, (for of course you would not be in the gay world) ... do not forget good *warm* clothing, and if you want any handsome, plain shawl or dress in Paris, (not odd-looking, my dear old sister!) buy it, and keep it as a present from me. ... You know I am very well known here, and live in the "Highest respectability", and so you *must not* be too dowdy. ... We shall dine at home, and I shall be as much with you as I can considering my great occupation and the quality of people who come to me. ... I advise you to get good walking boots and shoes ... at Paris ... for shoes here are *good for nothing*

– but you must scrape the souls (sic) as the Douane ...
seizes shoes.[13]

Ann decided not to come after all.

Little is known about the exact whereabouts of Lear in
the summer of 1844. He was certainly in Civitella in August
because he made two drawings there on 21 and 22 August.[14]
After a few days in Rome during which Ann's refusal of
his invitation arrived, he returned to Civitella for the month
of September, although he did not tell Ann where he was
going or with whom. (This summer in Civitella has been
overlooked in the chronologies of previous biographers.)
Much too late in the year (26 September) he made another
dash for the Abruzzi, planning to draw the places he had
missed the previous summer. Aware of his lack of ability
in figure-drawing, he seldom drew them outside a landscape,
but there was a little girl at Lake Scanno, a servant's child,
whom he found irresistible.[15] In his drawing she wore a mag-
nificent turban and a richly striped skirt that would not have
been out of place at the Ottoman court, and with it she main-
tained her own sturdy simplicity. Lake Scanno is a small lake
in a basin to the east of Lake Fucino, admired by tourists
to this day.

While in the Abruzzi Lear started to collect Italian folk-
songs, with piano accompaniment supplied by a professional.
He printed four at the end of his book on the Abruzzi. One
came from Civita Ducale, and was about a swallow:

How bella you are Rondinella
You come in the spring
How Bella, bella, bella (ad infinitum)

The three other pieces of music he included were the famous
Christmas tune of the *pifferari*, the tune they had danced to
at Tagliacozzo, and the contrapuntal song of the women of
the Anversa Gorge which Lear visited on this last trip to
Abruzzi. The Anversa Gorge was perhaps the most extraordi-
nary of all the gorges. "As I sat below a huge rock on which
a little goatherd was piping ... the sound of a chorus of many
voices gradually roused the echoes of the mighty walls: a
most simple and oft repeated air, slowly chanted by long

files of pilgrims, mostly women . . . they were on their way to the shrine of S. Domenico . . . carrying large bales of different coloured cloths on their heads." S. Domenico could cure the bites of snakes and mad dogs, and on his feast day the floor of his church at Cocullo, above the gorge, squirmed with the snakes of snake charmers. Lear has never been recognized as the father of folk-song collecting, but in fact he was very nearly the first Englishman in the field. Traditional ballads had been collected and published since the seventeenth century, but when tunes were included they were not collected from the original singer. The first person to publish sixteen tunes "noted direct from the lips of peasants" was the Rev. John Broadwood, and his book, *Sussex Songs*, was published privately in 1843, the very year that Lear collected at least two of his four Abruzzi songs. After Broadwood the floodgates were open, and by the time Cecil Sharp published part I of his *Folksongs from Somerset* in 1904 nearly a thousand folk-songs and tunes were in print. [16]

Lear's last tour of the Abruzzi was very nearly brought to a sudden halt. The Abruzzi was becoming an increasingly dangerous area for English travellers, for the British government was known for its championship of the liberal ideas that would eventually lead to the *Risorgimento*. When Lear was sketching near l'Aquila a policeman demanded his passport. Finding it was signed by Palmerston he marched him down the village street yelling in triumph to the bystanders, "I've got Palmerston." This was no laughing matter. Fortunately Lear was saved from being thrown into prison by the arrival of Don Francesco Console, a local bigwig to whom he had an introduction, "whereat followed a scene of apology to me and snubbing for the military". Then the rain came. Continuous sheets of it, gouging ravines down the mountain-sides and converting water courses to torrents. On 14 October Lear pocketed his damp sketch-books and admitted defeat. The tour that should have lasted two months was over in three weeks. [17]

The prospect of a visit to England always launched Lear "head over ears" into the production of oils. His oil landscapes were beginning their inexorable expansion sideways. "My six-foot painting progresses slowly," he told Ann. [18] He did

not mention the subject, but it was probably the Abruzzi.
When March brought the first whiff of spring, Lear did
a brief trip to Ardea and Practica, two towns by the sea,
south of Ostia.[19] He was in search of subjects and probably
accepted a lift in the carriage of Lady Susan Percy, one of
his most faithful patrons. In April he travelled south to the
Pontine Marshes. There he saw whole cities which had been
depopulated by malaria. One of the most dangerous places
was Lago di Paola, all girt about with "immense lots of tangle
jungle bungle greedy reedy grisogorious stuff . . . very wild
and uncomfortable tangly".[20] In the course of this journey
Lear stopped at Sermoneta, owned by his patron, the Duke
of Sermoneta. He drew the castle there with a wealth of detail,
declaring it to be "one of the finest in Italy", but malaria
again had left it desolate. The Sermoneta family had given
him the run of their archives in Rome and he was delighted
to find a bull of Pope Onorio III referring to the castle at
Sermoneta in 1222. His last ports of call on the way back
to Rome were the famous towns of Norma, Norba and Ninfa.
Ninfa was a strange collection of ruined churches that
appeared to stand abandoned in the middle of a lake. Malaria
again had been responsible. His drawing of the cyclopean
walls of ruined Norba overlooking the plain proves that they
are indeed "among the most interesting and surprising objects
of antiquity in Italy". To soften the effect of so much anti-
quity, he put some pelt-girt goatherds (of the Civitella variety)
atop the walls.[21]

Back in Rome, something important happened. In the mid-
dle of April 1845 a young man passed through Lear's studio
and, figuratively speaking, never left it. He was Chichester
Fortescue, a twenty-two-year-old Irish aristocrat who had
just won a first in classics at Oxford. He was making the
Grand Tour before following his father into parliament as
a Liberal. Fortescue was a young man with striking, slightly
dandified good looks. In spite of his grand background he
was shy and spoke with a slight stutter. He moved naturally
among artists and Bohemians and for a while was passionately
involved with the leading equestrienne of Astley's Circus.
He was tolerant of homosexuals and was later to vote for
John Simeon when he was blackballed as a pervert at the

Travellers' Club.[22]

Young Fortescue kept a diary of that month in Rome, commencing with an account of his first meeting with Lear. "Went to Lear's, where we stayed some time looking over drawings. I like what I have seen of him very much." The feeling was mutual, for Lear arranged to meet Fortescue at church on Sunday. Matins at the large Anglican church outside the Porta di Rapallo was a regular social occasion for the ex-patriot community. The incumbent was the Rev. J. Hutchinson, a friend of Lear's. "After Church," Fortescue continued, "we took a walk till dinner time." During that perambulation of Rome, Lear offered to take Fortescue on a longer one outside the city, and to give him instructions in the art of sketching.

Lear now set about taking the young man on all those tours of the environs of Rome that he had planned for Ann. Simeon was the only problem. Fortescue was travelling with a friend called Simeon Cornwall. Fortunately Simeon would be engaged at Tivoli on Thursday, 1 May. Fortescue went in the opposite direction with Lear. They spent the whole day exploring Lear's well-loved Campagna. They walked eastwards along the Via Salara to Ponte Salaro, the magnificent Roman bridge over the River Aniene. The bridge, rising solid and solitary from the plain, was a favourite subject of Lear's. (It was destroyed by papal troops in 1867.) The two men dined together in Lear's rooms. During that day a lifelong friendship was cemented. "Lear is a good, agreeable man – very friendly and getonable with," Fortescue wrote. Lear in turn found Fortescue amusing.

The next day they had an adventure. They had travelled north from Rome, to the tourist area of the Campagna round Lake Brucciano. Simeon was with them. They were sketching the tiny hamlet of Isola Farnese beneath its ruined castle when there was a sudden crash of thunder followed by torrential rain. "Lear and I ran to the Osteria at Isola. Simeon stayed behind under a rock. After eating our dinner and waiting some time we grew uneasy about Simeon, and set out in the rain to look for him. We found the little *fosso* which we had stepped across an hour before so swollen that we did not like to cross it, and Simeon . . . had to wade." Simeon was generally wet in any case. The following Thursday, on

a two-day expedition, he rode from Tivoli to Palestrina while Lear and Fortescue walked. That day was the most beautiful of all in a month of beautiful days. Lear showed Fortescue the famous aqueducts, "very grand they are . . . in the solitude of the glens they cross". They were entertained by a friend of Lear's at the hilltop town of Gallicano. That evening Fortescue wrote, "Lear is a delightful companion, full of *nonsense*, puns, riddles, everything in the shape of fun, and *brimming* with intense appreciation of nature as well as history. I don't know when I have met anyone to whom I took so great a liking." By the third Sunday Fortescue was finding it hard to be apart from Lear. When Lear had to cancel an appointment he was "disappointed and strolled alone . . . in rather a disgusted and gloomy frame of mind. . . . Went to Lear's in the evening." That day was 12 May, Lear's thirty-third birthday. There was now only a week until Lear's departure for England. By the Friday Fortescue "felt done, relaxed – in *abeyance*, as Lear says". On the last day, "Lear breakfasted with us. . . . He has gone by diligence to Civita Vecchia. I have enjoyed his society immensely and am very sorry he is gone. We seemed to suit each other capitally, and became friends in no time . . . he is one of those men of real feeling it is so delightful to meet in this cold hearted world." It was only Fortescue's relations who complained of Lear's "embarrassingly fervent devotion".

8

Queen Victoria 1845–46

Lear was in England for a year and a half, risking a northern winter for the first time in nine years. During that time he must have created a minor tidal wave in British publishing history. He brought out four books in one year (1846): *A Book of Nonsense*, *Gleanings from the Menagerie and Aviary at Knowsley Hall*, and two volumes of *Illustrated Excursions in Italy*. It was appropriate that *A Book of Nonsense* should finally appear while Lear was a guest at Knowsley. He was hesitant about publishing what was, after all, only "bosh", and hid behind the pseudonym of Derry down Derry. First editions of *A Book of Nonsense* are, like those of most children's books, rare. Life is hard for a book on the nursery floor. It appeared in two parts, each with thirty-six lithographical designs (one to a page) and with the limericks written in three lines beneath. Only in future editions were the limericks set in five lines. The pages were the shape and size of extra-large postcards.

It was equally suitable that *Gleanings from the Menagerie* should appear while Lear was staying at Knowsley. This was another vast book like *Parrots*; the seventeen illustrations had been lithographed by J. W. Moore and coloured by Mr Bayfield. Dr J. E. Gray of the British Museum wrote the introduction, pointing out that the chief value of Lear's drawings was that they were "accurate reproductions of living specimens." The menagerie at Knowsley had expanded dramatically once Lord Stanley had become the 13th Earl. Lear arrived in the middle of the great emu-breeding experiment of 1845. Lord Stanley kept a careful account of it in his diary. "April 9 1846 – My female Emu has laid about 20 eggs, but still the

male shows no signs of sitting. It is rather provoking, our Emu will not sit, while at Wentworth, their male is wanting to sit and has no eggs."[1]

The most demanding of the four books, the two volumes of *Illustrated Excursions in Italy*, one on the Abruzzi, one on the Papal States, remained to be worked on. Lear attempted to do this too at Knowsley, but the place proved a good deal noisier than it had been four years earlier, and a condition that Lear described as "too much friend-seeing" began to afflict him, so he moved to Robert Hornby's town house at 27 Duke Street, St James's.[2] The Abruzzi book differed from the Roman one. It was accompanied by a journal of his travels. This formed as important a part of the book as the thirty lithographs and forty engraved vignettes. It was not customary for artists to write on subjects other than painting, but the first volume of Ruskin's *Modern Painters* had appeared three years earlier and, heaven knows, that bumptious upstart strayed far enough from the point. (Lear referred to Ruskin as Rustbin, perhaps because Ruskin did not include him in any of his five volumes.) Lear made copious apologies in the preface for his temerity in venturing into print, asking "the indulgence of the Public towards the literary portion of the work, which I have thought it right to print with little alteration from my journals, written during my rambles, adding only . . . historical and other information concerning places listed".[3] His fears about his powers as a writer proved unfounded. Only when he included solid wads of Papal history did he become tedious. In future travel journals he supplied much less of this kind of information. One of the people who enjoyed the tale of his adventures was Queen Victoria. She also ordered twelve drawing lessons from the author.

By 15 July 1846, Lear was installed as drawing-master at Osborne House, the home that the queen and her consort had recently bought on the Isle of Wight as a decent and private alternative to the pavilion at Brighton. A new house was going up in the grounds, designed by Prince Albert, assisted by Thomas Cubitt. This was in the style of a Florentine villa with two towers, the flat tower and the clock tower, coated in "Cubitts" London Stucco. Terraces ran down to the sea embellished by Theed's "Narcissus at the Fountain"

and "Psyche Lamenting the Loss of Cupid". Albert liked Theed's graceful nudes, and it was suitable that Theed should eventually contribute to his memorial.

The drawing lessons took place every day, to start with, and Victoria recorded them in her diary.

15 July . . . Had a drawing lesson from Mr Lear, who sketched before me and teaches remarkably well, in landscape painting in watercolours.

16 July . . . Copied one of Mr Lear's drawings and had my lesson downstairs with him. He was very pleased with my drawing and very encouraging about it. . . .

17 July . . . I had another lesson with Mr Lear, who much praised my 2nd copy. Later in the afternoon I went out and saw a beautiful sketch he has done of the new house.[4]

Lear does not appear to have encouraged his royal pupil to draw from nature, as he had Fortescue. He would go out and draw the new flag tower and bring it indoors for Her Majesty to copy. The tower was not a very interesting subject, and Lear put a Norway spruce in the foreground and set Her Majesty the task of drawing this as well. Compared with Lear's, the queen's tree is a somewhat sketchy affair, and she fails to convey the depth and mystery of the mighty conifer.

Lear gave his last lesson to the queen at Buckingham Palace on 6 August (Her Majesty had moved back to London at the end of July). At least two of her little drawings of Osborne are preserved in the royal library at Windsor.[5] Beneath the one executed on 18 July she wrote, "copied from Lear". Beneath that of 20 July she wrote, "copied *partly* from Lear". Progress was being made. The social relations of the queen and the landscape painter had been good. The queen put him at his ease only too successfully. On one occasion, at least, according to Lady Strachey, he forgot himself.

Lear had a habit of standing on the hearthrug. . . . He observed that whenever he took up this position, the Lady in Waiting or Private Secretary . . . kept luring him away either under pretext of looking at a picture or some object of interest. After each interlude he made again for the

hearthrug, and the same thing was repeated. It was only afterwards he discovered that to stand where he had done was not etiquette.

On another occasion "the Queen was showing him some of the priceless treasures in the cabinets at Buckingham Palace. ... Mr Lear, entirely carried away ... exclaimed, 'Oh! how *did* you get all these beautiful things?' The reply was swift and sharp, 'I inherited them, Mr Lear.'"[6] A year later the Queen had one of Lear's drawings of Osborne engraved and sent him a plate by means of a lady-in-waiting. "I am really quite pleased with my little engraving ... you need not however tell everybody," he told Ann.[7] To Fortescue he confided, "I don't know if it is proper to call a sovereign a duck, but I cannot help thinking H.M. a dear and absolute duck."[8]

Lear may well have influenced the queen in another way. From 1847 onwards she started to make expeditions on pony back in the Highlands, always taking her sketch-book with her. These eventually involved passing nights away from home, often incognito and in considerable discomfort. ("Only ... two miserable half starved chickens for dinner," the queen wrote on one occasion.) The last great expedition occurred a month before Albert died. It was to Blair Atholl and involved fording the River Tarff in spate. The famous gillie, John Brown, led Her Majesty's pony on one side and the Duke of Atholl on the other, both up to their waists in water. The party's spirits were kept up by two pipers who waded ahead (piping, of course), and by draughts from the Duke of Atholl's silver flask. "The pleasantest and most enjoyable expedition I *ever* made," the queen declared.[9] A drawing of Glen Feithort made by Victoria on one of these expeditions has a strong feeling of Lear about it. Lear remained loyal to the royals for the rest of his life, and, when Albert died in 1861, he recalled with sadness a conversation they had had at Osborne: "Prince Albert showed me all the model of the House (then being built only), and particularly a Terrace, saying ... '*When we are old* we shall hope to walk up and down this Terrace with our children grown up into men and women'."[10]

Victoria was not the only "perfect duck" Lear met on that

long stay in England between 1845 and 1846. Chichester For-
tescue (his "Chicken") opened the gate on a whole flock of
adorable ducklings, his Oxford friends. "Jackson and Clutter-
buck, Lord Eastman, Church and young Baring are the best
(and I forget a divine Mr Montgomery – a jewel)," Lear
wrote to Fortescue during a visit to Oxford in February 1846.
At this time Oxford was, of course, a hotbed of religious
excitement. Some, like John Henry Newman, had gone over
to Rome. Many more, like Keble and Pusey, stopped just
short. Fortescue was one of these. Lear corresponded with
him on religious matters. He was more concerned about John
Wynne's beliefs, however. (Wynne was a friend of Fortes-
cue's.) "I do hope my friend John Wynne is not one of the
wavering," Lear wrote.[11] He was even more concerned about
Thomas George Baring.

Young Baring was blond, brainy and beautiful, like most
of Lear's favourites. He was one of the Barings, descendants
of a German cloth merchant who made a fortune in the City
in 1770. His father was Lord Northbrook who had held vari-
ous government offices. Thomas had been raised on the family
estate at Stratton and had done well at Oxford but, unlike
his father, had failed to achieve a double first. It has always
been assumed that Fortescue introduced Lear to Baring in
Rome, two years later.[12] Lear did indeed see Baring in Rome
in February 1848, when Baring was on the Grand Tour. "He
is an extremely luminous and amiable brick, and I like him
very much, and I suppose he likes me or he wouldn't take
the trouble of knocking me up as he does."[13] But an unpub-
lished letter from Lear to Fortescue of 11 October 1846, writ-
ten while Lear was staying once more at Knowsley, makes
it clear that he already knew Baring. Indeed, Baring may
have actually been staying at Knowsley with him for Lear
writes, "Baring sends his love."[14]

That August, 1846, Volume II of *Illustrated Excursions in
Italy* appeared. It was a slimmer affair than Volume I, cover-
ing the Papal States (tactfully referred to as the States of the
Church). There were twenty-five plates and fifteen vignettes,
mostly covering the coastal belt south of Rome and the hills
overlooking it (Latium and the Pontine Marshes). The litho-
graphs were accompanied by descriptive paragraphs, but not

a full text. These were places that Lear had visited many times. On at least one of these occasions he must have been with Penry Williams, for Williams contributed three vignette drawings of the costumes worn by the women at Nettuno, Sonino and Sezze. Sonino was famed as a bandit stronghold in the hills. Its women were notoriously pretty. According to Hazlitt, when four bandits from Sonino were executed in Rome, their wives took to "sitting as models to artists, on account of the handsomeness of their features and the richness of their dress".[15] Nettuno is on the coast near Anzio, of World-War-Two fame.

Like the book of Roman lithographs, Volume II was intended to show places that could be reached without spending more than a night or two away from Rome. Readers of *Illustrated Excursions in Italy* must have been puzzled by an advertisement for a children's book at the end of it. Listed with *South Australia Illustrated* and *New Zealand Illustrated* (both long forgotten tomes) was *A Book of Nonsense* by a certain Derydown Derring (sic).

During the stay in England Lear took a summer holiday with Ann at "sizzling" Eastbourne. Ann continued to skip from lodging to lodging. Sometimes it was not all her fault. On one occasion Mrs Dixon, her landlady at Charles Road, Brighton, started to burrow through into her neighbour's house in order to extend her own premises. It would have been convenient if Ann had now agreed to go and live with Mrs Warner, who was a wealthy and not very amiable widow, living in Bath. She must have been either a relation or a family friend, for when Mrs Warner was ill, Ann spent three months with her. Little gratitude had she got for it, and Lear received a letter from her full of "rudeness" about Ann and "frankness" about their mother. "Ann," Mrs Warner declared, had abandoned her in a "dangerous state of illness." But the last line of Mrs Warner's letter to Lear could not be ignored. "Unless you give me cause to erase it, I have remembered you in my will."[16] Not long afterwards shocking news came from Mrs Warner. Miss Burke, her companion, having embezzled large sums of money, and having "drunk her port wine in secret (five pints a day!!!!)" throughout Mrs Warner's last illness, had suddenly dropped down dead. "Poor Mrs

Warner," Lear cried. What she needed was "some respectable person to stay with her".[17] Ann ignored the hint.

While Ann was in Brighton Lear arranged for a miniature to be painted of her, possibly the one on ivory now in the National Portrait Gallery. He chose Mrs Arundale, the wife of a fellow-painter in Rome, to paint it. Ann wanted Mrs Arundale to come to her rooms. Lear was against it. "There is so much importance in getting a good light and an artist is so much more at ease in a studio with all the little necessities of art about. ... Besides you would be yourself so much more amused, and it would be a change for you from the everlasting parlour in Charles Street."[18] Lear was delighted with the likeness. "It is a *most beautiful* miniature, quite apart from the resemblance which, now I have looked at it a great deal, I really think cannot be improved in any one part."[19]

Lear came back to Rome a celebrity, Mr Edward Lear, by appointment. "I have hardly time to write, so many people are calling to congratulate me on my return," he told Ann. "Everybody exclaims at my well looks and says I have come back *half as big again* as I went."[20] (This is Lear's first reference to any increase in circumference.) His order book brimmed. "I have so much more to do than I merit by my actual place in artistic repute, that such success may give rise to complaints from those who are more skilful and yet have little to do."

Nevertheless Lear became depressed in Rome that winter. It was one of the wettest in memory. "It rained until it seemed as if a second Flood might be on its way",[21] and went on raining till the Tiber burst its banks and the Carnival was washed out in a tidal wave of mud. The Corso looked like the Grand Canal. "Strong galoshes" seemed the only remedy if you had no gondola.[22] The only consolation was that the excellent new Pope, Pius ix, had issued an edict that all the rain spouts of Rome were to be cut off so that they could no longer direct cascades of water down collars of passers-by. His Holiness had also sent 1,000 Scudi to the victims of the Irish Potato Famine, which was much on the minds of both Lear and Ann. Lear often saw him, "large and portly", walking in the street, dressed all in white.[23] He sent an engraving of him to Ann and she asked for more for her friends. Little did Lear realize that Pio Nono would

shortly be the cause of his leaving the country; the Pope was at this time on the side of a free united Italy.

And so the dreary Roman winter progressed. "Dull routine of work." Lear now gave no dinners for six gentlemen in his apartment. Instead he had one friend in on a Sunday evening as a sort of "good deed". The friend was quite often the Rev. James Hutchinson, whose sermon on Archdeacon Manning had been excellent (i.e. against Rome). Lear's menu was simple: macaroni, fried brains and a pair of pigeons. Old Giovannina was going downhill. "I am sorry to tell you my old landlady is getting very deaf and . . . rather stupid".[24] There was often no milk for tea when he came in from his seven-mile afternoon constitutional. When he complained she told him he should have ordered it, and then he lost his temper. He consoled himself with a stray tabby kitten called Birocchino. He watched indulgently while Birocchino amused "her innocent mind" with an easel peg, but when she swung like a gibbon from the curtains he declared "I do not . . . approve."

Lear now dined out less than formerly. Even the Knight family was a source of gloom rather than comfort. The old father of eighty-two, he declared, was more lively than the rest of them put together. Isabella never left her sofa, and her older sister was "fast declining in consumption though in no immediate danger".[25] Then Lear's dear friend, Lady Susan Percy, died suddenly at the age of sixty-three while feeding her canaries. The maid heard the cage fall and the birds all scream. She ran upstairs to find her mistress lifeless on the floor. Lear had seen Lady Susan three or four times a week ever since he came to Rome and they had made innumerable carriage rides together into the Campagna. "I could not fancy it was real, and it is only now that I begin by little things to be reminded that here we shall not meet any more." She was one of the last of an older generation of Anglo-Roman society. Sir William Gell, who had also died, had been another.

Lear began to think of giving Rome only two more years. He started to send back crates of books (he was a voracious reader). Sitting before his neglected fire, while his tea cooled, waiting for the sound of the milk bucket being hauled up

the well, he felt he had had enough of Roman discomfort. What with the political situation and the weather and Giovannina, he began to think life with Ann in London might be preferable. "We shall be very cosy and antique. I shall be forty or forty-one, you sixty or sixty-one. We must have an old cat, and some china."[26] When Lear reread the letter the next morning he had the sense to add, "This is all nonsense." He could not afford to live in England, for a start. It cost three times as much to live in London. Furthermore, he must save. He had taken to setting aside the profits from his publications as a kind of health insurance. The fear of blindness which had caused him to give up his zoological drawing was still with him.

9

Sicily 1847

Gloomy forebodings were forgotten in the spring. Fortescue had said he would come on a tour of Calabria and Lear decided to meet him at Syracuse, after first making a tour of Sicily in May and June. There was the problem of finding a travelling companion for the Sicilian tour. Lear had met young John Joshua Proby (known as Johnny to his many sisters) in Rome. Proby was typical of the young men Lear liked to travel with, freshly down from Oxford and interested in sketching. Like Fortescue, he had been brought up in Ireland. Unlike Fortescue, he was not particularly good looking, being short and somewhat rotund. Immensely ambitious, Proby's young life had not been full of success. At Oxford he had failed to obtain a first in Mathematics, possibly because his tutor was dismissed for Puseyism half-way through his course. Then he failed to become MP for County Wicklow, virtually a family seat. Disappointed, he had come to Rome to take up the study of painting. There, during the wet winter of 1846–47 he had become severely ill with what was described as a low "Roman Fever". His father was so occupied with relieving the victims of the potato famine that he could not visit him, and in the end Sir Robert Gordon, a distant relation, had come to the rescue. Gordon's chief claim to fame was that he sold Balmoral to Queen Victoria.

By May Proby was more or less recovered and agreed to accompany Lear to Sicily. They met in Palermo on the north-west corner of Sicily and set off on the same anti-clockwise circuit of the island that Lear had taken in 1842. Palermo had changed since Lear's previous visit. A large hotel, the

Trinacria, had gone up on the promenade to accommodate rich northerners in flight from the winter. (The Trinacria was a heraldic beast consisting of three human legs joined at the top.) Lear, no doubt because he was with Proby, stayed there. From Palermo Lear and Proby first made a short tour of some of the less-known places at the west end of the island. They spent some days drawing the ruins at Segeste and then set out for the coast of Marsala on an unsatisfactory pair of horses. Lear's persisted in "assuming a recumbent position", and Proby's had the manners of a boar. In the end Lear was reduced to riding astride the baggage.[1] "The Marsala trip does *not* pay," Lear told Fortescue, "the only break to the utter monotony of the life and scenery occurred by a little dog biting the calf of my leg very unpleasantly as I walked unsuspectingly in a vineyard."[2]

Lear made a series of twenty pen-and-ink drawings of his trip with Proby which have been preserved and reproduced by a member of his family, Granville Proby, in a book entitled *Lear in Sicily*. The incident with the "contiguous cur" shows a very slightly pot-bellied Lear with a curly bandit moustache being attacked by a creature that resembles a pig crossed with an alligator. Proby tiptoes to his aid in a boldly checked suit and a wide-brimmed hat. The couple then returned to Palermo to hire better animals and set off on the circuit proper.

Although Lear published no journal of his Sicilian journey, we have an excellent record of it from his letters to Ann. Each letter consists of several diary entries, and was posted in the next large town (a method to be recommended to travellers). Lear advised Ann to procure a map of Italy and "a little pink or blue paint to mark out my route . . . it will amuse you very much."[3] Conditions were unexpectedly tough whenever they left the main tourist route, indeed "most beastly". The heat was "awful" and the gnats, fleas, flies and wasps required "much philosophy to bear".[4] In the towns mobs of hideously deformed beggars persecuted the travellers, and they thanked their stars that they were neither rich nor female and, therefore, condemned to travel in *lettigas* – sedan chairs slung between two mules travelling nose to tail.

Things improved at Agrigento on the south coast, (then called Girgenti). "Nothing on earth can be so beautiful as

Girgenti with its six temples ... and the flowers and birds
are beyond imagination lovely."[5] Lear and Proby camped
out among the temples from before dawn until after dark.
They had a cook and a manservant to fetch and carry for
them and there was a hut to which they could retire for a
siesta. Lear was pleased with Proby who drew constantly.
"He is a good young man and an excellent fellow-traveller."[6]
On Sundays they dressed up and went to church in the town.
(On Sundays in the country they read the Book of Common
Prayer to each other – Ann would have expected this.) The
day before they arrived at Agrigento Proby and Lear executed
a joint water-colour. Both of them signed it and dated it
22 May 1847. It shows distant cliffs surmounted by a castle.
No doubt the picture was lovingly framed by one of Proby's
sisters when it reached his house, Elton Hall, near Peterbor-
ough. (Proby's mother had died when he was a boy.)

As they turned to follow the coast northwards Lear looked
forward eagerly to Syracuse and to Fortescue. They arrived
at Syracuse and waited, but no Fortescue came, and in the
end there was a letter saying he would be at Palermo. The
quarries of Syracuse proved a consolation. Known as *Latonia*,
the three quarries, excavated to supply material for the Greek
and Roman theatres, are still to be seen outside the town.
Originally they were roofed, but earthquakes brought down
the vaulting. "Being sheltered," Lear wrote, "they are really
quite like Paradise. Every kind of tree and flower grows luxur-
iantly in them, and they are as full as possible with night-
ingales."[7] Once more he and Proby virtually camped out.
The Latonia dei Cappuccini, the largest of the quarries, was
to be the subject of one of Lear's most famous oil-paintings
five years later. He made a detailed water-colour sketch of
it on 12 June.[8]

The two men now planned to progress rapidly up the east
coast, stopping at Catania to climb Etna (a hot and dirty
business), and at Taormina, "perhaps the most wonderful
place in the world" to draw the Greek amphitheatre.[9] There
remained only "that abominable north coast" to negotiate
with zig-zag roads over the sea and no parapets. They at last
found a good mounted guide called Giuseppe, "an angel of
comfort in a stocking cap", and something not too ferocious

to ride. Lear had "the best horse I ever rode on". Proby's
was rather stupid. But the heat was "frightful", and the food
almost non-existent. All day they stared at the sea, but there
was no fish, they passed herds of goats but there was no
milk, and although the branches of the trees were heavy with
fruit there was none to be bought. It seemed that the locals
took what they needed before dawn and sent the rest to mar-
ket.

Back at Palermo they quarrelled. It was the feast day of
Santa Rosalia. They had hurried along the coast in order not
to miss it. The King and Queen of Naples were to be there,
and the French fleet was in the bay. The Trinacria Hotel was
full and they got in only because two other Englishmen had
missed the boat. Needless to say, there were fireworks, and
the music went on till two in the morning. Proby was "most
interested" but Lear became crosser than ever. He told Ann,
"I am sorry my companion, as his health improves, *does not*
in temper He is sadly impervious and contradictory at
times.'[10] It was now that Proby declared that his father was
in line for the Earldom of Carysfort, and that he could expect
one day to be an earl too. Lear declared he would never have
gone with Proby if he had known this.

It was necessary, however, for the two men to be recon-
ciled fairly rapidly, for Fortescue again failed to turn up at
Palermo. His card was sent up to Lear's room at the Trinacria
to be followed by the entrance, not of the dear boy, but of
a man called Sir Frederick Scott. "I fear my visage fell very
rudely . . . I wish much now I had seen more of Sir F. Scott,
as he improves immensely on knowing him," Lear told For-
tescue.[11] By the time they had made the sea transit to Naples
(during which Proby, but not Lear, was sick) they were
friends again, and Proby had agreed to do the Calabria trip
with Lear.

Calabria 1847–48

Calabria Ulteriore, the toe of Italy, represented Lear's deepest penetration into the country. He went to it prepared by *The Mysteries of Udolpho* of Mrs Radcliffe. "Horrors and magnificence without end, torrents, fastnesses, caves and brigands, costumes and character."[1] Only five years earlier Rome had rung with the hair-raising tale of Arthur Strutt, painter and author of *A Pedestrian Tour of Calabria and Sicily*, who had been attacked by bandits in the Sila, stripped and beaten with axe handles and robbed of a box containing fifty-eight golden ducats.

The most dangerous characters to be met with in Calabria were fugitives from justice. Hardly less dangerous were members of the local Mafia, known as the Ndragheta (a Greek word meaning "strength"). Yet it was two Englishmen at the Hotel Giordano in Reggio who probably did Lear more harm than any of these. He overheard the following fragment of their conversation at breakfast:

1st man: I say, Dick, do you know who that fellow is who we were just talking to last night?
2nd man: No?
1st man: Why, he's nothing but a dirty landscape painter.

Lear called himself a Dirty Landscape Painter ever after. Yet he had arrived with faultless letters of introduction. These were the only means of safe travel. It was essential to arrive in Reggio di Calabria, the principal city (which faces Sicily across the narrow straits of Messina), well furnished with them. The recipients would in turn supply notes to the princi-

pal landed proprietors on a traveller's proposed route and recommend a reliable guide.

It was equally necessary to have a good dragoman, and one was recommended to him. His name was Ciccio, the name bestowed upon most southern Italians, but Lear had another name for him. He called him Dighi-Doghi-Dà. There was a reason for it. Whenever Ciccio said anything he ended with the exclamation "Dighi-Doghi-Dà!" It is thought that the name of the Yonghy-Bonghy-Bò derived from this.

Lear and Proby set off eastwards from Reggio on 25 June, with the two hottest months of the year ahead of them and no very clear idea of the route they would take.

Our plan was to do always just as we pleased – going straight ahead or stopping to sketch, without reference to any law but our own pleasure The general rule of keeping near the mountains is perhaps the best, and if you hear of a town, or costume, or piece of antiquity otherwise remarkable, to make a dash at it as inclination may devise, sometimes to be repaid for the trouble, as often the contrary.

The travellers aimed first for Bova, high on the southernmost tip of the Apennines, in the Aspromonte mountains. It was approached up a series of *fiumare*, or dry torrent courses. "Lonely places ... are these *fiumaras*: blinding in their white or sandy brilliancy, barring all view from without their high cliff-sides." One day they walked for seven hours under the hot sun. "The whole atmosphere seemed alive with *cicalas*, who burred and fizzed and shivered and shuddered and ground knives." A *locanda* at Condatori where they stopped for lunch was as vile a place as any in the land, but the horses could go no further in the heat. Not that the heat inside the wretched hut was any less than that outside it. "It was as dark as Erebus. So in the palpable obscurity I sat down on a large live pig, who slid away to my disgust from under me, and made a portentous squealing." Lear drew the interior of this den.[2]

Bova, "an eagle's nest of a place", was the point at which the travellers rounded the high peak of Aspromonte, and started up the east coast. The final climb took five hours.

Bova was remarkable not only for its position but because its inhabitants speak Greek. In 1911 Norman Douglas was delighted to find that he could easily communicate in Byzantine with the comely youth who led him down the mountain to the railway station.[3] The rule of the emperors of Constantinople which followed on the fall of Ancient Rome, was not established in the south of Italy until late. (Belisarius did not make his conquest until AD635.) Just as the Byzantines came late to southern Italy, so they left late. Although the Lombards had flushed them from Naples by AD763, they hung on in the inaccessible parts of Calabria.

Mrs Radcliffe could well have invented the mountain monastery at Polsi. "The silence of the long hall, broken only by the whispers of the gliding monx, was very striking." The night was more alarming. "Our bedrooms, two cells, were very high up in the tower and their windows unglazed. All night there were crashes of thunder." Outside, two monstrous dogs called Assassino and Saraceno patrolled. At Gerace (ancient Locris) there were more monks, flooding in from distant mountain convents for a festival. "Far, far over the terraces of crags . . . the long line of the processions crept slowly." In a frenzy of excitement Lear made fourteen drawings of Gerace, more than any place on the whole trip. As he became more euphoric, foreground figures became sketchier, and grazing animals were reduced to dots, white for sheep, black for goats. Sometimes he gave up altogether and just wrote "1,000 goats, black".[4] Lear has left us a vivid description of what it was like to draw Palizzi, a town built up the side of a nearby precipice:

> The afternoon sun reflected from the crags of the close and narrow valley, making it like an oven. Besides that, every available bit of standing ground is nearly covered with intractable cactus . . . and, add to their alarming prickles, that the stream was full of soaking hemp, the poisonous stench of which was indescribable, and that the juvenile underclothed population . . . came and stared at me, unblinking, for hour after hour.

At Gerace Lear and Proby stayed at the Palazzo Scaglione. The children of the Palazzo produced a welcome diversion.

Little Cicillo and his sister found sugar plums were a source of high edification. Lear was less attracted by the children of the poor and needy, and there were no sugar plums for those in a dark *osteria* they had passed on the way. "One sick unclothed child lay on a bed ... five others in similar undress perversely crawling about the floor like so many brown spiders." Lear's philanthropy stopped short at ugliness.

Whenever he could Lear stayed with landowners, despots grown eccentric from long isolation. Their hospitality could be overpowering. "The great penance of this roving life is the state of exhaustion ... in which you arrive at your evening abode; and as you feel very properly obliged to play the polite for a certain time to your entertainers, the wrestling between a sense of duty and an oppressive inclination to sleep is most painful. The good people, too, persist in delaying supper (in order that they may produce a good one)." Worse still was the after-dinner entertainment. Music had often to be endured. At one place their hostess rendered "15 songs with terrible energy", and at another community singing went on until four in the morning. When "cards prevailed" Lear was obliged to sit and watch. They provided "an amusement my ignorance of which I have often lamented in these regions". Even making conversation was penitential. The nobility seemed to wish only to discuss the new tunnel under the Thames!

Diggy-Doggy's horse lost a shoe on the approach to Stilo, the furthest point north on the trip and possibly the most magnificent. This made a slow journey slower, since Diggy rightly insisted on leading the animal. Stilo clings to the flanks of Monte Consolino. Lear failed to mention La Cattolica, built in the tenth century, perhaps the best-preserved Byzantine church in Europe.[5] He preferred Stilo's seventeenth-century churches. He spent half a day just looking at the place from different angles before venturing pencil to paper. "When the landscape painter halts for two or three days in one of the large towns of those regions, never perhaps to be revisited by him, the first morning at least is generally consumed in exploring. 4 or 5 hours are very well spent, if they lead to the knowledge of the general forms of the surrounding scenes."

Lear's host at Stilo was Don Cicillo Caristo, who served an unusual dish at dinner. "A small juvenile Caristo . . . during the midday meal, climbed abruptly on the table, and before he could be rescued, performed a series of struggles among the dishes which ended by the little pickle losing his balance and collapsing suddenly in a sitting posture in the very middle of the macaroni dish, from which Proby and I rejoiced to think we had been previously helped." On another occasion the travellers were served a dish of familiar birds, "among which my former ornithological studies caused me to recognize a few corvine mandibles".

Another and sadder world met their eyes when they crossed over the central ridge of the toe of Italy and descended to the plain of Givia on the west coast. Malaria had turned the population yellow and shrivelled many to mere skeletons. "After May," Lear wrote, "the whole of this wide and fertile tract . . . is not habitable, and in July or August to sleep there is almost with the certain consequence of fever." Here, too, they met the Brobdingnagian landlady with the naked breasts, "particularly hideous and clad in the slightest and most extraordinary of simple costumes . . . the apparition of her globe-like form was so remarkable that we paused on the threshold of so formidable a hostess – the rather that she had evidently been sacrificing earnestly to Bacchus." Doubts about whether they should stay under the lady's roof were dispelled when she threw a large broom down the stairs at them.

As they travelled southwards back to Reggio, Diggy-Doggy grew sad at the prospect of parting with his two gentlemen. Suddenly the plan was changed. Lear had developed an obsession about a place called Pentedatillo. He was haunted by a desire to draw this strange five-fingered crag which he had seen on leaving Reggio at the beginning of the tour. Proby preferred the safety of Messina across the straits. He had probably heard rumours of an impending revolution. Meanwhile Lear struck inland, sketch-pad at the ready. Pentedatillo did not disappoint him. "The views of the wondrous crags of Pentedatillo became astonishingly fine and wild, and as the sun set in crimson glory, displaying a truly magnificent and magical scene of romance, the vast mass of pinnacled

rock rearing itself alone above its neighbour hills". As night fell, "Darkness and terror seemed to brood over all the vast abyss."

Lear paused for the night at Melito on the south coast, with Don Pietro Tropaea. (It was at Melito that Garibaldi was to land.) There was darkness and terror within the walls of the villa of Don Tropaea, a house "animated" besides by "a very unpleasant huge tame sheep". Everyone seemed ill at ease. They pressed Lear with questions. Had he not seen anything unusual on the way? During dinner a man came in. There was a muttered conversation and Don Tropaea shouted

"The Revolution has already begun!" Donna Lucia Tropaea, bursting into tears, left the room . . . Don Pietro . . . became . . . incoherent Hardly had I forgotten the supper scene in sleep, when a singular noise awoke me. After all, thought I, I *am* to encounter some real Calabrian romance . . . The mysterious noise proceeded from under my bed, and resembled a hideous gurgling sob . . . Feeling certain that I was not alone [I] softly put out my hand for that never-to-be-omitted night companion in travelling, a phosphorus box, when before I could reach it my bed was suddenly lifted up by some incomprehensible agency below. Puffing and sobs, mingled with a tiny tinkling sound, accompanied this Calabrian mystery . . . I jumped off the bed, and with a stick thrust hastily . . . below the bed . . . Baa-aa-a! It was the sheep!

In spite of everything Lear was determined to draw Pentedatillo before fleeing back to Reggio. Even Diggy-Doggy "that phoenix of muleteers", was against it. No speech could be obtained from him "only a clicking sort of glossal ejaculation" similar to the one he used to communicate with his horse. Lear, on the contrary, was exhilarated by the experience. "Revolution or no revolution," he wrote, "here I am in the toe of Italy all alone and I must find my way out." The route to Pentedatillo involved climbing two *fiumare*, the second being that of Monaca, and at one point crossing the steep ridge between them. Only then did the place itself become visible.

It is not till after repassing the stream, and performing a weary climb on the farther side, that the stupendous and amazing precipice is reached; the habitations on its surface now consist of little more than a small village, though the remains of a large castle and extensive ruins of buildings are marks of Pentedatillo having once seen better days I had left Ciccio and the horse below at the stream, and I regretted having done so, when, as I sat making a drawing of the town, the whole population bristled on wall and window, and the few women who passed me on their way to the hanging vineyards, which fringe the cliffs ... by the edge of the river, screamed aloud on seeing me, and rushed back to their rocky fastness. As it is hardly possible to make these people understand ordinary Italian, a stranger might, if alone, be awkwardly situated in the event of any misunderstanding ... but they seemed filled with fear alone. I left this wonderful place with little regret, and rejoining Ciccio, soon lost sight of Pentedatillo, pursuing my way up the stream, or bed of the Monaca, which is here very narrow and winding, and so shut in between high cliffs, that in winter time the torrent prevents all access from this quarter.

Lear brought back two unique drawings of Pentedatillo in close-up, one on a wide sheet of buff paper showing each house piled on the roof of its neighbour.[6]

By two the following morning he was in Reggio di Calabria. At Reggio the scene that met his eyes was strange indeed. "All the quiet town was brilliantly lit up." Troops of peasants down from the mountains "all armed and preceded by bands of music and banners inscribed '*Viva la Constituzione*' were parading the high street". Lear proceeded to Giordano's Hotel, as he was anxious to get at his *roba*. The hotel was locked. After repeated yelling and hammering a waiter appeared, uproariously drunk, and Lear asked him if Proby had arrived from Messina. "Lovely boat! Lovely Messina! Lovely Revolution! Birra burra bà!" the drunken fellow crooned. Lear demanded his keys but was told, "No more keys! No more passports! No more king! No more law! No more nothing!" In the end Lear had to bribe a boatman

to row him across to Messina where he was reunited with Proby.

The tour of Calabria had been cut short with only two of the thirteen provinces visited. But Lear was not so easily discouraged. If he could not see Calabria, he would visit Apulia instead. The Apennines east of Naples, where Apulia lies, pile up to a lofty extinct volcano called Monte Vulture (sometimes spelt Volture). Dark are the slopes of Vulture, and darker is the Norman castle of Malfi, where the unhappy duchess was murdered. "All the requisites of the feudal fortress of romance", were there, Lear declared. He and Proby were led to their bedroom along a formidable long gallery, "its windows . . . seized every now and then with terrible fits of rattling". Signor Manassei, their host, was the agent of the absent Prince Doria, and a civilized man. His wife and two "merry daughters" were even more so. The visit was extended to four days so that Lear could make many drawings of the castle, and still find time for singing to the guitar, and loitering under the pergolas. It would be hard to go back to "rough travelling" after the company of such civilized women.

Lear and Proby returned to Naples via Venosa, birthplace of Horace. "Venosa," Lear wrote, "stands on the brink of a wide deep ravine, its cathedral and castle overlooking the whole area." There was an odd church here, attached to the ruined abbey of La Trinita, much visited by barren women. In it was a vestibule containing a round Roman pillar, worn smooth with female figures passing close between it and the wall in the belief that they would thus become pregnant. This is Norman Douglas's version.[7] According to Lear, "if you go [round] hand in hand with any person, the two circumambulants are certain to remain friends for life." He did not say whether he and Proby went round the pillar together.

High on the slopes of Monte Vulture they came upon the twin lakes of Monticchio, bright as a pair of blue eyes. They sat and gazed. "The large sheets of water . . . the absence of any building . . . the entire shutting out of all distance, makes quiet romance . . . complete," Lear wrote. And then as they sat drawing, a team of dancers appeared on the far side of the water. The bright figures moved in intricate pat-

terns, their swaying skirts faithfully reversed in the lake. There was a *festa* in progress at the monastery of St Michele di Vulture.[8] But the October rains were on their way and "chilling damp were the woods of Monte Vulture at sunrise". Lear had told Fortescue that the atmosphere had been "pisonous" in September, and now it was worse. He and Proby reached Rome on 14 October 1847 and separated with many expressions of good will. "I shall be exceedingly sorry to lose him," Lear told Ann. "He is a most excellent creature, and if ever he was cross, as unluckily I told you, I am sure it was more than half my own fault."[9] Four years later Lear heard of the earthquake that partially destroyed Melfi (on 14 August 1851). The Manassei family survived only because a preliminary tremor gave them time to run down to the vine pergolas. Eight hundred and fifty died in the town. The church of St Michele di Vulture fell into the lake.

Lear had returned to Rome sporting his usual holiday moustache. There were twenty-seven letters waiting for him to answer, and the first he tackled was from Fortescue, who had achieved what poor Proby had failed to achieve, a seat in Parliament. He had also inherited Red House at Ardee, near Dundalk, from his uncle, Mr Rixton. Lear poured out his heart to Fortescue in two letters. The days of lotus-eating in Rome, he said, were running out, and he was in a state of confusion about the future. He had promised Ann he would settle in England, but there were still places he wanted to see, particularly Corfu, Egypt and the Holy Land. He concluded the second letter sadly: "I wish you were downstairs in that little room."[10]

For a time the Roman social season proceeded as usual. Thomas Baring had arrived on his Grand Tour and Lear was teaching him to draw. He took Baring to the places he had visited with Fortescue. James Uwins was also in town. Then poor Proby, who had recently moved in with Lear, taking rooms in Giovannina's house on the same floor, had a dreadful shock. He had been setting out for Florence to meet Sir Richard Gordon when he heard that Gordon had died suddenly at Balmoral. Lear made the twelve-hour journey with the distraught Proby to Florence and stayed nine days with him. "I don't know when I was so sad." Proby now departed

for Egypt. Like Lear, he was to spend the rest of his days travelling, but while Lear travelled in search of art, Proby travelled in search of health. Signs of the mortal disease that was to kill him in ten years' time appeared again in Egypt. One of his sisters, Lady Claud Hamilton, always swore that the hardships of the Calabrian journey had broken him. "He joined company with Mr Lear, the artist, and they took a walking and sketching tour in Calabria together. This was too great a fatigue for Johnny, and to this journey I attribute the mischief which fixed the illness which consumed his life." Another sister, Lady Isabella Proby, disagreed. When Proby died in 1858 she wrote to Lear, telling him so. "I send these details of my brother John's death because I know you loved him," she wrote. "This was true," Lear commented, "I did love him very much."[11]

In Rome the English ate their Christmas dinners and attempted to ignore the rattling sabres of the approaching French army. On Christmas Day Lear and the Rev. James Hutchinson dined with an English family. "No plum pudding, a great grief to reflect on," he told Ann.[12] He was particularly generous to Ann and Sarah and Mary and Harriet that year, naming sums of money for all of them at the beginning of his letter and then doubling them at the end. Mary's husband, the naturalist Richard Boswell, had proved incapable of supporting her. There was even something for the Italian organ-grinder's boy whom Ann had rescued and was sending back to his native land. "I do so pity those poor little fellows. . . . It is a blessing to be able to make anyone pleased for ever so little time," he declared, and trusted there was enough in Drummond's bank to cover it all.[13] He had charitable obligations in Rome, too. He knew of an Italian family living on the edge of starvation and of a fellow-artist who was destitute. And at Epiphany, when the fairy called the Befana came, "every Roman had to give somewhat" to fill the shoe of "some child or other".[14]

At the beginning of March things began to look ugly. There was revolution in Lombardy and Rome now panicked. Lear packed his paintings, and filled three chests with books. "If I die," he wrote to Ann, "all is yours except for £25 for Bernard Senior."[15] There was "such sobbing and crying"

from poor old Giovannina, who could not be consoled, even by the fact that he had sold her all his furniture for thirty dollars.[16] Giovannina was indeed broken-hearted. She died within the year. "The senseless turbulence of those Italian idiots was too much for the poor old lady, who had been brought up in quiet, and was not used to guns and swords and burnings of convents – so she died."[17] Lear had decided to accept an invitation to visit Corfu, from George Bowen, who was president of the university. He planned to sail from Ancona, then, when troops on the road made that impossible, from Civitavecchia. In the end he sailed from Naples. "It would be quite impossible to make you understand how a few short months have changed all things and persons in Italy Restraints ... have given ... place to open speaking and ... liberal opinions Naples, I found more unsettled and excited than I had left Rome. None could tell you what would happen from one hour to the next." It turned out that Lear had left Rome only just in time. Richard Wyatt, the sculptor, who had chosen to stay, was nearly killed by a French shell that embedded itself in the wall of his studio. By the time that happened Lear was safely on the boat to Corfu, travelling via Malta.

PART IV

GREECE 1848–64

Constantinople 1848

The leaving of Rome was a disaster for Lear. Between the ages of twenty-five and thirty-five the city had provided him with a permanent home and the fellowship of a "united band of painters and sculptors".[1] Home for Lear for the next twenty years would be wherever he spent the winter. He boarded a ship at Naples with £150 in his pocket, all that he had in the world. He stopped off for a week at Malta. The social life that he had left behind in Rome recommenced instantly at Valletta. Some of it had come over on the boat with him. The other half, he declared, "rushed to meet me with open arms".[2] Sometimes there were three or four invitations to dinner in an evening, not to mention balls and the opera. There was also a certain good-natured Lady Duncan (a widow) for whose daughters Lear had written limericks in Rome.

Lear considered settling in Malta. After all, it combined the advantages of being in the Mediterranean as well as supporting a large British colony. The trouble was there was no landscape. Even the cows lived in cellars. "There is hardly a bit of green on the whole island Walls and bright white houses are all you can see from the highest places, excepting little stupid trees here and there like rubbishy tufts of black worsted. The harbours are very interesting, but I don't love water well enough to be always boating – nor can I draw ships well enough to portray such scenes characteristically."[3] He therefore went on to keep his appointment with George Bowen on Corfu.

Bowen was a person of some importance who intended to be more so. Lear stayed with him in almost vice-regal

splendour, on one occasion being put at the foot of the table to carve "a loin of mutton for 10 Greek professors ... I am quite sure you never could have guessed 36 years ago that I should ever do *that*," he announced to Ann.[4] It was in Corfu that Lear renewed his acquaintance with Sir Stratford and Lady Canning. Sir Stratford was British Ambassador in Constantinople (and is considered by many to have been responsible for the Crimean War). Lear and the Cannings were old friends from Roman days, and they invited him to travel with them in the man-of-war, *Antelope*.

Antelope sailed via Athens and Lear now had his first sight of the city. The glory that was Greece all but blinded him. "Never was anything so magnificent," he told Ann. The Acropolis, "a raft bearing golden temples", particularly amazed him. He crossed the city every day to draw the sun rise on "the astonishing monument.... The beauty of the temples I well knew from endless drawings – but [not] the sweep of the plain with exquisitely formed mountains down to the sea."[5] (The Acropolis was in open country then.) Although the heat of Athens in June was gruelling, Lear drew as if his life depended on it. At twilight little *gufi* of Athena (Lear always called owls by their Italian name, pronounced "goofy") were most companionable. The excavation of the Acropolis was still in progress in Lear's day. Seven years were yet to pass before the discovery of the Beulé Gate, the ceremonial arch under which the modern tourist enters.

The Cannings, having been posted to Athens in the past, knew everybody. Through them Lear met young Charles Church, a nephew of the great General Richard Church, who had commanded the Greek forces in the War of Independence. Charles Church was to become a lifelong friend. Lear admired his familiarity with all things Greek, including the modern Greek language. Church suggested "a dash into Greece",[6] assuring Lear that "all the reports of disturbances in Greece are nonsense, as he had just been all round it".[7] Church was referring to supposed disturbances in Greece following the 1848 revolutions in Europe. The call of Marathon, Thermopylae and Thebes, the ancient sites north of Athens, was too strong, even though the heat of summer was at its height.

The omens for the Attic journey were not good. Before he was clear of the city, Lear had fallen off his horse and severely sprained his shoulder. He had to negotiate Mount Pentalicon on foot, with his arm in a sling. And then "a Centipede or some horror" bit him in the foot "which swelled up all my leg". "If only," he sighed, "one could walk with one's foot in a sling!"[8] The great green island of Euboea (pronounced *Evia*) that hugs the east coast of Attica, was some consolation, with its fragrant pine trees full of "bright blue rollers". Back on the mainland, at Lamia there were storks, "Every home has . . . 8 or 10 nests, and the minarets (now only ruins) . . . are alive with them. The . . . clatter they make with their bills . . . makes you fancy all the town are playing *at backgammon.*"[9] But alas, where there are storks there are frogs and where there are frogs there are marshes. And where there are marshes there is the female anopheles mosquito. As Lear walked through the great pass of Thermopylae with his train of horses (which had somehow increased to seven) he felt far from well. Perhaps it was at this moment that he invented that immortal character, the "Old man of Thermopylae, who never did anything properly". At Thebes, birthplace of Oedipus, he collapsed.

Lear was almost certainly suffering from one of the graver varieties of malaria. Peaks of raging fever that induced near-unconsciousness were followed by the dreadful fits of teeth chattering that accompanied a drop in temperature. Lear must have thought of his brother Charles who died of malaria in Africa. There was no proper care available in Thebes. "Such a grangrongous place to meet such a grisgorious misfortune," Lear declared.[10] Fortunately a passing English nobleman made available his coach and four, and Lear, cradled on "an India-rubber bed" was returned feet first to the Hotel d'Orient, Athens, where he commenced the massive doses of quinine that were to become part of his daily routine.

Once in Athens the unhappy traveller was plied with jelly, porter, books and visits continual from the English residents. But the illness was a long one, and Lear an impatient patient. To Fortescue he wrote, "Of myself I can give you but a most flaccid account, generally to be summed up in the word 'bed'.... However I have known perfect health for 11 years

thank God, and if the tables are turned I must not be ungrateful."[11] But he *was* ungrateful, and two months was far too long to be lying on his back surrounded by places of such beauty.

Although Lear, for comfort, slept in "a large muslin bag tied to the ceiling into which [he crept] by a hole",[12] he was of course quite unaware that a mosquito was responsible for his illness, which he put down to his fall from his horse, or to an insect bite, or to "forgetting my umbrella".[13] Nothing was known about the causes of malaria, called Roman Fever in Rome, Greek Fever in Greece. Murray, in his original *Handbook for Travellers in Italy, the Papal States and Rome* (1843), nevertheless devoted a page to these causes. He advised tourists to avoid the sunny side of the street ("None but Englishmen and dogs walk in the sunshine in Rome," he declared), rapid transition from sun to shade, and overeating and drinking. He also noted that uninhabited marshes were dangerous overnight and the "miasma" rising round deserted villas on the Campagna could for some reason prove fatal. The mail couriers to Naples never slept on the marshes, and smoked as an additional security. Needless to say, Lear was up again too soon, and when he could barely hobble on sticks took the boat to Constantinople in pursuit of the Cannings.

Lear had a vision of Constantinople based on the poetry of Byron. He was particularly excited about the Sultan, "that Barbaric despot", adept in "bastinado and headchopping".[14] He entered the Sultan's realm in a sedan chair, able only to see that glorious skyline of domes and white minarets through glass, and spent the first night at the Pera Hotel. Fortunately Lady Canning removed him to the embassy, in the waterside suburb of Therapia, the next day. She was "like 70 mothers" to him and he was given a room in the guest-house at the bottom of the garden. The casement of his window, he told Ann, "quite overhangs the Bosphorus.... They have brought me nice tea and thin bread and butter."[15] Constance Canning paid him visits, they discussed shopping, and she brought him children's books, like Marryat's *The Canadian Settlers*, to read. But she could not always be with him, nor could young Captain Colbourne, one of the aides-de-camp who shared the guest-house. Invitably he felt lonely and frustrated.

All those romantic turbans out there, and the only one he could see was on the head of his *laquais* (servant). There were letters from both Charles Church and Proby, saying they were on their way but they didn't come. Rapidly he fell out of love with the Bosphorus, or rather his bit of it. He described it as 'the ghastliest humbug going!'' No wider than the Thames at Woolwich. When the wind got up, the waves had a habit of "building one another up to the very door quite unpleasantly".[16] In spite of this the wooden houses kept burning down. One night the Pera Hotel itself went up in smoke. Fortunately nobody ever seemed to get hurt and the suppliers of wood for new houses grew rich.

And then, on the last day of Ramadan (13 August) he felt better. "No consideration," he declared to Fortescue, "would prevent my devouring any small child who entered this room now. I have eaten everything in it but a wax candle and a bad lemon."[17] By the greatest good fortune he was in time to join the ambassadorial party on a visit to the Seraglio. Next day was the ceremony of the kissing of the Sultan's toe, lasting many hours. First pashas and grand viziers from all over the empire processed silently into the palace courtyard, riding horses which were almost more splendidly caparisoned than they. After a long pause the sultan's guard

entered, like "a grove of beautiful birds". Then there was
a longer pause before, suddenly, His Sublimity "shot in" from
a much-bedizened *kiosk* where he had been hiding. The Sultan,
a young man of twenty-five, wrapped in a shabby blue cloak
was something of an anti-climax. He looked worn and,
frankly, bored. Here was the owner of three hundred palaces
(or *kiosks*), Lear reflected, and what good had his riches done
him? They had reduced him to the condition of a lifeless auto-
maton. The ceremony had not yet even begun. One after another,
with funereal slowness, the portly pashas kissed the Sultan's
foot, sweeping the dust with their beards, and sprinkling
liberal portions of it over their jewelled caps. Then the priests,
dressed in every colour of the rainbow, did the same. The
chief priest, a sort of pope, put on a magnificent performance.
Dressed in gold and white, he dashed at the Sultan and fell
to the ground before him three times before retiring crabwise.
And then the Sultan was back in the *kiosk* "all of a sudden,
and the troops roared out Allah something. It was over."[18]

The beauty of Constantinople at first enthralled Lear.
Nobody had prepared him for the great mosques, "so snow
white".[19] His favourite place was the Eyoub cemetery above
the Golden Horn, where lay buried the standard-bearer of
Mohammed amid brightly painted and turbanned tombs.
From here, looking over the tops of a fine line of cypresses,
Lear could see the great skyline of Constantinople, far away
down the Golden Horn. He drew it three times. He did not
mention to Ann that the cemetery was inhabited by packs
of dogs that looked like "old mangy wolves.... If I were
Sultan for one day, wouldn't I send for 10 boatloads of dog's
heads!!!" But then he thought again. The cemetery smelt
bad enough, even with these scavengers at work on it.

The long-awaited trip to the bazaar in search of a present
for Ann came near the end of Lear's stay. He travelled from
Therapia in one of the embassy caiques with oarsmen and
velvet cushions. He held up an umbrella to keep off the sun
but remembered to dip it when passing the Seraglio as a sign
of respect to His Sublimity. Lear was enchanted by one of
the old shopkeepers. "A grand old creature with a beard two
foot long in a rose coloured gown, green turban and sky

blue girdle and yellow slippers!!!" If Ann was hoping for a rose-coloured gown she was disappointed. Lear bought two dress lengths of sensible Brousa silk in a dark stripe on white, one blue, one brown. "Neat and useful . . . and Lady C. says [it] will wash well.. . . They cost me very little."[20]

Despite its mosques and bazaar, Lear's final verdict on Constantinople was unqualified. He disliked it. He was a man of the Mediterranean, but of the western Mediterranean. The Turks, he declared, were a "semi-barbarous people" living "with all the evils of an English climate and none of its comforts.. . . I would not live in Constantinople could you give me even a Seraglio. Add the impossibility of going anywhere without an attendant, the immense distances of one place to another, the inconvenience of only water conveyance and the absence of *all* we Europeans consider as necessary to existence and Stamboul is but at best a profitable exile and thus I fear those who live there feel it to be." (He did not, of course, refer to the Turks.) He also intensely disliked the way they "muzzled" their women. "I quite long to pull off that dreadful bandage."[21]

Church had written suggesting a visit to the monasteries of Mount Athos in northern Greece (a suitable expedition for a young man about to be ordained). Lear agreed eagerly to meet him there but this left him in need of a travelling companion as far as Salonica. In the end he hired a personal servant, a Bulgar called Giorgio Coggachio (not to be confused with a later Albanian servant called Giorgio Kokali). "This man," Lear told Ann, "speaks Turkish, Greek, Bulgarian, Arabic and Illyric fluently; Italian and French extremely well; Albanian and English a little."[22] In the end Albanian and English were to prove the two languages he actually required. When Lear's ship reached Salonica he discovered that there was a cholera scare on Mount Athos and "the foolish Greek monks will not admit anybody to their convents".[23] Church was marooned there, so Lear set off without him on a tour of Albania.

Albania I 1848

Albania, "rugged nurse of savage men",[1] is unknown today and was unknown a century and a half ago. Lear's visit to it was his most daring assignment, demanding "great efforts of health and energy". The chief disadvantage of Albania, apart from the mountains, was the fact that it was still ruled by the Turks, and to travel there it was necessary to carry introductions or *boyourldis* to all the local beys or pashas from the Sultan. The writ of Otto, first king of independent Greece, did not run here.

Another disadvantage of Albania was the Turkish *khan*. A khan was a government owned inn, leased to a private landlord and built mainly for the comfort of mules. Food was provided for these, but seldom for their owners, who were expected to cook their own provender round a communal fire. Khans came in two categories. A category one khan was of two storeys built round a courtyard, like an English coaching inn or a Greek monastery. The cells on the upper storey were for human use, approached along a gallery. In category two khans, guests and their beasts were separated only by a slightly raised sleeping area round the fire. When they had eaten, the muleteers wrapped themselves in their capotes (hooded woollen cloaks worn by Greek shepherds), turned their bare soles to toast before the embers, and slept. Contact with the landlords' animals was frequently close, even in a category one establishment. In one Albanian khan fifteen ducks had thrust their heads through a hole in Lear's bedroom wall, "resting their heads on my pillow, each looking at me with one eye, seeming to wish I was made of

barley and duckweed".[2] On another occasion the person in the next room was a "perverse old goat with a bell", and on a third, a flock of pigeons passed through his room at dawn and dusk.

In category two khans the contact with dumb brethren was more intimate, especially at mealtimes. "The incessant chirp and flutter of chickens could no way be quieted until they had shared the picking of their ancestor's bones," Lear wrote on one occasion. On another, when the travellers were prepared for sleep, the "festive bouncings" of the cat family commenced. Worst of all had been a donkey that settled down one night with the sleepers round the fire and then decided to roll, causing a confusion in Lear's "nocturnal arrangements only to be remedied by complete decamping". "They are called khans because you khant sleep in them," he explained to Ann. A quiet smoke under the stars was often the only remedy available to the traveller.

In spite of all this, Lear, who was travelling without a companion for the first time since the Abruzzi, recommended carrying a minimum of gear. "Abandon firearms, gifts to the natives (including portraits of the Queen), green veils, blue spectacles and inflatable baths." Apart from the obvious necessities of life he recommended taking only a bag of rice and some curry powder. To his own luggage he of course added "a world of drawing materials . . . and a box of quinine . . . pills. Rather leave all behind than this." Regretfully, he admitted that a set of formal clothing for "consuls, Pashas and other dignitaries" was necessary.

It was the duty of Coggachio (the Bulgarian servant whom Lear had hired in Constantinople) to stuff this lot into "two brobdingnagian leather bags". Lear claimed to have invented a patent method of loading these. To avoid the embarrassment of a lopsided load that had to be counterweighted with stones, or which, worst of all, slipped under the animal's belly on a narrow mountain path, where access could not be gained to right it, he united his mighty leather sacks by a cord at their tops and dangled them across the pack saddle. After that there were no more "seceding bits of luggage". The solid frame of the Greek pack-saddle, which climbs part of the way up the animal's neck, contributed to the stability of the load.

Horses of an Arab type were used to carry the loads. They were small and wiry compared to English ones. Milords who brought their own saddles had to stuff straw under them to make them fit. Yet these little animals, with their hard hooves and their ability to clamber among boulders, had the fabled endurance of their race and could if necessary survive a sixteen-hour working day. Their slowest pace was a walk so brisk that even a wiry peasant had to run to keep up. Occasionally a pack-horse fell when crossing a river but such animals were usually the oldest in the train and their loads unbalanced them. Fresh horses were hired at each town.

Nor did Lear find the Turks themselves a comfortable people. He was now in the land of the chairless and, for that matter, of the tableless and bedless. What comfort was there at the end of a day, even as the guest of some local dignitary? A meal on the floor. Woe betide him who could not sit cross-legged into the small hours. Lear could only sit on the floor with his legs stuck out straight in front of him. His moment of greatest embarrassment came when he attempted to rise. There ensued "a perpetual scramble on the floor, reminding the performer of such creatures as swallows or bats" which are unable to take off from the ground. Fortunately his Turkish hosts were men of exquisite manners. "They never stare or wonder at anything . . . and I am satisfied that if you chose to take your tea while suspended by your feet from the ceiling, not a word would be said." Lear was to see an example of Turkish good manners when he clumsily crushed the pipe-bowl of the postmaster of Yenidge under his heel. The postmaster's comment was as exquisite as his pipe. "The event of breaking such a pipe-bowl would indeed, under ordinary circumstances, be disagreeable; but in a friend every action has its charm."

Near the beginning of his journey, on the plains round Lake Akhridha (now in Yugoslavia), Lear discovered one of the best things about the Turks. They did not persecute birds. "Anyway guns had been forbidden since the last rebellion." He could write Stanley a long "zoological" letter. The plains, he told the ageing earl, clamoured with geese and clattered with storks. Eagles, hawks and vultures abounded. Tortoises

ran across the paths in twos and threes. Above the lake itself
hung literally layers of birds. Suddenly through all these layers
a white egret would drop like a stone into the glass surface
of the lake. Lake Peupli was, if possible, even more beautiful,
hidden behind its high rampart of mountains. "So dreamy
and delicately azure.... It is long since I have tasted hours
of such quiet.... All the roughness of travel are forgotten
in the enjoyment of scenery so calm and lovely." He was
reminded of "the steep ravines and oak tufted rocks of
Civitella ... of the brightness of Italian mornings, the still
freshness of its mountain noon, the serenity of its eventide,
when laden villagers wind up the stony paths to aerial
homes."[3]

Lear, accompanied by Coggachio, now crossed the great
divide into northern Albania. The people of the province of
Ghegeria were "wild and savage", but immensely pictur-
esque. "How did I lament my little skill in figure drawing!...
The long matted hair and moustaches, the unstudied and free
attitudes, the simple folds of drapery, the expressions of the
individual, the grouping of the masses, all heighten the incon-
ceivable originality of these scenes." As for the women, it
was unfortunately considered good manners to pretend they
did not exist. If a group of them passed "shrouded in dark
feringhis with white head wrappers, it seemed an etiquette
... to look the other way".

The men of Ghegeria were dangerous, being exempted
from the rule about carrying guns. It was deemed prudent
for the foreigner (or Frank) to travel with a guard supplied
by the local Bey. It was also prudent for the Frank to assume
the fez or he might "possibly lose an eye in a day or two".
Robbers apart, the going was perilous in the hard heart of
Albania. Lear had not seen such "magnificent savagery" since
he left Calabria. Paths of sickening narrowness passed across
the faces of precipices of horrible depth. "In parts, eight
inches of slanting earth were all the foot had to depend on,
and I looked down the deep-shelving abyss with a conviction
that I might be better acquainted with it before long, the
rather, that the horses nerves were miserably troubled by
the ferocious attacks of some 14 or 15 dogs." In places, lentisk
and arbutus projected dangerously across the path. To all of this

the only comment of Giorgio Coggachio was "A bad road, sir."

They were now travelling almost due north, following the gorge of the "beautiful and melancholy" Skumbi, which they had to cross no less than twenty-two times on makeshift wooden bridges. Night was falling. Yet still Lear would draw, although "Dragoman Giorgio ... strongly besought me not to linger." Fringing a distant hill were the "silver minarets" of Byron's Elbassan, where "the pale crescent sparkles in the glen". Byron was fortunate to be a poet and not a painter in Elbassan. The men of Ghegheria regarded the figurative artist with extreme suspicion. When Lear set off to draw the principal mosque on his first morning he forgot to take with him his fez and his armed guard.

No sooner had I settled to draw than forth came the population of Elbassan.... There were soon from 80 to 100 spectators collected ... and when I had sketched such of the principal buildings as they could recognise, a universal shout of "Shaitan!" (Satan) burst from the crowd, and strange to relate, the greater part of the mob put their fingers into their mouths after the manner of butcher-boys in England. Whether this was a sort of spell against my magic I do not know, but the absurdity of sitting still on a rampart to make a drawing while a great crowd of people whistled at me with all their might struck me so forcibly, that come what might, I could not resist going off into convulsions of laughter, an impulse the Gheges seemed to sympathise with, as one and all shrieked with delight, and the ramparts resounded with hilarious merriment. Alas! this was of no longer duration, for one of those tiresome Dervishes, in whom, with their green turbans, Elbassan is rich, soon came up, and yelled "Shaitan Scroo! Shaitan!" ("He draws.") in my ears with all his force; seizing my book also ... and pointing to the sky.... It was in vain after this to attempt more; the "Shaitan" cry was raised in one wild chorus – and I took the consequences of having laid by my fez for comfort's sake, in the shape of a horrible shower of stones, which pursued me to the covered streets, where finding Bekir [the guard] with his whip, I went to work again

more successfully about the walls of the old city.

On another occasion Lear dropped his eraser which made "2 little hops upon the ground, as is the wont of that useful vegetable substance". This event "caused indescribable alarm to two orthodox Gheges, who jumped up and hissed at it, saying '*Shaitan!*'".

Almost more alarming than the Turks were the Turkish khans, and the most alarming of these was the khan of Tirana, in the far north of Ghegheria. (Tirana is the present capital of Albania.)

> O khan of Tirana! With its immense stables full of
> uproarious horses,
> With its broken ladders,
> With its walls falling in masses of mud from their osier-
> woven supports,
> With its thinly raftered roof,
> With its floor of shaking boards through which the
> horses below were open to contemplation,
> O khan of Tirana!

It was at the khan of Tirana that Lear had a strange neighbour. "A whirring, humming sound . . . began to pervade the apartment. Desirous to know what was going on, I crawled to the smallest chink . . . and what did I see? My friend of the morning . . . the maniac Dervish, performing the most wonderful evolutions and gyrations; spinning round and round . . . first on his legs, and then pivot-wise '*sur son séant*'" (on his bottom). The "ancient buffoon" was up betimes, whirling and foaming to give Lear a send-off the next morning.

Kroia was the most remote town that Lear visited in northern Albania. There he was the guest of little Ali Bey. Before Lear could hide himself in a khan, Ali Bey had summoned him to his palace, "all in a dreary courtyard, the high walls of which shut out effectually the glorious landscape below". "My dormitory," Lear wrote, "was a real Turkish chamber . . . the raised cushions on 3 sides of it, the high . . . carved wooden ceiling, the partition screen of lofty woodwork". The walls were covered with guns and horse-gear. Innumerable pigeon-holes of coloured glass served for windows. There

were ten kilted servants to wait on him. When they all rushed
to take his shoes off, he dismissed them. The Bey had already
had his high tea (Turks ate at the most inconvenient hours),
but Lear was summoned to the celestial divan. Upon it squat-
ted a boy of eighteen in a European frock-coat. Conversation
was slow until Lear took out a pencil and drew two examples
of European technology: a steamboat and a railway carriage,
on which the youth enquired if they made any noise,

> and I replied by imitating both the inventions in question
> in the best manner I could think of, "tokka, tokka, tok"
> ... and "squish-squash, thump-bump" ... a noisy novelty,
> which so intensely delighted Ali Bey, that he fairly threw
> himself back on the divan and laughed as I never saw Turk
> laugh before.... For my sins, this imitation became fear-
> fully popular, and I had to repeat "squish-squash," and
> "tik-tok", till I was heartily tired.

Lear escaped to draw for a few early hours the next morning,
but had to hurry back for dinner at the unspeakable hour
of eleven a.m. The meal was embarrassing. There were two
other guests, and Lear was requested to "tik-tok" and
"squish-squash" for their benefit too. Giorgio, who acted
as interpreter, "could ill keep his gravity" and the servant
corps de ballet became almost hysterical. Then Lear made a
serious gaffe. "Endeavouring to sit cross-legged ... I some-
how got my knees too far below the pewter table-top, and
a ... violent cramp seizing me at the unlucky moment in
which the tureen was placed on the table, I hastily endea-
voured to withdraw the limb, but unsuccessfully. Gracious!
Sidelong went the whole table, and all the soup was wasted
on the ground!" After the meal Ali showed Lear his empty
harem and asked him a very intimate question. "How does
the Frank make the collars of his shirt stand upright?" Giorgio
advised a Frankish laundress with a knowledge of starching,
and the Bey said he would purchase one at once from Trieste.
Leavetaking the next morning was prolonged and affecting.
The Bey was down by six a.m. to pump both of Lear's hands
in the European manner. "Long after I had left the
palace, he was watching me from his corner-window."

What did the future hold for the boy, Lear pondered, except to sit and smoke endlessly in his fortress home?

Lear was anxious to draw mighty Mount Tomohrit on his way south, but it was raining. The great monarch "frowned in purple grandeur amid cloud and storm". Undismayed, he splashed his way towards it. The fez didn't help. "To a man who wears spectacles, a fez is not advantageous as a covering for the head on a rainy day; the glasses are soon dimmed, and little does he see of all above, below, and around." He and Coggachio ploughed through a forest hung with wet creepers, their horses above the hocks in mud. Only a "tranquil young buffalo" peering "calmly out of a pool of black water" seemed to be enjoying it. Now the Skumbi had to be crossed, this time in spate, and at a point nearer to its estuary. The transit was "not a little dangerous.... The bridge was a long and narrow structure of a shaking and incoherent nature [and] presented wide gaps through which you saw the rushing stream. Each man led his horse very slowly from end to end before the next set foot on crazy fabric, which would not have supported two parties at once." Eventually Lear settled on the banks of the Apsus to draw the triple peaks of Tomohrit the rainmaker. That drawing would eventually form the basis of one of his major paintings.

By now Lear had determined to publish his drawings of Greece and Albania as illustrations to a diary of the journey. At the back of his mind he had an even more ambitious plan: to make a set of topographical drawings of the whole of Greece and Albania as illustrations to a new edition of Leake's *Travels in Northern Greece*, and *Travels in the Morea*, each in several volumes. On his return to London he would meet Colonel Martin Leake and his motherly wife. They became close friends.

Lear had now reached the coast near Avlona. The strangest feature of this area was the vast lagoons.

As we skirted these salt lagunes, I observed an infinite number of what appeared to be large white stones, arranged in rows with great regularity, though yet with something odd in their form not easily to be described. The more I looked at them, the more I felt they were not what they

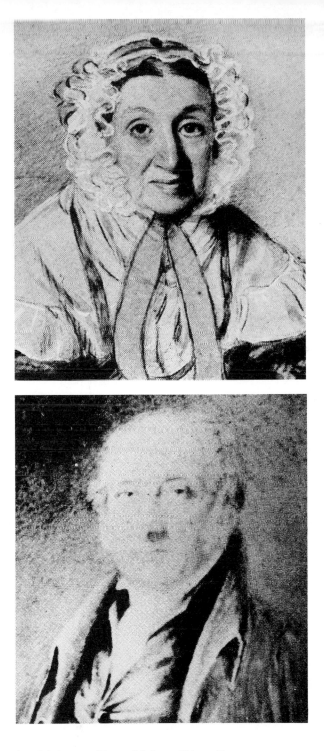

1 and 2 Ann and Jeremiah Lear, Edward's parents

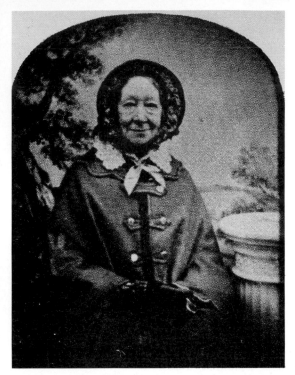

3 Ann Lear, Edward's sister

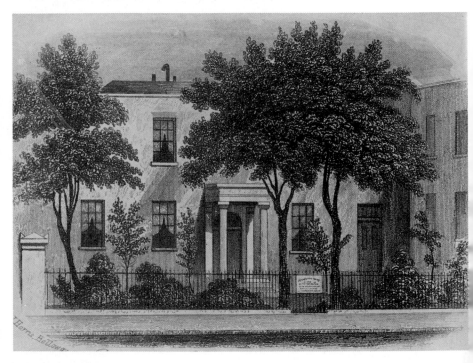

4 Bowman's Lodge, Holloway Road, London, Lear's childhood home

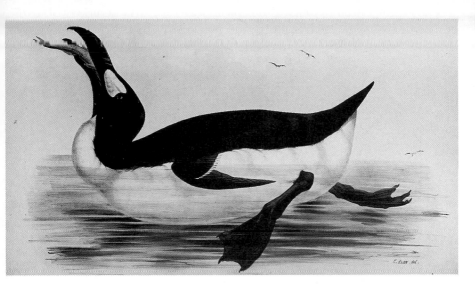

5 The Great Auk. A lithograph by Lear for Gould's *Birds of Europe*

6 Pentedatillo. A lithograph from Lear's *Journals of a Landscape Painter in Southern Calabria*, 1852

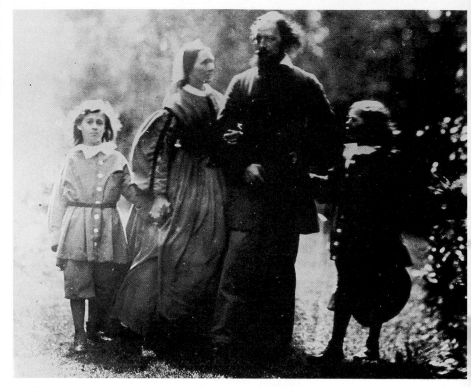

7 Alfred and Emily Tennyson with their sons at Farringford

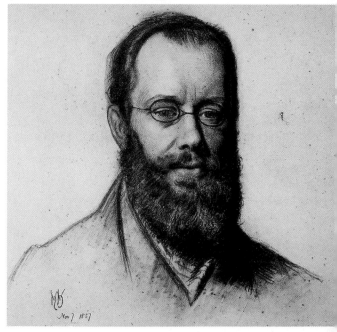

8 Lear, by William Holman Hunt, at the age of forty-five

Edward Lear & Chichester Fortescue.
From a Daguerreotype taken at Red House, Ardee, Sept, 1857.

Lear with Chichester Fortescue at Ardee, 1857

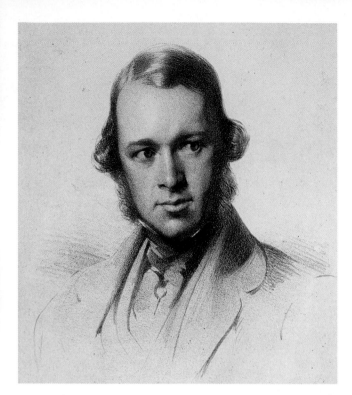

10 Franklin Lushington in youth

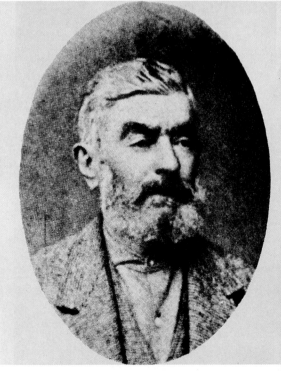

11 Last photograph of Giorgio Kokali, Lear's Suliote servant

12 Janet Symonds, for whom "The Owl and the Pussy-cat" was written. Daughter of John Addington Symonds

3 Villa Tennyson, the second house that Lear built at San Remo

14 Hubert Congreve

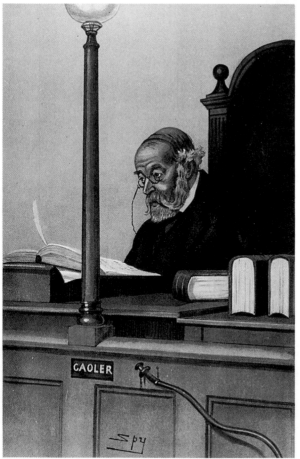

15 Franklin Lushington as Chief Magistrate to the Metropolis, after being a Police Magistrate for thirty dull years. Spy described him as "a creature of routine . . . a very kindly and attentive man – especially to the Police"

seemed to be . . . so I resolved to examine these mysterious white stones forthwith, and off we went, when – lo! on my near approach, one and all put forth legs, long necks, and great wings, and "stood confessed" so many great pelicans, which, with croakings expressive of great disgust at all such ill-timed interruptions, rose up into the air in a body of five or six hundred, and soared slowly away to the cliffs north of the gulf.

Now Lear was to visit the strangest, wildest place he would ever visit, there to make some of the strangest friends he ever made. It was said that no Englishman had ever been there. It all happened by chance. He had an introduction to a pair of German bachelors who lived together by the sea at Avlona in a state of constant conflict. It was they who advised him to visit the wild Khimara district, a strip of land wedged between the mountains and the sea, and offered him the loan of their servant, Anastasio, a Khimariote. Lear made no elaborate preparations for the week's journey. "A small knapsack contained all my property." He soon discovered that Anastasio was a popular character, hailed by all as *Capitano*. "With some he stopped to laugh and converse; others he saluted, after the fashion of Albania, [with] mock-skirmishes, drawing pistols . . . from his girdle, and seizing their throats with many yells." On the road he "sang at the top of an immense voice", letting off pistol shots "at irregular intervals" for variety.

After two or three days of travel, they found themselves looking down on the lost village of Dukadhes. This was their ultimate destination, or rather it was Anastasio's, for he lived there. "The spectator seems on the edge of a high wall, from the brink of which giddy elevation he looks down into a fearfully profound basin, at the root of the mountain." Dukadhes lay at the bottom of this dried lake, "its houses scattered like milk-white dice". Anastasio had asked to visit his wife and daughter, but it was in fact the beautiful Fortina he wished to see.

I never saw a more exquisitely handsome face than hers [Lear declared, evidently quite smitten]. Each feature was perfectly faultless in form, but the general expression of

the countenance had in it somewhat of sternness and traces of suffering. Her raven tresses fell loose over her beautiful shoulders and neck, and her form from head to foot was majestic and graceful to perfection. Her dress too, the short open Greek jacket or spencer, ornamented with red patterns, the many folded petticoat, the scarlet embroidered apron, admirably became her. She was a perfect model of beauty, as she stood knitting, hardly bending beneath the burdens she was carrying.

Anastasio had arranged that Fortina should act as one of their beasts of burden for a few miles. Anastasio explained to Lear that she had been unhappily married to a horrid old man, although *he* had always loved her better than anybody. Lear was deeply stirred. In every mountain village shrieking women were bewailing the newly dead, as was the custom. To Lear they seemed to bewail Fortina's lost happiness.

This was not the last he was to see of Fortina. Two days later "behold once more the beautiful Fortina carrying my knapsack and the capote of Anastasio, who had suddenly been seized by a great compassion for the mules, and thought fit to diminish their luggage". There was to be one last glorious evening with Fortina in a barn near Dukadhes. Gypsy musicians led by a "hideous idol-gypsy" had been hired to give the *milord* a suitable Khimariote send-off. "The fun grew fast and furious, and at length the father of the song became animated in the grandest degree. He sang and shrieked the strangest minor airs with incredible accompaniments, tearing and twanging the guitar with great skill, and energy enough to break it into bits. Everything he sang seemed to delight his audience, which at times was moved to shouts of laughter, at others almost to tears." At midnight the performers were dismissed but sleep was impossible. The daughter of the house chose to sit by Lear all night "and was particularly animated and loquacious, devoting herself to my instruction in Greek and Albanian phraseology. "Turkish pig," growled Anastasio. "Can't she let us sleep?" On the other side of Lear sat the sad Fortina. In the morning she wrapped her beautiful head closely in a white kerchief, and turned to go. Lear never saw her more.

Lear was distressed by the way Albanians treated their women. It was common enough to have to give way to a train of fifty mules loaded with firewood on a mountain track. It was almost equally common to see a line of women carrying 180-lb loads. "These poor creatures," he wrote, "are indeed little like women in appearance, for their faces are worn into lines and furrows of masculine hardness by excessive and early toil; and as they pitifully struggle up the rocky paths steadying their steps with a staff, or cross the stony torrent beds, bent nearly double beneath their loads they seem scarcely human." He once asked a peasant why he treated his wife thus. The man replied, "O Signore . . . we have no mules . . . that is the reason why we employ creatures so inferior . . . as a woman is." Yet when the younger women stood on a high ledge, tossing their bundles of wood to others far below in a ravine, they were fine to behold and the mountains rang with their high-pitched calls, which carried from peak to peak.

Now "the glittering minarets of Tepalen" were approaching, where Byron had stayed with "the wondrous Ali Pasha", the robber chieftain celebrated for his courage, his savagery and his greed. For many years Ali had defied Ottoman authority and ruled despotically in southern Albania. In this city he had built his palace. But of the "Marble-paved pavilion" there was now nothing to see but "a dreary blank scene of desolation. . . . The poet is no more. The host is beheaded, the palace . . . is levelled with the ground. . . . It is impossible not to linger in such a site and brood over such images. Of all the scenes I have visited, the palace of Ali Pasha at Tepalen will continue most vividly imprinted on my recollection." At the monastery of Zitza, Lear had the consolation of meeting the very monk who had entertained Byron when the poet was twenty-one. He was one of only two monks who remained there. Byron had been almost benighted in a dreadful storm on the way to Zitza, and had claimed for it an impressive mountain setting that Lear was sorry to confess it did not possess. Lear also met a man whose uncle had been with Byron at the end of his life at Missolonghi, as surrounded by his Suliote guard, he waited for an opportunity to march against the Turks.

There is a letter written to Charles Church[4] at this time in which Lear described a mysterious man he found hiding in a fortress in the vicinity of Zitza:

There was one who, with his face entirely muffled excepting one eye, kept aloof in the darker part of the chamber, until, having thoroughly scrutinized me, he came forward, and dropping his capote, discovered, to my horror and amazement, features which, though disguised by an enormous growth of hair, I could not fail to recognise. "The world is my city now," said he, "I am become a savage like those with whom I dwell. What is life to me?" And covering his face again he wept with a heart-breaking bitterness only life-exiles can know.

Yannina and its lake represented a return to civilization, to letters from home and the British Consul's copy of *The Times*. Lear read of further outbreaks of revolution in Europe which had continued throughout the year. He also heard that he had missed Church again. Church was now on his way to Prevesa to take ship for Malta. Lear was more eager for Church's company than he was even to see the southern half of Albania. "He was a great bit of fun," he told Ann,[5] and hurried after him, vowing to return to Albania the following year.

13

Albania II 1849

Lear failed to catch up with Church but he caught Cross instead. John Cross, a Knowsley friend, had offered to finance a winter flight to Egypt. Lear sailed to Alexandria via Malta and met him at Cairo. Cross was planning two desert expeditions, starting from Suez. It was to be the real thing, using camels for transport. Lear quickly mastered the art of camel riding, "perfectly delightful – like a rocking chair [but] I wish they would not growl so".[1] At night they were to rough it in tents under the stars. The only trouble was that Cross had brought with him so much sophisticated camping equipment that Lear feared they might be too well prepared against hardship for the adventure to be a romantic one. His own special purchases for the journey were merely a large umbrella and a "a hat lined with green".

The journey south from Suez to Sinai was safely accomplished, though whether it was romantic will never be known. Lear wrote Ann a long letter about it but the letter has been lost. His journey north from Suez with Cross has been fully documented and it was far from romantic. The two men now planned to visit Gaza (ten days across the desert) and go on to Jerusalem. But the weather "changed frightfully, torrents of rain fell and the wind was most terrible, and I caught a severe cold, and was extremely unwell Tent travelling is not like my doings in Albania, Turkey or Greece, where you can always reach a khan, and dry your clothes by a fire I decided on returning That excellent creature Cross would not leave me so at last I got to Suez."[2] Little did Lear guess, as he galloped back to Cairo in a four-

horse omnibus, that the event which was to transform his life was about to take place: his meeting with Franklin Lushington. When Lear met Frank in Malta that February he had had every intention of continuing at once his tour of Albania before the May rains commenced. Instead, as we know, he postponed it to tread the "haunted holy ground"[3] of Greece with Frank. They had ridden through Arcadia together and heard the pipes of Pan on Mount Helmos. They had gazed into the mirror of Lake Phonia and climbed to the windy temple of Bassae. What changes the two months with Frank had made on him can best be gauged by following him on his second trip through Albania, in 1849. This was to take him eastwards to Suli, and across the Pindus range to Thessaly. He would end up at Volo on the coast south of Salonica, and so complete the vast anti-clockwise tour begun the year before.

Lear took old Andrea Vrindisi with him on this second Albanian trip, the portly servant who had been with him and Frank in the Peloponnese. The choice was unwise. The crossing of the Pindus would require great endurance and agility and the weather was against them. The succession of spring days Lear had enjoyed with Frank had ended. The rain came down incessantly. Tracks were washed off mountainsides, rivers rose close beneath rickety bridges, meadowland turned to marsh and marsh to lake. The rock of the Suliote women at Zalongo was the place Lear most wanted to see. The story of the mass suicide of the women of this fiery tribe, as told in *Childe Harold*, who had chosen to die rather than submit to Ali Pasha, had coloured his mind from childhood. "As the enemy scaled the rock to take the women prisoners", he wrote, "they dashed all their children on the crags below, and joining hands while they sang the songs of their own dear land they advanced nearer and nearer to the edge of the precipice, when from the brink a victim precipitated herself into the deep below at each recurring round of the dance until all were destroyed."[4] But now, when he was within striking distance of Zalongo, it was too wet even to visit the rock. This was not the Lear of old. He had now become convinced that wet clothes would bring a return of malaria. He also began to complain about his right arm, which he

had injured when falling off his horse with Church a year ago, claiming it had been "practically useless" ever since. There had been no mention of this arm when he was with Frank; indeed, he had executed some two hundred sketches with it. The ascent of the Pindus was vile. They nearly lost a baggage horse over a precipice above the Acheron. "The basket containing the canteen was smitten by a sharp rock, and all my plates and dishes, knives, forks and pewter pans, which F. L. [Franklin Lushington] had bequeathed to me at Patras, went spinning down from crag to crag 'till they lodged in the infernal stream below." A bad omen. Andrea made heavy weather of the climb, and during the passage he was more than once "unable to advance for some minutes". Crossing the Acheron caused him even more trouble. "What a bridge! The river, confined between two very narrow perpendicular crags, boils and thunders below them, while the space between is connected by two poles, over which branches of trees are laid transversely, and over all a covering of leaves and earth by way of a pavement Slowly, on hands and knees, and holding the poles, I passed this bridge over the River of Pluto, its oscillations being far from pleasant, but the huge Andrea manifested much solicitude e'er he ventured his heavy frame on the slight support, throwing his shoes and most of his dress over ... before he attempted to cross." Worse was to come. He now proceeded to lead the way up the wrong ravine, for new mule tracks had been made since his last visit in 1833. At the end of a hard day they landed up where they had started.

At lakeside Yannina there was the usual brief moment of comfort in the house of the British Consul, and a chance to read *The Times*. Then it was over the top via "the gloomy pass of Metzovo". At the highest point of the pass, "the rock, bald and rugged, is so steep that the zigzag track cannot be overcome upon foot". Below, were the monasteries of Meteora, one of the great wonders of Byzantium. "The detached and massive pillars of stone, crowned with the retreats of the monks, rise perpendicularly from the sea of foliage," Lear wrote, "when at this early hour ... the bright eastern light strikes the ... magic heights." Yet Lear did not

tarry. Though he made a few sketches, he did not visit a single monastery. He never, for instance, saw the golden chapel at Baarlam. Perhaps he disliked the thought of being hauled up in a net. These giant nets were suspended from rickety winches operated by half-starved lay brothers at the top. In one of his drawings Lear portrayed a net full of monks in suspense.

Lear actually considered turning for home at this point. Only "the dread of so soon re-encountering the gloomy Pass of Metzovo" caused him to persevere. Eastwards towards the coast, on the Plain of Thessaly where the Ancient Greeks raised their famous horses, there was soft green grass for them to canter on and birds to make them laugh. Indeed, there was an ornithological cast of thousands. Vultures mobbed each other for food, storks bustled along like market women and "grey cranes" strolled in pairs, aloof as cabinet ministers in Hyde Park. The storks of Thessaly (now largely gone) were Lear's delight. They built their untidy nests on every chimney top with "infinite pains" and they made a clattering sound "like dice shaken in a box" to celebrate. One night the leg of a stork came through Lear's bedroom ceiling. The occupants of the nest remained loudly annoyed on the roof for the rest of the night. But the jolliest jester of all was the baby camel, "a white muff upon stilts . . . the little animal . . . chose to rush towards us with the most cheerful and innocent intentions, and skipping and jumping . . . thrust himself into the way of our 3 horses with the most facetious perseverance". A muleteer was now of the party and his horse was particularly nervous. It "reared, threw him and escaped. There was much difficulty in recapturing the terrified animal, and when we had done so, forth came the little muffy white beast once more, pursuing us with the most profuse antics over the plain, and rendering our steeds perfectly unmanageable."

But at Larissa, the capital city of Thessaly, the depression he had felt at Meteora returned more strongly, and with it, the desire to give up and go home. Undoubtedly, his obsession with Frank had brought on the present crisis. In his published journal he blamed it on the malarious miasma of Larissa. Although he was comfortably housed with the

many-wived Bey, the richest local proprietor (the Hon. Captain Colborne had given him an introduction), he could barely bring himself to draw the town with its many minarets or even the fine view of Mount Olympus so clearly visible to the east. "There is a heaviness in the atmosphere here, which ... combined with a constant fear of fever fits, prevents my making the least excursion in sketching any one of the beautiful things around me," he wrote.

Lear, however, did exert himself to the point of visiting the Vale of Tempe, close to Mount Olympus, "of all places in Greece, that which I have most desired to see". He made a famous drawing of Tempe, later to be used as the basis for an oil. He had expected the place to be a broad, green vale with sheep. But this was a narrow pass with the Peneus flowing deep in the midst, between the richest overhanging plane woods, only six miles from the sea. While visiting Tempe, Lear stayed with a respectable and hospitable "steeple-hatted" Dervish. A previous traveller, David Urquart,[5] swore that at night the Dervish roosted in a convenient cypress tree. Lear observed no "such birdlike system of repose", although the idea appealed to him.

Perhaps encouraged by the beauty of Tempe, he continued his journey to the port of Volo. But then the rain came in earnest. The rice fields of Thessaly became quagmires. The horses went in belly-deep and had to be unloaded. The only way to get them out was to encourage them to struggle, then rest, then struggle to extricate themselves. And the party was completely lost. The sounding of the waves of the Gulf of Volo was their only guide. As they were climbing the cliffs at the head of the gulf they had another accident. Andrea's horse fell and so did Andrea. It wasn't an ordinary fall. Andrea was precipitated from a rock four or five feet high. This, added to his weight, made the accident a serious one. "It was long before the muleteer and myself could lift the unlucky Dragoman onto his horse once more."

And now, after so much effort, Lear decided *not* to sail for Mount Athos. The wind, he declared, was in the south and the wet weather conducive to malaria. There was nothing for it but to turn round and go straight back over the mighty wall of the Pindus. The recent rain made the journey still

more dangerous. The River Salympria "at each ford grew more violent and rapid ... and streams running into the Salympria, mere rivulets on our journey hither, were now such foaming torrents that my little white pony could hardly accomplish the passage." Lear feared that the Metzovo river might be unfordable and that he would be kept a prisoner in the dreadful pass. But he crossed safely and embarked for Corfu via Malta.

The contrast between this second visit to Albania and the first, made before the "disaster to my heart",[6] is striking. It cannot be fully explained by the fact that southern Albania is different from the north, nor by the fact that it rained a lot, for it rained the first time too. Lear's whole attitude to the adventure had changed. The glorying in scenery and strangeness were gone and so were the wild evenings with primitive tribesmen (although there were wild Suliotes and Vlaks aplenty to be had in the south). Lear's chief desire, frequently expressed, seems to have been to go home. Although each journey took six weeks, the printed journal of the second was only one third as long as the first.

14

The Lushingtons 1849–54

Lear had cut short his first visit to Albania in order to catch up with Charles Church. After his second visit he hurried home to be with Frank. But when he reached London in July 1849 Frank was not there. He was on holiday with Harry, inspecting the war damage in Rome. Lear now decided that his travelling days were over and he would settle permanently in London, as he had planned two years earlier. In September he took a five-year lease on rooms at 17 Stratford Place, a cul-de-sac off Oxford Street (opposite the present Bond Street Station). He did not invite Ann to join him. "Dear Ann has been very unsteady in her habits this last summer," Lear's sister, Mary, wrote to her brother Frederick in America. "She compared herself to thistledown, blown here and there, but she will shortly be settled in a family at the West End."[1] "So good and yet so unable to be my companion," Lear concluded in his diary.[2] Yet she was quite a close neighbour.

Lear chose for himself "the stuccoed ... West End", because the fashionable galleries were there and he now proposed to be a fashionable painter. But he craved the "central roar"[3] of the law courts and Fleet Street, for there the Lushingtons and their fellow Apostles were to be found. The Apostles stayed together long after they came down from Cambridge. In London, if one called on another in his chambers, he would be sure to find a third present "while others would always 'happen' to join them for 'tea and anchovies', Cambridge fashion".[4] A typical entry in Henry Brookfield's diary (Brookfield had been an Apostle with Harry) ran, "Hied me to Harry Lushington's, where were Edmund

Lushington, Frank Lushington, Henry Lushington, Milnes, Monteith, Spedding, Venables". Although Lear came late to this distinguished band, he was accepted as an honorary Apostle. He often dined with them at the Cock in Fleet Street. Yet unaccountably the Frank of London was not the Frank of Arcadia. He seemed to be withdrawing. Only a few months after Lear's return to England, Henry Hallam, younger brother of the famous Arthur, had suddenly died. Henry Hallam had been Frank's "particular friend" at Cambridge. An aesthete, he had loved "the fanciful and even paradoxical". Frank had loved him without shame. In a brief memoir of him, privately published, he wrote, "His friendship was a necessity of existence Our weak speech and intellect cannot draw what only love can say."[5] In no place in his writings does Lear mention the sudden and tragic death of the younger Hallam, so uncannily similar to that of the older one, which had devastated Tennyson ten years earlier. It seems likely that he hoped, in some way, to take Hallam's place.

Frank did not neglect to take Lear to visit his friends, many of whom lived in large country houses. In 1850, they went to the Lake District together. There Lear first met Alfred and Emily Tennyson, who were on their honeymoon. They were fellow-guests of the Marshalls of Tent Lodge, Coniston (Tennyson had in fact been lent a cottage in the grounds). "In Memoriam", his lament for Arthur Hallam, had just taken Victorian England by storm, earning its author the laureateship and making him a celebrity. In spite of this he was still looking for somewhere to live, hence the length of his honeymoon. Carlyle and Coventry Patmore also stayed with the Marshalls that summer. So did Tom Woolner, the sculptor, and Aubrey de Vere, the Irish poet. Frank's older brother, Edmund, the Glasgow professor, and his sister Ellen were there too. The weather was awful of course. Coniston Old Man never took his hat off and one night the Tennysons' window was blown in. Emily, who was delicate, ended her lakeland holiday with a nasty cough although Carlyle, most uncharacteristically, shut at least one window which was afflicting the back of her neck with a draught. Emily was a semi-invalid, real or imagined, most of her life.

The next country home that Lear was to visit was Park

House, Frank's family home. Lear probably first arrived there
at the very beginning of 1851. The lives of the Lushingtons
were lived in pleasant places. They ruled benignly over the
village of Boxley, near Maidstone in Kent. Park House was
a large (but not large enough) bow-fronted mansion of the
late eighteenth century, overlooking a park that undulated
towards the North Downs. Nearby nestled the village church,
also in parkland, beneath immemorial elms. All was, and
is, unspoilt. As for the Lushingtons themselves, Evelyn
Waugh's Boots of Boots Magna could not exceed them for
close-knit eccentricity.

When Lear arrived at Park House the Tennysons were there
(still house hunting), and it was appropriate that they should
be, for there was a close connection between the Tennysons
and the Lushingtons. Ten years earlier Tennyson's widowed
mother had settled with her family at Boxley Hall, just beyond
the church, and Edmund Lushington had subsequently mar-
ried Alfred's youngest sister Cecilia. Tennyson had also writ-
ten a poem, "The Princess",[6] which was set on the day of
an actual event that had taken place a few years earlier at
Park House: the fête of the Mechanical Institute of 6 July
1842, and used for its characters thinly disguised versions
of some members of the Lushington family. "The Princess"
gives us the only picture we have of the young Frank. In
the poem a thinly disguised Frank (Walter Vivian) and six
fellow-undergraduates argue with "lady friends" led by a
thinly disguised Louisa (Lilia Vivian), Frank's younger sister,
described as "wild with sport, half child half woman", about
men's intellectual neglect of women, and Louisa's proposal
to found for women "a college like a man's for women".
The men win the argument but Frank admits that he wishes
Louisa had not yielded and playfully ruffles her ringlets by
way of consolation.

By the time Lear came to Park House, Louisa was no longer
"half child". She was twenty-five, and, with her sisters, had
indeed formed an academy: an academy for the education
of one small boy, their nephew Eddy. Eddy was the son
of Edmund and Cecilia. He was a child of golden curls and
promise. He could recite bits of Homer, he could sail and
play cricket, and he knew the names of all the wild flowers

in the park. He had two younger sisters, but they did not really count. His mother, Cecilia, was again expecting a child.

At the time of Lear's visit, the Lushingtons were preparing to celebrate little Eddy's seventh birthday. A decorated Christmas tree still stood in the garden but now fireworks and a magic lantern show were added to the post-Christmas fun. And of course everybody joined in the charades. Edmund, Eddy's father, had come down specially from Glasgow. Normally Lear would have shone in such a setting. Yet there are no reports that Eddy became enamoured of the Old Persons.

There were tensions beneath the surface at Park House, and these affected Frank more than anyone. Cecilia was a neurotic and unhappy woman, unable to shoulder her responsibilities as head of the household. She had lost much of the dark-haired, milky beauty she had possessed when she first came to the house as Tennyson's younger sister, although she still retained the fine contralto voice that was often compared to the poet's. As a child she had suffered more than Tennyson from the drunken madness of their father, a Lincolnshire clergyman. Now she suffered from continual headaches and unspecified complaints. An uproar in a distant room would warn guests that she was having one of her "storms".[7] When she became depressed she would move to the family's seaside house at Eastbourne with her sister Matilda (rumoured to be the only ugly Tennyson). Frank found Cecilia's crises irritating. He deplored her constant recourse to new doctors, declaring that "the good of a new doctor is generally transient enough" and considered that she would be better off with Edmund in Glasgow.[8]

Cecilia did however occasionally provide light relief. She, like Lear, would sing Tennyson's poems to an audience. Her perfect skin was now leathery, giving her the look of Meg Merrilles, but she was still tall and slim. She "stood at the open door, where she fancied she got more air", wrote a friend, Mrs Sellars, in her book, *Recollections and Impressions*, "and chanted, to numbers of her own composing, her brother's poems." Cecilia never failed to draw tears from her husband, Edmund, but the sight of "the ancient sybil singing in the doorway of a modern drawing-room . . . caused

irreverent concealed laughter" in others.

Frank also found Tennyson irritating. Tennyson was Harry's friend rather than his. Indeed, Tennyson had declared that Harry was the best critic he ever had, the one who could pick on the exact word that was wrong.[9] It was the poet's habit of "coming unwashed and staying unbidden" that distressed the fastidious Frank. Indeed he declared it to be "the greatest calamity of his family's existence".[10]

More deeply saddening to Frank was the fact that Harry, at present on leave from Malta, was due to return there, and, still worse, to take with him his sisters Louisa and Maria. Yet it is probable that none of these family problems affected Frank's mood so profoundly as did the presence of George Stovin Venables. Venables is perhaps the strangest character in all our story, a sepulchre of the purest white, whose name appears in no previous Lear biography. Yet he it was who did most to turn to dust Lear's hopes of happiness with Frank. George Stovin Venables was a Venables of Llysdinam Hall, Newbridge-on-Wye in Radnorshire (now Powys). He was the son of the Archdeacon of Carmarthen and a future Lord Lieutenant of the county, tall, fair, "strikingly handsome" and frightfully good at games.[11] But there was a fatal flaw in the character of Venables. He was hopelessly in love with Harry Lushington. "The great and beautiful attachment of his life" had begun at Charterhouse, where he had been the smaller boy's "champion and admirer".[12] During their first year at Cambridge, as Apostles, they had walked the fens together, contributing alternate lines to revolutionary poems.[13] According to Mrs Brookfield the friendship of Venables and Harry "indeed rivalled that of Tennyson and Hallam". Society accepted these "'bosom friendships", putting only three conditions upon them: the partners must be of the same age; they must be of the same social background; and third, the flesh must not therein enter. According to Venables, Harry's "purity and simplicity of ... nature repelled every form of vice without any apparent effort".[14]

The friendship of Harry and Venables did not end with Cambridge. When Harry resigned his Fellowship at Trinity Hall to move to the Inner Temple, Venables followed him, although he had been much happier tutoring at Jesus. When,

years later, Harry left to take up his appointment in Malta and Venables could not follow him, Venables declared, "the first part of my life has ended".[15] With the years, his loneliness increased. Any "slight circumstance" that reminded him of Harry brought back a violent attack of "the old feeling". The words "solitude", "heartbreak", "wretchedness", and "pain" appear frequently in his diary. Harry's letters from Malta were "'disappointing in [their] littleness", leaving "the state of himself . . . quite in doubt".[16] Even on leave Harry was as frozen as the pond down the road. Harry, like Frank, seemed to inspire adoration, and then discourage it. For Venables there was only one solution. If he could not have Harry, he would have his family. He proceeded to fall in love with every one of the Lushingtons at Park House. He stayed with them incessantly, becoming an unofficial uncle and a family chronicler. He paid court to all the young ladies. On one visit he rode the Pilgrims' Way on the downs with Emily in the morning, walked to Boxley with Ellen (who was poetic) in the afternoon and took a turn in the park with Louisa after tea. Meanwhile he found time for "talks" with Cecilia and listening to Eddy reciting Horace. In London Venables consoled himself with Frank, his neighbour at the Inner Temple. When Venables burnt his hand, Frank stayed the night and wrote his letters for him the next day. They took the train down to Maidstone together on Friday nights.

Thus it was that when Lear arrived at Park House for the first time, preparing to play the role of favourite uncle, he found that another uncle was there before him. Venables was a jealous man. At Cambridge he had resented Harry's friendship with Tennyson. He had no intention of sharing the Lushingtons, least of all Frank, with Lear. With the entry of Venables into Lear's story it is impossible further to evade the subject of Lear's homosexuality. "The love that dares not speak its name",[17] was as common in Victorian times as it is now, but the penalties for expressing that love were severe. When Lear was nineteen a man called Reekspeare was hanged for the rape of a boy. Yet at the same time adolescent boys were shut up in single-sex schools and fed on a heating diet of Greek poetry. John Addington Symonds (known by Swinburne as Soddington Symonds), author of a massive work

on the Italian Renaissance, claimed that he acquired "Arcadian tastes" from reading Plato's *Symposium* at Harrow. The *Symposium* recommended pure love between high-souled men. That, alas, was not the kind practised in the dormitories and studies at Harrow. The horrified Symonds witnessed "repulsive scenes of onanism, mutual masturbation and obscene orgies of naked boys in bed together. There was no refinement, just animal lust."[18] *Eric, or Little by Little*, which appeared in 1858, was about Harrow. It is sogged with sodomy. Although no indecent acts are described, the shadow of nameless vice hangs over all, and a boy called Ball is expelled for it. Venables was quick to pounce on mildly homosexual passages when he reviewed the book for the *Saturday Review* in 1858.[19] "The boys quote hymns, and, to the infinite indignation of all English readers, occasionally kiss each other (principally when they are *in articulo mortis*) exchanging moreover such endearments as 'dear fellow' and the like."

Lear had not been to a public school, but most of his friends had. In other respects his background closely resembled that of Symonds. The two men, who later became friends, had been separated from their mothers at the age of four and brought up in women-dominated households. Both had been sickly and withdrawn as children. But Symonds never had the fatal boyhood experiences at which Lear hints. Something of a similar nature probably did happen to Symonds's friend Cobham, an "enthusiastic" invert. As a boy of thirteen a friend of his older brother had seduced him in his mother's house, and he had never afterwards been able to experience love except in a rude masculine form.

It seems probable that Lear's love for young men was of the Platonic variety. He too mentioned reading the *Symposium*. He would probably have described his predilection in the way Wilde defended his at the Old Bailey:

Such a great affection as there was between David and Jonathan, such as Plato made the very basis of his philosophy, and such as you find in the sonnets of Michelangelo and Shakespeare There is nothing unnatural about it, and it repeatedly exists between an elder and a younger

man, where the elder has intellect and the younger man
has all the hope and glamour of life before him.

Lear was not only (probably) celibate, but he was faithful
to one partner, Frank, for many years. Before that there had
been his endless stream of "amiable" travelling companions,
all under twenty-five, mostly graduates of Oxford or Cam-
bridge. Thirteen can be named instantly: Arthur Stanley,
J. J. Hornby, Sir William Knighton, Sir John Acland, Charles
Knight, James Uwins, John Proby and Charles Church. Over
and above these were "Dear old Fortescue" and that "lumi-
nous and amiable brick", Thomas Baring, both of whom he
had met towards the end of his time in Rome. And then
of course there were Will Nevill and Bernard Senior, the
friends of his boyhood and youth in Holloway and Sussex.
Little Willi Marstrand, the Danish painter with whom he
spent such happy months at Civitella, was in a somewhat
different category from the rest. He was neither English nor
a gentleman. Yet one suspects that with him Lear may have
come closer to a physical relationship than with any of the
others. Lear put only this one earlier relationship into the
same category as his great love for Frank Lushington.

At Park House, Lear did have one advantage over the witty
and learned Venables. He could sing. And sing he did. All
the girls, and even Frank, sang and played incessantly, and
Frank also had a passion for opera (not shared by Lear), often
larding his conversation with phrases of operatic Italian. What
Lear sang was Tennyson. He had admired Tennyson's poetry
before Tennyson was famous, as early as 1842, when "The
Lady of Shalott" and "The Lotos-Eaters" had come out.
"There have been few weeks or days within the last 8 years,
that I have not been more or less in the habit of remembering
or reading Tennyson's poetry," he told Emily Tennyson that
year.[20]

To say Lear *sang* Tennyson is perhaps an exaggeration. He
probably half-sang, half-intoned the lyrics, to a vamped
accompaniment on the piano. It was a fortunate social
accomplishment at a house party where Tennyson was the
guest of honour. The laureate was enchanted. He declared
that he preferred Lear's settings to all others (and there were

many) because they did not interfere with the words, but merely threw a "diaphanous veil" over them. Lear could always make the company cry with "Tears, Idle Tears" from "The Princess":

> Tears from the depth of some divine despair
> Rise in the heart and gather to the eyes,
> In looking on the happy autumn-fields,
> And thinking of the days that are no more.

In 1853 Lear had three of the poems from "The Princess" professionally notated and published as sheets. Harry, Maria and Louise departed for Malta on 2 January. Only Frank's presence kept Venables in "comparatively good spirits". The house party was over, and Lear, presumably accompanied by Frank and Venables, returned to London. By this time Lear had become a student again. His decision is hard to explain. He had already attended two art schools, Sass's in Bloomsbury and the Academy in Rome (both with Sir Charles Knighton). But neither, in his opinion, had taught him sufficient about figure-drawing. The Royal Academy in this respect stood in a class by itself. Everybody who was anybody had studied there and most had won one or other of its much competed for gold medals. In Lear's day the Royal Academy was housed at the back of the National Gallery. (It had migrated from Burlington House in 1836 and was to return there in 1867.) Students paid no fees but supplied their own materials. A certain standard in figure-drawing was required for entry and half the applicants were turned down. To qualify for a three-month probationary period, a student was required to produce "a finished drawing in chalk, about 2 feet high, of an Undraped Antique Statue". Pieces of sculpture with arms or legs missing were not admissible.[21]

Lear went back to Sass's to prepare his drawing. When it was accepted he wrote triumphantly to Fortescue, "What fun. Pretty little dear! He got into the Academy, he did!" He would be a probationer until April when the drawings he had to make would be "sate on" again. "And now I go with a large book and a piece of chalk to school every day like a good little boy."[22] He drew himself sitting on a bench with a Jack Horner frill round his neck, surrounded by minute

classmates. That very summer the Royal Academicians had selected his "House of Claude Lorraine on the Tiber" for hanging. It was the first picture he had ever had hung in the Academy. In April he submitted three drawings including an "anatomised figure showing the bones and muscles". He was now entitled to attend life classes under the great dome of the National Gallery, the nude model being throned on velvet. Rules were strict, particularly for the female nude. No man under twenty (unless married) might enter the room, no student might move from the place allocated to him by lot during the two-hour session, and only black, white and red chalks could be used.

Lear left the Royal Academy schools after three terms. There is no record of his progress there, and it seems doubtful whether he attended regularly, for during much of 1850 he was preparing his *Journals of a Landscape Painter in Greece and Albania* for publication (Richard Bentley, 1851). It was the second travel book he was to produce in which the text took precedence over the illustrations, of which there were twenty. It is surely one of the best travel books ever written, a tale of genuine adventure told with humour by a man who made contact with the inhabitants of the landscape he was describing. The *Athenaeum* and *Tait's Magazine* both gave the book good reviews. "I should think that little book has had as much good said of it as any ever has."[23] Tennyson also liked the book which Lear gave him as a late wedding present. He wrote a poem about it, entitled "To E.L. on his travels in Greece". In it he mentioned by name places Lear had visited, including Mount Tomohrit and the "long divine Peneïan pass" (It had not seemed divine at the time!):

> Tomohrit, Athos, all things fair,
> With such a pencil, such a pen
> You shadow forth to distant men,
> I read and felt that I was there.

Tennyson was not a great traveller. He never saw Greece and only visited Italy once (soon after this meeting with Lear). Yet many of his poems were set in the lands of classical times, and it is possible that Lear's conversation provided him with material.

Lear wrote the Albanian book, he claimed, to make money for his old age. But he was now short of money. He always found London expensive and he could not earn while he was studying at the Royal Academy. If old Mrs Warner had not died the previous year Lear would have been in serious trouble. She was the disagreeable old lady whom Lear had tried to encourage Ann to go and live with at Bournemouth. Lear had benefited by £500 under her will (June 1849). Her remaining £50,000 she left to perpetual widows. "I thought, directly I heard of this matter, that I would instantly marry one of the 30 viddies," Lear wrote to Fortescue, "only then it occurred to me that she would not be a viddy any more if I married her."[24]

On 28 November 1850 he wrote to Stanley requiring a fifty-guinea advance on an eight-foot Acropolis. The foreground was filled with figures, he explained to Stanley, "as natural as they are picturesque . . . and indispensable to a good foreground subject".[25] Four months later Lear declared that he would dispense with the figures. Stanley, by now a sick man, was unhappy about their disappearance, fearing the expanse of unbroken foreground would be excessive. Lear insisted that, at sunrise, "solitude and quiet are the prevailing feelings". A literal representation of nature was becoming increasingly important to him. By June Lear was ready to take the "Acropolis" to Knowsley. He had all but hailed the cab for the station when the awful news broke. Ann tells the tale: Edward "had been very busy, engaged for several months in painting a large picture for the Earl, and had just finished it and was going down with it to Knowsley . . . to pay a visit there of a few weeks – when the family wrote to tell him of the Earl's death."[26]

Lear had not only lost his chief patron, but also a father-figure. "22 years ago I first went to Knowsley, and have received nothing but kindness from him and his family ever since, so it is no great wonder his death should cause me sorrow," he told Fortescue.[27] He at least had the comfort of looking back on a last happy week at Knowsley immediately after he returned from Albania. Robert Hornby had moved in with Stanley to escape the chill of Windermere. "My dear old friends I found just as ever, though 72 and

73 and every day has caused fresh shaking hands with old friends . . . I have been intensely happy . . . one has done little but laugh, eat, drink and sleep.[28]

Stanley's funeral procession was a mile long. His heir, the future Prime Minister Derby, did due honour to his father. Three hundred tenants on black horses rode before the hearse. Endless carriageloads of friends and relations followed it.[29] Having done that, he auctioned the menagerie. Literally thousands of specimens, collected over a lifetime, went for £8,000, half the cost of a year's maintenance. A butcher bought one of the eland for meat. Only a herd of crossbred cattle was allowed to remain undisturbed in the park.[30] No mention was made of the zebra-ass crosses that the earl used to drive in tandem.

The rest of the summer Lear spent in a state of profound gloom in a primitive farmhouse at Lydford in Devon. "I was obliged to select a deadly *cheap* place," he explained to Fortescue. "Lord how it rains!" he added.[31] By August all attempts at optimism had been abandoned. "I would not so much care for the wet, as for being obliged, when it is wet, to look at a dead wall and a rubbish heap opposite, and see nothing all day but 27 pigs and 18 cows." He had formerly doubted his ability to survive an English winter. Now he wondered whether he could survive an English summer. What really darkened his horizon was worry about his work. He felt he was making no progress as a painter. "I ain't sure if Lydford . . . won't have made me go *back*."[32] He was in no mood for company, nor did he get much. "There's only a curate as lives opposite, and keeps bees. All the rest of the village is miners, which reside underground." He advised Fortescue to stay away. "I wish I could see you," he wrote, "but I think you'd like me better where I am just now. I am so savage *Genus homo* I *ain't*. I'm a landscape painter, and I desire you to like me as such or not at all".[33] That month he attempted a walking tour with Frank in Cornwall. The expedition was not a success. The contrast between Frank as he was and Frank as he had been was painful. Lear complained of "his rhinoceros-like insensitivity" to Fortescue, and added, "I *wont* like anybody else, if I can help it, I mean, any new person, or scenes, or place,

all the rest of my short foolish life."[34]

Back in London, Lear began his painting of "The Quarries of Syracuse". Now, he complained, not only could he not draw, he could not paint. He was therefore ready for guidance when Robert Martineau brought the great William Holman Hunt to his studio the following summer of 1852. (Martineau was a student of Hunt's.) Hunt was one of the three original members of a secret society that described itself as the Pre-Raphaelite Brotherhood. The public had first become aware of the Brotherhood in 1849 when a painting entitled "Girlhood of Mary Virgin" appeared at the Royal Academy Exhibition with the mysterious initials P.R.B. beneath the name of its painter, Dante Gabriel Rossetti. John Everett Millais was the third member of the original brotherhood. Their aims were clear enough. They wished to replace the sentimentality of Raphael (whom they referred to as Mrs Slishy Slosh) with the austerity and naturalism of Giotto. By the time Lear met Hunt the Brotherhood was fast becoming accepted. Hunt's "Hireling Shepherd" was at that moment hung prominently in the Royal Academy Summer Exhibition and he was at work on "The Light of the World", the most successful picture the world had ever known (a picture that was shortly to tour the Empire by ox-wagon).

"He is very plain," Lear said of Hunt, "and educated by his own exertions."[35] In appearance Hunt was intense, dark and bearded, with eyes set wide apart. He was not strikingly handsome, as were his two young friends, Millais and Rossetti (with both of whom he had been in love for a time). He was in fact a manic depressive. Lear quickly recognized him as a genius. Thirteen years after they met he was still able to declare, "Daddy Hunt's head would cut up sufficient for 10 men, and his heart for 200 at least."[36] Although so much older than Hunt, he was eager to regard himself as an adopted son in professional terms and always referred to Hunt as "Pa" or "Daddy".

What Hunt thought of Lear the day they met Hunt describes in his book on the Brotherhood. He records how he went to Lear's chambers in Stratford Place to see his *numberless* drawings, which were in outline, with little to indicate light or shade. "Lear overflowed with geniality, and at the same

time betrayed anxiety as we turned over the drawings, avowing that he had not the ability to carry out the subject in oil. In some parts of them he had written, in phonetic spelling, the character of the points which the outlines would not explain – 'Rox', 'korn', 'ski', indulging his love of fun with these vagaries."[37]

Hunt was frankly shocked by Lear's method. The Pre-Raphaelite way was to paint in oils direct from nature. "The Light of the World", for instance, had been painted at night in an orchard (in spite of the fact that Hunt was frightened of the dark). It was now mid-August and Hunt planned to go to Fairlight Cliffs and paint his "Strayed Sheep" there. He invited Lear to come with him and complete "The Quarries of Syracuse". Lear was eager to paint at Hunt's side. He was less enthusiastic about sharing Clive Vale Farm with him (or anyone), explaining in a letter to Hunt that it would be better to divide the cottage and each have his own sitting-room, only meeting at meals. Hunt and William Rossetti (brother of Dante Gabriel) arrived together. "It was curious," Hunt wrote, "to see the unexpected guardedness of Lear's reception of us, but he gradually thawed, and by the end of dinner he was laughing and telling good stories. When the cloth was cleared he said, 'Now I had intended to go to my room, but, if you do not mind, I'll bring down some of my drawings and pen them out here'."[38]

Clive Vale Farm was named after a steep little valley that runs down to the sea on the eastern edge of Hastings. Beyond it the Downs begin and continue uninterrupted to Fairlight. Hunt had a specific point on the Fairlight Cliffs in mind for his sheep. It was known as the Lovers' Seat and looked west over Covehurst Bay. He had come to know it while staying with Robert Martineau's parents at Fairlight Lodge.[39] Each day for the first ten days Hunt took his pupil, Lear, with him to the Lovers' Seat. Lear painted "the same landscape which I was using for my background. Thus he obtained acquaintance with my manner of work He soon after found some limestone rocks that had been extensively cut away, which served exactly for the principal feature of his Quarries of Syracuse. He began this on a canvas some 5ft in length and his occupation separated us until the evening meal."[40]

Back in the lamplit parlour of the farmhouse, Hunt talked about painting while Lear made notes in *Ye Booke of Hunte*.[41] Then Lear would talk of poetry. Hunt had no great knowledge of poetry but he was attracted by it. It had been Rossetti's talk of Shelley that had caused Hunt to fall in love with him. Indeed, it was Rossetti who had introduced him to Lear's Nonsense, explaining that they were by "a dear old boy of at least 35".[42] They invited Tennyson down for "a rural Sunday" but he didn't come. Millais did, and Lear was exceedingly alarmed. Johnny Millais was from a rather grand family, and although he was still very young, his "Christ in the Carpenter's shop" had made him notorious if not famous. Lear enquired anxiously of Hunt, "Is he disposed to lord it over others?" Hunt admitted that he had a knack of making others carry his parcels. "Oh, but I won't carry his!" Lear said. "Yes you will," Hunt replied. "you won't be able to refuse."
Hunt's record continued,

When the visitor arrived good comradeship was quickly established. The next day was perfect for a good walk, and we started early to reach Winchelsea and Rye, and take our chance for luncheon at the Inn. We descended to the beach by Fairlight Cliffs, and had not walked far when we came upon cuttlefish bones lying about, clean and unbroken. Millais when he had picked up a few, declared that he would take them home. The argument that they could be bought at any chemist's in London availed nothing, neither did the remark that with our system of painting they were scarcely wanted. Millais said he had never before seen such good ones, and that a painter never knew when he might find them essential, so he filled a large handkerchief with the spoil. At the end of ten minutes he came up to me and coaxingly said, "I say, carry these for me now, like a good fellow, do." Lear was already exploding with laughter, while I said, "I am not going to spoil you. I will put them down here; no one will take them, and you can get them on our return, or carry them yourself, my dear boy." ... "You carry it for me, King Lear," Millais said. At which that monarch of merriment,

doubled up with laughter, declared that he would take the bundle, which he did with such enjoyment that he was incapable of walking sedately while the memory of my prophecy was upon him. "He doesn't carry his own cuttlefish" passed into a proverb among us.[43]

William Michael Rossetti was a less alarming guest. He helped Lear with reading the proofs of his *Journals of a Landscape Painter in Southern Calabria*, now almost ready for publication. "Get it and recommend it astuciously to heapes of Dukes and Dsses," Lear wrote to Fortescue.[44]

By the end of the summer "The Quarries of Syracuse" was well advanced. "Daddy" Hunt returned to London, relieved to be with lads of his own age. He confided to Frederick George Stephens, one of the Brethren, "Lear is a very nice fellow but much too old to live with always I am obliged to humour [him]". His opinion of Lear's painting was equally unflattering: "I am letting him see me paint, which from his productions I confess myself unable to feel is a very great advantage."[45] Lear, on the other hand, looked back with unmixed pleasure on the stay with Hunt. The weather had, in fact, been poor, so poor that Hunt had been obliged to stay on until 24 November in order to accumulate enough fine days to finish his sheep picture. (His patron had insisted on a "sunlit quality" for the painting.) Lear made no mention of the bad weather, although he had grumbled about it incessantly the previous summer in Devonshire and would grumble about it the following summer at Windsor. To him, Hunt's company was sunshine enough. Furthermore, unlike Hunt, he was convinced that he had benefited greatly from Hunt's example. His "Thermopylae" was hung in the British Institution in 1853 and sold for a good price.[46] Its bright colours were strongly Pre-Raphaelite. "It is all the result of Holman Hunt's teaching," he declared proudly to William Michael Rossetti. Without it "Mount Oeta would probably have been done in black and white, the sky and sea grimy grey and all the rest umber."[47]

Hunt was certainly influenced by Lear and admitted it. "I am indebted to you," he wrote, "for the amount of culture

that I have got since the first time I met you."[48] As a compliment to Lear he painted a rolled-up copy of Lear's song, "Tears, Idle Tears" into the bottom corner of "The Awakening Conscience". A girl, seated on her seducer's lap at the piano, leaps to her feet. The song she has been singing (Thomas Moore's "Oft in the Stilly Night") has reminded her of her lost innocence, and her great eyes fill with tears. A moral enough theme, one might suppose, but when Lear saw the original sketch in January 1853, he strongly advised Hunt against going ahead with the picture. To the Victorians, the elaborate boudoir was instantly recognizable as that of a kept woman or even a prostitute. With typical thoroughness, Hunt had actually gone to St John's Wood and hired a room in a *maison de convenance*. Lear wrote to him, "I think with you that it *is* an artificial lie that a woman should so suffer and lose all, while he who led her [to] do so encounters no share of evil from his acts."[49] Nevertheless, he also knew that such a picture would not sell. As a result of Lear's warnings Hunt ceased work on the picture for six months. Eventually Thomas Fairbairn, who was also a patron of Lear's, sponsored it, although he paid Hunt no advance. When the picture was finally exhibited it was, as predicted by Lear, attacked for its sensational subject while its spiritual message was left unread.

It seems almost certain, too, that Lear's talk of foreign parts inspired Hunt to travel. In 1854 he set out for the Dead Sea to paint "The Scapegoat", a shaggy billy portrayed starving to death in the desert. True to his principles, he engaged a local goat as a model, which was carried, protesting loudly, to the lake shore. The bleating of the goat attracted armed robbers and Hunt was obliged to sit at his easel with a rifle under his arm. He rather enjoyed doing this. In contrast to Lear, Hunt liked guns, and was surprised that Lear would "rather be killed than fire a pistol". How, he enquired, could "a man of nearly six foot, with shoulders in width equal to those of Odysseus . . . be so beset with fears?" Lear feared almost everything a traveller was likely to meet: "Horses he regarded as savage griffins, revolutionists . . . as demons and customs officers were of the army of Beelzebub."[50]

Lear stayed on in Sussex for the winter because the ceiling

at 17 Stratford Place had fallen in. Luckily he had a friend in Hastings, Frederick North, the local M P, who had a fig tree in his garden and two charming daughters. Lear needed a fig tree for his "Syracuse" and he moved in with North's gardener. He brought a stuffed jackdaw with him, and wired it into the branches, being careful not to let Daddy Hunt know. When the winter day ended he would stride unbidden through the French windows of the Norths' house and sit at the piano. There the daughters of the house, Catherine and Marianne (who was to travel the world as a distinguished botanical artist), often joined him. "He would sing Tennyson's songs for hours," Marianne recalled, "composing as he went on, and picking out the accompaniments by ear, putting the greatest expression and passion into the most sentimental words."[51] The constant company of two cultivated women made Lear's thoughts turn, briefly, to marriage. "I *don't* mean to marry," he told Fortescue. "The thought of annual infants would drive me wild. If I attain to 65 and have ... lots of spoons etc to offer, I may chain myself."

In the 1850s Lear reached the apex of his life as a painter. His large oils were fetching good prices. The "Syracuse" was awarded the Art Union Prize and sold for two hundred and fifty guineas. A year later he told Fortescue that he had sold a picture to Richard Bethell. "My large Parnassus is bought by the new Solicitor General – my old and kind friend, Mr Bethell (Sir Richard to be shortly). It will be capitally placed and well seen – a future which compensates for my not having got so much for it as I axd."[52] Bethell became Lord Westbury, and his daughter, Gussie, was in due course to play an important part in Lear's life. With the money from this and other sales, added to the profits from his new book, *Journals of a Landscape Painter in Southern Calabria* (1852), he risked taking a year's lease on prestigious premises at 65 Oxford Terrace near Hyde Park. He also distributed funds to his sisters. The redoubtable Sarah, aged sixty, was in the process of emigrating to New Zealand with her children and grandchildren. (Sarah was the only one of his sisters to have children.) "Like a nass", he became excited about the move and spent time he could ill afford advising Sarah on mosquito nets. Money also went to Mary "who is horridly poor and married to

a brute of a husband, and Harriet, who was dying and needed port wine".[53] Always in Lear's life there was this background of near destitution.

That summer there were many visits to grand country houses. Lear described one to Knowsley to Fortescue. "The Premier was very merry," he declared. Lear's conversation at Knowsley had in fact mostly been with young Lord Stanley, the Premier's son, who took him on a ten-mile walk round the park. It was to this "rising statesman" that Lear proposed two revolutionary suggestions for the benefit of mankind: cremation and daylight saving. Stanley considered the former would make an abominable stink and the latter he received with "a shout of laughter".[54] Nevertheless, Lear came home with an order from the earl for an eight-foot "Windsor Castle" to partner the late earl's "Acropolis".

Painting Windsor Castle proved a dismal occupation. After a week in the rain at the Prince Albert Tavern, Lear wrote to Hunt, "the sky is always beastly blue black (I have sent for no end of tubes of that ingredient) . . . the distance also is blue, grey and black . . . and the castle . . . has been for two days jet black – two more scumbled grey . . . and the remaining two days utterly invisible".[55] At the dinner-table of John Wynne (an Oxford contemporary of Fortescue's) he fulminated against the climate, declaring that if Dante came back he'd surely include the English climate in his Inferno. "At this profane exuberance I thought I saw a haunch of mutton shudder . . . judge then what the human beings did!"[56]

By the autumn of 1853 Lear was dreaming of the "palms and temples of the south". He was then staying in Leicestershire, seeking, amid dripping oaks and slippery rocks, for a foreground for his "Temple at Bassae". "Oh to be in Arcadia once more along with the temple." He wrote to Emily Tennyson,

I am turning over some mode of leaving this loathsome climate and getting a living for the remainder of my life, even if as a shoeblack, so I could see the sun Stay here I won't, to be demoralized by years of mud and fog and gnats and rheumatism and small beer and stupid boors and coalfires . . . and midnight atmospheres all the year

round. I have had enough of it, and forthwith I am grow-
ing moustachios in sign of going elsewhere.[57]

Then he became ill, so that he was obliged to leave England
at once, without even waiting for Holman Hunt, who was
planning to travel to Jerusalem with him. "You will be sorry
to learn that my lungs and throat are ... much worse," he
told Emily Tennyson. "I wish I could see you, but I shall
wait to see my friends with comfort in Heaven."[58] On 6
December 1853 he boarded the S.S. *Indus* for Alexandria.

Lear's mood was once more one of euphoria, as he sailed
out of the English winter. "Perfectly wonderful",[59] he de-
clared, the sea "so smooth ... with bright moonlight nights,
music etc". Even Malta was included in his praise. "Glad
... to see old Malta again, though most friends are gone."[60]
Harry Lushington was in England for Christmas. Lear
planned to take a boat up the Nile and being without a com-
panion, settled for a Cook's tour. He hated it. Among that
flock of English tourists he found not one who was either
"intellectual" or "amiable". He felt lonelier than he had in
the wildest parts of Albania. One place, and one place only,
delighted him and that was the island of Philae, laden with
temples, floating above the first cataract, where the Nile
divided into many channels. Lear was not alone in admiring
the lovely island. The intrepid Amelia Edwards, who des-
cribed it twenty years later in her gigantic book on the Nile,[61]
declared that Philae was one of the three best things she saw
in all her thousand-mile journey. She recommended
approaching it by water. "Seen from the level of a small boat,
the island, with its palms, its colonnades, its pylons, seems
to rise out of the river like a mirage."[62] The desert and the
Aswan mountains made a perfect foil for it. "Every sketcher,"
she declared, "sketches it." Lear told Ann, "The great Temple
of Isis, on the terrace of which I am now writing, is so
extremely wonderful that no words can give the least idea
of it." The rest of the party travelled on into Nubia but he
remained at Philae. Cooks organized a dinner-party every
night in the ruins of the temple, as fresh boatloads of tourists
arrived. Lear continued to paint Philae for the rest of his life,
making in total twenty important oils of it. It was well that

he made records of it, for it was flooded by the building of the Aswan dam and now lies beneath Lake Nasser. The temples have been removed to a new island, Agilquyyah. The boat from Alexandria once more deposited Lear at Malta. There was no Frank there this time, but Harry and Louise invited him to stay at their villa for three days. Harry was pale and worn, although, as Venables was to point out, he "retained all his life . . . his beautiful countenance".[63] Lear returned to England to find Frank deeply roused by the British plan to invade the Crimea, that rather improbable piece of Russia that dangles into the Black Sea. He wrote a patriotic poem about it, entitled "The Muster of the Guards", published with three others in a Macmillan Shilling Pamphlet, *Points of War*, 1854. It commenced: " 'Tis the Grenadier Guards a going marching to the war, Mid the tears of wives and mothers and the prayers of many others," and concluded, "Cheer boys, cheer, 'till you crack a thousand throats."

The *Christian Monitor* thought it "striking" and even Tennyson liked it. It may have given him the idea for "The Charge of the Light Brigade".[64] In the midst of these world events a private tragedy occurred. Louisa died. Three months after Lear left Malta she became ill and Dr Galland, Harry's French physician, recommended a holiday in the Pyrenees. By chance Lear and Frank had been planning a walking tour there together. Now, instead, Frank went with his sister Ellen to join Louisa. By the time they met her at Marseilles she was much worse. They tried to get her to England but at Avignon "the dear child" died in Frank's arms. Lear consoled himself by walking in the Swiss Alps with Bernard Senior.

In spite of Louisa's death, Frank's obsession with the war increased, and when Harry returned home on leave in early September 1854, he added fuel to the flames. The three great battles of the Crimean War were fought that autumn. Frank covered Alma, and Harry, Inkerman (leaving Balaklava for Tennyson). Their poems were jointly published in another Macmillan Shilling Pamphlet, under the title, *Two Battle Pieces* (1855). "Alma" displayed a deep ferocity in Frank's character:

Charge! thro' sheets of leaden hail! though the bellow of
doom –

Charge! up to the belching muzzles – Charge! drive the bayonet home.

Just as Harry was about to return to Malta in 1855 Frank was offered the post of judge at the Supreme Court of the Ionian Islands in Corfu. Lear had encouraged him to apply for this post in order to get him out from under the shadow of Park House. For a time there seemed little hope of his obtaining it. When Lear asked Fortescue to use his influence, as an MP, on Frank's behalf, Fortescue explained that while he appreciated Lushington's knowledge of modern Greek, the appointment would probably go to a member of the Scottish bar, since Corfu civil law resembled that of Scotland.[65] Typically, when Frank was offered the post he hesitated about taking it. Finally Venables informed him that it was about to be offered elsewhere and he accepted. With Lear's separation from Frank in sight, the Park House set could safely draw him in for the first time. Lear was invited to join in all Frank's farewell ceremonies in May, including a final dinner-party at Venables's club. All three of them travelled down to Boxley together. Lear now discovered that Eddy had been struck by a mysterious illness. Lear supported him for short strolls round the garden, and also formed part of a *troika* of "uncles" which pulled Eddy's bath chair all the way to the abbey and back. He even ingratiated himself with the boy's mother, the difficult Cecilia, by giving her an album of thirty-five of his assorted drawings, inscribed "Cecilia Lushington from Mr Lear. May 25th 1855". (This album is now at the Houghton Library.)

Everybody accompanied Frank to Dover on 21 May. The day afterwards Venables was "utterly prostrated with grief".[66] But Frank, as usual, kept up his spirits "wonderfully", and Lear, the seasoned traveller, though lamenting, was busy calculating how long the journey to Corfu would take. Little did he guess how brief would be Frank's absence.

15

Harry 1855

Harry had been suffering for some time from a sinister swelling near the spine, but Dr Galland considered there was no immediate cause for concern although his patient was becoming very lethargic. "In Malta," Harry declared, "to get up from your chair... is... as great an effort of will as to walk half of a mile in England."[1] Even his impassioned speeches to the council were now delivered in slow motion. With Louisa gone, he was not sure that there was a reason for existence, although Frank's "transitory visit" had been a "great blessing".[2] Meanwhile the war was putting a heavy administrative and emotional burden on him. Many of the ships for the Crimea picked up supplies at Valletta. (One of his jobs was to requisition mules on the island.) And his thoughts were always over there with the common soldier. As he slowly roasted in Malta, he imagined the snows of Sebastopol, and composed "The Road to the Trenches", his most successful poem.

> Here, or there? the drifts are deep:
> Have we passed him? No!
> Look, a little growing heap,
> Snow above the snow,
> Where heavy on his heavy sleep
> Down fell the snow.

The poem appeared in another joint collection with Frank: *La Nation Boutiquière* (a nation of shopkeepers).[3] The title poem by Harry argued at length against a commercially convenient treaty with the Russians. Venables, to his eternal

regret, told him he did not think much of it. Frank only contributed his five earlier poems.

On 1 July the awful news broke. Harry was desperately ill and coming home with Dr Galland and his sister Maria. They had reached Lyons. At first the Lushingtons do not appear to have taken the news too seriously, although both Lear and Venables hurried down to Eastbourne to be with them on their summer holiday. Venables, as usual, rode by the marshes with Emily in the morning and walked with Ellen on the cliffs in the afternoon. In the evening Lear talked of the war, so helping, Venables confessed, to relieve the silence which was the Lushingtons' invariable reaction to disaster. When Lear followed them to Park House he found himself less welcome – by Venables at least. Venables confided to his journal, "In the evening, while the others were out and I was in the schoolroom with the children, I heard that Lear was here, and to my great disgust he is settled here."

While Lear was at Park House a frantically agitated letter arrived from Maria. Harry was approaching Arles and "in great danger". Venables knew he must go to him at once, although he dreaded the "effects of novelty" upon his system.[4] On 15 July he took the boat to Boulogne and reached Arles two days later. One look at Harry showed him there was no hope. He was weak and gaunt and he had almost ceased to eat. "How we are to get over this journey I do not know."[5] On a bookstall in Lyons Venables found a tattered copy of Horace's *Odes* and took it back to the hotel to read to Harry. Where parts of a line were missing Harry could still supply them. As they passed through Avignon by train Harry pointed silently to the Protestant cemetery where Louisa was buried.

By the time they reached Paris it was clear that Harry could go no further. His symptoms became hourly more alarming. Venables was now Harry's chief nurse. Monckton Milnes, who happened to be in Paris, found the sight affecting. "Poor Venables is there," he wrote, "tending him like a lover, and carrying him about in his arms."[6] Edmund and Emily were summoned from Park House (but not Ellen as the scene might be too affecting for her). When they were assembled Edmund was delegated to go into Harry's room and tell him he was

going to die. The time for his last words had come. Harry seemed "surprised and very unwilling to believe it".[7] The family went into his room by turns. The parting with Venables was particularly moving. "No man ever had such a friend and we kissed each other several times." Harry died the next day. "He looked troubled until the final trance fell on him. A painful spectacle if it had been a stranger, instead of the one dearest to me in the world.... It is the loss of half myself." Frank arrived from Corfu the next day. "Dreadfully distressed," Venables commented. "But even he does not love as I do."[8]

Harry, having negotiated the customs with some difficulty, was buried in Boxley churchyard. The huge flat stone that covers the Lushington family vault was raised with crowbars, and his coffin was placed on one of the shelves. Venables held Emily, "greatly agitated", in his arms. Lear gave Frank what comfort he could. Venables now pressed ahead with his wooing of Emily. Back at Eastbourne, where the family resumed their interrupted holiday, Emily became "very confidential", but Venables "said nothing definite".[9] Meanwhile Lear continued his pursuit of Frank, who was "lower than I ever saw him".[10] His grief at Harry's death had been violent at first. Now it settled into a deep immovable sadness. He was far from well himself, eating little and coughing much. Lear was invited back to Park House. Should Frank, or should he not, return to Corfu? Lear took a firm stand. Frank *should* go, on account of the mild climate. "Fogs and East Winds," he told Emily Tennyson, "together with the peculiarly sad yet harassing life at Park House, would do him... widening injury."[11] There were other reasons why Frank should go abroad. "There will be far more chance of him marrying if abroad," Lear wrote, "than if he were the mere younger brother whose prospects are more or less postponed to household affections."[12]

Lear now offered to go with Frank to Corfu. Venables was violently opposed to the plan. Frank should take a post in England. The three sisters sided with Venables. Lear found himself a member of one of the most lugubrious house parties ever held at Park House, and there had been a few. "Confined and uncomfortable", was how Venables described such par-

ties.[13] During the day Venables took the ladies round the park in turn. Lear went for walks in the other direction with Frank. In the evenings the family sat and stared at the darkening view from the bow window. A Park House silence was as no other silence. Venables had suffered a series of these a year earlier when a decision was being taken about Harry's return to Malta, and had noted some in his diary:

"Evening of dead silence."

"Evening again without a word."

"Evening almost more intolerable and despairing than any I remember."[14]

At one stage Lear all but bolted, but Emily Tennyson restrained him by letter. She assured him that the Lushingtons must long to "break through their reserve for the sake of one who has shared so much with them". "They do understand you," she added, "though the gift of utterance is, except on rare occasions, denied them."[15] In the end Frank decided to return to Corfu accompanied by Lear.

This decision naturally increased Venables' vindictiveness and, back in London, his treatment of Lear amounted to the scandalous. According to Lear, he circulated the story that "my going there is to benefit myself by Frank's position and increased income".[16] Lear did his best to placate Venables and even invited him to dinner, but the occasion, according to Venables, was "not . . . wholly pleasant".[17] Lear was not the only friend that Venables lost through Harry's death. Just as his determined courtship of Frank Lushington offended Lear so his false wooing of Emily Lushington (for he had no intention of marrying her) offended the barrister, Benjamin Chapman, one of his oldest friends. Chapman had hoped to marry Emily. "That true-hearted, gauche Chapman [is] unable to bear up after the loss of Harry following the great loss of Emily Lushington," a friend wrote to Monckton Milnes.[18]

Lear now went to Ireland to pour out his heart to Fortescue. "He spoke to me more of himself and his secret feelings than he has ever done," Fortescue wrote. He "showed me a good deal of his . . . self-tormenting sensitiveness".[19] Fortescue obviously referred to Lear's feelings for Frank. Lear and Frank

now planned a farewell weekend with the Tennysons at Farr-
ingford, but as the time approached it looked as if Frank
might not be able to come. "I have never seen Frank in such
deep distress," Venables wrote in his diary on 21 September
1855. Nor was Emily Tennyson entirely looking forward to
the visit. She wrote to Lear, "Not only are you to be sofa
to my shyness and Frank's silence but you are to be yourself
wellest and freshest and happiest."[20] By now Lear was cough-
ing too. But the three-day visit proved a success.

Indeed, this probably ranked as one of Lear's happiest
country-house visits with Frank. Frank was always at ease
with Emily Tennyson, who regarded herself as one of the
"Frank Lushington Brotherhood" and was probably a little
in love with him. Farringford House was (and is) a place
of supreme beauty, set on the westernmost promontory of
the Isle of Wight. From the great semi-circular window of
the drawing-room could be seen a view of cedar-shaded lawns
and beyond them a sea of Mediterranean blue.[21] Indoors,
it was a typical Victorian home, filled with clutter. The walls
were painted in dark colours; pictures, including many Lear
water-colours, were hung as close as stamps in an album and
there was a scattering of white marble busts from the antique.
The drawing-room with the bow window was Emily's terri-
tory. In it were placed her little rosewood piano with the
embroidered panel, and the red velvet sofa where she spent
most of the day, screwing her book round to catch the light
from the window. "Ally's territory was his study upstairs,
facing the other way."

Lear outlined his first day at Farringford House in his thank-
you letter to his hostess. It started with an early breakfast
with three-year-old Hallam and eighteen-month-old Lionel,
accompanied by their nursemaid. Lionel was Frank's godson.
"Dear little boys," Lear said. "When they are gone, you and
Alfred and Frank begin to talk like Gods together, careless
of mankind."[22] Next, the poet walked round the farm with
Frank, who could advise him on practical matters. Frank
always regretted that he had not inherited the farms that went
with Park House since Edmund made such a mess of the
hop gardens. Lear, meanwhile, made a few sketches in the
garden, probably of the great cedar of Lebanon that still stands

outside the bow window. In the afternoon there was the walk up Head Down. At the top, the poet usually spent an hour in meditation. (The Tennyson Monument was erected at this point in 1892.) Ahead the downs descended like a roller-coaster to the detached chalk pillars known as the Needles. There was a short-cut home, straight down the side of the downs to a black door (now green). This door was surely the one at which Maud's lover waited while she danced the night away in the arms of her husband. To open it was to re-enter Tennyson's private paradise. After tea Lear sat with Hallam and made one of his alphabets for him. The letter H he chose to illustrate with a hat, but not the wide-brimmed Italian revolutionary affair worn by Papa to the scandalization of the island. (One local to another: "I'd rather walk twice round Freshwater than once round Tennyson's hat.") This was a topper, "so silky and fine and when it was brushed O! how it did shine!" The boys insisted it was Mr Lear's own hat. Some weeks later the alphabet was ironed on to the linen by the poet himself and Hallam declared it was "bootful".[23] All was "bootful" all day, even though Emily ruined dinner by forgetting to serve fish on a Friday. "Mr Lear's singing made us forget this, whatever else it brought to mind."[24] He sang for two or three hours, including the whole of "Mariana" (in the moated grange) and "The Lotos-Eaters". Then he rendered the lovely lyric,

O that 'twere possible, after long grief and pain
To be once more where I have been, in my love's arms again.

Through spectacles misted with emotion, Lear surely detected a tear on the cheek of the Judge.

On Saturday evening, company was invited. There was Sir John Simeon from neighbouring Swainston,[25] a cultured man who kept a Greek temple in his grounds. (It was he who was blackballed at the Travellers' Club.) Miss Cotton was there, the daughter of another landed neighbour, Benjamin T. Cotton. She was accompanied by a friend. The ladies were

no doubt intended as dinner-table partners for the two bach-
elors, but Emily had more serious plans for Miss Cotton.
She had decided that it was time that Lear married. When
he sang the words "O let the solid ground not fail beneath
my feet, before my life has found what some have found
so sweet," Emily felt that she was making progress. Tennyson
was certainly moved. The song came from "Maud", his newly
completed monodrama.[26] On the Monday morning all four
Tennysons breakfasted at six thirty to see Frank and Lear
depart. "When they were gone," wrote Emily, "we went
up to the attic and looked through the telescope and we
thought we saw a boat."[27] After that Emily set one of Frank's
Crimean poems to music. The happiness of the holiday
extended to the voyage home. Lear and Frank took the little
steamer to Lymington and, on that "golden morning", Lear
thought of the last boat trip to Patras seven years earlier.
"The three or four days 16 October – 20 October 1855 were
the best I have passed for many a long day," Lear told Emily.

There was an embarrassing letter waiting in London. It
came from Emily and it was about Miss Cotton. Neither
lady had evidently understood the irreversible nature of Lear's
bachelorhood. "I am afraid you will not believe me when
I tell you what a hero of romance you are. How Miss Cotton
was found all pale after a sleepless night, how her companion
came and poured into my ear a mighty river of thanks and
praises and admiration."[28] "Alack! for Miss Cotton!" Lear
replied at once, "and all admirers. But we all know about
the beautiful blue glass jar which was only a white one after
all, only there was blue water inside it." Could Lear have
said more clearly, "I am not what I seem."[29]

Happiness, as usual, brought on an attack of The Morbids.
Why, Lear asked Emily, could he not enjoy "any one thing
on earth while it was present – [without] always looking back
or... peering into the dim beyond!" Head Down had
brought back memories of Civitella, the hilltop village in
the Sabine Hills where he had stayed with Willi Marstrand
so many years ago. Suddenly he knew the line of Tennyson
that would perfectly illustrate sunrise behind the rock of Civi-
tella. It came from "A Dream of Fair Women" and it ran,
"Morn broadened on the borders of the dark".[30] Lear had

been planning a series of Tennyson illustrations for several years.[31] When, in 1854, an edition of the poems appeared illustrated by Hunt, Millais and Rossetti, he was undismayed. In *his* illustrations the human figure would not appear. Mountains and lakes would express what men could not. He outlined his plan in a letter. "I don't want to be a sort of pictorial Boswell, but to be able to reproduce certain lines of poetry in form and colour.... When the 300 drawings are done I shall sell them for £18,000, with which I shall buy a chocolate coloured carriage speckled with gold and disport myself about all the London parks."[32] For the next forty years he was to match the views in his sketch-books to lines from Tennyson.

A farewell visit to Park House was as unsuccessful as Lear had predicted it would be. Indeed, at first he had decided not to go, saying "Eastbourne days did me harm enough".[33] The Lushingtons were in deep gloom, as was to be expected, and Lear himself had fears about his Corfu venture with Frank. Ellen was considering whether or not to accompany Frank, and suffered until the last minute from the famous Lushington indecision. Lear was in favour of her going with him, for then Frank would have his own establishment and be properly cared for. After many changes of mind Ellen decided at the very last minute not to go. "The Miss Lushingtons have settled nothing, late," Lear declared,[34] and lapsed into a new senility fantasy, in which Emily Tennyson moved to Boxley. "I wish sometimes you could settle near Park House. Then I might have a room in Boxley, and moon cripply cripply about those hills, and sometimes see Hallam and Lionel's children and Frank's grandchildren, and so slide pleasantly out of life."

Before sailing he returned to Stratford Place for the last time. "Three chairs, a coalscuttle and a table are the prevailing furniture." The crates of pictures and furniture had already gone ahead and, after a sudden spell of bad weather, were probably at the bottom of the sea. "As for me, I have to look forward to a new beginning in life," he wrote, without obvious enthusiasm.[35] He boarded the Ostend steamer at

Dover on the eve of 21 November "Just as my dear Franklin Lushington came."[36] Back in his chambers, Venables knew that he had lost Frank for ever. "The estrangement," he wrote, "is complete."[37]

Corfu with Frank 1855–58

Though the Alpine passes were deep in snow, Lear and Frank travelled "on sofas", to use Lear's expression, in well-equipped railway carriages. Lear had provided himself with five cloaks and a fur cap (bought at the last moment at Dover). Frank was the perfect companion. "Nothing can be so kind and thoughtful as my dear friend all the way . . . buying cakes or bread and bringing them to me, and saving me all the trouble possible, although he, from being my mere travelling companion in 1848–49, has now risen to one of the highest places of the land."[1] But when they reached Corfu the honeymoon ended. George Bowen, now Government Secretary, could accommodate only one of them, and that naturally was the Judge. Lear had to set about house-hunting. Since Ellen had not come, he had assumed that he would share a house with Lushington, but Lushington had decided against it.

Finding somewhere to live in Corfu City was extremely difficult. All the best houses were taken by the families of officers serving in the Crimea, for Corfu, like Valletta, was a garrison town. On the Esplanade troops drilled constantly. Even Frank had to wait until rooms in fashionable Condi Terrace, near the Esplanade, were vacated. Lear, too, dreamed of rooms in Condi Terrace, but he had to make do with an unfurnished flat down by the harbour. The sea made a noise and so did the populace who paraded below his window every evening. The light reflected off the sea was too bright, and the walls were a hideous shade of yellow.

But Frank was the true source of Lear's dissatisfaction. He had gone off with Bowen. He rode and shot and sailed with

Bowen in the afternoons (which was Lear's time for a walk) and in the evenings he took part in unspeakable "vice-regal gaieties". The weather was awful. Finally, in despair, Lear sat down and wrote what he later called the "doldrums" letter to Ann, a letter of which he was afterwards bitterly ashamed:

I am out of spirits enough sometimes. It is better you should know this... than that I should sham and tell you I am happy. I suffered much from loneliness in Egypt, but then I had a never ending fund of novelty and excitement which kept distress at bay.... If Ellen Lushington had come out and they had had a home my days would have gone by in hopes of someone to speak to in the evenings, and some distant resemblance of better hopes might have been looked at even though I knew they were shadows and not real.[2]

By Christmas Lear was more depressed than he had ever been in his life. The perpetual rain didn't help. "It seemed to come down almost in one solid mass."[3] There was nowhere to walk, except the Esplanade in the centre of the city, and that was full of soldiers. There was nowhere to dine except the "disgusting" mess of the Sutherland regiment, and nothing to do afterwards except sleep as soon as possible. In fact, he declared, "I hardly know what to do from sheer melancholy." He asked Ann to write once a week instead of once a fortnight, which he had not done since things were bad in Rome. Added to this was the knowledge that he was driving Frank away by his ill-temper. On one occasion, when Frank and Bowen came to his flat, he was "in an ill humour about a foolish misunderstanding which I now repent of".[4] Frank placated him by taking him to the opera, but he didn't like the bright lights. The gift of Frank's gold watch was more acceptable. The silver chain on it had been Harry's.[5]

The arrival of spring lifted Lear's spirits. His moods, like those of his landscapes, were powerfully affected by the weather, and during the first year in Corfu the influence of sun, wind, rain and fog can be seen in rapid succession. "The flowers are now quite absurd... there are really too many. The last two days have brought out millions of Trumpet lilies stuck as thick as can be all over the fields – they look like

so many white paper scrolls!"[6]

A ride with Frank through these must have brought back memories of Arcadia. Lear understood Frank's problems. The Corfiotes were immensely litigious and a thousand cases came up a year. "Poor dear boy, such loads of work... and yet he bears up so well. You know it is the first winter he has ever been away from his family."[7] And of course Frank was right not to want to live with him. "It would not have done... for we are both nervous and fidgety... and one of us has not the best temper!"[8]

The time had come to explore the rest of the island. Three roads splayed from the city. One or two dusty miles of any one of these had to be endured until "you get into scenery".[9] Lear's favourite was the one to the south of the city, the

fashionable carriage parade which rejoined the coast at One Gun Battery (modern Kanoni). Off this road to the left, two miles from the city, was the hill of Ascension (now Analipsis), with the famed view of the city crowned by the citadel across the bay.[10] "Few prospects can be more truly exquisite than this... especially when the sun is sinking, and the lower olive-trees become dark in shadow, the citadel like a golden rock, and the farthest Albanian heights a world of rosy snow." Here at Ascension, amid "an immense crop of marigolds, geraniums, orchises, irises... and the pale lilac asphodels",[11] Lear planted his easel, resolving to send off to England for an eight-foot canvas to put on it.

Lear was to paint the view from Ascension at least fifteen times,[12] and he would continue to execute studio water-colours of it almost until the day of his death. It was to become

one of his sacred places. At Ascension he began his lifelong love affair with olive trees, "my quiet olive groves".[13] He had always drawn trees well, but the gnarled and twisted trunks of the untamed Corfiote olive suited his style of draughtsmanship to perfection. Countless pencil studies of olives reminiscent of Arthur Rackham have survived.[14] But other beauties also bloomed at Ascension. "There are two *awful* sisters here," he informed Holman Hunt. "English but brought up here, and so simple and good, and so full of poetry... and all the nettings whereby men are netted." He added, "I call the house Castle Dangerous."[15] Lear referred to the Cortazzi sisters, who lived with their parents in a spacious villa. (Ascension was a fashionable residential area. Sir John Young and Lady Young spent the summer there in the High Commissioner's villa of "Mon Repos".) Mrs Cortazzi was a Hornby and their father was Italian. Lear favoured Helena who knew most of Tennyson by heart. "The older is my alarm... I begin to feel I must either run for it, or rush into extremes." By "extremes" Lear referred to the possibility of marriage. "Sometimes at 43 I cannot help believing that a half and half life will get too wearisome to bear e'er long."[16] To Ann he confided, "if only one could unmarry again if it didn't suit."[17]

Lear was swiftly becoming a celebrity in Corfu. Before spring was out Ann was instructed to address his letters simply, Edward Lear, Corfu.[18] "A burst of people" came to the studio. One day General Macintosh himself arrived with his ADC. The general "did not expressly buy anything. But he asked if I had any painting of Bassae! How I wished I had the unfortunate monster here!"[19] Sir John, the High Commissioner, told Fortescue "we have found him a most agreeable person... especially Lady Young, who has taken to sketching with great ardour". Lear had his doubts about "roaring" Lady Young, who had added the sight of him sketching to her "objects of interest" in the Corfu countryside. On one occasion when he was at Ascension, Milady and her suite, "galloping furiously on... 16 horses, came rushing through my quiet olive groves". Fortunately they were "soon off again for... our gracious sovereign seldom remains long in one place".[20] Nevertheless, Lady Young had

her uses. She invited him frequently to the Palace that still overlooks the Esplanade (now the cricket ground). At first, he went grumbling. He detested both dancing and cards and he disliked wearing tight evening dress.[21] Then they discovered he could sing. "Lear," Frank wrote to Emily Tennyson, "has now become the most admired musician in Corfu!"[22]

At the beginning of February, Lear was offered a job, the first and last of his life. It was the directorship of the new art department at the University of Corfu. A salary of £100 per annum plus free house and a four-month annual holiday was tempting, but he did not hesitate to decline it. He would remain independent, for all the risks.[23] Instead he bought one of the new "photographic machines", second-hand. "If I can come to use this mode of working," he told Ann, "it will be of great service to me." There are no examples of Lear's photographic work, so he presumably did not come to use the new "mode of working". No doubt the contraption with its twelve-inch glass plates proved too unwieldy to carry up to Ascension and it ended up in the Corfu auction room where it had been acquired.

In April, as the result of a chain reaction precipitated by the posting of the General, Lear moved into the end house of Condi Terrace. He was delighted by the views from his studio windows. "I open the wooden blinds of the west window and watch the very amusing groups of every sort of dress coming up from Fort Neuf."[24] He "moved in gradually, all the things being taken on men's heads". Extra furniture he obtained, like the camera, from an auction of an officer's effects. His talk was now of "tables and chairs, salt spoons, towels and sheets.... Excuse so much prattle," he said to Ann.[25]

Now that he had a suitable home, suitably furnished, he needed a suitable servant. At this point Giorgio Kokali entered his life. Lear sometime called him by his Greek name, "Yorky", sometimes by the English version, George, but finally settled on the Italian, Giorgio. If Frank was the unattainable mistress in Lear's life, Giorgio was to be the humdrum necessary wife. He was five years younger than Lear, being in his thirties. His brother, Spiro, was Frank's man. He was a flashing-eyed Suliote from Albania, a refugee from

the persecution of Ali Pasha; one of the tribe whose women had thrown themselves over a cliff to save their honour. Giorgio had worked seven years for General Congers, and had excellent references. He asked only £30 per annum.[26] Great was the rejoicing when Giorgio served his master with his first dinner, "A pilau of rice and mutton, the very best dish in the world, and a dish of Jerusalem artichokes, an omelette and pancakes... it is really a great thing to get ones meals hot and comfortable."[27] Within a fortnight the proud master had ventured upon a dinner-party, which culminated in nothing less than a bread-and-butter pudding! Yes, the "jewel" had learned to make his favourite dessert, the one, it seemed, that Lear used to serve at dinner-parties at Oxford Terrace. When Lear went to dinner at Frank's a few days later, what should he meet but bread-and-butter pudding? Giorgio had taught Spiro the recipe. Soon, no doubt, bread-and-butter pudding would spread around the city and even reach the Youngs at the Palace.

Lear now started a serious study of Greek (so that he would not be cheated in the market). He engaged a tutor who came in early every morning for an hour. He also gave Giorgio writing lessons. Seeing enough of Frank continued to be a problem. "The Midge" was the fly in the ointment. "The Midge" had been Harry's yacht in Malta and Frank had inherited her along with such land in Kent as Harry possessed. He spent every moment away from the law courts in the boat. She must have been a large craft, having accommodation for at least half a dozen passengers as well as crew. Lear tried to convince himself that he liked sailing. He accepted an Easter trip round the north of Corfu island. "It will be nice if *settled*," he told Ann. It wasn't. They had not reached the latitude of Monte San Salvatore (2,972 feet, now Mount Pantokrator), the highest mountain on the island, before he was complaining. "I do say all boats are hateful... screwy and bumpy and squashy and fidgety." Then Frank insisted on a tiresome visit to the almost barren island of Fano with the boat "all on one side". Returning from Fano to Paleokastritsa they were becalmed and there was no escape from

roll, roll, pitch, pitch, creaking, flapping and bumping till

I could have thrown myself overboard.... The nuisance of knocking one's head, and being in a cramped cabin is not repaid by any society in the world. I really believe the liking for yachts is merely a fashion, just as many women will bear the utmost pain in lacing to be in the mode.... At all events I think it is the last as well as the first yacht trip I shall ever have.[28]

Fortunately the rocky bay of Palaiokastritsa was extremely lovely. "The beauty and quiet of the place is delightful.... It is surrounded by great rox... and if this place were anywhere else it would be a watering place." Lear came back to draw it many times.[29]

In May Frank had to go to Malta to meet his brother Tom, who, with his wife and their four children, was on his way home from India. Fortunately several friends arrived in Corfu to keep Lear company. There was Charles Church (of the first Greek trip), now a prebendary, and Charles Street, the son of Lear's sister Sarah.[30] Charles was a nice enough young man, over from New Zealand on holiday, and Lear tried hard to regard him as a son rather than a nephew, but he was obliged, after this visit, to confess that he found him rather dull. Nevertheless the two men maintained a correspondence for the rest of Lear's life. According to Ann, Charles wrote dutiful letters but duller than his mother's.[31]

There was also little James Uwins of Roman days. Lear suggested they should share rooms, but Uwins was not the Uwins of yore. He had withdrawn behind a great grey beard, and, although he agreed to a cup of tea, he soon became a remote figure glimpsed only occasionally in the town. After six months he returned to Naples, having hardly spoken to a soul. "Odd and unsociable old tortoise," was Lear's comment, "hoary hermit". Uwins, presumably, had not married. Unfortunately four militia regiments were leaving for the Crimea at the same time, taking with them Lear's "five favourite wives".[32] Frank was back in time for Ascension Day on 6 June. Lear had been looking forward to this day for professional reasons. He had been assured that on that day the space that he had left in the foreground of his painting of Ascension would be filled with brilliantly costumed

dancers. (As it is today.) It wasn't. Indeed, the whole fête was a disaster, just "a bunch of Cockneys... no better than Greenwich fair". Fortunately the ladies at Castle Dangerous were always "at home" on Ascension Day. Frank and Lear called there after the fête. "By degrees our party broke up, except Frank and I who had a quiet end of the evening, tea and music with Mr and Mrs Cortazzi and their daughters. Never having been out of Corfu, it is the world to them, and I think they did not like our *not* being enraptured with the miserable Cockney Fair." The day was saved by an evening of intelligent conversation, a rare commodity on Corfu. It seemed wrong that Helena, "with her complete knowledge of Italian, French and Greek, her poetry and magnificent music... is not thought half as much of as that large Miss 'A. Z.', who can only talk English and dance polkas".[33] Lear liked intelligent women.

The weather was now "seriously warm" and umbrellas were being used for their original purpose. "I delight in the heat and would it were never less," Lear assured Ann. It was time to move into the country for the summer. With a servant like Giorgio, presumably accustomed to campaigning with his former employer, there was no need for delay. The dust of "Cockney-stupid Corfu" could be shaken from his feet at once. He set out for a little known village on the far side of Monte San Salvatore. He never gave its name (because it was so complicated), referring always to it as "Hocus Pocus". We only know that it overlooked "my old friends the Khimariote Mountains, those mountains in Northern Albania, where lived the sad-eyed Fontina, for ever separated from her lover.[34] Here Count Voulgari had lent Lear a semi-abandoned country home, and here Giorgio set about arranging Lear's camping furniture, bought at auction. "I never made a better purchase... than... the take-to-pieces table," he told Ann.[35] There was also a take-to-pieces bed. "I rise very early... and after coffee go out from 5... to 8.... Then I return and open out or arrange my drawings – write Greek etc... 'till 12, when I dine; mostly on fowls ...not to speak of a whole bottle of country wine.... Then I read and then sleep, 'till it is time either to work or to explore some new part of the island." At sunset there was

"the eternal omelette", and a second bottle of wine.[36]

Then the small animals started. It was Giorgio who produced them. Lear had given Frank a hedgehog, to hoover up his black beetles, before they left. Now Giorgio imagined "a Zoological Collection to be part of my will. So at Hocus Pocus I found one day three tortoises, another day a young fox, a jay, a nightingale, all of which I had to deny myself the pleasure of accepting." In its proper place Lear delighted in the wild life of Corfu, particularly the little pea-green tree frogs, the yellow orioles and the blue rollers. Best of all were the fireflies. "They are here by millions now. The whole land is . . . lit with myriads of tiny lamps."[37]

Frank came to spend a night with Lear in camp, a considerable sacrifice, since the journey each way took two days. From Hocus Pocus Lear moved to still remoter valleys, and finally to the Monastery at Niffess where "Cypresses stand up like columns against the evening sky". Here at last was a landscape that could compare with Italy. And, what was more, there was a festa that knocked the wretched Ascension affair into a cocked hat. Eighty-four women "danced . . . three steps on and two back as gravely as if it were at a funeral". They were "loaded with finery . . . purple silks, striped skirts, orange striped aprons, crimson velvet vests". Ahead of them choregoi jumped "as far [and] as high as they pleased", for three hours on end, just like the urchins before the marching troops in Corfu. "There, Ma'am," said Lear to Ann. "Don't say I never recommend you a quiet, neat dress. If you wear one such as these, I would advise you to walk on the Parade at Brighton once or twice, when I am certain it would have a very pleasing effect."[38]

A return to the hot city inevitably meant a return of the blues. Almost at once there was a disagreement with Frank about the dinner hours. Lear preferred to eat at one, like the natives, "an infinitely more rational mode of spending the day than that of the English here who persist in coming in to eat at the only tolerable hours of the day in Summer, viz, 5 to 7".[39] Frank, because of his work, was obliged to dine in the evening. Lear persuaded several of his favourite officers' wives to switch to a main meal in the middle of the day. Then there was the business of Frank's hedgehog. Lear

explained it to Ann. "All unexpectedly, Mrs Hedgehog has produced *four* small hedgehogs, for all the world like little hairbrushes. Now, I maintain, I only presented [Frank with] *one* beast, and that these four are consequently *mine*, and very possibly the Judge and I should have gone to law about the case, only the four little brutes have considerately died one and all."[40]

Suddenly the heat became unbearable, and he who had boasted that there was no heat too hot for him repented of his statement. A steamy humidity made exertion intolerable. "The weather has scandalized me very much," Lear declared.[41] He could no longer manage even the daily walk to Ascension, and instead rented an empty farm cottage there and furnished it with a couple of cart loads of *roba*. Then the north wind started, which on Corfu can blow like a hot hair-drier, all through July. At first he was glad because it blew away the "malarial miasma" from the Khalikopoulos Lagoon which lies behind Ascension, but it made work out of doors impossible, sending his papers to the four corners of the earth. There was no escape even indoors. Finally, he concluded, "I would rather have 555,000 fevers . . . than the noise all the blinds and all the doors are making." The big canvas still had not arrived from England. It had been sent by sail, not steam. Filling the smaller one was chore enough. "Strange," he mused, "that what to me is always painful and disagreeable work, painting, should in a couple of months, create a work which not only gives pleasure to its possessor at present but may continue to do so to hundreds of others for a century or more." He thought of William Nevill's wife, who was near death. He hoped William had moved the "Philae" he had bought to the end of her bed so that she could enjoy "the palms and temples" for the last time. (This was the twin to a "Civitella" the Nevills had bought.) At night he watched a pair of baby owls tied to a post in the farmyard outside the cottage. "The paternal and maternal owls bring them mice and worms in the prettiest way possible. I am sure nobody ever gave *me* mice and worms, as poor Mrs Warner would have said."[42] Frank was at his least obliging on Sunday 14 July. Lear took him a small "Philae", but received little attention because it was not the walking season. Nor was it the

talking season, for Frank now devoted Sunday to writing letters home. "The little Edmund," Lear remarked rather unsympathetically, "grows worse." He referred to Eddy. When Frank decided to sail to Albania with some friends, no doubt with the intention of shooting something, Lear took a snap decision and said he would go too. He planned to continue across the country to Salonica and then, at last, to visit "long destined Mount Athos".

Lear had long been fascinated by the earth-spurning monasteries of Mount Athos. Now he was to spend two months among them and see all twenty of the major ones, as well as many of the seven hundred smaller communities and hermitages. This, he claimed, would be a unique achievement. It is true that Sir George Bowen had published what was described as a "full account of Mount Athos and its romantic community" a year earlier,[43] but few visitors had attempted the perilous paths that Lear proposed to take. Unfortunately he published no account of his amazing journey, though he kept an elaborate diary, which he had intended to publish. He did, however, write a long letter to Ann, a copy of which fills nine sheets of foolscap.[44]

Mount Athos occupies an eighty-mile-long peninsula southeast of Salonica. The Holy Mountain itself, ringed with forests, rises at the end of the peninsula, but monasteries cling to precipices along both coasts. Below them the sea "rages always". Lear and Giorgio entered by the wooden gates at the northern end. Through these must pass no female creature, neither nanny-goat nor hen nor even she-cat. An abbot confided to Lear the problem of keeping down the population of mice without them. "I have sent over to Imbros and Lemnos for 20 score," he said. "Fancy 400 Tom Cats in a boat!" Lear declared. (One day there would be only one Pussy-Cat and its companion would be an Owl.) The rule was that all tours of Athos commenced at the capital monastery, Kariess, inconveniently placed half-way down the peninsula. At Kariess sat the grand synod of monks from all Athos, whose duty it was to inspect Lear and Giorgio and issue them with a pass. Lear, as usual, was well prepared with letters of introduction. "Next morning the synod of 20 were assembled and I am put at the end of the table while my letters were

read."[45] A "circular" was then duly provided along with the usual offering of ouzo and Turkish delight.

The layout of the monastery at Kariess was typical of all those "astounding places.... They resemble a village in a box. High walls surround all. Nearly all have a great tower at one end. All have a courtyard more or less large, and this court contains... sometimes two or three churches, a clock tower, a refectory, fountains etc. Round three or four sides of the court are the cells, galleries above galleries of honey-comb arches." The "strangers' room" often looked out over the best view of the mountains. But Lear had caught the unmistakable odour of fever at Kariess. Giorgio had, alas, caught more than the odour, and, "foolish fellow", said nothing until they reached Philotheo, the fourth of a string of monasteries descending the east coast of the peninsula. He was suddenly very ill. "The medicines I gave took no effect because not applied early enough... the fever increased and I dared not give quinine as yet.... The return to Kariess would be madness... all the adjacent convents were... impossible, but 7 hours off was Lavra, the largest of all the monasteries... where I had very particular letters to Melchi-sedek." So far Lear and Giorgio had been travelling on foot, but now he resolved to get a mule at another small monastery, Karacallas, ride to Lavra at the southern tip of the peninsula, obtain three more mules, and return for Giorgio. The monks at Karacallas, however, were "more like dead men than any I have yet seen, and they would not take my letter to the abbot because he was asleep". There was nothing for it but to walk to Lavra. "Oh, how terribly alone I felt," Lear told Ann. "The word *alone* in Mount Athos has a far deeper mean-ing than anywhere else... even if one should meet with a *Caloyer* [hermit] I knew well he would only... say 'how should I know?' to whatever questions I asked him."[46]

Lear's stamina was astonishing, considering that he had fallen down a flight of sixteen steps while still with Lush-ington's party in Albania. ("No, I didn't injure my head," he told Ann, "the other end.") He had been unable to walk for four days. Eventually the mules were obtained and taken back to Philotheo, and Giorgio was loaded on to one. During the journey to Lavra he was held in the saddle with the greatest

difficulty, being delirious most of the time. When he was eventually on a bed at Lavra, Lear decided the end was near. He wrote to Lushington to tell him to warn Giorgio's brother. He also bled Giorgio and gave him "physic enough for 6". The fever dropped, but total prostration continued. Lear prepared himself for one of those long stays that are so often imposed on travellers where they would least have chosen. "I could not have left a good servant (or indeed any servant) alone in such a place," he told Ann. True, the Great Lavra was magnificent, the earliest of the monasteries, founded by St Athanasios in 963. It was famous for its great corridor of cells and its courtyard filled with fragrant orange and lemon trees. Less fragrant was Abbot Melchisedek. The "dear old man" smelt like a goat and taking meals with him was a doubtful pleasure. Furthermore "the table cloth... was not less than a quarter of an inch thick in ancient dirt". Occupations were in short supply. Lear, of course, drew Lavra from every possible angle. Otherwise he watched the tom cats in the galleries that led to the cells and smoked five pipes a day, well above his average.

One day he made an excursion to St Nilo, traversing the perilous shale below the peak of Mount Athos. St Nilo, he declared, was "the saddest spot I ever beheld!" Two old men lived there, neither more than half-witted. They said only, "'Are you a Christian', hundreds of times over." (In the early 1950s Sydney Loch, a Scottish traveller, found two old men *still* living there though, presumably, not the same two.[47]) Mount Athos, like English folk-song, seems to have the curious ability to be always dying but never dead.

Great was Lear's relief when Giorgio was well enough to travel to St Paul's, a Corfiote foundation, which was sure to be friendly. The descent to St Paul's, round the tip of the peninsula, was "frightful", especially for Giorgio. Fortunately the mules of Athos, unlike their masters, were "lambs in temper, cats in ability", and proceeded downhill in a series of leaps. "They put all their four feet together and *slither* down large bits of stone 10 or 20 feet long – stopping just in time to jump neatly to the next. In particularly dangerous places, they stop and scratch their noses with one hoof." They did this on one of the paths to St Paul's. It was as high as Beachy

Head above the sea and consisted merely of "projecting bits of rock two or three feet wide.... In one place there is a... space... and you step literally *over* the sea. Here I observe the mules like particularly to scratch themselves."

While on Athos Lear was surprised to see a mule being made, surely a rare process, since it presumably involved a female horse. (Mules are neuter and are the progeny of a jack ass and a mare.) Perhaps the *Pantokrator* (Almighty) was looking the other way. Mule-making (often fruitless) was a common enough sight in most Mediterranean countries. Like everybody else, Lear regarded it as a form of entertainment. On Cephalonia he referred, to "an attempt at Mule-making, a Gentleman and ten men ass-isting".[48] On Crete, his way also was enlivened by mule-making. As on Cephalonia, it didn't work. "Sure if all mules, and they are legion, are so made, it is a difficult art," he concluded.[49]

Lear's tour of Athos described a figure of eight, with Kariess at its centre. On their second visit to Kariess it was Lear's turn to contract malaria. "The shaking fit only lasted one hour, and the hot fit... made me delirious directly – but not till I had taken a vast dose of physic. I have no fear of fever now as I can doctor it beautifully." Giorgio fed him appropriate food. He bought "a cock from an unwilling monk who used the brute as a clock, and made me broth". The nine monasteries on the northern circuit included Roussikon, the great Russian monastery of six thousand monks "with its pea green domes and golden crosses", now sadly decayed, and Vatopedi, "second in size and dignity only to Lavra. And here let me stop. O my! I am so sick of convents," Lear declared. "Mount Athos is one of the most extraordinary places in the world and I never intend to see it again."

It was the monks that Lear couldn't abide. The spiritual reason for their way of life concerned him not at all. He appeared unaware that they deprived the body in order to achieve Transfiguration or Metamorphosis of the soul. He despised not only the monks but all the trappings of Greek Orthodoxy, and only looked inside the churches out of politeness. "I listened meekly to the dreadful nonsense stories they told me of this or that picture. One floated from Jerusalem by sea, one cried when the Turks came", and so on.[50] Worst

of all was the monks' attitude to women. "That half of our species, which it is natural to every man to cherish and love best, ignored, prohibited and abhorred. . . . God's world and will turned upside down. . . . If this be Christianity, let Christianity be rooted out." Honest family men, be they Jews or even Turks, were to be preferred. (These strong views were voiced to Fortescue and marked "Confidential".) Then followed Lear's well-known diatribe against "muttering, miserable, mutton-hating, man-avoiding, misogynic, merriment-marring, monotoning, many-Mule-making . . . minced-fish and marmalade masticating Monx!"[51]

Lear's relationship with Lushington continued to deteriorate after he returned from Athos. He made the mistake of moving in with him for a few weeks while his own flat was being repaired. On his first night under Frank's roof Corfu experienced its worst earthquake in years. "I thought I was in the steamer . . . and I called out to the steward . . . But . . .the sound of all the bells of the city going at once and the cries of all the people rushing into the churches . . . brought me to my senses." At that moment in Crete five hundred people were dying, and in Malta Harry's villa was rent from top to bottom.[52] Frank was unaffected by the tremor. Lear and Giovanni (another of Giorgio's brothers) discovered him in bed "quietly making experiments with a compass as to the exact direction of the earthquake, from some water shaken out of a glass by his bedside".[53]

Lear now moved into the flat next door to Frank. The view was less good than Frank's because it was not high up and on the end of the terrace, but the wind did not rattle the shutters so. Also there was a spare bedroom and even a kind of cupboard for Giorgio. Lear's life now started to go by the clock once more. Occasionally he took an early-morning stroll with Frank, up and down Condi Terrace, before Frank went to the court, more often a country walk in the evening. Sometimes they dined alone together at home. Just when things were going better, little Eddy became dangerously ill. A swelling near the boy's spine had increased and he had been taken to London for treatment.[54] By July he had dropsy in both legs, and could not stand. By August the family, who were once more at Eastbourne, were nursing him round

the clock. Even Edmund, his father, had come down from Glasgow, "to see this glorious beauty fading from our view".[55] In Corfu Frank expected each mail steamer to bring the dreadful announcement. So great was Frank's agitation that Lear began to hope that the next letter would tell "of the dear little boy's being in heaven". But Frank still prayed for his recovery, for he was "resolute in not looking beyond the present sorrow . . . whereas I even *make* sorrows rather than have none".[56] Lear's wish was granted. The heir of the Lushingtons died on 20 October 1856. "May you be ever spared such a tearing away of life from life," Edmund wrote to the Tennysons.[57] To Frank he described the beautiful deathbed. "He was like a little angel all through his illness, and I could fancy I heard him say, 'I should like to stay with Aunt Emily and Nelly [Ellen] and papa and mama, but I should like to see Uncle Harry and Aunt Louisa again, so whichever God thinks I ought to do I shall like.'"[58]

Frank's distress was pitiful. Lear privately suspected he would leave Corfu. But at least during the boy's illness he had become minimally more approachable. He did not, of course, "allow anything to interfere with his professional life". But he did not go out into society, "so I am more with him . . . and he can talk to me."[59] One day Frank on his pony overtook Lear walking back to town. He dismounted and walked home with Lear, and passed on the description of Eddy's funeral that he had just received. Lear was probably the only person on the island who could envisage the scene at Boxley churchyard. This was the Golden Age of grief and death once more, temporarily, drew the two men together.

The worst winter for thirty years on Corfu was to follow. "I have been . . . living in one constant tempest of rain, hail, thunder and lightning and above all, WIND!" Lear told Ann. "The noise and hullabaloo keeps me from sleeping – so that I have sometimes been quite unwell."[60] In Frank's flat on Sunday evenings, it was worse. The rattling of windows and doors drowned the rare comments the "dear fellow" vouchsafed while writing endless letters home. Lear's spirits sank. One day, heavily mackintoshed, he ascended to Ascension but it was impossible. The ground was too "squashy" to stand on and there was no hope of making sufficient studies to

finish his painting, which he now referred to as "The Great Corfu," by the spring. He had hoped to send it to the Great Manchester Art Exhibition but it was impossible. There were acres of blue sky to fill in, and he wished he had been constructed more like an octopus. He could have done with twenty pairs of hands "not to speak of an elephant's trunk to pick up . . . brushes when they fall".

Slowly Lear descended into the gloom of the previous winter, waking late and angry, getting "crosser and crosser" throughout the day and going to bed "in a positive rage". Once more he started to refuse invitations. He even turned the Cortazzis away from his door one morning, "a circumstance all Corfu will be sure to hear of directly, and I never the last of".[61] He had been in the middle of a piece of sky, but nobody on Corfu would understand *that*. In the evenings he reduced his sketches of the twenty monasteries on Athos to small gouaches which sold for £15 a time.[62] In them the transparency of the original wash and the sensitivity of the original line unfortunately disappear. Blue becomes the prevailing colour, with white highlights. The mechanical work bored him, and he often took it over to Frank's in the evenings. "I would sooner make faces through a frying pan for money," he told Ann.[63] Sometimes he sank to decorating "d'oyleys". "I am sorry to destroy your illusions with vulgar truth," he told Ann, "but the fact is . . . that I thought a whole set drawn nicely would SELL here! O shocking!"[64] Ann sent out lengths of cotton jean and fringing. The trip to Athos had left Lear hard up. Everything depended on selling the Great Corfu for five hundred pounds. Bills kept arriving from home, including a big one for the storage of his furniture. And now it was Christmas again.

Christmas was grim as usual. The party at the Cortazzis' was too large and noisy. But fortunately there was a parcel from home, which he opened with the zest of a schoolboy. Ann had sent him everything he had asked for and more, including a *large* penwiper, a pair of slippers (worked by herself), a silk handkerchief in "dark or Waterloo blue" to wear round his neck, and, best of all, "some of those chocolate cakes or drops" he had longed for so often on the Holy Mountain. There was also a rattle made of coral with silver bells

for little Ida Shakespeare, the baby upstairs, who wouldn't be parted from it, or from "a small part of Mr Lear's beard". Ida was an obliging baby who only cried at regular hours and so acted as a clock for Lear. "The whole was enclosed in a most amiable spotted wrapper",[65] and cunningly made to look like a canvas since it was to be despatched from Foord's, the art gallery at 90 Wardour Street, through which Lear now sold such of his pictures as had not been commissioned by private patrons. He used to call the gallery "Foord's of Wardoff Street" because it warded off the wolf from the door.

The prospect of a visitor from England, S. W. C. Clowes, had brought some relief. Lear had met Clowes, a Derbyshire landowner, at Knowsley. He set about adding bits of second-hand furniture to the spare room. Great was his disappointment when Clowes decided to stay at home and stand for the General Election of 1857. It was a visitor of Frank's, his nephew William Lushington, that brought Lear most pleasure that Christmas. William was one of the talking Lushingtons, related to Justice Stephen Rumbold Lushington, and had inherited their ability to tell stories. When William left Lear wrote to Ann, "I miss William Lushington extremely. Frank is generally so occupied and thoughtful that we go for miles and miles in silence."[66] In seven years, Lear told Fortescue, "Frank has become 70, and I have stuck at 20 or any boy-age all my life."[67]

Suddenly, just as the weather was improving in May, Lear bolted for England. He had not planned to go, but he found there were a thousand reasons why he should. He needed Holman Hunt's help with the Ascension painting and he wanted to publish the Athos drawings (presumably with the journal). To Fortescue, on 1 May, he confided his real reasons. "I can't stay here any longer – without seeing friends and having some communion of heart and spirit. With one who should have been this to me, I have none."[68] In another letter he wrote, "I feel convinced we are best when not with each other."[69] Yet, strangely enough, Lear's trip to England almost exactly coincided with Frank's return there on leave.

Soon after his arrival in England Lear wrote the following note to Ann:

Dear Ann,
 At half past one o'clock
 THE CORFU PICTURE WAS SOLD
 TO W. EVANS ESQ. MP
 FOR 500 GUINEAS
 HURRAH!
Your affect. Grandfather
 Edward Lear[70]

Fortescue was also informed. "Poor old boy!" he confided to his diary.[71] Lear was in fact only 47. At this time Fortescue seemed to be the only person Lear could truly confide in, the only one who could supply "consistent kindness and reciprocity".[72] "I sat with old Lear both nights," Fortescue wrote, "he in low spirits, longing for 'sympathy' which means... a wife."[73] Lear only wanted a wife when very depressed. Fortescue also wanted a wife, and he had one in mind. He had become involved with the incredibly beautiful Lady Waldegrave, daughter of the opera singer, Charles Braham, who was unfortunately still married to her third husband, old Mr Hargreaves of Nuneham Courtenay. (Throughout her subsequent marriages she retained the title of her second husband.) Fortescue had seen her for the first time when he was twenty-seven. He had now been deeply in love with her for seven years. His diary reports the details of every costume with which she chose to dazzle him. It also records the appalling visitations of the "blue devil" of depression which he, like Lear, suffered, no doubt brought on by self-enforced celibacy.[74]

Lear first met Lady Waldegrave at Nuneham Courtenay. She found him amusing and wept at the Tennyson songs. She even persuaded him to dance! "Did me a great deal of good," he told Ann.[75] Lear was perhaps more deeply moved by the beauty of Lady Waldegrave than by that of any woman. In his diary Fortescue wrote, "I asked him if he understood her incredible fascination. He said, 'Yes, I do. I find when I look at her myself sometimes that I can't speak.'"[76] When waving goodbye to her after a visit to Nuneham Courtenay, he turned to Fortescue and said, "Well, I can understand a man raving about her."[77] A year later at Strawberry Hill,

Lear, who was in bed with a cold, said to Fortescue, "she is more beautiful than last year, her cheek like rose leaves".[78] Lear now made a long, deeply "sympathetic" visit to Fortescue at his estate in Ireland. The Red House, outside the small town of Ardee (nearest railway station, Dundalk on the north-west coast), was ruled by Fortescue's aunt, Mrs Ruxton, a tough, independent old lady. In future he and Fortescue were to exchange news of "our old ladies". At eighty-five, Mrs Ruxton still walked the grounds at six a.m., conducted prayers at nine a.m., visited the poor "by dozens" all day, driving her own pony chaise, and was good company at dinner. "She is only a *little* deaf," Lear reported to Ann.[79] Her Irish stories, told in dialect, were hilarious. Fortescue found the visit minimally less delightful than did Lear. Once more, as when they had first met in Rome, he had to cope with Lear's excessive demonstrations of affection.[80] Also Lear was drinking too much, as he himself admitted many years later. But the liquid eyes of the calves of Ardee haunted Lear for many years to come.

Lear dreaded the return to Corfu and the lowering Lushington. Christmas was coming by the time he reached the island. It was even worse than he had expected. The Cortazzis had left. "Never any breadth... of intellectual society... you can [not] even swear properly by reason of the... neighbours." Pianos on both sides played "jocular jogs continual", and "if I can't sleep, my whole system seems to turn into pins, cayenne-pepper and vinegar". Even walking became "impossible alone". Sunday morning church was discontinued. "I felt I should make faces at everybody." Another big picture, "something to gnash and grind my teeth on" might be the answer.[81] Lear stayed at home and read the New Testament in Greek. He had now mastered liturgical Greek as well as Modern Greek, and was even making progress with the ancient variety. In the next few years he read several of the great plays and also Plato's *Phaedo*, which did for death what the *Symposium* did for homosexual love. He found in the Greek language a strange happiness that many have found before and since. To Emily Tennyson he wrote, "Greek... is the foundation of all knowledge and happiness... far beyond cleanliness or Godliness."[82]

For a biographer of Lear, 1 January 1858 is a red-letter day. It is from that date that his diaries have survived, although in fact he is known to have kept a detailed daily journal most of his life. One of the first subjects touched on in the first surviving diary was, of course, Frank, "indifferent and passive to all but his own routine". At dinner in his rooms "he took a good cigar for himself from a box at the other end, but offered me none".[83] Of all things, he had bought a dog, and he knew how Lear detested dogs. "Now that he has got a dog, one cannot help feeling how far more agreeable it is to him to walk with that domestic object, to whom he has not the bore of being obliged to speak."[84] A dog was indeed the final insult. At Easter Lear made another of his impulsive dashes, this time to the Holy Land. It was his third attempt to reach Jerusalem and Lady Waldegrave had encouraged him by commissioning a pair of pictures. As he packed a tent, saddlebags, quinine, for the miles on camelback, he felt a faint twinge of guilt about the expense. If Clowes had been able to come (apparently there had been some plan of this sort) he would have paid – though without him Lear would be able to keep his own "thread of thought . . . unentangled".[85] Frank insisted on lending him a pistol, and, worse still, on teaching him how to use it. Lear reached Jerusalem full of longing and expectation. The Holy City looked golden from the Jaffa road. A closer view was disillusioning. "Let me tell you, physically Jerusalem is the foulest and odiousest place on earth," he told Lady Waldegrave. "A bitter doleful soul-ague comes over you in its streets – and your memories of its interior are but horrid dreams of squalor and filth."[86] He set off speedily for Petra and the interior.

The journey to Petra was notoriously dangerous. To Lear's horror he discovered he was expected to take *fifteen* armed (and paid) men with him to counter Arab tribesmen. Abdel, his dragoman, insisted on using camels, though Lear detested the "gulpy, roary, groany" creatures.[87] Nevertheless the five-day journey to Petra through one of the lowest, hottest terrains on earth, went well. At night they pitched their tents on the sand and gazed into the starlit silence. Near dawn Lear wrote in his diary, "What a strange calm world . . . becamelled with ghostly wanderers."[88]

The rose-red city in its stratified canyon was, of course, extraordinary. "As the path wandered among huge crags and on to broad slabs of rock, ever becoming more striped and glowing in colour, I was more and more excited with curiosity and expectation."[89] So was Giorgio. "Oh master," he exclaimed, "me have come into a world where everything is made of chocolate, ham, curry-powder and salmon." In camp that night "ten black images squatted in a line immediately above the tents". In the morning many more of them descended to desecrate "this hollow lotos-land".[90] Lear had paid his levy to the Sheikh of Haweitat, but these were the fellaheen of Dibdiba and other villages on the hills. Though theoretically under the Sheikh of Haweitat, he had been absent for a long time and they demanded an extra handout for themselves. Lear refused to pay and went off to draw in the canyon. When he returned for a lunchtime break there were two hundred of them and the absentee Sheikh had himself arrived on a white horse, but nothing had been settled. Lear gave orders to pack up and leave, scratching his name on a rock in case a search party should be sent to look for him. He was about to mount his camel when things turned really nasty. "One of the younger brutes seized my beard, he was severely rebuked by an elder for this peculiar development of impropriety, though there was no abatement of ear-nipping and arm-pinching." Then "a fresh supply of savages joined in the tumult . . . unbuttoning all my clothes, extracted in a twinkling everything from all my many pockets, from dollars to penknives to handkerchiefs and hard-boiled eggs, excepting only my pistols and watch." Finally the Sheikh persuaded the brigands to desist, but they continued to pursue the party until convinced there was nothing left to steal.

Undeterred, Lear now headed for Masada, overlooking the Dead Sea, where Hunt had painted his goat. (On the rock of Masada the Jews who escaped the sack of Jerusalem had held out for three years.) Then he turned back to face Jerusalem once more, for My Lady's commissions were for a matching Masada and Jerusalem.[91] Lear at last came to terms with Jerusalem from the Mount of Olives, where he now camped, looking across the valley to the city. True, the mountainside was stony and the Arabs in the village at the top as usual

were "dreadfully noisy... the odious people always yell and quarrel".[92] But the view of Jerusalem "all gold and white beyond the dark figs" was "most lovely". Furthermore his tent was comfortably furnished and he had hired an Arab to sit at the door and screech up to the people at the village for water and milk. "I never heard such voices as these people have."

Lear's last port of call was the Lebanon. There he found the last of the Cedars of Lebanon in an "Orientalised Swiss scenery".[93]

So fine a view I suppose can hardly be imagined... the mountain forms an amphitheatre.... Far below your feet, quite alone on one side of this amphitheatre is a single dark spot, a cluster of trees: these are the famous Cedars of Lebanon... I cannot tell you how delighted I was with these cedars! Those enormous old trees, a great dark grove, utterly silent, except the singing of birds in numbers. Here I stayed all that day, the 20th [May] and all the 21st.

There was only one problem. At six thousand feet, "the cold was so great I could not hold my pencil well".[94] In one of the sketches that Lear brought back from the Lebanon a pair of massive trees almost filled the sheet of his sketch-pad. Beyond and below them were more distant trees and the white shoulder of a mountain.[95] This sketch was eventually to be transferred to a nine-foot canvas that was to cause Lear problems for the next ten years.

Back in Corfu, hatred and malice seemed as prevalent as in Jerusalem. A frightful row had blown up in government circles. Bowen had denounced Frank to Sir John and Lady Young, as the worst enemy they had. There seemed no end to the "fiend Bowen's frightful blackguard's career of shame and wickedness", Lear declared. Frank decided the only honourable action was to resign. He was anyway dissatisfied with his position. A letter exists in which Lear requested Prime Minister Derby's son (the future fifteenth Earl) to obtain an increase in salary for Frank.[96] Also, there was illness again at Park House, and Tom had just died in India. Lear

and Frank travelled to England at the beginning of August and parted at Dover. Corfu with Frank was over. It had lasted three years. A decade would pass before Frank obtained another position.

17

Rome Again 1858–60

In London Lear found himself in a torment of indecision. "Incapable of deciding whether life can be cured or cursed – I totter giddily, refusing to take any road, yet agonised by staying irresolute."[1] He stayed with Holman Hunt. "One thing is a fact," he wrote, "living with Daddy Hunt is more a certain chance of happiness than any other life I know of." Although he only saw Hunt at breakfast and late at night, Daddy's mind, "*active and truthful*", pervaded the house.[2] Lear also considered living with Fortescue, "though not during the lifetime of the dear old lady" at Ardee.[3]

Nobody seemed interested in the Palestine drawings although Woolner said they were the best things Lear had ever done for "excessive fineness, tenderness and beauty".[4] They were passed round at a party at Sir Richard Bethell's house that winter. The occasion was a failure from Lear's point of view. "Tittering, laughter and a bore . . . but no lifelike care for Palestine itself. . . . At 11.00 I came away, I confess very angry."[5]

Christmas was approaching yet again. Clowes was off to Rome and Lear, eager for a travelling companion, decided to go with him and settle there once more. It was a mistake. "So dismal has been the return here," he told Fortescue, "that only . . . the even temper and kindness of Clowes, could have kept me above water."[6] Rome had become busier, smarter and noisier than it had been in the forties. When Clowes broke his collar-bone out riding with Charles Knight, Lear's loneliness reached alarming proportions. Yet again he asked Ann to write weekly. It was as bad as the first Christmas

in Corfu, three years earlier. There was, however, the consola-
tion of a warm welcome from his "ancient aquaintance".
Foremost among these was Penry Williams. Penry was almost
as brisk as ever. John Gibson was also still there, but fallen
sadly in Lear's estimation. He "has the smallest portion of
brains a human being can have and yet imitate Greek sculp-
ture".[7] As for the younger artists, they were "off my beat".
According to art historians, Marstrand was in Rome between
1855 and 1860, but Lear makes no mention of him. Among
the social set he naturally sought out Isabella Knight. "Poor
thing," he told Ann. "She has now been on her back for
20 years."

Rather surprisingly, Lear took a three-year lease (com-
mencing January 1859) on the most expensive flat he was
ever to inhabit, at 9 Via Condotti. He furnished it equally
expensively. He even ran to a portable w.c. and fitted carpets.
"You never came such a swell at Rome before," Fortescue
remarked somewhat sourly. "Your ample and carpeted apart-
ment," he added, "will surely convince our countrymen of
your genius."[8] Giorgio arrived from Corfu three days after
Lear had moved in. Within minutes he had made his master
his first cup of coffee. Then he set to work at once on a length
of calico, "violently hemming" ten dusters and two aprons.
But he quickly grew sad sitting twelve hours a day in his
"miserable little box of a kitchen". Like his master, he was
lonely and would not mix with the Romans, whom he
regarded as half-witted bunglers and dirty to boot. Finally
he blurted out the truth. He had a wife and was frantic for
news of her. "Mr Giorgio is married and has three children!"
Lear announced to Ann. "The fact of his never telling me
is one of the curious points of secretive character the Orientals
always have. Fancy! In nearly five years never saying a
word!" When Lear asked him why he had not mentioned
the matter before he replied that, "I had never asked him
so he thought it not right to tell me!"[9]

Shared loneliness drove Lear and Giorgio increasingly
together. After Lear had been obliged to read aloud a letter
announcing the death of Giorgio's six-year-old daughter, he
took him on an expedition to Frascati in the Alban Hills to
distract him. He often walked with him in Rome. And they

worked at Giorgio's writing together. After two and a half years of instruction, Giorgio could now sign a receipt for his wages in a shaky copperplate hand.[10] Giorgio also played his part on Lear's open afternoons. As soon as Lear had furnished 9 Via Condotti he announced the days of these, as was the custom among Roman artists. Giorgio, dressed in a new suit, went up and down admitting "the mob", shouting up to his master in Greek, with an unmoving countenance, "4 male and 6 female Arabs" or, on one occasion, "One old Arab on four legs" (a clergyman on a pair of crutches).[11] After Petra, "Arab" was not a term of endearment with Giorgio.

The great social event of 1859 in Rome was the visit of the Prince of Wales, a mere sixteen-year-old. Lear was fortunate indeed to have his studio singled out for inspection. He had one hour's notice of the royal intention. Frantic was the work with broom and dusters, immaculate was Giorgio in his new suit as he opened the door to the young sheikh, obsequious was Lear as he waited on the fourth-floor landing to do the honours. "Nobody could have nicer or better manners than the young prince, nor be more generally intelligent and pleasing," he wrote in his diary. "I was afraid of . . . showing him too much, but I soon found he was interested in what he saw both by his attentiveness, and by his intelligent few remarx." Lear showed the young prince the Corfu and Palestine oils, and, more alarming, "'the whole of the sketches' and when I said 'please tell me to stop, Sir' . . . he said 'O dear no!' in the naturalest way."[12] "He does not purchase or order anything here," Lear told Ann. "Giorgio said, 'he is all so like a half crown and a shilling.'" He referred to the Queen's portrait on these coins.[13] But now Garibaldi's forces were approaching Rome with a view to ousting the Austrians, and Lear's customers were, once more, fleeing for the coast. In May he followed them to England, hoping things would calm down in time for the winter season.

He settled at a boarding-house at St Leonards, one of the sort that Ann was so prone to. He did this because he was, as usual, short of "tin" and preferred not to borrow again from Fortescue. (Not that he disapproved of borrowing, for a man who will not borrow "nourishes . . . a selfish and icicle

sort of pride".[14] Life in 119 Marina was not of the best. He was obliged to dine daily off what he took to be the same leg of circus elephant. Also there were not enough water-closets to go round. "There is only one. And that one is very difficult to get at ... because everyone wants to go there at the same moment ... I have been downstairs to this confounded w.c. three times and I see no other recourse but to strip and rush into the sea, there to combine the worship of Neptune and Cloaca ... under one and the same liquid altar." He was tempted to sign himself "Yours costively".[15] Nevertheless he worked hard at Hastings and discouraged "followers" except at the weekend.

As always, he read widely and voraciously. At one stage (in Corfu) he reported having nine books on the go together, and snatching at them in turns. "Some *Jane Eyre*, some Burton's *Mecca* ... some Shakespeare, some *Vingt Ans Après*, some Leake's *Topography*, some Rabelais, some Tennyson, some Gardiner Groke, some Ruskin, and all in half an hour." On 19 October 1859 he was reading Beckford's *Portuguese Convents*.[16] This had been published in 1835 by the notorious William Beckford (1760–1844), author of *Vathek*, and builder of the ill-fated Fonthill Abbey in Wiltshire. It describes strange goings-on in monasteries where "wanton-eyed" novices, dressed as women, perform fervent Oriental dances or take the heroines' parts in passionate tragedies, severely hampered by earrings, trains and voices in the process of breaking.

One of the few visitors Lear agreed to see that summer was a man hardly less strange than Beckford himself. David Urquart (1805–77), author of *Spirit of the East* and Fortescue's brother-in-law. In the language of a contemporary, Urquart was "under the absolute dominion of a mania with regard to Russia".[17] He also had an obsession about nudity and Turkish baths, and had attempted to cure his child's teething troubles by putting it in a "hot air bath" (the equivalent of a sauna). The child had died of congestion of the brain and the parents had been brought before an inquest. They remained undismayed. In advance of their visit to Lear they sent "a huge paper on Turkish Baths".[18]

Another visitor was Frank. He proved friendly. It may

have been his idea to solve Lear's financial problems by rounding up a group of subscribers to buy the massive "Bassae" for the Fitzwilliam Museum. It was, after all, he who had first gazed upon that mountain temple with Lear when they were in Arcadia ten years earlier. It could, on the other hand, have been Lear's idea, for it was he who sent out the letters to the "70 Elders", who might be expected to subscribe to the "Bassae relief" fund. The money was raised and the picture duly hung at Cambridge. "The accurate topographical features will be recognized by all who know the place", the fifteenth Earl of Derby declared.[19] "It will do wonders for my reputation," Lear assured Fortescue.

Frank was not with Lear when he visited Tennyson that summer. Emily, the mother-philosopher-angel-prophet, most of the time on her sofa, was all sympathy over the faithlessness of Frank. Alfred was in London, seeing the "Idylls of the King" through the presses. Hallam and Lionel, now aged seven and five, were "complete little darlings" in Fauntleroy suits, though, alas, they preferred football to Greek. "A twitching regret bothers me at having left the place," Lear told Fortescue.[20] In December 1859 the English winter drove Lear, gasping for breath, back to London and, subsequently, to Rome. He announced his departure from Sussex to Fortescue in verse.

> I send you this, that you may know
> I've left the Sussex shore,
> And coming here two days ago
> Do cough for evermore.
>
> Or gasping hard for breath do sit
> Upon a brutal chair
> For to lie down in Asthma fit
> Is what I cannot bear.
>
> Or sometimes sneeze and always blow
> My well-developed nose
> And altogether never know
> No comfort nor repose.[21]

In Rome it looked as if the "frightful Italian juggle" had calmed down. The city was in fact almost empty. Of the

two thousand British residents, only two hundred and fifty had returned. Giorgio was summoned once more from Corfu. Soon after the "tiresome noise" of the pre-Lent carnival there followed the more tiresome noise of rioting in the Corso. There were ugly incidents in the streets and Lear saw two men stabbed at Tivoli. Giorgio was instructed to take a basket with him when he went shopping "to put your head in if it happens to be cut off". "No, sir," was Giorgio's ready reply, "I take soup tureen – hold him better."[22] Soon afterwards war was officially declared and Lear left Rome for the last time, with two years of his lease still to run. "I have grown very fat of late," he told Ann.[23] It was to be his last letter to her.

The Death of Ann 1860–61

Lear spent the summer of 1860 visiting country houses as usual. A visit to Farringford with Frank was wrecked by Julia Margaret Cameron with her pioneering camera. Mrs Cameron had bought a house in the village in order to be close to Tennyson. To Lear she was an alarming lady, having a deep voice and being apt to drop "bomb-shells". She went bareheaded and corsetless, and draped herself in velvet curtains. Her hands were blackened with the chemicals of the dark-room, and Garibaldi, who stayed with the Tennysons a few weeks later, once pushed her away from him when she was pleading on her knees for a sitting. He was under the impression she was a Freshwater beggar.[1] Mrs Cameron at once recognized Lear as a lion. She pursued him with her grand piano, carried by eight men. (Emily Tennyson's was out of tune.) She wanted to photograph him singing Tennyson's songs. "Odious incense, palaver and fuss," Lear growled.[2] "Pattledom has taken entire possession of the place." (Mrs Cameron was one of the famous Prattle sisters; Virginia Woolf's mother was another.) But Lear was a match for her. "We jarred and sparred and she came no more."[3]

The change in Tennyson's character, which Lear observed on this visit, was not entirely the fault of Mrs Cameron. She was only one of the increasing number of his worshippers. Many men of distinction risked the sea voyage to his island retreat: statesmen, thinkers, even an English cardinal. As a result the poet not only became increasingly conceited, he also developed a fear of people. When Lear and Frank set out with him on his usual walk to Head Down he tried to

turn for home whenever he saw others approaching. "But Frank Lushington would not go back, and led zig-zag-wise towards the sea." In the end Tennyson insisted on taking them by "muddy paths (over our shoes), a short cut home." "I believe that this is my last visit to Farringford."[4] He was wrong. There was worse to come.

Lear now started on "The Cedars of Lebanon", the last of his mega-canvasses. He well knew it was a gamble. If the picture did not sell he would have earned nothing for a winter's work. "One must ... risk ... something," he told Emily Tennyson, or "turn into a stagnant snail".[5] He risked a good deal by staying at Oatlands Hotel, Walton-on-Thames, which not only cost four guineas a week but also had the arrivals and departures of its guests announced in *The Times*.[6] The Cedars was Lear's excuse. Oatlands had been a royal hunting lodge and in the seventeenth century cedars were planted in its grounds. After dinner he socialized for an hour or two with his fellow-residents. His health stood up remarkably well to hours of drawing in the frozen park – it was an exceptionally cold winter and his first in England for eight years. The thaw was his undoing. "Lo! as I began to write," he told Emily Tennyson, "horrible, squashfibolious meligoposhsquilous sounds were heard". The hotel cistern was bursting, and "torrents of water like fire from cannons burst forth".[7] He returned to London.

He took rooms at 15 Stratford Place, two doors along from the flat with the fallen ceiling. There were acres of the Cedars canvas to be covered, and, increasingly, he resented the labour. "No life," he told Fortescue, "is more *shocking* to me than the sitting motionless like a petrified gorilla ... hour after hour, my hand meanwhile peck-peck-pecking at billions of damnable little dots and lines ... I wish I'd 200 per annum! Wouldn't I sell all my colours and brushes and damnable messes."[8] Tennyson was in receipt of a state pension of £200 and Lear often referred to it.

On 4 March 1861 Ann, who had been posing for Lear for four or five hours a day, was unable to come to his studio. A swelling had appeared on the back of her neck and she felt nauseous. Within a few days it became apparent that she was dying, and Lear went daily to her bedside in the little

rented room at Stonefield Street, Islington, not far from the Holloway Road. Her approach to death was profoundly Christian. She "speaks of dying as a change, about to bring such great delight, that she only checks herself for thinking of it too much."[9] As Lear took turns with his sister Ellen, now a widow, at Ann's bedside, Ann would suddenly speak. "What a blessing you are here! Not among the Arabs!" Or, "What a comfort you have been . . . all your life."[10] "Edward, my precious, take care you do not hurt your head against the bed iron."[11] Her small body was rapidly wasting away. After midnight, on 11 March, she became unconscious. Lear wandered the streets for the rest of the night, calling on the Nevills at Stoke Newington. In the morning he paid the figure on the bed a last visit. Then he paced Stonefield Street until, just after midday, he saw the curtains of her bedroom window close. It was over. Ann had slipped away from life as quietly as she had lived it. She was in her seventieth year.

All through that evening Lear sat at home writing letters, trying to comprehend the terrible change that had taken place between the rising and the setting of the sun. He had lived his life for Ann, through his letters. She was the one for whom he had won his successes and to whom he had confessed his defeats. Without her, life seemed unreal, a mere shadow. That evening he described her death in his diary. "She died as a little child falls asleep." Then he wrote a note to Fortescue saying, "I shall be so terribly alone."[12] Four years later he wrote "What I should have been unless she had been my mother I dare not think."[13] Her life had been one of pure unselfish goodness. He hastened to the Isle of Wight for sympathy. He received little. That visit to Farringford of 1861 was so awful that a year later Lear still shuddered at the recollection of it. "This time last year at Freshwater!"[14] Tennyson's brother Horatio was coming to stay and the house was upside down. Lear must stay at the Royal Albion Hotel. He achieved only one audience with Emily during which, no doubt, she spoke, as she had in her letter of condolence, of "the holy ones who have left us", stretching out "shining hands to help us to come to them".[15] Alfred was totally pre-occupied with the possibility of transferring to Macmillans. Lear left after five days without saying

goodbye. An added sorrow at this time was news of the death of his sister Mary on her way home from New Zealand, where her unpleasant husband had obliged her to live in a grass hut. In America, four of Lear's nephews, the sons of his brother Frederick, were fighting for the North and one for the South.

When "The Cedars" was finished in mid-May Lear proclaimed it his masterpiece and worth £735. He asked this preposterous sum because Millais, that "French dancing master",[16] was asking £450 for his small "Spring". He overlooked the fact that Millais, whom he had met again recently, and found he disliked increasingly, was a star. When "The Cedars" was hung a few months later at a big exhibition at Liverpool it was praised but did not sell. When it was hung (too high) the following year at the Royal Academy Summer Exhibition it was savagely attacked by Tom Taylor in *The Times*. (Taylor was a wit and playwright and, to make matters worse, he had been a close friend of Frank's at Cambridge.)

With the failure of "The Cedars" began the decline of Lear's reputation as an artist. In the fifties his work had been well hung in large exhibitions. By the sixties the public, sheeplike, had turned away from him. He blamed their behaviour on neglect by the press. But there was a reason why the press neglected him. He was too seldom in the country. "The Cedars" was probably no worse a picture than "The Acropolis", painted ten years earlier, but in the early fifties Lear had spent several years living more or less continuously in England. He was then able to promote his work by exhibiting at his studio, dining out and doing the rounds of the country houses.

Three weeks in Florence that summer were financed by Lady Waldegrave out of sympathy. Lear met Giorgio there and they made expeditions into the hills, but Lear missed writing letters to Ann. "The want of the constant journal I have sent to my dear sister for so many years, makes every hour seem very strange and sad and blank," he told Fortescue.[17] Back in England he published a third edition of *A Book of Nonsense*. (A second had come out in 1855.) Composing limericks was a continuous process with Lear. Waiting for

customers at 15 Stratford Place was a good time for composition. Since neither Routledge nor Smith and Elder would take the book, he once more published it himself. Half the edition was sold within days, in spite of the *Saturday Review* which declared it "a reprint of old nursery rhymes".[18]

The news of Frank's engagement arrived when Lear was back at St Leonards. Frank's intended was Miss K. M. Morgan, orphaned daughter of a clergyman, who had been brought up with his sisters at Park House. "Do tell me what you think of Kate Lushington," Emily Tennyson wrote. Unfortunately Lear's reply is lost, but one may guess, from hints he dropped, that the answer was "not much". It was the end of an era, and it was winter, time to "wander south". But where? Though Corfu no longer contained Frank, it did contain Giorgio. He chose Corfu. In his heart he knew "we come no more to the golden shore where we danced in the days of old".[19]

Corfu without Frank 1861–64

Lear was to spend another three winters in Corfu, this time
without Frank. At first the "tittle, tattle" place exasperated
him more than ever and he quickly declined invitations from
"a multitude of new and uninteresting aquaintances".[1] He
missed the Cortazzi family sadly. At least the new Governor,
Sir Henry Storks, was well bred. He even walked home one
day from One Gun battery with the "dirty landskipper". Lady
Somers was one visitor who made life bearable. Lear had
met her ten years earlier and considered her "a most sweet
creature. Her expression of countenance is one of . . . unmiti-
gated goodness," he had told Fortescue.[2] Virginia Somers
was not only beautiful, she was courageous, and claimed to
be the only woman to have spent two months on Mount
Athos. She evaded the well-guarded entrance by the simple
expedient of arriving by sea and camping on the beach. She
was visited by various "mucilaginous monx" who seemed
to find her pleasing rather than otherwise. Virginia was
another of the Pattle clan.

Lear's first duty on arriving was to meet Giorgio's family
for the first time. They consisted of Giorgio's mother, "good
old Basilia", his brother Christos (the other brothers were
living away from home), and his three boys, Nicolá, Lambi
and Dmitri. With families come problems. Christos was
already suffering from tuberculosis and during Lear's second
Corfu period he became steadily worse, until Lear was writing
to Fortescue, he "has now, it seems, really taken to die . . .
George has therefore a double journey to his mother's daily,
and to sit up all night. 'I like to give him his medicine,'

says the good man."[3] By this time "Nick the pickle" was playing truant from the school Lear was paying for.

Finding somewhere to live in Corfu was, as usual, a problem. Lear stayed temporarily at the Hotel St George overlooking the harbour. (The five-storey building still stands on the Line Walk, next to the National Bank of Greece.) The mountains and the seagulls were delightful. As he painted he could watch a man fishing below him all day with a five-pronged spear, wearing nothing but a waistcoat and trousers ("Would I were that man."). He could also inspect whole regiments of the British Army. "Just now I looked out of the window at the time the 2nd were marching," he told Fortescue. "I had a full palette and brushes in my hand. Whereat Col. Bruce saw me and saluted, and not liking to make a familiar nod in presence of the whole army, I put up my hand to salute, and thereby transferred all my colours into my hair and whiskers, which I must now wash in turpentine or shave off."[4]

But soon the Hotel St George fell out of favour. Unfortunately a certain Colonel Maude lived upstairs and maintained six dogs in the cellar. Once Lear shouted at the colonel and cried with shame afterwards. There was also a family with twins and a violin next door. These poor little mites made a frightful racket until one died and the other "ate the violin". Then "trouble on trouble, pain on pain", the drain smells began. After a month in Corfu he wrote in his diary, "It does not seem possible to exist here." The world was rapidly becoming too small a place to contain him.

Lear now became far from well. The tell-tale crosses that indicated epileptic seizures appear on many pages of the diary, sometimes in pairs, sometimes on as many as three days in succession. The after-effects of these spasms are also mentioned. An afternoon fit of the severity 6 could keep him indoors for the rest of the day. "No end of indigestion and bother: and afterwards, dim sight and very weary nerves." By "weary nerves" Lear indicated that he was in a very bad temper. The effect that epilepsy was having on his sight worried him increasingly. One day he went to Ascension to draw but was "knocked out at 5.00 . . . not seeing the hills or sky".[5] "I am mortissimo in body and soul," he wrote, "yet looking

back, even as far as 6 years old, how can it be otherwise? The wonder is, things are as well as they are through constant fighting."[6] He still regarded the age of six, when the fits had begun, as the time when his life had taken a fatal downward turn.

Nature alone provided balm. He found a brief moment of peace on the cliff above Palaiokastritsa, the rocky bay into which he and Frank had sailed five years earlier. All was silent "excepting only a dim hum of myriad ripples 500 feet below me". But then news came of the imminent arrival of "one of those accursed picnic parties with . . . scores of asses male and female", and he scurried away.[7] On the slopes of wild San Salvatore things were better. Below him a silver ribbon of a river threaded through a blue plain. Beyond were the Albanian mountains. "A breeze of blue and gold and green" blew in his face. He had a sudden memory of "*that* kind of happiness", the happiness of Amalfi with Uwins, Civitella with Marstrand, the Abruzzi with Knight, Sicily with Proby and, of course, Greece with Frank.[8] Increasingly he felt, as he had years ago in the Lake District, that nature was his true friend, not man. On 12 May, his fiftieth birthday, he had a strange experience in the holy grove of Avonios. Standing in the "warm-semishade", surrounded by the soaring pillars of tree trunks, he felt no longer one of mankind, but one of them. Perhaps, after death, he would become a tree. "The Elements," he wrote that day, "seem to have far more part with me . . . than mankind."[9]

Lear arrived back in England for the summer of 1862 with precisely twopence in his pocket. (He had been robbed on the steamer.) For two years he had hardly sold a thing. "The Cedars" still hung round his neck like an albatross. (He threatened to make an overcoat of it.) "How debts of frames and colours are to be paid I do not know," he told Emily Tennyson.[10] He was becoming increasingly bitter towards the idle nobility. "O how sick I am of the upper 10,000," he wrote in his diary.[11] Their conversation compared to that of the middle or professional classes was "a norful bore", he told Emily Tennyson.[12] And they were so slow to pay. "Great people generally suppose that artists gnaw their colours and brushes for food," he informed Fortescue.[13] He also turned

against the artistic establishment, and particularly the Royal Academy. "If the Royal Academy is a national institution, then it ought to be forced to reform. Or it might cease to be ... National ... and then no-one can complain that it is rotten and narrow."[14]

The great social event of 1862 had been the marriage of Fortescue to Lady Waldegrave. His seven years' devotion to her had finally borne fruit after the death of Mr Hargreaves. "I am the luckiest dog in the world, and have been half seas over with happiness ever since," Fortescue wrote to Lear.[15] Not everybody was happy. Old Mrs Ruxton of Ardee strongly disapproved because it was highly improbable that Lady Waldegrave would bear a child. Lear, while publicly rejoicing, was secretly sad. All but two of his ten best friends were now married. There would be no more cosy London breakfasts. "Never more, Oh! never we shall meet to eggs and toast and T".[16] Breakfasts at Fortescue's London house had become special occasions. At one of them, Fortescue recorded in his diary, Lear had sung "Tears, Idle Tears". At another he had met the painter Frith.[17] Equally precious had been dinners at the Blue Posts Tavern in the Strand. Yet the marriage was not without advantages for Lear. Lady Waldegrave now set about adding a new room to Strawberry Hill. "I never saw a more beautiful room," Lear told Fortescue. Any other woman would have decorated it with "diabolical panels of mirror" but not she. She was going to fill all the empty frames with pictures, and, since she had the moral courage to buy only pictures she genuinely liked, those pictures would probably be his.[18]

But it was time to return to Corfu and the Tyrants. The Tyrants were mass-produced water-colours copied from the sketches accumulated during half a lifetime. First Lear would prepare and mount thirty pieces of paper, then he would draw thirty identical scenes. Then, working his way along the line, he would paint in all the green or tawny foregrounds, all the amethyst backgrounds and all the skies, using a bottle of ready-mix water-colour for each. When they were dry, a few Chinese white highlights were added, a frame was affixed and, hey-presto, there was an instant work of art for sale. He did sixty in two sizes, for he was not one to do

things "by halves and squittles".[19] At the end of two months he felt "like unto a spawned salmon". He exhibited them in his studio and they were borne away at once by the "small capitalists of Corfu".

Suddenly Lear was happy again. He made a new friend, a charming young man called Evelyn Baring, a young cousin of Thomas Baring, "the luminous brick". Evelyn was in Corfu as ADC to Sir Henry Storks. As well as being brilliant, like all the Barings, Evelyn had a sense of humour. It was to him that Lear wrote one of his most deeply argued letters:

> Thrippsy Pillivinx,
> Inky tinky pobblebookle abblesquabs? – Flosky!
> beebul trimble flosky! Okul scratchabibblebongibo, vid-
> dle squibble tog-a-tog, ferrymoyassity amsky flamsky
> ramsky damsky crocklefether squiggs.
> Flinkywisty pomm,
> Slushypipp[20]

Lear's love of Corfu now knew no bounds. He wrote a letter full of elaborate guide-book praise of the island to a certain Mr Beadon who was considering a visit. He spoke of 'Snow covered mountain ridges . . . fern-filled groves . . . orange and lemon groves . . . amethyst hills'. The list was endless. He was so pleased with it that he copied it into his diary.[21] At this point the rumours started that the British were going to leave Corfu.

The British Government had for some time considered that the Ionian Islands should be returned to Greece. The Greek monarchy was about to be restored (again) at Athens. They had even considered ex-Prime Minister Derby as a suitable applicant for the post. Lear's glee at that prospect can be

imagined. "You may not have heard," he wrote to one of the two Drummond brothers, his bankers, "that I refused the throne of Greece, King Lear the first, on account of the conduct of Goneril and Regan, my daughters, which has disturbed me too much to allow my attention to governing."[22]

Lear decided at once that he must make drawings of all seven of the Ionian Islands for publishing in a large book. He devoted two months in the spring of 1863 to visiting them. None, he declared afterwards, excelled Corfu itself in splendour and variety of landscape. Yet even on Paxos, the smallest (five miles long and two miles broad), he found subjects of beauty: the western cliffs "rarely surpassed in grandeur", and the pretty harbour of Gaio where "the calm sea reflected the line of houses".[23] On each island he was received by the Resident, but he preferred the "hearty welcome and joyous hospitality" of the peasants.[24] The British governors were not only dull, as might be expected, but they were also remote from the people. The Resident at Paxos actually lived on an island in the harbour. Giorgio was at his best on these expeditions. He provided simple picnics of bread, sausage, cheese, eggs and always an excellent bottle of wine. It was embarrassing that he plundered the local gardens for onions. Being a Greek, he could not enjoy a meal without one.[25]

Immediately after this tour Lear returned to England. Unfortunately he was taken ill with sunstroke at Ancona during a prolonged customs inspection and arrived home very weak. "You may suppose my plans for [the] London season are all gone to the winds," he wrote to Fortescue, in a shaking hand. "It is an odd full stop to my triumphant 8 weeks' success in the Island tour."[26] He found little pleasure either in transferring the Ionian views to lithographic stones for his large illustrated book. One day he took some much-needed exercise by walking up to Highgate cemetery to see Ann's grave. Bowman's Lodge was on the verge of demolition. A red rash of speculative development already covered part of the grounds and new buildings pushed up close against the back windows. He gave a woman two shillings to show him round and climbed up what was left of the front steps. "The parlour at once annihilated 50 years . . . there were the two bookcases and the old 'Secretary' my father used to write

at." The sight of his own little bedroom caused him deep emotion; so also did "the painting room, the happiest of all my life, perhaps".[27]

In spite of his admiration for Lady Waldegrave he found her high society dinner-parties extremely long and dull. Some of them ran to sixteen courses, and although Lear continued to be enchanted by her "perfectly natural and kind manner", he confessed that the guests at *all* her homes were exquisitely boring, being mostly politicians invited for the advancement of Fortescue. At Carlton Gardens he feared he had upset her ladyship by refusing to sing, but he "felt like a cow who has swallowed ... a boiled weasel".[28] At Strawberry Hill, during the Christmas recess, nobody asked him to sing, which was worse. They played whist instead.

Lear returned to Corfu as soon as Christmas was over, refusing to admit that *all* the English must go. Lear wrote a half-humorous letter to Fortescue asking him to use his influence with Palmerston. He required a place created for him at court, that of Lord High bosh and nonsense producer with permission to wear a fool's cap.[29] The case, of course, was hopeless. The British had already started blowing up the forts, which the Corfiotes found insulting. Even more insulting to them was the fact that parties of English went "to see the beautiful blow up". Nevertheless, many of the locals were sorry to see the English go. Domestic servants, yachtsmen, innkeepers and small shopkeepers had depended on the British army. Giorgio's mother, old Basilia, considered migrating with her family to Patras or the Piraeus.

Frank was also deeply disturbed about affairs in Corfu. Before the decision to cede the Ionian Islands had been made there had come the scandal of the dismissal of two Greek judges, Marcoran and Xidian, by Gladstone with the approval of Sir Henry Storks. Frank had rushed to their defence in a tract entitled *Ionian Judges*, published in London in June 1863. It had been suggested that Marcoran, at least, had become involved in island politics, but Frank denied it. "A more high minded gentleman ... never sat upon the bench in England," he declared. It was monstrous that these "two Ionian gentlemen" should "one morning, while in active performance of their functions, be relegated into private life by

a notification of the Official Gazette, without the courtesy of the slightest whisper of explanation or the faintest expression of regret." About Gladstone's two-month sojourn on the island, in order to draw up its new constitution, Frank was equally scathing. He accused Gladstone of "considering everyone who differed from himself not simply as unfit to govern but as unfit to have a voice at all".

Lear had hardly arrived in Corfu before he had to leave. His "beautiful rooms" were taken by others and his furniture sold in the auction rooms that he had so often frequented. "I shall sit upon an egg cup and eat my breakfast with a pen," he told Fortescue.[30] In search of a winter home he sailed for Athens with Evelyn Baring. Together they watched "the loveliest place in the world" vanish amid puffs of smoke from the exploding forts. That night Lear wrote a fragment of a Nonsense Song (not to be confused with the limericks). It was his first.

> She sits upon her Bulbul
> Through the long long hours of night
> And o'er the dark horizon gleams
> The yashmak's fitful light
> The lone yaourt sails slowly down
> The deep and craggy dell
> And from his lofty nest, loud screams
> The white plumed Asphodel.[31]

Crete 1864

Flushed out of Corfu, Lear took refuge in Athens, and considered spending the winter there. "Very odd are the recollections of 1848–49," he declared. The Acropolis was still there and so was old General Church, and fat old Andreas, the dragoman of the Peloponnese tour, who touched him for a dollar to his delight. But the houses and streets were all different. The place seemed pervaded by "a queer analytic dryness of soul".[1] The young men on the staff of the British Embassy struck him as particularly silly, "abusing this place and these people, as such fools do all places". His heart, however, warmed to the Ambassador for his efforts to keep "the 'staff' from killing a poor centipede". On an impulse he set out for Crete. After all, he could hardly produce a topography of Greece without covering the largest of the islands, the one that lies, like a ruled line, below the Peloponnese.

Crete was to prove the last of the great adventures. In Lear's day it was little known to travellers. There was only one fairly recent book on it, Robert Pashley's *Travels in Crete*, 1837. The island was in a state of ferment. There had been an insurrection against the Turks six years earlier, and a bloodier one was just around the corner. "Its elements are extremely volcanic," Lear observed in his diary. He was fortunate to find Mr Drummond Hay, a sympathetic British consul, stationed at Hania, the western port at which most visitors disembarked. Drummond Hay lived outside the town, at Halepa, in a beautiful Turkish-style house looking down on Hania (now Khania) Bay. His wife was Spanish. Lear described her as "the most beautifullest and fascinatingest of Spa-

nish ladies'.[2] More fascinating still was the Drummond Hays' four-year-old daughter, Madeleine. Lear made her an animal alphabet and then, not content with that, illustrated the numbers up to twenty. He used to watch her in the courtyard from his window, playing with a monkey, guarded by her Arab servant, Hassan.

Lear planned to make a circuit of Mount Ida, first following the coast eastwards through the ports of Rethymnon and Herakleion. The journey to Rethymnon involved "execrable stone staircase roads". At one stage they had to cross a river which was up to Lear's waist. Being unable to swim, he rode a donkey across. He was getting too old for a place as savage as Crete. The khans of the island surpassed any he had known for sheer filth. They were literally pot-houses, "innumberable little pots hanging on high", and were frequented by "disgusting drunkards" who frequently fought. In one he saw bugs being crushed on the rim of a convenient coffee-pot. At night he could not sleep because of the fleas. In the middle of one sleepless night, he wrote in his diary, "Dreadful suffering So terrible a night and it is only 1.30 now."

In Albania, fifteen years earlier, he would have made a joke of such things. Now they made him bad tempered, and even Giorgio's philosophic calm occasionally cracked. After one sorely trying day he wrote, "George horrid cross; I much more so. The fault was mine." He did, however, laugh when he heard that the ruffians at a khan, where he had left his flea-powder, were taking it as snuff. He began to compare each new sight unfavourably with something he had seen before. The olive trees at Halepa were "dry, squat and humdrum" compared to those at Ascension; the gorges of Mount Ida could not be compared to those of Aspromonte in Calabria, the waterfalls of Topolia were mere echoes of those at Tivoli. Increasingly, his memories were going further back still. At Aghios Thomas, east of Mount Ida, he heard the far-off cawing of rooks, "which brings back the days ... when I first heard the voice of rooks in Sussex." He had seen so many places. "So strange and dreamlike is life."

Yet there were beautiful places in Crete that Lear could admire in their own right. There was Lake Konia (Kourna), for instance, on the way to Rethymnon. The lake lay at the

foot of steep hills and, while Giorgio cooked a midday meal, Lear described the scene in his diary. Beside the lake were shady oaks filled with nightingales that sang all day. Zeriff, the muleteer, "hubble-bubbled" and "4 sitting Cretans gossiped quietly apart". An hour or two later Lear picked up his pen once more. "Lunch is done: the wrens and titmice sing still, Zeriff hubbles, the 4 Cretan creatures sleep, and the sun comes over the oak trees I lie beneath so I move."

The landscape-painter perceives the Moufflons on the tops of the mountains of Crete

A perfect traveller's afternoon. The idyll ended with an unpleasant struggle up the side of the hill to the peculiarly beastly khan at Episkopi.

So long as they were not found in khans, Lear liked the Cretans. He admired the discreet good manners of the shepherds and their magnificent costumes, with sashes and waistcoats and great baggy trousers. He appreciated, too, the impulsive generosity of the children. A little boy was so delighted with Lear's drawing of a donkey that he ran home for a few lemons to offer him. Another brought a gigantic bundle of lettuces and refused to take any back. And there was a charming little Turkish girl in fez and baggy trousers. The animals, too, were agreeable. "The compact trotting horses" covered the ground well, and there was a mule that

could jump fully loaded. The acrobatics of the moufflons or wild goats on vertical surfaces delighted him (until he was charged by an enraged male). Even his greatest enemies in the animal world were less beastly in Crete than elsewhere. He declared "The dogs are all timid, amicable and curly-tailed.".

At Herakleion they picked up a muleteer called Konstandi-nis and turned inland towards the mountain. They walked over the ruins of the palace at Knossos unaware that these were beneath their feet (Arthur Evans, their excavator, was still only a boy of thirteen at the time). Mount Ida proved coy, perpetually drawing veils of mist across her snowy cone. The recognized place for a view was the monastery at Arkhadi, but when Lear reached it, down came the yashmak. He blamed his hosts. "Churlish monx!" Fortunately the abbot, Gabriel Marinakis, proved far from churlish, and healths, "Cretan fashion", were drunk abundantly. Lear little guessed that he was dining with a future national hero. In an insurgence two years later Abbot Gabriel Marinakis, with typical Cretan courage, put a light to the monastery powder magazine, choosing to blow up himself and his monks rather than surrender to Mustafa Pasha. Lear's problem at the monastery was on a smaller scale. "One of the worrying parts of these Cretan travels is the impossibility of *chamber pots*," he declared. Potless, he was obliged to leave the monastery in the middle of the night. "Lo! when I went out, the door shut to I had to roam about to get a priest to open it!"

The journey back to the Drummond Hays was a hard one. When they got there, they were informed that the best view of Ida was to be obtained at the next door village of Phré! There was nothing for it but to set out once more. They reached the house of a man called Tzoustakis and climbed on to the roof, to find, sure enough, a view of Ida, admittedly distant, but "by far the best I have yet seen Never till now have I had much respect for Ida. A dream-like vast pile of pale pink and lilac." Lear spent an atrocious night under the Tzoustakis roof, and was on top of it again, to draw sunrise on Ida, at four thirty a.m. His sketches of Ida at sunset and sunrise are beautifully reproduced on facing pages in *The Cretan Journal*.[3] It is an odd fact that some of

his finest water-colours were produced in the most adverse circumstances, and, often, in very low spirits. This is even more true of the view of Palaiokastro, made early on the Cretan visit. (He had made a brief tour of the western end of the island before proceeding to Mount Ida.) It had rained for twenty-four hours and he was thinking of giving up Crete altogether. Yet he had been told that the ruins of Palaiokastro should be visited. "Very little interest in scenery," he wrote. "A wild grave circle of hills surround this place ... all the distance ... more or less blotted out by cloud." Yet out of this unpromising material, in half an hour, he made a water-colour sketch which, in the opinion of Peter Levi (who saw it in the house of George Seferis in Athens), is "one of my favourite paintings in all the world".[4] Perhaps because of his depression, Lear pared the scene to the bone, leaving only a sweep of lowering grey mountains in the background and a tawny shoulder of hillside in the foreground. The swiftness of execution has given the sketch a lyrical, almost abstract quality, and yet the mountains have extraordinary solidity. "Made what I could of the Palaiokastro sepulchers," Lear wrote dismissively.

Lear spent the last few days in Crete with the Drummond Hays. They were the happiest of the whole six weeks. He was by now besotted with the tiny Madeleine. After dinner on the day he returned, Mr and Mrs Hay went for a walk and Lear, who had been up since dawn, fell asleep on the sofa, "waking to find little Madeleine lying by me with her arms round my neck kissing me and patting my eyes. Darling little child." No line in all Lear's diaries brings out more strongly his sense of physical loneliness.

Lear and Giorgio boarded the ancient steamer *Persia* on 31 May, after the normal "confusions". Lear stood on the deck with Giorgio, pointing out "the multitude of Isles of Greece". Lear's liking for the Suliote continued to grow. He had always admired Giorgio's patience and good manners, calling him "a curiously philosophic man" and "a gentleman in all respects". Now constant contact with Lear had refined him. Giorgio's dry comments on life delighted Lear, who repeated them as a proud parent might. Remarks like, "There is no need to dine with pigs more than once in 24 hours",

or "The nightingale must be an intelligent bird, for he never repeats himself", he found vastly amusing and passed on to Fortescue. It became increasingly painful for Lear to see Giorgio treated as a servant at khans. His own accommodation was bad enough, but he shuddered when he thought of the vile pigeon-holes into which they stuffed his friend. Once Giorgio had to share a room with a large batch of silkworms. His discomfort was doubled because he was not allowed to smoke his pipe. Perhaps the most touching proof of affection was when Lear knelt to cut Giorgio's in-growing toe-nail. "Jesus Christ washed the feet of 12 followers," Giorgio commented. "You may therefore rightly cut the nails of one."

While they were walking, Lear and Giorgio kept up a kind of incessant "chaff". This confused Konstandinis, the muleteer. He was young and his "visage ... promising", but he was somewhat thick in the head. (Also "a very smelly man he is", Lear observed.) There was a more serious side to Giorgio. He was beginning to see landscape through the eyes of individual artists. When he saw a village on a pointed hill he said, "If Mr Williams were here he would have plenty to do," recognizing it as the sort of place that Penry Williams would paint. And he was becoming fascinated by insects and flowers, wandering off during the siesta to look for them. When the ship reached Syra the two men parted, Giorgio making for Athens and Lear for England. "I hate him leaving me," Lear wrote in his diary.

PART V

THE RIVIERA 1864–69

Gussie Bethell 1864–67

In the summer of 1864 Lear decided to marry. He had returned from Corfu to Stratford Place to find "The Cedars" still staring across the floor of his studio at "The Masada". They had been available to the public all through the winter but the public had not availed themselves of them. It was a sign. He was not, after all, a painter. That is to say, he was not a painter of enormous oils. "My pictures can never be perfect," he told Holman Hunt. "They are born with one leg shorter than t'other."[1] So he would marry. He had mentioned this alternative to Fortescue a few years earlier at the same time as lamenting the lack of a £200 a year pension. "Wouldn't I sell all my colours and brushes and damnable messes! Over the world I would rove . . . I would, marrying a black girl at last and slowly preparing to walk into Paradise!"[2]

The Honourable Augusta Bethell was not black, but she had a modest private income. She was the daughter of an old patron of Lear's, Richard Bethell, now Lord Westbury and Lord Chancellor. Gussie was commonly referred to as "poor dear little Gussie". She was a younger sister and homely of countenance. Her chief quality was "sympathy". She had been one of Lear's child-friends, and she had grown up "absolutely good and sweet and delightful, bother!"[3] By the age of twenty-four she had already resigned herself to the role of maiden aunt. Her passion was for the four children of her sister, Emma Parkyns: Violet, Guy, Slingsby and Lionel. She wrote tales of fairylore for them, and had just published these in a book called *Echoes of an Old Bell* (1865). Lear hurried

to call on her on his return from Crete, but nothing was said. The courtship of Gussie was to be a slow affair. It extended over this and three subsequent summers in England. By December 1864 Lear had made no decision about Gussie and it was time to fly south again.

Flushed out of Corfu, he had no winter nest to which he could return. He spent each of the following three winters in a different place, first Nice, then Malta, then Egypt. He disliked Nice, where his rooms at No. 61, Promenade des Anglais were too expensive, and "the atmosphere of swelldom and total idleness" was odious, but like so many Englishmen, he was in search of the nearest warm winter. By comparison with Corfu, Cannes was accessible. You simply took the boat from Dover to Calais and then the train, spending a night at Paris and changing at Marseille. Lear could be there in three days comfortably. The journey to Corfu had taken three weeks. One ship bringing Lear back from Corfu had docked at Zante, Malta and also Sicily. ("Witch fax I only came at graineously, as it were, grain by grain, as the pigeon said when he picked up the bush[el] of corn."[4]) At Nice Lear met a bunch of "jolly, cheerful children", called Charlotte, Hugh and Reginald Fitzwilliam, the offspring of Lord and Lady Fitzwilliam, and relatives of Mrs Wentworth, his first patron.[5] He confessed to taking an absurd amount of time off from his "Tyrants" to write them a story entitled "The History of the Seven Families of Lake Pipple Popple". The families were all of young animals, and they had adventures which did not always end happily. Lear was to write one other story in this style.[6] Neither story was as successful as his verses but they contained the stirrings of what would soon develop into the Nonsense Songs.

In Nice Lear resumed the study of botany that had so fascinated him as a boy. In the hills round Grasse he found some remarkable hybrids; these included Multipeoplea Upsidownia, Bottleforkia Spoonifolia and Piggiwiggia Pyramidalis (the latter a bluebell with piglets in the place of bells). These were submitted to the Fitzwilliam children to further their education and later printed under the name of Professor Bosh in *Nonsense Songs, Stories, Botany and Alphabets* 1871. Professor Bosh included some recipes in his book including one for

Crumbobblious Cutlets, made from strips of beef which required no cooking. The cook was required merely to "place the whole in a saucepan, and remove to a sunny place, say the roof of the house (if free from sparrows) . . . and leave it there for about a week".

Finding Nice a bore, Lear set out with Giorgio on a fortnight's walk along the Cornice (as it was then called) to Genoa (a task not possible since the invention of the motor car). The weather immediately changed. An icy rain descended down the back of his neck. All he saw was obscure torrents, unpleasant villages and roaring sea. "Not one single peacock hue of sea or sky," he wrote in his diary, quoting Tennyson.[7] But towards the end of December the weather improved. At 3.45 pm on 30 December he drew the tawny cliffs at Menton, stretched over the sea like sleeping lions. It was reminiscent of the Cretan drawing of Palaiokastro, pared down and utterly devoid of humanity. The art dealer who sold it to the Liverpool Library in 1944 declared that its "technique was far in advance of its time".[8]

When Lear returned to England for the summer of 1865 he went down to Lord Westbury's stately home of Hackwood Park near Basingstoke. He had decided that he was going to propose to Gussie. It was not, perhaps, a fortunate time to choose. "Miss" was in deep mourning for her mother, whom she had nursed for years, to the point of self-immolation. Immediately doubts assailed the would-be bridegroom. "If her life is sad, united to mine, would it be less so?" he asked himself. Would *his* be less so? And then Gussie's relatives were appalling. She had a string of Honourable brothers (including one called the Honourable Wally). Worse still was her father (now no longer Lord Chancellor) who took Lear for "an endless circulation" of the woodland walk and never stopped talking. He talked about his late wife "of all women the most perfect in mind" (she was in fact an exceptionally stupid woman), about the Italian estates he would leave to the Honourable Wally, about Hackwood which he only kept on "to please Gussie", about his own career in the Lords (quite unimpeded, he assured Lear, by the loss of the Chancellorship), even about God. "If it were not for Gussie's sake, this is the last walk I would ever take

with him," Lear declared. The next day he took the train from Basingstoke, in deep despair. It had been "a trap ... a snare. ... Alas, alas, alas![9] This will I fear be my last visit here."[10] He was back in August to try again, but by now the flame was burning low. Gussie did her best to bring him to the point by singing soulful songs at twilight. "Gussie, poor dear, played the *Cloches du Monastieri* [sic] and for a moment one's heart returned",[11] but not for long enough. He left for Venice, vowing once more never to return. It was Lady Waldegrave who offered an expenses-paid trip to the lagoons. She was in need of more pictures for Strawberry Hill, and presumably couldn't afford Canalettos. Lear did not care for Venice. He cared for it even less when he saw the effect of "thickphoggs" on all that water. At heart Lear was a landsman, finding poetry in "plains, or mountains, or woods or rox". His paintings of Venice were detailed but humdrum. Ignoring Turneresque effects of light on water, he made drawings of streets of palazzi so dull that he could have copied them from prints.[12] After a few weeks he caught a heavy cold. "Nor must I podder any more by canal sides and in gondolas," he told Drummond.[13] He prepared to leave for Malta but just before he went he heard a piece of very good news. While breakfasting at the Danieli, he observed in *The Times* that Fortescue had been appointed Irish Secretary.

I threw the paper up in the air and jumped aloft myself – ending by taking a small fried whiting out of the plate before me and waving it round my foolish head triumphantly, till the tail came off and the body and head flew, bounce, over to the other side of the *table d'hôte* room. Then only did I perceive that I was not alone, but that a party was at breakfast in a recess. Happily for me they were not English, and when I made an apology, saying I had suddenly seen some good news of a friend of mine, these amiable Italians said, "Bravo, sir. We too rejoice. If we had some little fish we would throw them all over the place too!"[14]

Lear disliked Malta almost as much as he disliked Venice, but he went there because his "intimate friend", Evelyn

Baring, was there with Sir Henry Storks. He arrived only to find that both Baring and Sir Henry had left for Jamaica. *"Shocking!"* Worse still, he could only find rooms at Sliema, even further round the bay than Harry's house had been. Valletta was three miles away, unless he made "a detestable crossing by boat". This made it necessary for him to hire a Maltese servant to assist Giorgio who was "often unequal". The house was a vast one and eerie at times. There were "inscrutable" noises, sounds of creaking and strange echoes. Lear, rather surprisingly, confessed to a "strange dread of new places", which he had had since childhood.[15] Also he didn't like the colour of his apartment. "My rooms are painted one blue, one orange, one green."[16] The people who visited his studio were idiots. "Because I cannot have some three or four hundred visitors lounging in my room I am dubbed ... a savage." Their incessant questions were "ludicrous". In the spring he travelled home via Corfu, dropping Giorgio off there. He walked for the last time up to Ascension, beneath "the loved olives" and gazed again upon the "Paradise"[17] of sky, sea, and mountains that he had first seen nearly twenty years ago. Would Gussie like to live there? he asked himself.[18] All his former resolutions forgotten, he went home to find out, and called on her at her father's London house the day after his arrival.

Gussie was not at home, but he was invited there to dinner a few days later. "Would this, the last dream, burst like a bubble?"[19] He decided that it probably would, and departed after dinner without saying anything, leaving the unfortunate Gus in suspense. Then Lady Waldegrave gave him some advice. Gussie, she declared in her forthright manner, was a young woman with an inadequate portion and Lear was in no position to support her. This stark helping of reality brought him out in a rash all over. Now, for the first time, Gussie took the initiative. She started to send her sister, Emma Parkyns, round to Lear's studio at Stratford Place and on several occasions he pretended not to be "at home". "I dread the re-opening of the Gussie Question," he wrote in his diary. On an impulse he decided to leave England for ever, even giving up the last year of his lease at Stratford Place. He would fly away to the Nile and rejoin the pelicans.

Ploffskin, Pluffskin, Pelican jee,-
We think no Birds so happy as we!
Plumpskin, Ploshkin, Pelican jill.-
We think so then, and we thought so still. [20]

On this second trip up the Nile Lear was not lucky enough
to be alone. He went with his cousin Archie, from Canada,
a man of so little sensitivity that he was capable of "finishing"
Philae ("more beautiful than ever") in three hours. Fortun-
ately Archie was a compulsive shopper, and when he wasn't
rifling the bazaars he was occupied with labelling his "affle"
nice purchases. "I often feel any amount of loneliness is
necessary at times," Lear observed to his diary. [21] Lear trav-
elled as far up the Nile as the Nubian desert this time. His
water-colours became elongated, like bookmarkers on their
sides, and the predominant colour was sand. As usual he wrote
directions on them himself. On one of Denderzh, made at
9.15 am on 2 February 1867, he wrote "sand", "perfectly
smooth yolk-of-egg sand", "more sand" and "infinite
dust". [22] The stay in Egypt was followed by a brief, unsuccess-
ful attempt to see Nazareth and Galilee which he had missed
on his previous visit to the Holy Land. The sight of the Easter
pilgrims pouring through Bethany was too much for him.
He felt one of those sudden revulsions he had felt at Larissa.
In spite of his resolutions he returned to England.

The summer of 1867 was over when he received yet another
invitation to go down to Hookwood Park. Not only did he
accept, but he took with him two trunk loads of *roba*, prepar-
ing for an indefinite stay. "I do not say I have decided to
take this leap in the dark, but I say I am nearer to doing
so than I ever was before," he wrote in his diary. [23] On the
Sunday morning, no doubt after church, he asked for a pre-
liminary interview with Emma Parkyns, the go-between, to
inform her of his intention. She told him that he and Gussie
"could not live together happily". [24] This, after she had encour-
aged him to make an offer to her sister for four years! This,
when they had just invited him to stay for an indefinite period!
The ways of women were indeed strange. Once and for all
the dream was shattered; Lear left at once. Dignified resigna-
tion was the only answer. He must "accept a lonely destiny

... and make the best of it".[25] "It was decreed that I was not to be human," he wrote in his diary some years later.[26] Once more he left England abruptly, not even informing Fortescue, who had waited in all day at Carlton Gardens, nursing

a boil in an unmentionable place.[27] Before he left Lear did, however, find time to write a story for Violet, Guy, Slingsby and Lionel, entitled "The History of Four Little People who went Round the World".[28] He also let Louisa, Lady Ashburton have "The Cedars" for £200.[29]

John Addington Symonds 1868–69

> Down the slippery slopes of Myrtle
> Where the early pumpkins blow,
> To the calm and silent sea
> Fled the Yonghy-Bonghy-Bò.
> There, beyond the Bay of Gurtle,
> Lay a large and lively Turtle; -
> "You're the Cove," he said, "for me;
> "On your back beyond the sea,
> "Turtle, you shall carry me!"
> Said the Yonghy-Bonghy-Bò,
> Said the Yonghy-Bonghy-Bò.

The turtle carried Lear, slighted in love like the Yonghy-Bonghy-Bò, to Cannes where he was to spend the next three winters with increasing dissatisfaction. There he met a man who was a warning against matrimony. John Addington Symonds (Johnny to his friends) had tried marriage as a cure for homosexuality and it had led to tuberculosis and a massive lung haemorrhage. Three years previously he had married Catherine North, sister of Marianne, whose piano Lear had played at Hastings. Now he was travelling Europe with his wife and small daughters, in search of a cure. Although only twenty-seven years old, he looked like a gaunt scarecrow. Symonds, Lear and Catherine composed a poem together:

Lear: "What makes you look so black, so glum, so
 cross?
 Is it neuralgia, headache or remorse?"

Symonds: "What makes *you* look as cross, or even more
so?

 Less like a man than is a broken Torso?"

Catherine (exasperated with Lear's perpetual moaning):
"Return at once to cold, stewed, minced,
hashed mutton,

Two wristbands ever guiltless of a button . . .

To make large drawings nobody will buy,

To paint oil pictures which will never dry,

To write new books which nobody will read,

To drink weak tea, on tough old pigs, to
feed."[1]

In Cannes that winter Symonds "knew the utter blackness
of despair". "The last night I spent in Cannes was the worst
of my whole life. I lay awake motionless, my soul stagnant,
feeling what is meant by spiritual darkness. . . . Catherine
who kept hold of me, seemed far away." The quotation is
from Symonds's extraordinary memoir, only available to the
public since 1976.[2] In writing it, he sat down "soberly to
contemplate my own besetting vice". Since Lear may have
shared Symonds's problem, this remarkable document is
worth a mention. Symonds had picked up a liking for "Greek
love", as he called it, as a boy at Harrow. He had stayed
up reading Plato's *Symposium* all through one long summer
night until the sun lit the bushes outside the window. He
had read, enthralled, of the dinner-party at which Socrates
discussed types of homosexual love with his young men, but
firmly resisted the attempts of the handsome Alcibiades to
seduce him after dinner under his cloak. Symonds too had
not at first allowed himself full physical expression of that
kind of love, and he had married in an attempt to stifle it.
Lear met him at Cannes at the moment of crisis. Made desper-
ate by the falseness of his position with Catherine, he had
decided to become a full, practising homosexual. He would
surrender himself sexually to "male beauty and vigour" while
remaining husband and father. He still preferred a woman
for his "life companion". But whereas in the past "Corsican
drivers, Florentine lads upon Lugarno in the evenings, *facchini*
[porters] at Venice, and especially a handsome Bernese guide

... all these dragged at the sleeve of my heart",[3] now they would gain admittance. Catherine must learn to look the other way when the gardener emerged from her husband's study adjusting his belt.

It is not known whether Lear and Symonds discussed their "congenital malady". It would surely have been to their advantage if they had, for Victorian homosexuals were fearfully alone. Symonds describes the immense relief he felt at the end of his life when he read Krafft-Ebing, and discovered "my history is only one out of a thousand". The two men must surely have discussed the writings of Ancient Greece for Symonds was compiling his *Problem of Greek Ethics*[4] about Hellenic homosexuality. We know they discussed Walt Whitman (whose *Leaves of Grass* had appeared a decade earlier) and if they discussed Whitman they discussed the poem "Calamus". Symonds had no doubts about the true nature of universal comradeship recommended in "Calamus". It was nothing other than man's "impassioned love for man".[5] Whitman later hotly denied Symonds's interpretation. It is impossible to leave the subject of Symonds without mentioning his version of Giorgio, a gondolier called Angelo Fusato. Symonds bought Angelo a gondola, and, some time after his meeting with Lear, Angelo became a permanent member of Symonds's household. Like Lear's Giorgio, he was "strikingly handsome", with "the wild glance of a Triton";[6] like Giorgio he eventually confessed to a wife (or woman) and children. In both cases the master became a family friend, helping the servant's relatives with loans and introductions.

It was for three-year-old Janet, Symonds's enchanting oldest daughter, who was ill in bed at Christmas, that Lear wrote and illustrated the poem, "The Owl and the Pussy-cat", his first complete Nonsense Song and the only one with a happy ending.[7] While Symonds made his love poems acceptable by changing the sex of the loved one, Lear chose to express his emotional despair under the guise of fantasy. For he, surely, was the Owl and Gussie the Pussy-cat. "The Owl and the Pussy-cat" was printed in Lear's second Nonsense book, in 1871. This was entitled *Nonsense Songs, Stories, Botany and Alphabets*. The eighteen-seventies were to be the decade of Lear's Nonsense Songs, just as the eighteen-thirties had

been the decade of the limericks. The limericks had by now proved phenomenally successful. In 1863 a tenth edition of the original *Book of Nonsense* appeared. Forty-three Old Persons had been added to the original. The first American edition had just come out with William Hazard of Philadelphia. Yet this success had brought Lear surprisingly little personal recognition. He told Lady Waldegrave of an incident in England a year or two later:

A few days ago in a railway as I went to my sister's a gentleman explained to two ladies (whose children had my "Book of Nonsense") that thousands of families were grateful to the author (which in silence I agreed to) who was really Lord Derby: and now came a showing forth, which cleared up at once to my mind why that statement has already appeared in several papers. Edward Earl of Derby (said the Gentleman) did not choose to publish the book openly, but dedicated it as you see to his relations, and now if you will transpose the letters LEAR you will read simply EDWARD EARL. – Says I, joining spontanious in the conversation – "That is quite a mistake: I have reason to know that Edward Lear the painter and author wrote and illustrated the whole book." "And I," says the Gentleman, says he – "have good reason to know Sir, that you are wholly mistaken. *There is no such person* as Edward Lear." "But," says I, "there *is* – and I am the man – and I wrote the book!" Whereon all the party burst out laughing and evidently thought me mad or telling fibs.

So I took off my hat and showed it all round, with Edward
Lear and the address in large letters – also one of my cards,
and a marked handkerchief: on which amazement devoured
those benighted individuals and I left them to gnash their
teeth in trouble and tumult.[8]

It was Symonds's idea to go to Corsica in April 1868. They
travelled together as far as Ajaccio, then Lear went on alone.
He did not travel in his normal way. He seemed eager to
get the journey over as quickly and comfortably as possible.
He hired a two-horse carriage and he paid the price. On a
precipitous mountain road the drunken driver went berserk.
"He took a fit of cursing . . . and of beating his poor horses
on the head. In this instance they backed towards the precipice
and the coachman continued to beat. The result was hideous
to see." There were screams and a splintering crash as carriage
and horses cascaded down the rocks until they came to rest
in a clump of chestnut trees. "A ghastly sight. I can't get
rid of it. One horse killed, the other horribly injured. The
little beast of a driver not so badly hurt as he ought to have
been."[9] Luckily Lear had chosen to walk up the mountain
behind the carriage, no doubt to spare the horses! In spite
of everything, Lear made some inspired drawings particularly
of the Forest of Bavella. He arrived at this extraordinary place
just as the mist was rising to disclose "the whole forest, as
it were, in the pit of an immense theatre confined between
towering rock-walls".[10] He was to use the subject in three
oil paintings.[11]

Later that summer of 1868 he paid a visit to England, being
careful to avoid Gussie. "Verily, this coming to England is
Hell."[12] He felt lonely even with his friends. He was closer
to them by letter. There was a ghastly fortnight at Southbor-
ough, near Tunbridge Wells, with Frank and Kate during
which not only "the dear boy" but his wife, excelled them-
selves in silence. It made him "foam and burst".[13] "The
melancholy of the Lushington atmosphere culminates on Sun-
day," he wrote. Frank read famous sermons aloud. "It is
absolutely dreadful."[14] But Gertrude, his goddaughter, was
a consolation, "the sweetest, and funniest creature" who sent
him into fits of laughter by reciting "The Owl and the Pussy-

cat". When Gertrude became provoked by her father's constant allusions to the "beauty spots" of Greece, Lear wrote a poem about them. It began,

> Papa once went to Greece,
> And there I understand
> He saw no end of lovely spots
> About that lovely land.
> He talks about these spots of Greece
> To both Mama and me
> Yet spots of Greece upon my dress
> They can't abear to see!

Even with Fortescue, he felt less comfortable now that he led a life of "whizzy pleasure". Lady Waldegrave had become a close friend of the Duc d'Aumale, the fourth son of King Louis Philippe, who had escaped to a villa in Twickenham in 1848. (D'Aumale was no faceless royal exile, but a distinguished soldier and historian, who returned to France after twenty years in exile to become a member of the National Assembly.) At Strawberry Hill, Lady Waldegrave established a mini-court for him. But Lear found the mindless gossip of his courtiers and the "check-chock" of billiard balls intolerable and told Fortescue so. He had become quicker than ever to take offence, and some suspected slight during a visit, like being taken to the train too early, would precipitate a thank-you letter that was anything but thankful.

Farringford House was also impossible. He had been there again in 1864. "I found all that quiet part of the island spoiled. . . . Not only is there an enormous monster Hotel growing up in sight, but a tracing of the foundations of 300 houses, a vast new road and finally a proposed railway cutting through John Simeon and A.T.'s grounds from end to end."[15] The poet was hard at work raising an immense bank to obscure the ugly sights before his study window. This, planted with trees, remains.

Lear spent the period after Christmas at Cannes working on the Corsican journal. He planned it as a companion volume to a Riviera journal (which never appeared), having the same format as the Calabrian and Albanian journals. He had ceased to work on the Cretan journal. The task of preparing the

woodcuts for the forty Corsican vignettes was a laborious one. As the Symonds family had left, he took to inviting Giorgio in for a drink and a cigar in the evenings. He now lived in cheaper rooms at the Villa Montaret, 6 Rue St Honoré, overlooking the beautiful bay at Maison Guichard, since the "sheep foolies", as he called his customers, had not bothered to visit his studio when it was in front of their noses. He did not like it: "My floor, or flat, here is very unsatisfactory in some points i.e. being in a house with three other floors full of people. Noises abound." There followed the usual litany of complaints.[16] He failed to mention at least one consoling feature of Cannes in the winter of 1869. He met Prosper Mérimée, author of such witty and learned novels as *Colomba*. Mérimée was in the last melancholy year of his life, but he could understand an artist, for his father had been a painter. In the spring Lear went to Paris, where Mérimée had recommended an engraver for the forty plates for the Corsican book. In fact, as Lear told Holman Hunt, no engraver, French or English, could do justice to the sensitive lines of his drawings[17] and he was right. One does not associate Lear with Paris, and he did not care for the place. He took a north-facing room at the Hotel du Louvre in the Rue St Honoré where he always stayed, when passing through, and paid ten francs extra for the "Bedlam" of a *table d'hôte*. He saw only engravers and waitresses. "Nobody," he told Fortescue, "takes the slightest notice of me, save a small . . . Spanish baby . . . made of Spanish Liquorice who is . . . in the corridor at all hours."

By the time Lear returned to London he was heartily sick of the "Corsican horror of a book . . . which I would flee from altogether if . . . tenacity (or pig-headedness) . . . would allow me ever giving up anything I take in hand."[18] He had come home only to see the book through the presses of Cassell, Petter and Galpin, and to write to subscribers. It was due out at Christmas, under the title of *Journal of a Landscape Painter in Corsica*, and was to sell at one pound. He left England on 10 December. To Fortescue he wrote, "I doubt under any circumstances my coming to England next summer. Life has been of late simply disgusting to me there, and I have seen only glimpses of those I care for."[19] This time his exile

would be permanent, he vowed. He longed to flee those dinner-tables of which he made such meticulous plans in his diary.

> O dear! How disgusting is Life!
> To improve it O what can we do?
> Most disgusting is hustle and strife,
> And of all things an ill fitting shoe.

He was approaching sixty and he planned to "await death" somewhere far from home, either in one place "or running about continually like an ant".[20] He felt utterly "dimbemisted – cloudybesquashed"[21] as to future plans. On the whole he favoured the idea of settling in one place. He did not count on staying there for twenty years.

PART VI

SAN REMO 1870–88

Villa Emily 1870–71

The problem was *where* to await death. Cannes might have
seemed the obvious choice, being so easily accessible by rail
from England, but, after months of agonizing, Lear decided
to build a house just up the coast at San Remo, which he
had visited and found rather "bald" on his Riviera walk five
years earlier. Land was cheaper in Italy, and there was less
danger of some "Belgravian idler" putting a house between
his and the sea. (How little Lear knew!) At San Remo he
met a civilized public-school man called Walter Congreve,
and there happened to be a plot for sale next door to his
house. That clinched the matter.

It was a major decision. Lear had never owned a house.
All his adult life he had lived in lodgings or hotels. He wrote
to Woolner, breaking the news. "I have bought a bit of
ground at San Remo and am actually building a house there.
As I have sold no drawings and have no commissions ahead,
I shall endeavour to live upon little figs in summertime, and
on worms in winter."[1] Lear had no intention of living on
figs and worms. He intended to live, partly at least, on his
friends. The letter to Woolner was itself a thinly disguised
begging letter. Fortescue received a more open request, and
equally openly refused it. "If I had £300 or £400 you should
have it without interest – but our mode of life is so expen-
sive."[2] Lear was not without capital. He had saved £3,000
during his working life. If the house and land cost £2,000,
he would invest the remaining £1,000 to live on. This would
bring in the lordly sum of £30 per annum.

Needless to say, there were delays. The villa took eight

months to build. Lear moved to a hotel in San Remo on 22 June 1870 to see the foundations laid. Then he was obliged to move to the Alpine village of Tenda, near Cuneo, because of the heat. He stayed in a converted monastery, the Certosa del Pesio, "a beastly place" which had been converted into a pension with two hundred cells. Worst of all, like so many men after retirement, his health took a sudden turn for the worse. He mentioned it quite casually as item twenty-seven in a letter of thirty-five numbered items to Fortescue. "I must tell you that I have been at one time extremely ill this summer. It is as well that you should know that I am told that I have the same complaint of heart as my father died of quite suddenly. I have had advice about it, and they say I may live *any* time if I don't run suddenly, or go quickly upstairs." He had run up a little rocky slope near Tenda "and palpitations were so bad that I had to tell Giorgio about it, as I did not think I should have lived that day through".[3]

Sitting at the hated communal *table d'hôte* in the hotel and surrounded by seventy strangers, did not improve his condition, until dear little Arthur and his dearer little sister arrived with their mother. Arthur's sister described their meeting with Lear in her memoirs:

One day there appeared at luncheon sitting opposite to us a rosy, grey-bearded, bald-headed, gold-spectacled little old gentleman who captivated my attention. My mother must have met him before, for they greeted each other as friendly acquaintances. Something seemed to bubble and sparkle in his talk and his eyes twinkled benignly behind the shining glasses. I had heard of uncles; mine were in America and I had never seen them. I whispered to my mother that I should like to have that gentleman opposite for an uncle. . . . The adoption took place there and then. . . . He took me for walks in the chestnut forests; we kicked the chestnut burrs before us, "yonghy bonghy boos", as we called them; he sang to me "The Owl and the Pussy-cat" to a funny little crooning tune of his own composition; he drew pictures for me. I still have a complete nonsense alphabet, beautifully drawn in pen and ink and delicately tinted in water colours, done on odd scraps of paper, backs

of letters, and discarded manuscript. Every day Arthur and I found a letter of it on our plate at luncheon, and finally a title-page for the collection, with a dedication and a portrait of himself, with his smile and his spectacles, as the "Adopty Duncle".[4]

By October Lear had moved back to San Remo, Giorgio was on his annual leave in Corfu. The villa looked as if it would never be finished. They had promised he could use the studio by January, but now he doubted it. Suddenly his nerve cracked. He would sell everything and go to America. Instead he stayed and sank into one of his deeper depressions. "I review my whole life in such hours, and full of evil as it undoubtedly is, I am obliged to conclude . . . that the 'particular skeleton' . . . was not of my making, [commencing] when I was 5 or 6 years old."[5] He referred, as usual, to his epilepsy. A few months later the death of Frederick Harding reminded him of another irreversible misfortune of his childhood.

In March 1871 Lear moved into the new house. He called it Villa Emily (not, he insisted, after Emily Tennyson, but after his New Zealand great-niece). It was an impressive stucco villa in the Italian style. There were seven windows along the façade on both floors with an iron balcony running beneath the upper ones. Three of these lighted his studio. The lower ones all gave on to the terrace. The setting was equally delightful. The villa, which faced south, was perched high above the bay of San Remo, where the Alps descend to the sea, and the garden, a former olive orchard, went down like a flight of steps in front of the house. Lear, the master of a house at last, walked enchanted through spacious rooms. "I never before had such a painting room, 32 feet by 20 – and with a light I can work by at all hours, and a clear view over the sea."[6]

He set about furnishing his palace with stuff that had been stored at a cost of £30 a year in the London Pantechnicon. Here Frank was able to help, for in 1869 he had at last, after ten years out of office, been appointed Metropolitan Magistrate at the Thames Court. This made it possible for him to arrange a certificate of London residence for Lear, a necessary

form for getting furniture exported duty free. Now out came all the tables, cupboards, beds and, best of all, the "Fortescue", a vast knee-hole desk that "the dear kind old fellow" had given him some years earlier for Stratford Place. This found a home in the new library where "twittery birds" alone broke the silence.

No sooner did Lear have a studio than he was back at work. "I am not yet become a vegetable," he told Lady Waldegrave.[7] "I am going to do a big second [Nile] Cataract for next year's Academy, and a big something else for the International," he wrote. He also set about completing the impossible task of "topographising" Europe with pen and pencil. "I should certainly like, as I grow old ... to work out and complete my topographical life, publish all my journals illustrated, and illustrations of all my pictures."[8] He submitted three water-colours to the Old Watercolour Society, in an attempt to gain membership. "They elected 6 new members. Me not."[9] Admirers of Lear may find it surprising that he was not accepted as a water-colourist in his day, but two points must be remembered. It was not his swift water-colour sketches, so much admired today, that he submitted to the society, but his studio water-colours. These, as Hofer points out, were the "stained drawings" in the eighteenth-century style, the work of pencil rather than the brush.[10] Lear never attempted "tinted steam" à la Turner. In the opinion of Philip Hofer, his style as a water-colourist was formed by 1846, before he left Rome. As Brian Reade puts it (Arts Council Exhibition Catalogue, 1958), he remained faithful to "Neo-Classical-Romantic conventions applied to 'dramatic' or 'picturesque' landscape."[11]

On the literary side, he worked on an Egyptian journal which was probably never completed and apparently no longer exists. But even Lear could not work all the time and friends were thin on the ground apart from Congreve next door. Congreve lived by taking pupils and letting out a few villas. What had begun as a casual acquaintance soon deepened over the garden fence, although Congreve was always reserved. His past was tragic. A Rugby man, he had just been appointed second master at Marlborough when his second wife became ill and he had been obliged to bring her

to Italy. There she and their eldest son had died, leaving him with two younger boys, Hubert and Arnold.

Forty years later Hubert recalled his first meeting with the new gentleman next door.

> One evening in the early autumn . . . I ran down the steep path . . . [from] our house . . . to meet my father; I found him accompanied by a tall, heavily built gentleman, with a large curly beard and wearing well-made but unusually loosely fitting clothes, and what at the time struck me most of all, very large, round spectacles. He at once asked me if I knew who he was, and without waiting for a reply proceeded to tell me a long, nonsense name. . . . This completed my discomforture. . . . Laying his hand on my shoulder, he said, "I am also the Old Derry down Derry, who loves to see little folks merry; and I hope we shall be good friends."[12]

They did become good friends. Lear frequently invited Hubert to his studio to see his drawings, and happy hours were spent while Lear reminisced about his journeys. He offered both the boys drawing lessons. After the first lesson he noted in his diary, "Gave the two young Congreves their first lesson in drawing; they are the nicest little coves possible."[13] He became convinced that Hubert, in particular, had a gift, and advised him to take up art as a profession. He, in turn, drew them. A pair of boys in straw hats and knee breeches bask in the shade of olives in a painting entitled "San Remo from the Villa Congreve" (1870).[14] Above their heads is a view of the city and, beyond it, the cobalt bay. Normally Lear would have placed a group of peasants where the Congreve boys are. Lear called frequently on the Congreves, "dropping in often at our midday meal, when he would sit, generally without taking anything, beyond a glass of his favourite Marsala". Sometimes he strolled over in the evening, when he "delighted us all by singing his Tennyson songs, set to music by himself, which he sang with great feeling and expression and with what must have been a fine tenor voice. He accompanied himself on the piano with spread chords, of which he was very fond. He generally finished up with some humorous

songs, sung with great spirit, our favourite being 'The Cork Leg'."[15]

The rest of San Remo society Lear classed as acquaintances rather than as friends. Many of them were winter visitors. Immediately below Lear's villa lay the property of Lady Kay-Shuttleworth, who most unfortunately died the year Lear moved in. The property was inherited by the apparently agreeable Ughtred Kay-Shuttleworth, and his wife, a sister of Catherine Symonds. Kay-Shuttleworth was MP for Hastings. Then there was the Rev. Henry Tozer, who had written the book on the Aegean Islands. Lear gave a dinner and invited Miss Percy (presumably one of the Percys) and Mr Baring (certainly one of the Barings). "*You* may say they were sick directly afterwards," he told Fortescue.[16] He probably was himself. He had started to have bilious attacks or "accidents", and had to be careful.

For commune with true friends Lear turned to letter-writing. He confessed that it was "my principal delight". He did it on Sundays in the library and wore a tail-coat for the occasion. It was hard for his busy friends to keep up their end of the correspondence. Fortescue, now at the Board of Trade, was constantly scolded for not writing. Lear even suggested that he should give up "the Bored" and come to be consul in San Remo![17] "I do not much suppose we shall ever talk as of old, until we come to sit as cherubs on rails."[18]

The garden was Lear's other recreation. He had started to design it before he moved in: fencing and planting cypresses. A rose pergola on metal arches was erected below the terrace. Roses increasingly delighted Lear:

> And if you voz to see my roziz
> As is a boon to all men's noziz –
> You'd fall upon your back and scream –
> "O Lawk! O criky! it's a dream!"[19]

It was evident that a gardener would be necessary, and young Giuseppe the bandy-legged (but otherwise not bad-looking) was hired. Giorgio was prepared to do light work in the garden but Lear did none at all. He drew himself wielding watering-cans or plucking giant caterpillars in a large

straw hat, but it was all a joke. He preferred to view the garden from the terrace and to attend to the terracotta pots there.

In fact his friends did visit him. Frank came during Lear's first October in the new house (1871), not accompanied by his wife. The two men made a little tour along the coast to Genoa. In August Lear had seen the Knights in Rome. He had visited the city to avoid the problem of Giorgio's holiday, and had some rude things to say about bumptious priests. He was just settling down to his first winter in the new home when he received a most unsettling suggestion. Thomas Baring (now Lord Northbrook) offered him a six-month visit to India, "tin carte blanch".

India 1872–75

Lear temporized about India for a year. At the end of March 1872, he went to Cannes to discuss the matter with Lord Northbrook, who by then was on his way east to take up the post of Viceroy. He began to envisage life in the vice-regal retinue. He doubted if it would suit him, "always accustomed from a boy to my own ways uncontrolled". He would prefer, if he went at all, to travel independently, paying Northbrook in drawings. He had always longed to see "the Himalayas, Darjeeling, Delhi, Ceylon etc", but he longed even more to stay at home and get on with the planting at the Villa Emily. He had also just acquired Potiphar, a cat.

Still undecided, he went to England in spite of his vow never to return. He required a new set of false teeth and more spectacles. The visit was to be to London only. "I will never again commence the ineffable worry of distant hurried journeys to country houses, at serious expense," he vowed.[1] In fact he travelled the shires as usual until he was on the point of turning into "a railway whistle or a boiler about to bust".[2] To his alarm he discovered that he had picked up nearly £1,000 worth of commissions for paintings of India! When Northbrook sent him £50 for a drawing of Cairo, to be executed on the way out, the deal was clinched. India it must be.

Just before leaving England Lear hit his temple in a fall and injured his right eye. (He never fully recovered the sight in it.) Somewhat shaken, he nevertheless travelled to San Remo to collect his luggage, then to Corfu to pick up Giorgio (who had taken Potiphar there and lost him). Frank had advised Lear to take Giorgio to India on account of his failing

health. In some ways this was a mistake, for a *sahib* who travelled with a white *wallah* was considered not quite *pukka*, and might even be suspected of depravity.[3] An Englishman was expected to travel with several Indian servants in his retinue, who, in Lear's opinion, would quarrel like Arabs.

When he reached Suez, Lear suffered something approaching a brainstorm. He had booked a passage to Bombay on a French ship which was about to depart. Half his baggage was already in a lighter on its way to the ship, when a customs official (a breed he never cared for) ordered it to be transferred to another lighter for no apparent reason. Lear, his injured temple throbbing under the sun, refused, at which the customs officer mounted his high Arab horse and departed. Lear turned on his heel and also departed – to San Remo. Afterwards he attempted to analyse his state of mind. "In vain, in vain I look back in search of a reason for the deterioration of health and mind in those days at Suez.". He felt that his irrational fury savoured of insanity. Could his brain be deteriorating as a result of epilepsy? Yet he had suffered a similar violent swing of mood at Larissa in Albania in 1849, he noted in his diary. That was after parting with Lushington.[4]

Lear now dug in at San Remo for the winter with a new cat. The cat was called Foss, and was a year old, being the brother of Potiphar. Foss was somewhat ill-supplied in a certain quarter, having only half a tail, but nevertheless always carried his whiskered stump at a jaunty angle. There was a superstition in certain parts of Greece that a cat "will never leave the house where it left that useful member."[5] Giorgio was determined not to allow Foss to suffer the fate of Potiphar. Lear at first took a somewhat distant attitude to Foss, and once banished him to the kitchen for tearing up letters (an unforgiveable crime). But gradually he admitted that the animal was "a sort of companion". In fact Foss was to take up an increasingly large space in Lear's life so that, in the sketches he made in his letters, it became almost as large as its master, with eyes like saucers. Lear even gave a Fossical Dinner for the Congreves. The menu ran:

Soup	Potage au Petit Puss
Fish	Queues de Chat
1st Entrée	Oreilles de Chat, Frites a la Kilkenny ...

The main course was, of course, "Gros Chat Noir". Foss, fortunately, was a tabby. What the guests actually received was what they always had at Lear's villa, according to young Hubert Congreve: "Soup, mutton pilaf and a plain pudding, Giorgio Kokali . . . not being strong as a cook."[6]

With a good fire going in the library, Lear settled down in the evenings to read some of the books that he had always meant to read. He chose the letters of Horace Walpole (1717–97), the famous queen of Strawberry Hill, and was delighted by the wit and malice of many of the volumes. When he

Foss

reached the end of the book he felt it like a death. "There is nothing like a diary of letters for showing the real nature of the writer."[7] Still hungry for memoirs, he now read those of Thomas Moore in eight volumes,[8] "a more loveable character than Horace Walpole but he was not so wise".

He continued to work in his studio during the day. The gallery was now open to the winter visitors at San Remo, who proved just as stupid as those at Cannes. When a visitor to the "Eggzbbission" asked if a beech tree in one of the Tennyson paintings was a palm, Lear said it was a Peruvian

Broccoli. There were five unfinished oils on display, illustrating themes from Tennyson that he was to use later in his book illustrations. There were also ninety-nine water-colour drawings.

In April he was "very ill indeed ... eight or nine days in bed, and with a slow recovery".[9] He was probably suffering from heart trouble, again, for he anticipated instant obliteration. He decided the cause was the sedentary nature of his life "after moving about as I have done ever since I was 24 years old. ... And although I may be finished off equally suddenly if I move about, yet I incline to think a thorough change will affect me for better rather than wusse."[10] He had decided to go to India after all.

Meanwhile the Akond of Swat was much on his mind, as he explained to Fortescue in twenty-two rhyming couplets with chorus:

Who, or why, or which, or *what*, is the Akond of SWAT?
Is he tall or short, or dark or fair?
Does he sit on a stool or a sofa or chair,
 or SQUAT,
 The Akond of Swat?

The Akond was, of course, a real (and sometimes troublesome) person "of whom one has read in the papers". He ruled a region on the North West Frontier. The Fortescues immediately launched the song in London society and soon rooms full of crinolined ladies and whiskered gentlemen were belting out Squat, Hot, Blot and Garotte, as loudly as Lear instructed.[11] "It delighteth in some quarters" here too, Lear declared modestly. It was at this time that he wrote "The Pobble who has no Toes". In an alternative version,[12] an additional character is introduced, the Princess Bink, who grants the Pobble her hand on condition that he surrender his toes. "To place in my Pa's museum collection, as proof of your deep genteel affection." This matrimonial turn of events may have been introduced after the news of Gussie's marriage arrived. She had married an elderly invalid called Adamson Parker, against the wishes of her family. Lear was outraged that she should have given herself to a man far more gravely incapacitated than himself. Again India seemed the

only answer, but now Lear saw it more as a flight into death than away from it. He made a new will and put his papers in order, starting with all the letters he had ever received, wondering that "one of the most selfish and cantankerous brutes ever born" should have so many friends. He kept Fortescue's complete correspondence and those of Ann and Lushington. Of the rest, he retained specimens of letters from four hundred and forty-four writers, thinking, he told Fortescue, "that my life, letters and diaries would [one day] be . . . interesting".[13]

A boat for India could now be boarded at Genoa, since the Suez Canal had been completed. Once more Lear had second thoughts at the foot of the gang-plank. Perhaps after all he was not ready to cross the Styx. When the ship was delayed by a day he ordered his luggage off and prepared to return to San Remo for the second time. But the ship and he sailed together on 25 October 1873. The tedious voyage lasted a month and the most tedious parts of it were the "horrid German, Gerwomen and Gerchildren on board". He recorded a conversation with a certain Gerpessimist.

G.P. You vear spegtacles alvays?
E.L. Yes.
G.P. They vill all grack in India, von pair no use.
E.L. But I have many pairs.
G.P. How many?
E.L. 20 or 30.
G.P. No good. They vill all grack. You should have got of silver.
E.L. But I have several of silver.
G.P. Dat is no use; they will rust; you might got gold.
E.L. But I have some of gold.
G.P. Dat is more worse; gold is always stealing.[14]

Lear and Giorgio arrived in Bombay on 22 November 1873. Lear's reaction to India was, as might be expected, mixed. As so often in his travels, a mood of ecstasy was followed rapidly by one of despair. The sight of Bombay drove him nearly mad from sheer beauty and wonder. "O new palms!! O flowers!! O creatures!! O beasts!!"[15] But the vice-regal

pomp of Lucknow when he reached it was as bad as he had imagined it. Northbrook was there on a state visit accompanied by his secretary, the almost equally dear Captain Evelyn Baring, RA, but oh "the fuss and pother" of being the Viceroy's guest! Lear had to be paraded through the streets first on an elephant and then in a carriage like minor royalty, sitting next to Northbrook's only daughter, Lady Emma Baring. Worse still, he had to attend endless state dinner-parties, one of them for fifty-six persons ("light and fuss" without end). Worst of all, his evening dress had not arrived from Bombay. He considered himself lucky to find the time to sketch the ruins of the residency, destroyed in the mutiny sixteen years earlier, but already half engulfed in vegetation. In this melancholy place at least he could escape "the miserable hullaballoo". As for Calcutta, it was so full of English that he could only dub it "Hustlefussabàd". Nevertheless, he stayed three weeks at Government House, no doubt to save money.

He had decided that he would see practically everything, and had planned two gigantic circuits from Bombay, one northwards to the Himalayas, the other south to Ceylon. The northern circuit was the more elaborate, including, as it did, Lucknow and Cawnpore in the Ganges basin, Darjeeling in the Himalayas and Calcutta on the east coast. From Calcutta he travelled back up the Ganges, visiting Benares, Delhi and the Taj Mahal, and made a second assault on the mountains at Simla (he never got as far to the northwest as Swat). The great adventure of this northern trip was the climb towards Kanchenjunga. Kanchenjunga, rather than Everest, was the star of the Himalayan range in the high days of the Raj, although it is now calculated to be a thousand feet lower. Lear planned to draw it from Darjeeling. In parts the track to Darjeeling was so steep that the horse-drawn gharrys, even with frequent changes of animals, could not pass. The *dak* bungalows where he and Giorgio spent the nights had much in common with the remembered khans of Albania. He now considered the filthiest of these was better than a government reception. Nevertheless, the whole trip would have been more enjoyable if he had not recently suffered a collapse of his sketching stool beneath him, inflicting considerable damage, he told Fortescue, to "the other end

from my head".[16] The accident had laid him up for several days.

Four of Lear's patrons had ordered pictures of Kanchenjunga, the third highest mountain in India. From Darjeeling Lear got a good view of it. But "Kinchinjunga [sic] is not . . . a sympathetic mountain. It is so far off, so very Godlike and stupendous." It was bitterly cold up there at dawn. Giorgio covered his master with capotes, but even so he could hardly hold a pencil. Nevertheless this was the best view of Kanchenjunga that he was able to obtain. He went back into the Himalayas at Simla, but the view from there was not so good.

In the Ganges basin he could no longer ignore the natives, although, having no Indian servants, he barely communicated with them. He witnessed the great crowd scenes on the banks of Holy Ganga, but was more moved by quiet domestic scenes, "the beauty of white sheets, both in light and shade". Also black bodies and white waist-cloths. He was delighted by the physical beauty of the Indians, particularly the young women in their saris, which exposed a pleasing strip of brown between the spencer and the skirt. He suggested to Fortescue that "so economical and picturesque an apparel" should be introduced into England. As for the English in India, "I don't know why they dress at all."

The Indian landscape also delighted him. In the early morning he was surprised by a "general misty greyness, more like England . . . owing to the profusion of vegetation". By day there was "a *green* tone throughout . . . relieved with vividly bright bits of light". Indian architecture he considered beyond his comprehension, but he could not ignore the Taj. "The vast glittering Ivory white Taj, and [the] contrast of the dark green of Cypresses. . . . And then the effect of the innumerable flights of bright green Parrots flitting across like Emeralds, and of the scarlet leaved Poinsettias . . . the 'Tinker' or 'tinpot' bird, ever at work."

Lear was about to set out on the southern half of his journey when he was trapped by the monsoon at Poona, in the hills above Bombay. A worse fate could hardly be imagined. He was staying in a large hotel, full of English families in flight from "mouldy" Bombay, and the only people who would

speak to him were their sons, "Lively youths, more informative than their elders." The food was much too plentiful. Even at breakfast two kinds of meat were served and he ate too much out of boredom. He also drank a good deal too much. "Good heavens!" he exclaimed, "if any of my old friends could know how much Beer and Brandy and Sherry this child conshumes [sic], would they recognise me?" Overeating and overdrinking, combined with overheating, did not improve his health. On 5 July 1874 he wrote in his diary, in a handwriting scarcely readable, "I sits shitless and necked [naked] and scratching of the prickly heat. Omy! Don't I?"

In spite of all this, he was not idle. In his bedroom he sorted through his Indian productions so far: "500 drawings large and small, besides 9 small sketchbooks and 4 of journals", and packed them in tin boxes. And he wrote "The Cummberbund: An Indian Poem". It was a variation of the poem about the lady of Bulbul, but this time:

> She sate upon her *Dobie*
> To watch the evening star
> And all the *Punkahs* as they passed
> Cried, "My! how fair you are."

There were now six stanzas and when the poem appeared
in the *Bombay Times* it was admired. English children, in the
care of *ayahs*, must have delighted in lines like

> Above, on the tallest trees remote
> Green *Ayahs* perched alone,
> And all night long the *Mussak* moan'd
> Its melancholy tone.

The last verse of the poem suggests that the "horrid cumm-
berbund" was related to Lewis Carroll's "frumious Bander-
snatch":

> Beware, ye Fair! Ye Fair, beware!
> Nor sit out late at nights,
> Lest horrid *Cummberbunds* should come
> And swallow you outright.

Carroll's poem "Jabberwocky" appeared in *Alice Through
the Looking Glass* in 1872. Lear had read *Alice in Wonderland*
when it was published in 1865, but made no comment.[17] In
1869 Fortescue drew his attention to the book, saying "It
is very pretty nonsense."[18] Dodgson was twenty years Lear's
junior.

Lear and Giorgio now set off on their southern trip, pre-
sently reaching Madras, but by August the east or Coroman-
del coast was like one of Mr Urquart's Turkish baths. They
travelled through tropical jungles and visited two famous
temples. Here Giorgio, who throughout the journey had been
"much the regular old clock he has been for 17 years",[19] lost
his temper, saying he had led a wretched life for years,
estranged from his family, at the will of a selfish master.
Lear dismissed Giorgio on the spot. "If I have been, as he
says, a bad master to him, we ought to part," Lear argued
in his diary, "if not, still we ought to part." But Lear was
"worried and puzzled and sad beyond much endurance" by
the quarrel, and the two were quickly reconciled.

Master and man now crossed to the tropical vegetation
of the Malabar (west) coast. At Calicut (not to be confused
with Calcutta) they embarked for Ceylon and there Lear was
able to do penance for giving Giorgio the sack. He nursed

him through a serious attack of dysentery in the course of which the faithful Suliote nearly died.

Suddenly Lear had had enough. He had criss-crossed the sub-continent, using every known means of conveyance: train, elephant, mule, carriage and boat. He had walked in the Himalayas. He had stayed in palaces, hotels, daks, even tents and railway carriages. Now he cursed "all Indian ways and Indian life" like a true sahib. The Indian adventure which was to have lasted eighteen months, was brought to a close after thirteen. On 12 January 1875 he embarked at Bombay for Brindisi. Behind him, up the gang-plank, went a thousand drawings in tin boxes.

Hubert 1875–80

How pleasant to know Mr Lear!
Who has written such volumes of stuff!
Some think him ill-tempered and queer,
But a few think him pleasant enough.

His mind is concrete and fastidious,
His nose is remarkably big;
His visage is more or less hideous,
His beard it resembles a wig.

He has ears, and two eyes, and ten fingers,
Leastways if you reckon two thumbs;
Long ago he was one of the singers,
But now he is one of the dumbs.

He sits in a beautiful parlour,
With hundreds of books on the wall,
He drinks a great deal of Marsala,
But never gets tipsy at all.

He has many friends, laymen and clerical,
Old Foss is the name of his cat;
His body is perfectly spherical,
He weareth a runcible hat.

When he walks in a waterproof white,
The children run after him so!
Calling out, "He's come out in his nightgown,
That crazy old Englishman, oh!"

He weeps by the side of the ocean,
He weeps on the top of the hill,
He purchases pancakes and lotion,
And chocolate shrimps from the mill.

He reads but he cannot speak Spanish,
He cannot abide ginger-beer;
Ere the days of his pilgrimage vanish,
How pleasant to know Mr Lear!

Lear now did something embarrassing. He fell in love with young Hubert Congreve. Hubert was no longer a jolly "little cove". He was a lean, dark-eyed youth of seventeen. Lear had left him in charge of the Villa Emily while he was in India, writing him long letters, and Hubert may well have been the unknowing cause of his sudden return from Suez in 1872. When Lear finally arrived home from India he discovered that the villa had been ransacked. Fortunately nothing of value, apart from the artist's winter clothes, had been taken and Hubert was forgiven. During the next two years Lear became increasingly involved with Hubert. Early in 1877 he invited him on a trip accompanying Giorgio to Corfu. Since his illness in India, Giorgio had been slowly wasting away and Lear had decided that he must return to his now motherless family (Giorgio's wife had died while he was in India). Lambi, Giorgio's middle son, aged fifteen, was to be left in charge of the villa with Giuseppe, the garden boy. Lear's excuse for inviting Hubert was that he himself couldn't cope with money matters. He thrust a bundle of "uncounted" notes into Hubert's hand at the beginning of the journey, swearing that cash transactions were "an abomination of this child"[1] When Hubert read Lear's diaries he must have been surprised by the meticulously kept accounts that rounded off every year.

The journey to Corfu did not begin well. The weather at Brindisi in February 1877 was foul and the inn fouler:

We found deep snow and a strong gale blowing [Hubert wrote years later] and I shall never forget the night we spent there. It was cold and wretched in the extreme and Lear was thoroughly dejected, and though a fowl we had for dinner ... roused him to make some jokes ... all his

fun vanished when we got into beds with a single thin
blanket each in a room with fine snow drifting in through
the badly fitting windows.

At this stage Hubert persuaded Lear to let Giorgio embark
alone for Corfu, and turn for Naples and Rome. The journey
now took on a distinctly honeymoon quality:

> No one knew his Rome better than Lear, and in a week
> he had shown me more of the wonders and beauties of
> the old city and its surroundings than most people see in
> three months. We spent a Sunday at Tivoli, where the
> changed conditions due to the union with Italy struck him
> very much. "Why! last time I was here," he said, as we
> strolled up the main street of the old town, "I saw two
> men stabbed, and had to fly for fear of being dragged in
> as a witness."

The drawing lessons of course continued. Hubert was
enough of an artist to appreciate the quality of Lear's sketches.
"Whatever may be the final verdict on his 'Topographies'
(as he calls his works in oil or water-colour)," Hubert wrote,
"no one can deny the great cleverness and power of his artist's
sketches. They were always done in pencil on the ground,
and then inked in in sepia and brush washed with colour
in the winter evenings." Hubert could also laugh at Lear as
he defended his bag against a host of urchins, hitting out
right and left and shouting, "*Via, via pellandroni.*"

If taking Hubert for a tour could be passed off as edu-
cational, taking him into the Villa Emily could not. According
to Hubert, throughout his boyhood Lear had always
expressed this ultimate intention. When Hubert's father had
made his Italian chambermaid pregnant and proposed to
marry her, Lear, disapproving strongly, was able to claim
that Hubert needed protection. Lear's happiness was short-
lived. Hubert was soon sent home to England to get some
further education. Lear was desolate. That summer of 1877
he reached the depths of despair. The dreadful news of the
separation broke when Lear was on his second visit to England
after returning from India. He wrote, "In vain I work for
an hour, tears blind me. In vain I pace the large room or

try to sleep I was never nearer utter and total madness than now."[2] And, "How to 'accommodate' a brain diseased."[3]

The precise nature of Lear's relationship with Hubert is unascertainable. Hubert is barely mentioned in the letters to Fortescue and is only referred to obliquely even in the diaries. Hubert, on the other hand, was perfectly open. He avowed his affection for Lear, "my dearest and best friend of the older generation . . . who for 19 years stood in almost a paternal relationship to me". The chances are that while Hubert may have shared Lear's bedroom he never shared his bed. One is inevitably reminded of Johnny Symonds's unrequited passion for Norman Moor, the comely sixth-former at Clifton, whom he met when he was lecturing there, "a lad . . . more beautiful than Aphrodite rising from the waves".[4] The boys were of the same age and background and each had lost a parent (Norman was fatherless). In both cases the older man played the part of tutor to the younger. In the course of teaching, Symonds allowed himself only a few trifling intimacies: "As he read, I leaned on his shoulder . . . and I felt his voice vibrate in the lungs." These intimacies in Symonds's case led to regretful longing and elicited the cry, "O Love, why has thou brought me to this barren shore again?" No doubt Lear felt much the same. Both men were permitted one glorious honeymoon trip with their beloved, during which many cultural sites were visited. Symonds took Norman to London "for 6 delightful days." For him, as for Lear, it was a catastrophe when the boy left for university. "I know how cold it must be in his bedroom – how very cold the sheets are (college sheets are always cold) – how hard and narrow the bed is . . . oh child, child."

By an extraordinary coincidence Symonds was staying in the house below Lear's in San Remo during the whole of the year, 1876, that Lear's passion for Hubert was at its height. He was a guest of Miss Jenny Kay-Shuttleworth. (It will be recalled that Symonds's sister, Catherine, had married Sir Ughtred Kay-Shuttleworth MP). It is hard to believe that Lear did not discuss Hubert with Symonds. It is a strange fact that Lear appears nowhere in Symonds's *Memoir*, but many of Symonds's distinguished friends suffered the same fate,

since the book was chiefly a study of his own sexual deviation. Perhaps, also, he did not appreciate Lear's having informed him that he published too much for the good of his reputation.

Nearly two years later relations with Miss Jenny Kay-Shuttleworth began to cool. There had been rumours about a building going up between Lear and the sea almost since he had built his villa, and from time to time he made references to the felling of olive trees. The land went with the Kay-Shuttleworths' villa, but they were only tenants. It was owned by a Quaker called Hanbury, an analytical chemist. Hanbury had promised Lear from the beginning that he would not build, and while the Kay-Shuttleworths were there it would have been legally difficult for him to do so. Now it appeared that a German hotel-keeper called Wolfen had been planning to build a hotel for several years. Lear referred to them as the Dirty Trinity. He broke the awful news to Fortescue: "A huge hotel is to be built just below my garden. If it is on the left side, it will shut out all my sea view."[5] In fact it was the treacherous Miss Kay-Shuttleworth who had introduced the German to Hanbury. They were all in it together, "The dirty Chinese Quaker Druggist, the fat Wolf Fish and Jenny Shuttleworth," Lear declared to Fortescue.[6]

When Lear came back from a summer in the mountains in 1879 there was a thing the size of the Langham Hotel, painted wedding-cake white, right in front of his studio windows. He declared that if he entered the room inadvertently while the blinds were up, "the dreadful glare of the white-washed monster would blind him for ten minutes".[7] He could no longer even enjoy the terrace. On the spur of the moment he wrote a rude letter to Johnny Symonds, who sent the letter straight to *The World* which published a paragraph of it. Lear sat back and waited for a libel action. "The dreadful part," he told Fortescue, "was the ill feeling and bitterness." The hotel became an obsession. It filled his letters. Visitors to San Remo reported the same. When Marianne North came to stay with Lear (surprising in view of the fact that she was Symonds's sister-in-law), he made an effort to be cheerful and discuss the flora of India. "As the train was moving off, he looked in at the carriage window and moaned out 'Hasn't somebody been good not to mention the Enemy all day.'"[8]

Another young woman to whom he attempted to be agreeable that season was the charming Miss Bevan, the eldest daughter of the British Vice-Consul at San Remo. When he called on her family one afternoon, he found her younger brothers and sisters at tea and started singing.[9] Miss Bevan, who was evidently a witty creature, collaborated with him to produce the self-portrait in verse, "How Pleasant to Know Mr Lear". He always referred to the poem as "My and Miss Bevan's verses".[10] Perhaps she provided the line, "Some think him ill-tempered and queer". She was one of the increasingly few who thought him "pleasant enough". There was an additional reason for Lear's increasing withdrawal from society. His "boles" were playing him up. He admitted to "Sundry accidents to my behindical boundaries", and added, "I am horribly afraid that something hideous will one day happen while I am in the midst of society."[11]

Frank came out with his wife Kate early in 1878. He openly admitted to Venables that he had come with the intention of "fitting up" the drawing-room of a friend "very prettily and very cheap out of Lear's studio". He did however intend to buy pictures "of the grandest scenery on the grandest scale. I never meant to put off Tom Ridley with pot-boilers." Business, presumably, completed, Lear and the Lushingtons departed for Mendrisio early in June. Frank reacted typically to Lear's summer retreat. "If you want a nice hill with a hotel on top, then you have it," he told Venables. But gradually the beauty of the place stole over him and before leaving he wrote of Monte Rosa, rising "like an island out of a sunset cloud" with the Matterhorn peering over its shoulder.[12] Lear's aspect pleased him less. "I'm afraid he is not getting younger, any more than is the usual fashion It must be a terribly dreary life that he has here during the summer, with hardly an English body to speak to and with none of the natives yet discovered worth speaking to." He found it irritating that Lear took only the *Telegraph* which "reports one side very well, the other very badly".[13] There were arguments about both Gladstone and Disraeli.

Perhaps it was solitude that now drove Lear in search of Giorgio. Lear's domestic arrangements had deteriorated sadly since his return from India. Giorgio had been in Corfu for

fourteen months now. Finally, unable to bear it any longer, Lear went to Corfu. He found Giorgio living in miserable rented rooms, too ill to travel. In the opinion of the doctor, he should have been dead. Lear gave him money to pay the rent of better rooms and returned to San Remo bowed down with guilt. What had he done to Giorgio? He had forced him to live abroad all those years and not even rewarded him with enough money to keep his family decently. He obtained permission for Giorgio to join him at Mendrisio, a resort in the Swiss Alps on the slopes of Monte Generoso. Lear was to spend six summers there in all (1878–83). The reunion was touching. Giorgio appeared beneath Lear's window, with his bags, saying, "I am here, Master." He was like a skeleton. For six weeks Lear devoted himself to Giorgio. Gradually the sick man began to take a few unsupported steps. By the end of the visit he was walking behind Lear, carrying his folio as of old. But the roles of master and servant had finally been exchanged for that of friends.

Giorgio's position at the villa was now that of pensioner, although he was only sixty-one. His son, Lambi, attempted to take his place, but Lambi was a wild Albanian lad. By the age of seventeen he had become unmanageable and been sent back to Corfu where he worked as a waiter until he was conscripted into the Greek army. Then he deserted and resurfaced at the Villa Emily, bringing with him Dmitri, his younger brother, still a child. But things went wrong again. This time he took up with "a horrid w[hore] of a woman". In the end Lear sadly turned him adrift.

In July 1878 Lear read in the newspaper of the premature death of Lady Waldegrave from pneumonia. The happiness that Fortescue (now Lord Carlingford) had awaited so long had vanished like a puff of smoke. Frances had never had children and there was nothing of her left. For a time Fortescue's depression was so deep that it seemed he could not survive. He retired to Chewton Priory, near Bath, his wife's family home, to mourn by her grave. Lear pounced. He invited Fortescue to spend the rest of the summer at Mendrisio, sending letter after letter suggesting different routes. Unexpectedly in November, Fortescue accepted. Constance Braham, the niece whom Lady Waldegrave had brought up

as a daughter, was getting married at Cannes, and he would combine the wedding with two months at the Villa Emily!

This was a surprise indeed. Staying at the same hotel in Switzerland was one thing. Sharing a home with the man who was about to become Lord Privy Seal was quite another, particularly with the domestics in such a state of disorder. Fortescue had not left England for fourteen years! Lear hastily suggested the Hotel Londres. It was just below the villa. Fortescue could always spend a night or two in the villa, to see the way "this child lives". Rooms for Fortescue were booked, postponed, cancelled and rebooked. Lear went up and down the hill making arrangements with the manager. In the end Fortescue arrived immediately after the wedding on 24 January 1880, and stayed for February and March. The visit seems to have brought him some comfort. He referred affectionately to the peace of San Remo, and especially to Foss, in several letters. Foss's owner had certainly promised to try to be "a good boy and as cheerful as possible".[14]

Lear also made an extra special effort to be pleasant when the newly married Constance Strachey arrived for luncheon with her husband. The former Constance Braham had had pleasant memories of Lear since the days of her childhood at Nuneham Courtenay. Now she found him much aged and broken though retaining "the same sad whimsical personality and undefinable charm".[15] Lear gave her two wedding presents: first a diary, then, forgetting that he had done that, "one of my little 'Topographicals'". Constance treasured that "delicious harmony in blue of the Vale of Tempe" for the rest of her life. Lear can little have guessed that this lovely young woman, thirty years later, would publish a remarkably scholarly edition of his letters to Fortescue, the nearest thing to a biography Lear was to have until almost the outbreak of the Second World War.

But Lear's thoughts were still full of the "Awful Hotel". He claimed he could neither paint nor poetize. A row of cypresses would be inadequate. His schemes for a remedy came "thick as flies upon a plum". He considered emigrating to New Zealand, but in the end he decided to build another villa. Letters went out to all his friends for loans, and a plot just along the hillside was bought.

Lear made his last visit to England (and this really was his last) in the summer of 1880, no doubt attracted there by the presence of Hubert. It was a sad occasion. He was "handed over the streets . . . by polite policemen in mercy to my blindness – but horribly exasperated by the quality of respirators or refrigerators or perambulators or whatever the wheels are called that bump your legs with babies' heads".[16] London had, in fact, overtaken Lear. By now Gilbert and Sullivan were at the height of their success and there was an underground station in the Holloway Road. He mentioned neither. He at least had the consolation of staying with Frank at 33 Norfolk Square, Hyde Park (only a few doors from Symonds). Frank spent only half the week with Kate and the children in the country. His marriage does not appear to have been a happy one. Kate Maria, as she was now called, had developed into a somewhat formidable woman,[17] and Frank and his children (there were two boys now, Frank and Harry, as well as Milly, a second girl) seem to have spent a good deal of time with the ever-adoring aunts at Park House. His letters to Venables were full of references to the aunts and the children who, like all the Lushingtons, were usually in bed with something or other, but there was seldom if ever a mention of Kate Maria. To Venables again he confessed a mild interest in Henry Brookfield's pretty daughter. He caught a glimpse of her full-length at a window when he was processing through London in judicial garb.

Lear was naturally pleased to have the Thames Magistrate so much in town. But Frank was often out even in the evenings and Lear dined alone at some tavern, usually the Blue Posts, in the Strand, where he had often gone with Fortescue. Lear was not always the most agreeable of dining companions. When, at the Blue Posts, a man behind him "played tunes with a wet finger on the glass, a sound which, going through the ears was destructive", Lear said to him "Sir, I am very very sorry but I *must* request you positively to desist immediately from making that disgusting noise."[18] Dinner-parties were even worse. One given by Lord (and beautiful Lady) Somers "made me wish I was an Octapod or a Jerusalem Artichoke or a Hippopotamus". But if he could flog the massive "Athos" or the equally massive "Bavella", they would

pay for a storey or two of the new villa. Also there was always the hope of picking up a naughty joke with the port:

Fat Rothschild: What shall I go as for the Fancy Dress Ball?
Napier Sturt: Go as a ham with your prick in a paper frill.[19]

With Gussie and her husband at the Lodge, Wimbledon, Lear found more refined entertainment. Gussie had brought the paralyzed Mr Parker up from Brighton for a couple of months' distraction. "She certainly is an admirable creature, and now I know all the circumstances of her marriage I admire her more than ever."[20] He also visited his sister Eleanor, now eighty, at Leatherhead. "Dear old Nell," he called her. She was a "larky old bird",[21] but not long for this world and he knew he would not see her again. She lacked the intellect of either Ann or Sarah, but she was a kindly soul, much given to making tarts and pies. Her banker husband had left her comfortably off, with three servants.

There was not even cheering news from Professor Bosh (the name he had conferred upon his publisher, Robert Bush). A year earlier Fortescue had described seeing on his premises at 42 New Bond Street, "a pile of smart red and green books, and behold it was a new Nonsense Book".[22] He referred to the second of Lear's books of Nonsense Songs,[23] the one that included "The Dong with the Luminous Nose", "The Pobble who has no Toes", and "The Quangle Wangle's Hat". Now the only news that Robert Bush could give him was that he was going bankrupt. "Here's a shindy! Bush is become a Bankrupp . . . shall I have to go to prison?"[24] But Lady Ashburton, his faithful patron, had better news for him. She had framed "Kasr-es-Saad," his new painting of the rose-coloured Nile cliffs at Philae, in such a way that it would never be framed again. "Yesterday at Lady Ashburton's [at Kent House, Knightsbridge] I saw my 'Crag that Fronts the Even'[25] let into the wall in a vast black frame all the room being gilt leather! Never saw anything so fine of my own doing before, and walked ever afterwards with an elevated and superb deportment and a sweet smile on everybody I met."[26]

He now set out on a pilgrimage to the West Country to see Lady Waldegrave's grave at Chewton Priory. He didn't get there. "Destiny unceasing persecutes me through this 'progress'," he declared. It was blowing such a gale of rain that the smaller Somerset stations were "blown clean away". Sitting in a "lousy trap" on the way to Chewton, a gale of rain hit him full in the face. When he asked to have the window closed, the driver said, "There ain't no point in pulling it hupp . . . there ain't no glass."[27] Lear gave up. Instead he went to the well-heated Royal Bath Hotel and imagined the "lost one's grave".

Lear saw much of Hubert while he was in London. At the beginning of July 1880 he attended prize-giving at King's College and wept copiously. "Hubert called up 11 times. Great applause. It was no slight task to keep nerves straight."[28] They spent many happy evenings together. Hubert later recalled one of these:

> I had just finished my exam, and he carried me off to dine with him at the Zoological Gardens. "You are just beginning the battle of life," he said, "and we will spend the evening where I began it." It was a beautiful evening in July and we dined in the open and sat under the trees till the gardens closed, he telling me all the story of his boyhood and early struggles He was then absolutely natural and we were like youths together, despite the forty and more years that lay between us.[29]

But, Hubert apart, London was becoming increasingly repulsive to Lear. It was a prison, "a horrible nightmare".[30] He left for Italy early, at the end of August, not waiting for the autumn fogs to drive him out. He would never see England again.

The End 1880–88

On a little heap of Barley
Died my aged Uncle Arly,
And they buried him one night, –
Close beside the leafy thicket; –
There, – his hat and Railway-Ticket; –
There, – his ever faithful Cricket; –
(But his shoes were far too tight).

The Villa Tennyson was to be an exact replica of the Villa Emily, so that Foss should not become confused. It still lacked a roof when Lear returned from England in the autumn of 1880. He went up to Mendrisio for two months and, according to Hubert, they spent a "very happy week" together there. "We walked up to the Monte Generoso," Hubert recalled, "Lear plodding along with his heavy step at . . . about 2 miles an hour, and frequently pulling up to admire the view and to exclaim, 'O mi! ain't it fine!'" At Varese near Milan, on the way back to San Remo, Hubert was impressed by "the old man's care and gallantry" to a young lady who accompanied them on a walk. At San Remo a week later Lear saw Hubert for the last time. The Congreves were leaving for good. "Lear completely broke down."[1]

The Villa Tennyson was habitable by the following summer, and so closely resembled the Villa Emily that Lear sometimes forgot which house he was in. A second near-vertical garden was established and pocketsful of Alpines were brought back from Mendrisio for the terrace. Sarah sent

THE END

others from New Zealand. "Gardening," Lear told his god-
daughter, Laura Coombe, "is really the only unchangeable
pleasure left in life."[2] His pleasure in flowers, which had been
so evident in Arcadia with Frank, had once more come to
the fore. Several drawings of the flora of the sub-continent
were included in his Indian portfolios, including one of lotus
flowers, sometimes known as Egyptian waterlilies.[3] (These,
of course, were not the lotus devoured with such dire conse-
quences by Tennyson's Lotos-eaters. They ate the fruit of the
Lotus bush, a Mediterranean shrub.) Meanwhile the Villa
Emily remained unsold, although the price had been reduced
from seven thousand pounds to three thousand. For a time
it was let to two ladies who proposed to open a girls' school
in it. (French and the globes would be taught, but washing
would be extra.) Unfortunately the ladies were no ladies,
and decamped without paying the rent. Lear eventually sold
the house for sixteen hundred pounds. (The Villa Emily was
still standing in 1976, embellished by a two-storey verandah.
So was the hotel.)

As the winter of 1882 approached Lear worked furiously
to produce enough water-colours to cover the walls of his
new studio for the first open day, when the visitors' season
commenced. He overdid it. A bad attack of giddiness left
him frightened. Giorgio told him he worked too hard and
drank too much. Giorgio, after all, knew better than anyone
how fast the Marsala bottles went down, not to mention those
of Lear's favourite wine, Barolo. Lear paid no attention. He
continued to fill his gallery with pictures that nobody wanted,
even at five pounds a water-colour or forty guineas an oil.
Lear had in fact come to the end of his career as a recognized
painter. It was ten years since the Royal Academy had
accepted one of his pictures (a Megaspilion in 1873). In all
Lear had had nineteen pictures hung in the Royal Academy,
the first being "Claude Lorraine's House on the Tiber", 1850,[4]
but he had never been accorded the envied right to put RA
after his name. His last large oil was probably the "Kasr-es-
Saad" already mentioned.[5] But the painting had not re-estab-
lished him in London art circles because he now rarely sold
on the open market. His customers were once more private
patrons, as they had been at the beginning of his career. And

251

sometimes these patrons became a trifle patronizing.

The fifteenth Earl of Derby was the most outspoken of them. He had succeeded his father, the Prime Minister, in 1870, having held the offices of Colonial Secretary and Foreign Secretary under him. The alarming honesty that brought the latest Derby's public career to a close (he went over to Gladstone on a point of principle) is clearly apparent in his letters to Lear, who pressed drawings on him to cover the cost of every domestic disaster. The camel's back was all but broken when the 15th Earl's contribution to the Villa Tennyson was assessed by Lear at £500 in water-colours. (He did not buy oil-paintings.) The young earl wrote the following comment on Lear in his diary:

> In a world, where nothing succeeds like success, he has done himself much harm by his perpetual neediness. An artist who is always asking his friends to buy a picture, and often to pay for it in advance, makes outsiders believe that he cannot know his business, which in Lear's case is certainly far from the truth. But *he has been out at elbows all his life*, and so will remain to the last.[6]

An added objection Lear's patrons may have made to his work was its repetitiveness. The "Kasr-es-Saad" was by no means the only painting of the Nile executed by Lear in the late 1870s. Since 1873 he must have painted it fifteen times, almost always in the region of the Island of Philae. In his studio water-colours the repetition of subjects was even more marked. His thoughts increasingly returned to the journey in Arcadia with Frank thirty years earlier. He painted the monastery at Megaspilion so frequently and so fast that in a water-colour he sold to the Rev. Henry Tozer[7] it looked more like a piece of chewing gum stretched across the face of the cliff than a building.

There may have been another reason why people did not buy Lear's pictures. He was rude. Sometimes he opened the door himself, he used to freely admit, in order to keep out Germans.[8] A friend said, "If the Queen comes to your gallery, you had better not say that sort of thing."[9] The Queen very nearly had come when she was visiting Menton the previous year. Giorgio had baked endless batches of macaroons for

her. In the end Her Majesty was prevented by frontier problems. After that winter Lear closed his gallery for ever, proposing to sell what little he did at Foords (by now Foord and Dickenson's) of Wardour Street.

Foord had just arranged an exhibition of his Nile drawings. This had put him in touch with a new friend, Amelia Edwards, author of *A Thousand Miles up the Nile*, and Miss Edwards had reviewed the exhibition in the *Academy Magazine*. He wrote to her asking advice about publishing his Egyptian journal, while admitting that his book, unlike hers, would be "egotistical and unmitigated."[10] Miss Edwards offered to give him an introduction to Harpers, but nothing came of it. It is appropriate that the modern edition of Miss Edwards' book (1982) has a Lear water-colour of Philae on the cover. Lear's letters to her are preserved at Somerville College, Oxford.

Gussie, newly widowed, arrived in San Remo in the spring of 1883, chaperoning a brace of nieces. "I wish I were not so dam old," was Lear's comment when he had heard of her husband's death.[11] "What will happen now, who can tell?" Nothing happened, although she visited him daily. After she had gone Lear concluded, "Had her husband died 10 years ago I might even then have [had] a good woman to nurse me to the last."[12] He certainly needed a good woman to control his servants. Increasingly the calm of the Villa Tennyson was riven with the manly yells of the Kokalis in the kitchen. Lambi, the black lamb, was back again, and now Nicolá, the oldest boy, had moved in, although he worked by day as a waiter in San Remo. Little Dmitri was still there, and not so little and not so good any more. They all fought, and Lear was frequently asked to act as referee.

Meanwhile, old Giorgio was changing. He was becoming bad tempered and positively rude. Then it transpired that he, who had counselled sobriety, was on the bottle himself. In June 1882 he disappeared. All was confusion at the villa for days until the French authorities cabled to Nicolá requiring him to retrieve his father from Toulon. Giorgio has been found destitute and raving in the hills above the town. Apparently he had been on his way to Frank in England. "The brain is affected to a miserable extent", Lear wrote, "and I see

no prospect but of a gradually increasing idiocy The poor fellow is generally quiet enough, but has become melancholy and semi-savage, sometimes not speaking all day, or bitterly angry when he speaks at all."[13] Once more Lear took Giorgio to Mendrisio, this time taking Nicolá too to act as a nurse. He returned in the autumn to find Lambi in trouble again. He had been caught stealing wine. Then *he* confessed to a wife and two children in Corfu. History was repeating itself. The three brothers furiously opposed the insistence of the two older men that Lambi should be shipped home. The following summer Lear once more took Giorgio up to Mendrisio, hoping that the mountains would work their magic for the third time, but Giorgio grew rapidly weaker and it was obvious that the end was near. In his last days, on the slopes of Monte Generoso, he was once more the calm philosopher that Lear had known for thirty years. Early in the morning of 8 August 1883, Lear wrote to Fortescue, "This is to say that my dear good servant and friend George died quite calmly an hour ago Please write to me."[14] Giorgio was buried at Mendrisio. He was in his sixty-seventh year.

Lear was more profoundly affected by Giorgio's death than by that of anyone in his life, apart from Ann. "I wish that I could have merited such a friend, and that I had never been hasty or cross," he told Emily Tennyson.[15] He turned to "In Memoriam" for comfort, and in particular to the lines, "Men may rise on stepping stones of their dead selves to higher things", which he interpreted as meaning that the deaths of friends guide us towards Eternity. He arranged photographs of those who had been his stepping stones on the bedroom wall at San Remo, starting with Ann and ending with little Giuseppe, who had died lately of fever after gardening in the rain. Lear had a firm belief in Eternal Life. "That there *is* a life beyond this, it seems to me the greatest absurdity to deny."[16] "That all this trouble-whirl of sorrow and worry, all these entangled and dumb feelings are nil, I cannot believe," he wrote in his diary.[17] He had remained a loyal church-going (but non-communicating) member of the Church of England all his life, and the broad church views he had held as a young man had not changed. What he really couldn't stand were clergymen and, worse still, sermons.

In Corfu a preacher had aroused such fury in him that he
had decided it would be safer to stay at home on Sundays.
He had unburdened himself to Lady Waldegrave. "I begin
to be vastly weary of hearing people talk nonsense un-
answered, not because they are unanswerable, but because
they talk in pulpits."[18] At San Remo the Rev. Fenton's
effusions from the pulpit had reduced him to an almost equally
dangerous state. He declared that the man was "as complete
an ass as any parson can be," and feared that his sermons
might cause him "to get up and snort and dance and fling
my hat".[19] During the last few years of Lear's life the Rev.
H. S. Verschoyle took over as Anglican chaplain at San Remo,
but Lear found him excessively high. "Where," he appealed
to Fortescue, "are the followers of A. P. Stanley, Maurice and
Jowett? Is there no medium between damning Jews and
Catholics to eternal burning and ... walking among those
dear candlestix?"[20]

Within two years of Giorgio's death Nicolá was dead too.
Like his uncle, Christos, he had contracted tuberculosis of
the lungs. By November 1884 he was "less and less at work
and more and more obliged to lie down".[21] Lear proclaimed
that no son of Giorgio should "die in a hospital if I can help
it". By February 1885 Nicolá was in "constant suffering"
and Lear spent many hours with him in the wretched little
servant's bedroom, hours that were neither "lively, lovely
nor luminous",[22] for during them Lear learned more than
he wanted to about "good old Giorgio". When Giorgio had
gone home to Corfu on leave each year, apparently it had
been to another woman, not to his wife. He had spent his
money on her and on drink and had cruelly maltreated his
children. Nicolá's memories of childhood were all unhappy
ones. He died on 4 March 1885, at the age of thirty-four.
Lear informed Fortescue who merely observed that "the poor
fellow" had been "fortunate to be in your care".[23] He was
one of the majority who found such pampering of servants
embarrassing. Lear was aware of this. "I scout the notion
of treating domestics less kindly than horses or dogs, and
even when they are ever so much in fault I think it is wise
to keep them from total ruin."[24]

Every time a Kokali died, Lear's health took a step down-

wards. The first descent had been immediately after Giorgio's death, when he became seriously ill with pleurisy. Then, after Nicolà's death he very nearly died of pneumonia, and he knew he would "never again be quite well". He was seventy-two years old. Once more he made his will, this time bequeathing eight thousand of his drawings to Lord Northbrook.[25] Then he rallied.

Not only did he rally but during that winter he redrew all two hundred of the Tennyson illustrations. This time he made them barely four inches long and mounted them on cards eight at a time, with the appropriate quotation beneath each. In a letter to Amelia Edwards he referred to these tiny drawings as his "eggs".[26] In the summer he drew them all again, this time a size larger. His habit of repeating the same drawing over and over again seemed to be exceeding the bounds of reason. The action was becoming as obsessional as telling beads.

The problem of how to reproduce these drawings at moderate cost became the major preoccupation of his last years. He had already experimented with Autotype, Photochromo-lithography and Aquatint, but they had failed. In 1885 he invited a lithographer called Frank Underhill out to San Remo. As a young man, Underhill had helped Lear with the lithographs for the Ionian Islands book, and during his stay the men became close friends. (Lear even left him something in his will.) Lear had had such high hopes of Underhill's work that he had actually sent to the printers a list of the illustrations and a flowery dedication to Emily Tennyson. But Underhill's pulls were "absolutely good for nothing".[27] Lear blamed himself. "I did not set out properly at the first to make the drawings really fit for reproduction." Now he tried Photocopy and Platnatype. Often he all but despaired. Once he said, "Anything more utterly beastly than the appearance of these wretched drawings just now, can't be imagined." But still he persisted. It was not until the autumn of 1887, within a few months of his death, that he finally abandoned the project.

By now, however, he was much enfeebled and could no longer walk well but only "doddle". He could still get as far as the Rail, as he called the station, and it was there that

Constance Strachey saw her last of him, as she and her husband passed through San Remo station on their way north. "It was Sunday and he happened to be walking drearily away from the station as our train slowed into it, out of earshot of our calls. The sad, bent, loosely clad figure with hands clasped behind him, we did not know was walking away from us then and for ever."[28]

Lear was indeed withdrawing, even from his friends. The rift between him and Fortescue began to widen. Fortescue's career had taken a turn for the better after Lady Waldegrave's death. He had been created Lord Privy Seal in 1881, and Lear had been delighted, drawing him as a furry *phoca* (the Greek for seal), wearing a "crownet". But Fortescue was a Liberal, serving under Gladstone, and Lear had about as much time for the GOM as he had for Gerpeople. In fact he became a perfect bore on the subject, and wrote one of his few overtly political limericks about it.

There was an old man at a station
Who made a promiscuous oration;
But they said, "Take some snuff!
You have talked quite enough,
You afflicting old man at a station."

Fortunately for Lear, Gladstone (and Fortescue) went out of office in 1885 and Fortescue suggested coming to stay. Fortescue still looked superb and Lear hurried him to the local photographer, Bassano, to have a last picture of dear "Chicken" taken, in a top hat.[29] But the visit was not a success. Fortescue was put up at an hotel and a week after his arrival became ill from sitting too late on the promenade and staring out to sea thinking about Lady Waldegrave. The two men, who had been separated by such great distances for so long, lay in rooms only a few hundred yards apart, exchanging notes, for Lear was also suffering with his chest. The problem of Christmas dinner loomed alarmingly. In the end Lear agreed to go to Fortescue, although he had sworn never again to dine away from home. "Only please let me come in my thick woollen everyday dress – indeed I have long ago cut off the tails of my black dress coat."[30] Lear arrived at six, and was virtually carried home at nine by Luigi, his new

servant, and the new gardener. According to Fortescue, Lear seemed "the better for his dinner".[31] By the year of 1886 Lear was suffering from severe bronchitis, at times breathing only with the greatest difficulty. From then onwards he rarely left his sofa. To reach the hearth rug became an excursion, a "totter" to the terrace a major event.

When one of the Barings visited him in April Lear asked him to witness a third will.[32] The new will reversed the one under which Northbrook was to have eight thousand drawings and Fortescue all the letters and diaries. Frank was to have everything. It is not known whether Frank had any hand in this decision. It seems unlikely, for he was a man of scrupulous honesty, and anyway considered Lear's paintings of little financial value. On the other hand, for personal reasons he may have desired control over the diaries.

An added reason for supposing that Frank had a hand in the new will is that he had not seen Lear since he had visited him the previous May. Frank had then been shocked at the change in Lear and felt certain that he would never see him again.[33] It is therefore conceivable that the subject of the will came up between them and a new one was made, which was not witnessed until a year later. Certainly, while Frank was with him, Lear was much concerned about the disposal of his worldly goods. "I turned over the possibility of getting rid of many matters before I go."[34]

While Lear was writing his will, back in London, trumpets were sounding for his Nonsense. Ruskin had just declared, in the *Pall Mall Magazine* for February 1886, "I really do not know any author to whom I am half so grateful, for my idle self, as Edward Lear. I shall put him first of my hundred authors." Lear now sent Ruskin the remaining three Nonsense books (it appeared that Ruskin possessed only one). "Beautiful," he declared to Fortescue, "is the abundance of recent appreciation of Nonsense."[35] There had been several new editions of his fourth Nonsense book since it had appeared ten years earlier.

Frank paid his final visit to Lear in November 1886. He came, as on the previous occasion, without Kate Maria. He, unlike Fortescue, was permitted to stay in the villa, and was able to give an account of Lear's life there during his last

year on earth. "He is sadly aged and feeble, very crippled at times with rheumatism . . . has to be dressed and undressed by his manservant, Luigi, and goes to bed by six o'clock." (Lear was in fact now paralyzed down the right side.) "The only point in which he is quite his old self is his intense interest in all his friends and his pleasure in hearing from them." Later Frank wrote, "He really lived upon the letters of his distant friends more than any man I have ever known."[36] It was the thought of his friends that kept Lear alive and he never ceased to admit that he was indeed most fortunate in them. He was now a rudderless hulk. Masts and spars were gone. Only stout hawsers held him to the shore, and these hawsers were letters from home. All must be tested regularly. Frank, Fortescue, Emily Tennyson and North-brook all received regular bulletins, written usually within four days of the receipt of theirs. It was at this time that Lear completed the obituary in verse that he had commenced some years earlier, entitled "Incidents in the Life of my Uncle Arly." It was to be circulated among his friends and was as full of sadness as any nonsense poem could be.

A visit from Northbrook in late January encouraged him. Fortunately he had brought his wife, the charming Lady Emma, "more delightful than you would ever imagine".[37] It was probably the Northbrooks who insisted that Lear should have a last photograph taken. A photographer from Roncarlo's studio in San Remo brought his apparatus up to the villa. Lear was propped up in a chair in his bedroom. The following dialogue ensued.

Manipulator (From the depths of the curtain and the black box): Mr Lear!
Mr Lear: How do you know my name?
Manipulator: I used to see you 35 years ago at Hallmun-del's, the lithographers. I was the boy. You ain't altered.

"So I suppose," Lear commented to Fortescue, "I am only 38 years old!"[38]
Lear's arm in the photograph is raised above the arm of his chair, and there is a reason for this. According to Mrs Hassall, his doctor's wife, "Foss was to have been taken with him but he jumped down at the last minute. In the photo

you can see Mr Lear's hand, as it was when holding the cat."[39] Lear's obsession with Foss was, if anything, increasing along with the girth of his beloved. (Foss could now barely pass through a door.) Lear had elevated him to the peerage, and designed a coat of arms for him. One evening, with Hubert, he pulled scraps of paper out of the bureau and drew Foss Couchant, Foss Rampant, Foss Dansant and Foss "a 'untin".

Another visitor that last spring was an up-and-coming young American publisher from Boston called Dana Estes, who was travelling in Europe with his wife. Estes was planning an American edition of Tennyson's poems and hoped to use Lear's illustrations. He arrived at San Remo on 7 May 1887. "Upon enquiring for Villa Tennyson I was warned not to visit it, unless I was a friend of its inmate. I found Mr Lear sitting up for the first time for several weeks." Estes was a polite young man and he thought the drawings "very interesting", but he had to confess that "some of the portions are unfinished in details and would require *very artistic treatment* at the hand of an engraver".[40] He did not use them.

At this moment Luigi handed in his resignation. Lear summoned Gussie out from England again. She stayed at a hotel for a few weeks, coming up to the villa daily. On her last day he all but popped the question. But she left for the station at five and again nothing occurred "beyond her very decidedly showing me how much she cared for me". Perhaps he was waiting for Gussie to propose. "This I think was the day of the death of all hope", he wrote in his diary.[41]

Lear, unbelievably, struggled up to the mountains again that summer. The previous year he had described himself as being pushed into railway carriages like a sack of coal. This time he was accompanied by his new manservant, Giuseppe Orsini, and his devoted physician, Dr Hassall. He did not, however, attempt Mendrisio, but stopped short at Adorno near Biella, in Italian Piedmont.[42] Fortunately Giuseppe Orsini was proving a jewel. At first Lear had not cared for him, insisting that he looked like Daniel O'Connell and was smelly to boot. (He always found "the odour of unwashed men" worrying.)[43] But Giuseppe had advantages. He was a pigeon-fancier and soon populated the terrace with twelve of them. "No bird is more beautiful than a pigeon," Lear

declared. And he came to prefer Giuseppe's slow movements to Luigi's quicksilver ones. "It seems all very like a dream," he concluded.[44]

Mrs Hassall, Lear's doctor's wife, became a frequent visitor during the last two years of his life. "A pleasant and sensible woman," he declared, "but there is no interchange of thought in these days."[45] Nevertheless she was capable of sharing a joke, and Lear wrote the following improbable letter to her:

> I was sorry to see so little of the Doctor yesterday, but I rise so late now and go to bed so early, that I have but very little leisure time. The best conditions of finding me now-a-days are from 12 to 1 pm, in the garden, which I get to when it is fine. I did not say all I might have said to Dr Hassall about my health, thinking he might upbraid ... me for doing more than I ought to do at my age, and considering how feeble I am, consequently – though I tell you in confidence – I did *not* tell him that I had climbed to the top of the tallest Eucalyptus tree in my garden and jumped thence into the Hotel Royal grounds, – nor that I had leaped straight over the outer V[illa] Tennyson wall from the highroad, – nor that I had run to Ventimiglia, having beaten Foss by 8 feet and a half.[46]

But Foss's racing days were also over. Soon after Lear's return from Adorno he took sick, becoming paralyzed down one side and died. He was then fourteen years old. "Foss is dead," Lear announced to Lord Aberdare on 29 November. "And I am glad to say did not suffer at all He was placed in a box yesterday and buried deep below the fig tree at the end of the orange walk. All those friends who have known my life understand that I grieve over . . . the memory of my poor friend Foss." He knew that his grief over the cat would be more acceptable to his friends than his grief over Giorgio had been. He erected a stone above the "Gatto Foss", claiming that he was thirty-one years old. He was becoming very confused. He wrote a letter to Fortescue two days after Foss's death giving the month as July when it was November. Although the letter was intended for Fortescue, halfway through it Lear started addressing his remarks to Frank, enquiring after "the 2 fevery boys". Fortescue and

Frank were not acquainted and Fortescue forwarded the letter to Frank with a formal note: "Lord Carlingford sends this to Mr Lushington as it is evidently meant for him."[47]

An added sorrow at this time was the death of Lear's nephew Charles Street. "I am in terrible distress," he told Fortescue. It had happened "*quite* suddenly . . . in that lately happy house". Charles left a widow, the charming Sophie, and a daughter in his fine house, "Kohanga", at Parnell, Auckland.[48]

Many of the letters Lear wrote to Fortescue in the last few months of his life were mere notes, "just to let you know I still exist". He found the day of an invalid intolerably dull, although he managed to read and enjoy the newly published biography of Charles Kingsley. Without work or company, the hours dragged and when he had the strength to write there was nothing to say. He recounted to Fortescue a conversation he claimed to have once heard at a village prayer meeting.

1st old woman: Say something.
2nd old woman: What shall I say?
1st old woman: How can I tell?
2nd old woman: There is nothing to say!
1st old woman: Say it then, at once![49]

Sometimes he could only send a card with the words "Improving", or "Got your letter."

By the beginning of January 1888 he was gravely ill. Up to this moment he had never mentioned a symptom unless he could announce it was less acute. In his last letter to Fortescue, written on 9 November 1887, he confessed, "I have gone back a good deal lately The pains inside are says Hassall caused by Champagne . . . a great and ridiculous bore, as Frank Lushington has just sent me 30 bottles."[50]

Dr Hill Hassall and the Rev. H. S. Verschoyle (the two men were close friends) were with him on the night of 29 January, 1888. Mrs Hassall also was present until midnight when her husband requested her to leave, "fearing the last scene might try me too much". Lear by then was sinking into unconsciousness, recognizing nobody, "the good, great heart simply slowly ceasing to beat".[51] Half an hour after midnight Lear

called Giuseppe and commended himself, not to God, but to his friends. "I feel that I am dying," he said (in Italian). "You will render me a sacred service in telling my friends and relations that my last thought were for them, especially the Judge and Lord Northbrook and Lord Carlingford I did not answer their letters because I could not write ... no sooner did I take a pen in my hand than I felt as if I were dying."[52]

Two hours later he died peacefully.

Epilogue

"My dear old Lear died at San Remo today," wrote Frank to Hallam Tennyson, having been informed by telegram. He went out at once but was too late for the funeral which took place at the English cemetery in San Remo. It had been a dreary enough affair. "I have never forgotten it," wrote Mrs Hassall. "It was all so sad, so lonely. After such a life as Mr Lear's had been, and the immense number of friends he had, there was not one of them able to be with him at the end." Apart from Dr and Mrs Hassall, there was only the Rev H. S. Verschoyle present. Lear's policy of discouraging casual acquaintances had proved successful.

When Frank arrived, he had to arrange for the despatch of all Lear's papers and diaries to his own home at Southborough, for of course Lear had left them to him and not to Fortescue, as originally planned. He had also left Frank "all my oil paintings and watercolour drawings framed or unframed and finished or unfinished". In addition Frank had to put the villa on the market for the benefit of his oldest daughter, Gertrude. These things done, there was left only the matter of the wording on the tombstone. Lear had wanted just his name and dates to appear, but such brevity was shocking to Frank. In the end the tombstone read:

IN MEMORY OF
EDWARD LEAR
LANDSCAPE PAINTER IN MANY LANDS
BORN AT HIGHGATE MAY 12 1812
DIED AT SAN REMO JANUARY 29 1888
DEAR FOR HIS MANY GIFTS TO MANY SOULS

"all things fair,
With such a pencil such a pen,
You shadow'd forth to distant men,
I read and felt that I was there."

These words of Tennyson were chiselled on a white marble slab, the twin of one which Lear had erected in memory of Giorgio.[1] The two stones now stand alongside each other inside identical iron railing fences, looking very like those of a long-married husband and wife. In this, at least, Frank had carried out what surely were Lear's wishes.

The Tennysons produced a more fitting memorial to Lear. Within a year of his death they published a book containing his famous Tennyson illustrations. Admittedly they only included sixteen of them, along with six vignettes, and the edition was limited to a hundred subscribers. Written on the fly-leaf of an extra, unnumbered, copy were the words, "To Franklin Lushington from Tennyson and Emily Tennyson." Frank had contributed a brief introduction, the first public acknowledgement of his forty years of friendship with Lear. He confined himself to Lear the traveller, the role in which he had liked him best, describing those "flights ever bolder . . . impervious to discomfort and fatigue and almost to illness that might have quelled the stoutest energy". In a piece written for *Macmillan's Magazine* ten years later, Frank allowed himself a personal anecdote or two about his trip to Arcadia with Lear, which he described as "a 2 months' journey of riding and sketching through the wildest and loveliest corners of Greece".

To see the Tennyson drawings published had been Lear's dearest wish for close on forty years. As far back as the early fifties (soon after his first meeting with Frank), he had started making lists of suitable poetic phrases for which he would choose illustrations from his sketch-books. The book was to bear a "sort of resemblance to Turner's *Liber Studiorum*". It would give samples of a wide variety of landscapes. The Tennysons' edition in fact confined itself to illustrations to three poems. All, suitably enough, had landscape for their actual subject. They were: "To E. L. on his Travels in Greece", "The

Daisy" (inspired by a visit to the Riviera), and "The Palace of Art", by far the longest of the three. This described a palace that stood upon "a huge crag platform", and contained tapestries illustrating a variety of landscapes.

It is a shock to open Lear's *Tennyson* for the first time. Gone are the delicately traced outlines of mountain ranges, seemingly traced by a spider's leg. In their place are crudely blocked-out dreamscapes in black and grey wash, all detail lost in passages of overpowering darkness. Civitella, for instance, the glorious Sabine peak where Lear had lived with Marstrand, is reduced to a grey pyramid with an impenetrable blackness of tortured trees in the foreground. Stranger still is the five-fingered Calabrian crag of Pentedatillo, "the almost last bit of rock in Italy" seen from the seashore. A vast moon rests upon the sand and, in the foreground, a black figure staggers under the weight of the sky. Beneath it is written,

> One seem'd all dark and red – a tract of sand
> And someone pacing there alone,
> Who paced forever in a glimmering land
> Lit with a low large moon.

Yet the semi-abstract nature of these drawings was only the extreme development of a tendency that had already appeared twenty years earlier, notably in some of the sketches made in Crete and on the Riviera. A possible reason for the twilight aspect of these drawings was that Lear was himself moving in a twilit world. He had virtually lost the sight of one eye. In a letter to Holman Hunt written in 1880, he had confessed, "blind as I am, I am compelled to begin with a forcible dark outline, and that aint easy to get rid of – though without it I could do nothing".[2]

Meanwhile Frank, back at Southborough, went through Lear's diaries, and presumably discovered much about his friend, including the fact that he had been an epileptic. He also no doubt registered Lear's unhappiness during the three years between 1855 and 1858 when they were together in Corfu. But what did Frank do then? We only know that from about the time of Frank's death in 1901 all the diaries

written before 1858 vanished. And this in spite of the fact that Lear had made it clear to Fortescue years earlier that he considered his diaries to be more worthy of publication than many he had read. We shall never know what happened to them.[3]

As the century came to a close, Frank had more important things to think about. The trumpet call of war, this time the Boer War, was once more flaring the old warhorse's nostrils. Again he charged into verse. In 1899 he wrote a poem called, "Play out the Game" (which owed nothing to Henry Newbolt, whose *Vitai Lampada* was not published till 1908).

> Sweep once more the slumbering chords – wake once more the tones that linger
> Faintly echoing far away, in the wandering thoughts of an aged singer
> Hail, Australia! Welcome Canada! Greater Britain all round the wave,
> Fight one fight and carry one banner, plant it firm on tyranny's grave! . . . [4]

Frank's race was nearly run. He died in 1901, at 33 Norfolk Square, after only a few days' illness. "He was on the bench at Bow Street as usual on Thursday last," *The Times* recounted, "and, though he appeared to be unwell, his health did not give rise to any anxiety until Saturday, when an attack of Lumbago, from which he was suffering, was followed by a seizure of rheumatic gout." Frank was buried in Boxley churchyard. Tom's son, the Rev. Godfrey Lushington, conducted the service, and among the mourners were representatives of the Metropolitan magistrates, the Treasury and Bow Street Police Court. Venables was not there. He had died a few months earlier.[5] Like Frank and Lear, he too was now a traveller in another place.

> As in strange lands a traveller walking slow,
> In doubt and great perplexity,
> A little before moonrise hears the low
> Moan of an unknown sea.

Postscript

There remains only to explain the mysterious survival of Lear's Nonsenses a century later, verses dropped so casually throughout the course of a long life. The landscape paintings he had laboured over for fifty years were forgotten within twenty years of his death. When Lady Strachey published his letters to Fortescue in 1907 she introduced him on the title page as "Author of 'The Book of Nonsense'". Nothing more.

The success of the Nonsenses had amazed Lear. That success only increased with time. Almost as soon as he was dead the first collected edition was brought out in the USA by Roberts of Boston. It was prefaced by the famous last photograph and two articles about Lear from leading London periodicals. By the time Lady Strachey published her second volume of his letters in 1911, the Nonsense books were in forty editions. It was in that year that she brought out her own edition, entitled *Queery Leary Nonsense*, published by Mills and Boon. It had particular charm for collectors, since it included not only an introduction by Evelyn Baring (Lord Cromer), the second of Lear's beloved Barings, but also Lear's collection of coloured birds, which no nursery should be without. Since then the editions of Lear's Nonsense verse have been uncountable. In 1984 John Vernon Lord brought out a very complete and well-indexed edition with his own illustrations. It is perhaps a mistake to push Lear off his perch as an illustrator, but such a lively interest in his poetry bodes nothing but good for the future of his reputation.

Why have these apparent frivolities lasted into the last

quarter of the twentieth century? Why are they quoted almost daily both in conversation and the media? The charm of the limericks, written in Lear's twenties, was that they turned the ordered world on its head. But the world is on its head all the time now, and still the little ones lisp, "There was an old man of Calcutta..." (I have heard Indian children recite this limerick with exceptional charm.)

The survival of the ballads, written in Lear's sixties, is more easily understood. Like the limericks, they celebrate the outsider. Their principal characters are socially unacceptable. The Dong has a luminous nose, "Of vast proportions and painted red". The Yonghy-Bonghy-Bò's head is far too big for his body, The Pobble has no toes. But they go beyond the limericks and mix absurdity with pure poetry. For lines like the opening of the Dong are surely poetry.

> When awful darkness and silence reign
> Over the great Gromboolian plain,
> Through the long, long wintry nights;
> When the angry breakers roar
> As they beat on the rocky shore;
> When storm-clouds brood on the towering heights
> Of the Hills of the Chankly Bore.

The characters are made ridiculous only so that their tragedy will be acceptable. But the tragedy is real enough. And it is the tragedy of Lear himself, a man also disfigured and apart.

> And the Dong was left on the cruel shore
> Gazing-gazing for evermore
> Ever keeping his weary eyes on
> That pea-green sail on the far horizon.

APPENDIX I

Wills of Edward and Ann Lear

WILL OF EDWARD LEAR

Lear left £2,668 19s. 2d. His will was proved by Franklin Lushington of Templehurst, Southborough, Tunbridge Wells. His executors were Franklin Lushington, Bernard Senior, Hubert Congreve and Frederick Thomas Underhill. He left all his papers and paintings to Franklin Lushington and the proceeds from the sale of the Villa Tennyson and its contents to Franklin's eldest daughter, Louisa Gertrude Lushington. By far the largest financial bequest, a sum of £1,000, went to his grandniece, Emily Gillies of Dunedin Cottage, New Zealand. (She was the daughter of Charles Street.) Other relatives who benefited were Lear's brother Frederick, of Hillsborough, Missouri, who received £100, and the children of his brother, Henry, who were to share £100. Below are listed the friends who benefited:

Alan Nevill (godson) £300
Percy Edward Coombe (godson) £100
Hubert Congreve £300
Arnold Congreve £25
Frederick Thomas Underhill £100
Cavalambos Kokali of Brindisi £50
Demetrio Kokali of Corfu £50

WILL OF ANN LEAR

Ann's will was made at Leatherhead in 1860 and her executor was Bernard Senior. Her effects amounted to less than £450.

She left her money, her gold watch and a brooch with a lock of her grandmother's hair in it, to Edward. Her clothes were to be divided among her sisters.

WILL OF FRANKLIN LUSHINGTON

This is not at Somerset House and has not been traced.

APPENDIX II

Present Location of Lear's Drawings

Lear claimed that he would leave 8,000 drawings, but friends estimated the number at nearer 10,000. Nothing like this quantity has been traced, although some suspect that a cache may lurk in New Zealand, the home of Lear's grand-niece, Emily Gillies. In 1929 the two largest collections of Lear's drawings, those of Sir Franklin Lushington and of Lord Northbrook, were auctioned at Sotheby's. A great part of these was bought by two Americans, William B. Osgood Field and Philip Hofer. They, in turn, donated their treasures to the Houghton Library of Harvard College in 1942. This library owns the largest collection of Lear's drawings in the world.

In England, the largest collection is at Liverpool City Library and consists of two-hundred-odd drawings stuck into albums by Lord Northbrook. Two Athenian institutions, the Benaki Museum and the Gennadio Library, own large collections of the Greek drawings.

Notes and References

For the sake of convenience, I have used the following abbreviations for the most commonly quoted sources.

EL Edward Lear
F Chichester Fortescue
FL Franklin Lushington
ET Emily Tennyson
HH Holman Hunt
GV George Venables
Stanley The 14th Earl of Derby
Ly.W Lady Waldegrave
Ann Letters from Lear to his sister Ann
Alb. *Journals of a Landscape Painter in Albania*, etc, 1851
IJ *Indian Journal*, 1953
Cor. *Journal of a Landscape Painter in Corsica*, 1870
CJ *Journal of a Landscape Painter in Crete*, 1985
Exc. in I *Illustrated Excursions in Italy*, 2 vols., 1846
S.Calab. *Journals of a Landscape Painter in Southern Calabria*, etc, 1852
LEL *Letters of Edward Lear*, ed. Lady Strachey, 1907
LLEL *Later Letters of Edward Lear*, ed. Lady Strachey, 1911
Northbrook 7 Albums of Lear's works at Liverpool City Library
Lord *The Nonsense Verse of Edward Lear*, illustrated by John Vernon Lord, 1984
TRC Tennyson Research Centre, Lincoln
RA Cat. Catalogue of Royal Academy Exhibition, 1985
VN Vivien Noakes's *Edward Lear: The Life of a Wanderer* (BBC, 1985)
AD Angus Davidson's *Edward Lear: Landscape Painter and Nonsense Poet*, 1938

1 Franklin Lushington

1 Ann, 8 Mar. 1849.
2 George Granville Bradley (1821–1903). Bradley was a close friend of Frank's at Rugby although four years older. Later, Dean of Westminster.
3 Waller, John O., *A Circle of Friends*, 1986, pp. 51–59.
4 Brookfield, Frances, *Cambridge Apostles*, 1906, p. 188.
5 Henry Lushington to Monckton Milnes, Aug. 1841.
6 Ann, 8 Mar. 1849.
7 FL's introduction to "A Leaf from the Journals of a

273

Landscape Painter", *Macmillan's Magazine*, Apr. 1897.

8 Ann, 8 Mar. 1849.
9 FL's intro. to "A Leaf from the Journals...".
10 Ann, 4 and 21 Apr. 1849.
11 D, 1 Aug. 1873.
12 FL's intro. to EL's "Illustrations to Tennyson", 1889.
13 Congreve, Hubert, preface to LLEL.
14 FL's intro. to "A Leaf from the Journals...".
15 Ann, 21 Apr. 1849.

2 Childhood

1 IJ, 13 Jan. 1874.
2 Ann Lear, senior, was the great-great-granddaughter of John Grainger of Sunnyside, near Newcastle. After the rebellion of 1745 her grandmother, Florence Brignall Usher, settled in London where she owned property both in the City and in Whitechapel.
3 Moore, Thomas, RA Cat., p. 166. The ms, with comic illustrations, is in the Pierpont Morgan Library, New York.
4 D, 21 Aug. 1873.
5 D, 14 Feb. 1880.
6 D, 15 Aug. 1866.
7 *Ibid.*
8 D, 17 Feb. 1887.
9 D, 24 Mar. 1877.
10 Ann, 9 Sept. 1848.
11 Mrs Bowen, unpublished recollections, dictated by her grandmother, Sophie Street, widow of Charles Street, 1907.
12 VN, p. 208. No source given. Frederick Harding must not be confused with the painter J. D. Harding (1758–1863) who was twenty-four years old at the time.
13 RA Cat., p. 75.
14 Mrs Bowen, *op. cit.*
15 Ann to Frederick Lear, 10 Sept. 1847.
16 Ann, 15 Dec. 1856.
17 RA Cat., p. 77.
18 D, 18 Sept. 1861.
19 EL to F, 9 Mar. 1858, LEL, p. 92.
20 VN, p. 18.
21 EL to F, 3 Jan. 1858.
22 EL to F, 2 Sept. 1859, LEL, p. 148.

3 Parrots

1 Preface to *Nonsense Songs and Stories*, sixth ed.
2 Fowler, *Autobiography*.
3 RA Cat., p. 80.
4 EL to Lord Northbrook, 11 Oct. 1867, at Houghton Library.
5 RA Cat., p. 82.
6 RA Cat., p. 81.
7 EL to Charles Empson, 1 Oct. 1831.
8 EL to Arthur Aitken, at Royal Society of Artists.
9 EL to Empson, 1 Oct. 1831.
10 At Houghton Library.
11 23 Jan. 1834. Quoted Brian Reade, *Edward Lear's Parrots*, 1949, p. 16.
12 D, 26 June 1862.
13 Reade, *op. cit.*, p. 26.
14 D, 7 Feb. 1881.
15 D, 2 Sept. 1862.
16 EL to Empson, 1 Oct. 1831.
17 *The Dickensian*, No. 48.

18 Fowler, *op. cit.*
19 EL to Empson, 1 Oct. 1831.
20 D, 20 Feb. 1885.

4 Knowsley

1 Diary of Frances Lady Shelley.
2 *More Nonsense*, 1872,
 introduction.
3 Liebert, Herman W., *Lear in the Original*, 1975.
4 Fowler, *Autobiography*.
5 Creevey Papers, 1903, vol. II, p. 57.
6 EL to F. LEL, pp. ix–xx.
7 D, 1 May 1884.
8 EL to Stanley, 2 June 1836.
 James Hunt was presumably keeper of the reptile house.
9 RA Cat., p. 87. This beast could have strayed from an eighteenth-century bestiary.
10 EL to Charles Empson, 1 Oct. 1831.
11 Reproduced by Liebert, *op. cit.*
12 EL to Gould, 31 Oct. 1836.
13 D, 12 May 1862.
14 RA Cat., p. 95.

5 Rome

1 Ann, 3 June 1848.
2 Greville, Charles, *Memoirs*.
3 Ann, 3 Nov. 1837.
4 Ann, 4 Dec. 1837.
5 Ann, 14 Dec. 1837.
6 Ann, 27 Jan. 1838.
7 Ann, 14 Dec. 1837.
8 EL to Mrs Roberts, 1 Mar. 1838.
9 Baedeker, *Central Italy*, 1893.
10 Ann, 29 Mar. 1838.
11 Almost certainly Miss Hosner.

Listed in Murray's *Handbook for Rome*, 1871.
12 Haydon, Benjamin, *Autobiography and Journals*, 1853.
13 Ann, 14 Dec. 1837.
14 Ann, 27 Jan. 1838.
15 Ann, 14 Dec. 1837.
16 Letters of Harriet, Countess Granville, 1894.
17 Murray, John, *Handbook for Rome*, 1871, p. xliv.
18 Ann, 29 Mar. 1838.
19 Ann, 14 Dec. 1837.
20 Ann, 27 Jan. 1838.
21 Ann, 29 Mar. 1838.
22 Ann, 3 May 1838.
23 Ann, 27 Jan. 1838.
24 Ann, 29 Mar. 1838.
25 Ann, 27 Jan. 1838.
26 Ann, 29 Mar. 1838.

6 Civitella

1 Ann, 29 Mar. 1838.
2 Mrs Uwins, *A Memoir of Thomas Uwins RA*, 1858.
3 DNB.
4 Ann, 11 May 1838.
5 Mrs Uwins, *op. cit.*, vol. I, p. 305.
6 Ann, 29 Mar. 1838.
7 Mrs Uwins, *op. cit.*, vol. I, p. 280.
8 Ann, 11 May 1838.
9 Ann, 3 May 1838.
10 Ann, 11 May 1838.
11 Ann, 21 May 1838.
12 Ann, 28 May 1838.
13 Palmer to Richmond, *Letters of Palmer*, vol. I, p. 138.
14 Ann, 10 June 1838. "Savage Rosa" was a highly romantic Neapolitan landscape painter of the seventeenth century, the predecessor of Claude Lorraine

and the inventor of the romantic
bandit.

15 Ann, 10 June 1838.

16 RA Cat., p. 138.

17 Northbrook, vol. VII,
Kingdom of Naples.

18 Ann, 27 Jan. 1838.

19 Ann, 26 Sept. 1838.

20 Ann, 10 June. 1838.

21 Ann, 26 Sept. 1838.

22 I am indebted to Deryk Webley
of Merthyr Tydfil for
information on Penry Williams.
He is at work on a biography of
the painter. "Italian Girls
Preparing for a *Festa*" and
"Neapolitan Peasants at a
Fountain" are his best-known
paintings. Both hang in the
National Gallery, London.

23 Ann, 11 Oct. 1838.

24 EL to Lord Aberdare, 25 Sept.
1884, Glamorgan Library.

25 Ann, 11 Oct. 1838.

26 Ann, 26 Sept. 1838.

27 EL to Gould, 17 Oct. 1839.

28 Ann, 26 Sept. 1838.

29 Madsen, Karl, *Marstrand*, 1906.
One of a large number of
illustrations.

30 D, 16 Jan. 1867.

31 D, 7 Apr. 1860.

32 D, 18 Oct. 1873.

33 RA Cat., p. 138. Lear was to
paint Civitella at least five more
times. The largest painting, of
1847, was more than six feet
long (RA Cat., p. 140) and
was known affectionately as
"the old brown picture". It
ended up on the premises of
the Clothworkers'
Company.

34 EL to Stanley, 26 Jan. 1838,
PRO Liverpool.

35 EL to Gould, 17 Oct. 1839.

36 Benezit, E., *Dictionnaire de
Peintres*, 10 vols. 1976.

7 The Abruzzi

1 Mrs Uwins, *A Memoir of
Thomas Uwins RA*, 1858, vol. I,
p. 330.

2 EL to Gould, 27 Feb. 1841.

3 EL to Gould, 28 Aug. 1841.

4 There is some disagreement
about the date of these drawings
which are reproduced in *Lear in
the Original*, 1975, by Herman
W. Liebert, and ascribed by him
to the mid-thirties because Lear
was still thin. But Lear was still
thin in the series of riding
instruction cartoons which
Charles Knight gave him in
1842, and both series were
found in the same album.
Furthermore, Phipps Hornby
did not take up his appointment
at Woolwich until 1841.

5 Liebert, *op. cit.*

6 EL to Gould, 27 Feb. 1841.

7 EL to Stanley, 5 June 1842,
PRO Liverpool.

8 RA Cat., p. 102. Isabella Jane
Knight's Commonplace Book is
at the British Museum.

9 RA Cat., p. 102.

10 EL to Gould, 12 Aug. 1844.

11 Exc in I. Subsequent quotations
in chapter 7 from same source
unless otherwise attributed.

12 D, 19 June 1871.

13 Ann, 27 Aug. 1844.

14 RA Cat., p. 102.

15 Northwood, vol. II, p. 35.

16 Fox Strangeways, A.H., *Cecil Sharp*, 1955.
17 This short visit to the Abruzzi is ignored by Briony Llewellyn's chronology of Lear's travels in the RA Cat. The long visit is ascribed to 1842 instead of 1843. VN is accurate in her chronology.
18 Ann, 24 Sept. 1844.
19 Northwood, vol. IV, Arden and Practica, 10 Mar. 1845.
20 Exc. in I, vol. II, 3 April.
21 *Ibid.*, p. 28.
22 F's diary, . . . *and Mr Fortescue*, ed. Osbert Wyndham Hewett, 1958. Subsequent quotations to end of chapter 7 from same source.

8 Queen Victoria

1 J.E.Gray, preface to *Gleanings* . . .
2 EL to F, 11 Oct. 1846. VN is possibly mistaken in supposing that he "took rooms on his own".
3 Exc. in I, vol. I, p. viii.
4 Edited transcript of Queen Victoria's Diary, Royal Archives.
5 RA Cat., p. 159.
6 LEL, p. xxi.
7 Ann, 6 Feb. 1847.
8 EL to F, 29 Dec. 1861.
9 Queen Victoria, *Leaves from the Journal of our Life in the Highlands*, 8 Oct. 1861.
10 EL to F, 29 Dec. 1861, LEL, p. 214.
11 EL to F, 12 Feb. 1848.
12 VN, p. 63.
13 EL to F, 12 Feb. 1848, LEL, p. 6.

14 EL to F, 11 Oct. 1846.
15 Hazlitt, William, *Notes of a Journey through France and Italy*, 1826, ed. P.P.Howe, 1932.
16 Ann, 22 Nov. 1838.
17 Ann, 11 Apr. 1847.
18 Ann, 30 Dec. 1846.
19 Ann, 28 Oct. 1847.
20 Ann, 30 Dec. 1846.
21 Ann, 6 Feb. 1847.
22 Ann, 8 Jan. 1847.
23 Ann, 24 Jan. 1847.
24 Ann, 8 Jan. 1847.
25 Ann, 6 Feb. 1847.
26 Ann, 27 Mar. 1847.

9 Sicily

1 Proby, Granville, *Lear in Sicily*, 1938.
2 EL to F, 16 Oct. 1847, LEL, p. 3.
3 Ann, 7 May 1847.
4 Ann, 23 May 1847.
5 Ann, 17 June 1847.
6 Ann, 23 May 1847.
7 *Ibid.*
8 Walker Art Gallery, Liverpool.
9 Ann, 11 July 1847. The sketch is one of the six Sicilian studies at Liverpool City Library.
10 Ann, 17 June 1847.
11 EL to F, 16 Oct. 1847, LEL, p. 4.

10 Calabria

1 S.Calab. All quotations in chapter 10 from this source unless otherwise attributed.
2 Northbrook, vol. V.
3 Douglas, Norman, *Old Calabria*, 1915. The Byzantine Greek villages of Calabria are not to be confused with the

ancient Greek colonies of the area.

4 Northbrook, vol VI.

5 The survival of La Cattolica is entirely due to its remoteness. So special is the church now considered that it was chosen for the cover of the 1987 Blue Guide to Southern Italy.

6 Northbrook, vol. VI.

7 Douglas, *op. cit.*, p. 40.

8 Northbrook, vol. VII.

9 Ann, 16 Oct. 1847.

10 EL to F, 12 Feb. 1848, LEL, p. 9.

11 EL to F, 25 Nov. 1848, LEL, p. 119.

12 Ann, 8 Jan. 1848.

13 Ann, 23 Dec. 1847.

14 Ann, 25 Jan. 1848.

15 Ann, 18 Mar. 1848.

16 Ann, 9 Apr. 1848.

17 Ann, 21 Apr. 1849.

11 Constantinople

1 EL to 15th Earl of Derby, n.d.

2 Ann, 1 Apr. 1848.

3 Ann, 19 Apr. 1848.

4 Ann, 14 May 1848.

5 Ann, 3 June 1848.

6 EL to F, 19 July 1848, LEL, p. 10.

7 Ann, 3 June 1848.

8 EL to F, 19 July 1848, LEL, p. 10.

9 Ann, 19 July 1848.

10 EL to F, 19 July 1848, LEL, p. 10.

11 EL to F, 25 Aug. 1848, LEL, p. 12.

12 Ann, 23 Dec. 1849.

13 EL to F, 19 July 1848, LEL, p. 10.

14 Ann, 9 Sept. 1848.

15 Ann, 12 Aug. 1848.

16 Ann, 27 Aug. 1848.

17 EL to F, 25 Aug. 1848, LEL, p. 12.

18 Ann, 27 Aug. 1848.

19 Ann, 12 Aug. 1848.

20 Ann, 9 Sept. 1848.

21 Ann, 12 Aug. 1848.

22 Ann, 13 Nov. 1848.

23 Ann, 12 Sept. 1848.

12 Albania I

1 Byron, *Childe Harold*.

2 G and A. Subsequent quotations in chapter 12 from same source unless otherwise attributed.

3 EL to Stanley, 1848, Liverpool PRO.

4 AD, p. 63.

5 Ann, 7 Nov. 1848.

13 Albania II

1 Ann, 9 Jan. 1849.

2 Ann, 11 Jan. 1849.

3 Byron, *Childe Harold*.

4 G and A. Subsequent quotations in chapter 13 from same source unless otherwise attributed.

5 Urquart, David, *The Spirit of the East*, 1831.

6 Ann, 8 Feb. 1848. The phrase referred back to a romantic misfortune of Ann's.

14 The Lushingtons

1 Mary Lear to Frederick Lear, c. May 1850.

2 D, 25 Apr. 1858.

3 Tennyson, Hallam, *Tennyson*, vol. I, p. 182.

4 Brookfield, Frances, *Cambridge Apostles*, 1906, p. 89.

5 FL and HSM, *Memoir of Henry Fitzmaurice Hallam*, 1850. HSM was probably Henry Sumner Maine, the historian of the British Constitution and a fellow Apostle with Franklin Lushington and Henry Hallam.

6 "The Princess" is today famous for the nine songs that the women sing. They include "The Splendour Falls" and "Now Falls the Crimson Petal, now the White".

7 Diary of GV, 2 Mar. 1856.

8 Waller, John O., *A Circle of Friends*, 1986, p. 206.

9 "The Princess" was dedicated to Henry Lushington.

10 Henry Hallam to Frances Brookfield. Waller, *op. cit.*, p. 153.

11 Brookfield, *op. cit.*, p. 19.

12 *Ibid.*, p. 363.

13 "Swing at Cambridge" about a rick-burner of that name, was the least unsuccessful. Lushington, Henry, and GV, *Joint Compositions*, 1840.

14 GV's introduction to *The Italian War, 1848–9, and the Last Italian Poet*, 1859, pp. lxv–lxvi.

15 Diary of GV, 1848.

16 Diary of GV, 1854 and 1855.

17 Douglas, Lord Alfred, "Two Loves".

18 Hyde, H. Montgomery, *The Other Love*, 1970, p. 110.

19 Hyde, *op. cit.*, p. 111. All contributions to the *Saturday Review* were anonymous, but GV was a regular critic and the style is his.

20 EL to ET, 2 Dec. 1851.

21 Sanby, William, *History of the Royal Academy of Arts*, 1862, vol. II, p. 440.

22 EL to F, 20 July 1850, LEL, pp. 23–24.

23 EL to F, 26 Aug. 1851, LEL, p. 22.

24 EL to F, 1 .Aug. 1849, LEL, p. 16.

25 EL to Stanley, 28 Nov. 1850.

26 Ann to Fanny Lear, 29 Sept. 1851.

27 EL to F, 19 July 1851, LEL, p. 18.

28 EL to F, 1 Aug. 1849, LEL, pp. 15–16.

29 Pollard, William, *The Stanleys of Knowsley*, 1868.

30 By a freak of history, there is now a safari park at Knowsley. The house is inhabited partly by the Derby family, partly by the police. It is not open to the public.

31 EL to F, 19 July 1851, LEL, pp. 18–19.

32 EL to F, 26 Aug. 1851, LEL, pp. 21–22.

33 EL to F, 19 July 1851, LEL, p. 18.

34 EL to F, 26 Aug. 1851, LEL, pp. 20–22.

35 EL to ET, 1857.

36 D, 27 May 1865.

37 HH, *Pre-Raphaelitism and the Pre-Raphaelite Brotherhood*, 1905, Vol. I, p. 328.

38 HH, *op. cit.*, vol. I, p. 241.

39 It seems highly probable that the cliff-top background to Hunt's sheep is no more. The houses of Sea Road, Fairlight, which were built there after his time, are falling one by one into the sea.

40 HH, *op. cit.*, Vol. I, p. 330.

41 Lost.
42 Hunt, Diana Holman, *My Grandfather, His Wives and Mistresses*, 1969.
43 HH, *op. cit.*, vol. I, p. 333.
44 EL to F, 23 July 1853, LEL, p. 28.
45 HH to F. G. Stephens, n.d., Bodleian Library.
46 City of Bristol Museum and Art Gallery.
47 RA Cat., p. 144.
48 HH to EL, 24 Apr. n.y.
49 The Pre-Raphaelites, Tate Exhibition Cat., 1984, p. 121.
50 HH, *op. cit.*, vol. I, p. 332.
51 North, Marianne, *Recollections of a Happy Life*, 1892.
52 EL to F, 23 Jan. 1853, LEL, pp. 27–29.
53 EL to F, 23 July 1853.
54 EL to F, 19 June 1853.
55 EL to HH, 11 July 1853.
56 EL to F, 10 July 1853.
57 EL to ET, 8 Oct. 1853.
58 EL to ET, n.d., 1853.
59 Ann, 17 Dec. 1853.
60 Ann, 19 Dec. 1853.
61 Edwards, Amelia B., *A Thousand Miles up the Nile*, 1877.
62 *Ibid.*, p. 307.
63 GV's introduction to *The Italian War 1848–9 and the Last Italian Poet*, 1859, pp. lxv–lxvi.
64 Written 2 Dec. 1854.
65 F to EL, n.d., 1855.
66 Diary of GV, 21 May 1855.

15 Harry

1 GV's introduction to *The Italian War 1848–9 and the Last Italian Poet*, 1859, p. xlviii.
2 Henry Lushington to GV, 13 May 1855.
3 Macmillan shilling pamphlet, 1855.
4 Diary of GV, 7 July 1855.
5 *Ibid.*, 17 July 1855.
6 Brookfield, Frances, *Cambridge Apostles*, 1906, p. 200.
7 Diary of GV, 10 Aug. 1855.
8 *Ibid.*, 11 Aug. 1855.
9 *Ibid.*, 6 Sept. 1855.
10 *Ibid.*, 21 Sept. 1855.
11 EL to ET, 11 Nov. 1855.
12 EL to ET, 18 Oct. 1855.
13 Diary of GV, 24 Feb. 1854.
14 *Ibid.*, late 1853 and early 1854.
15 ET to EL, Nov. 1855.
16 EL to ET, 28 Oct. 1855.
17 Diary of GV, 6 Sept. 1855.
18 Montieth to Milnes, 12 Nov. 1855, Houghton papers, Trinity College, Cambridge.
19 F's diary, 16 Sept. 1855, . . . *and Mr Fortescue*, ed. Osbert Wyndham Hewett, 1958.
20 ET to EL, late Sept. 1855.
21 Farringford House is now a hotel.
22 EL to ET, 28 Oct. 1855, TRC.
23 ET to EL, 11 Jan. 1856, TRC.
24 *Lady Tennyson's Journal*, 17 Oct. 1855, ed. James O. Hoge.
25 Now the Swainston House Hotel.
26 F to EL, 7 Nov. 1855. Early in 1858 Lear published this song and another lyric from "Maud": "Come not, when I am Dead", along with two more from "The Princess": "How they Brought her Warrior Dead" and "As Through the Land at Eve we Went"; and one from "In Memoriam": "The Time Draws Near". The notation was the work of Frances Rimbault

(1816–76). At the same time he re-issued the songs published in 1853.

27 *Lady Tennyson's Journal*, 17 Oct. onwards, pp. 54–55.
28 ET to EL, 27 Oct. 1855.
29 Lear referred to the well-known moral tale by Maria Edgeworth, "The Purple Jar".
30 EL to ET, 28 Oct. 1855.
31 EL to ET, 2 Dec. 1851.
32 Richardson, Joanna, *Edward Lear*, 1965, p. 25.
33 EL to ET, 28 Oct. 1856.
34 EL to F, 16 Nov. 1855.
35 EL to ET, 28 Oct. 1855, TRC.
36 Ann, 21 Nov. 1855.
37 Diary of GV, 31 Dec. 1855.

16 Corfu with Frank

1 Ann, 29 Nov. 1855.
2 Ann, 13 Dec. 1855.
3 Ann, 4 Dec. 1855.
4 Ann, 7 Jan. 1856.
5 Ann, 25 Dec. 1855.
6 Ann, 18 Apr. 1856.
7 Ann, 18 Dec. 1855.
8 Ann, 3 Apr. 1856.
9 Ann, 1 Mar. 1856.
10 Ascension stands on the highest point of the peninsula that divides the Bay of Garitza from the Lagoon of Halikiopolou, now transversed by the airport runway. The acropolis of ancient Corcyra (Corfu) stood on this hill.
11 Ann, 3 Apr. 1856.
12 One of these is reproduced in RA Cat., p. 148.
13 Ann, 10 Jan. 1856.
14 See "Study of Olives" reproduced in Philip Hofer's book, *Edward Lear as a Landscape Draughtsman*, 1968, p. 4. Hofer dates this drawing 1849. Lear's first visit to Corfu was in 1848.
15 EL to HH, 11 May 1856.
16 Ann, 10 Jan. 1856.
17 Ann, 11 Sept. 1856.
18 Ann, 1 Mar. 1856.
19 Ann, 18 Apr. 1856.
20 Ann, 10 Jan. 1856.
21 Ann, 4 Dec. 1856.
22 EL to ET, 13 Apr. 1856, TRC.
23 AD, p. 96.
24 Ann, 18 Apr. 1856.
25 Ann, 3 Apr. 1856.
26 Ann, 25 Dec. 1856.
27 Ann, 25 Dec. 1855.
28 Ann, 18 Apr. 1856.
29 *Ibid*. Palaiokastritsa unfortunately *is* now a watering place, albeit a small one.
30 Sarah's husband was also named Charles.
31 Five of Lear's letters to Charles Street in New Zealand have been preserved along with his letters to Ann.
32 Ann, 11 May 1856.
33 EL to ET, 9 Oct. 1856.
34 Ann, 19 June 1856.
35 Ann, 29 June 1856.
36 Ann, 19 June 1856.
37 Ann, 18 Apr. 1856.
38 Ann, 29 June 1856.
39 Ann, 11 May 1856.
40 Ann, 20 June 1856.
41 Ann, 11 May 1856.
42 Ann, 15 July 1856.
43 *Mount Athos, Thessaly and Epirus*, 1855. Leake had covered Athos early in the century (*Northern Greece*, vol. III). Rycant and Curzon had also

written on the subject, as had a Frenchman, Pierre Balon, in the sixteenth century.

44 Ann, 8 Oct. 1856.

45 The author, for obvious reasons, has been unable to seek hospitality at Kariess, but in 1986 her reception at the monastery of Voulkano in the southern Peloponnese, visited by Lear with Franklin Lushington in 1849, was very similar, with the monks sitting down both sides of a long table in council. As it was Lent, black coffee and a dry crust were served in place of ouzo and Turkish delight.

46 Ann, 8 Oct. 1856.

47 Loch, Sydney, *Athos, the Holy Mountain*, 1957.

48 D, 2 May 1863.

49 D, 17 Apr. 1864.

50 Ann, 8 Oct. 1856.

51 EL to F, 9 Oct. 1856, LEL, pp. 41–42.

52 Dr Galland to GV, c. 1857. Venables' Letters at National Library of Wales.

53 Ann, 8 Oct. 1856.

54 Dr Galland to GV, *op. cit.*

55 Edmund Lushington to the Tennysons, 6 Oct. 1856, TRC.

56 Ann, 19 Oct. 1856.

57 Edmund Lushington to the Tennysons, 6 Oct. 1856, TRC.

58 Edmund Lushington to FL.

59 Ann, 19 Oct. 1856.

60 Ann, 25 Dec. 1856.

61 Ann, 15 Dec. 1856.

62 Some of these can be seen in the Rev. H. F. Tozer's collection at the Ashmolean Museum, Oxford.

63 Ann, 25 Jan. 1857.

64 Ann, 25 Dec. 1856.

65 Ann, 19 Jan. 1857.

66 Ann, 25 Dec. 1856.

67 EL to F, 9 Sept. 1856.

68 EL to F, 1 May 1857, LEL, p. 50.

69 EL to F, 9 Sept. 1856.

70 Ann, n.d. 1856.

71 F's diary, 8 Aug. 1857, . . . *and Mr Fortescue*, ed. Osbert Windham Hewett, 1958.

72 *Ibid.*, 16 Sept. 1857.

73 *Ibid.*, 9 Aug. 1857.

74 *Ibid.*, 16 Sept. 1855.

75 Ann, 31 Aug. 1857.

76 F's diary, *op. cit.*, 16 Sept. 1855.

77 *Ibid.*, 9 Aug. 1857.

78 *Ibid.*, 3 Nov. 1858.

79 Ann, 14 Sept. 1857.

80 Hewett, Osbert Wyndham, comment in F's diary, *op. cit.*, p. 111.

81 EL to F, 6 Dec. 1857, LEL, pp. 65–68.

82 EL to ET, 1856.

83 D, 28 Feb. 1858.

84 EL to F, 27 Dec. 1857, LEL, p. 72.

85 EL to F, 27 Feb. 1857, LEL, p. 88.

86 EL to Ly. W, 27 May 1858.

87 D, 25 Mar. 1867.

88 D, 10 Apr. 1858.

89 D, 13 Apr. 1858.

90 *Ibid.*

91 RA Cat., p. 54.

92 Ann, 23 Apr. 1858.

93 EL to Ly. W, 27 May 1858, LEL, p. 109.

94 Ann, 26 May 1858.

95 RA Cat., p. 70.
96 EL to the fifteenth Earl of
 Derby, n.d. 1858, Liverpool
 PRO.

17 Rome Again

1 D, 12 Nov. 1858.
2 D, 22 Nov. 1858.
3 EL to F, 16 June 1858.
4 Woolner to ET, 22 Nov. 1858.
 Thomas Woolner by Amy
 Woolner, 1917, p. 154.
5 D, 16 Nov. 1858.
6 EL to F, 13 Dec. 1858, LEL, p.
 123.
7 EL to F, 4 Feb. 1860.
8 EL to F, 15 Jan. 1859.
9 Ann, 16 Feb. 1860.
10 EL's account book.
11 Ann, 19 Feb. 1859.
12 D, 29 Mar. 1859.
13 Ann, 22 Mar. 1859.
14 EL to F, 7 Sept. 1859, LEL, p.
 152.
15 EL to F, 2 Sept. 1859.
16 D, 19 Oct. 1859. He referred to
 *Recollections of an Excursion to the
 Monasteries of Alcobaça and
 Batalha*, 1835.
17 McCarthy's *History of our
 Times*, vol. III, p. 276. Despite
 his obsessions, Urquart had
 been a successful diplomat,
 serving under Lear's friend,
 Canning, in Istanbul in 1831.
18 EL to F, 12 June 1859, LEL, p.
 140.
19 Fifteenth Earl of Derby to EL,
 25 Nov. 1859.
20 EL to F, 12 June 1859, LEL, p.
 138.
21 EL to F, 14 Nov. 1859, LEL,
 pp. 155–56.
22 Ann, 27 Mar. 1860.
23 Ann, 11 Apr. 1860.

18 The Death of Ann

1 1864. There is still a monkey
 puzzle tree in the gardens,
 planted to mark Garibaldi's
 visit. Both it and the great cedar
 outside the drawing-room
 window survived the storm of
 October 1987.
2 D, 16 June 1860.
3 EL to HH, AD, p. 142.
4 D, 17 June 1860.
5 EL to ET, 1860.
6 Hewett, Osbert Wyndham,
 comment in . . . *and Mr
 Fortescue*, 1958.
7 EL to ET, 1860.
8 EL to F, 9 July 1859, LEL, p.
 143.
9 EL to F, 7 Mar. 1861, LEL, p.
 183.
10 D, 9 Mar. 1861.
11 D, 10 Mar. 1861.
12 EL to F, 18 Mar. 1861, LEL, p.
 184.
13 D, 17 Jan. 1865.
14 D, 21 Mar. 1862.
15 ET to EL, 15 Mar. 1861.
16 D, 22 Apr. 1861.
17 EL to F, 8 June 1861.
18 AD, p. 134.
19 D, 16 June 1860.

19 Corfu without Frank

1 EL to F, 1 Dec. 1861, LEL, p.
 206.
2 EL to F, 23 Jan. 1853, LEL, p.
 30.

3 EL to F, 31 Mar. 1864, LEL, p. 308.
4 EL to F, 21 Jan. 1862, LEL, p. 222.
5 D, 29 Jan. 1862.
6 D, 24 Dec. 1861.
7 D, 12 May 1862.
8 D, 10 May 1862.
9 D, 12 May 1862.
10 EL to ET, n.d. 1862.
11 D, 20 Dec. 1867.
12 EL to ET, 6 Mar. 1861.
13 EL to F, 1 May 1863.
14 EL to F, 23 Mar. 1863, LEL, p. 280.
15 F. to EL, 19 Sept. 1862, LEL, p. 247.
16 EL to F, 23 Mar. 1863.
17 F's diary, 18 June 1854 and 18 Mar. 1855, . . . and Mr Fortescue, 1958, pp. 74 and 81.
18 EL to F, n.d. 1862.
19 EL to F, 25 Nov. 1858, LEL, p. 119.
20 EL to Evelyn Baring, Queery Leary Nonsense, 1906, p. 6. Evelyn was to have a distinguished career in Egypt, and later become Lord Cromer.
21 D, 30 Mar. 1863.
22 EL to Drummond, 23 Mar. 1863.
23 Views in the Seven Ionian Islands, 1863, plate XVIII.
24 Ibid., introduction.
25 D, 12 May 1863.
26 EL to F, 17 June 1863, LEL, p. 283.
27 D, 10 Sept. 1863.
28 EL to F, Sept. 1863, LEL, p. 294.
29 EL to F, 6 Sept. 1863, LEL, p. 289. Lear used a Greek word.
30 EL to F, 31 Mar. 1864, LEL, p. 304.
31 D, 4 Apr. 1864, Lord, p. 162. This fragment was not printed in Lear's lifetime. He wrote another version, with four extra verses while he was in India in 1873–74, which commenced "She sate upon her Dobie".

20 Crete

1 CJ. Subsequent quotations in chapter 20 from same source unless otherwise attributed.
2 EL to ET, 31 June 1864.
3 CJ, pp. 100 and 101.
4 The Spectator, 21 Apr. 1985.

21 Gussie Bethell

1 EL to HH, Jan. 1865.
2 EL to F, 9 July 1860, LEL, p. 143.
3 D, 7 Nov. 1862.
4 D, 29 May 1862.
5 D, 24 Feb. 1865.
6 "The History of Four Little People who Went Round the World" (see page 212 and note 28).
7 D, 11 Dec. 1865.
8 The Menton drawing forms part of a portfolio of nine mixed Lear water-colour drawings acquired for Liverpool Library on 29 Jan. 1944 for £60.
9 D, 9 July 1865.
10 D, 8 July 1865.
11 D, 23 Sept. 1865.
12 RA Cat., pp. 116 and 152.
13 EL to Drummond, 21 Dec. 1865.
14 EL to Ly. W, 24 Dec. 1865, LLEL, pp. 63–64. The Italians' comments have been translated.
15 D, 28 Dec. 1865.

16 EL to Ly. W, 13 Feb. 1866,
 LLEL, p. 69.
17 Ann, 19 Apr. 1848.
18 D, 18 Apr. 1866.
19 D, 29 May 1866.
20 Lear's "The Pelican Chorus". A
 MS version set to music is in the
 Houghton Library.
21 D, 6 Feb., 8 Feb. and 24 Jan.
 1867.
22 The Denderzh drawing forms
 part of the portfolio bought by
 Liverpool Library (see note 8).
23 D, 2 Nov. 1867.
24 D, 3 Nov. 1867.
25 D, 5 Dec. 1867.
26 D, 20 Oct. 1879.
27 F to EL, 14 Nov. 1867.
28 Published in *Nonsense Songs,
 Stories, Botany and Alphabets*,
 1871.
29 Louisa Ashburton, the wife of
 William Bingham Baring,
 second Baron Ashburton
 (1799–1864), head of the Baring
 family. Lear and Frank
 Lushington were guests of the
 Ashburtons on several
 occasions.

22 John Addington Symonds

1 Lord, p. 126.
2 Symonds, J. A., *Memoirs*, 1984,
 ed Phyllis Grosskurth, p. 174.
3 *Ibid.*, p. 177.
4 Privately printed in 1874 and
 described in his *Memoirs* as a
 history of Greek love.
5 Symonds, J. A., *op. cit.*, p. 20.
6 *Ibid.* p. 271.
7 RA Cat., p. 180.
8 EL to Ly. W, 17 Oct. 1866,
 LLEL, pp. 78–79.

9 EL to F, 6 May 1868, LLEL, p.
 104.
10 Cor., 28 Apr. 1868.
11 One of these is reproduced on
 the cover of Dorothy
 Carrington's *Granite Island: A
 Portrait of Corsica*, Penguin ed.
 1984.
12 D, 9 July 1865.
13 D, 11 July 1868.
14 D, 2 Oct. 1869.
15 EL to F, 19 Oct. 1864, LLEL,
 p. 47. Fortunately the westward
 extension of the Isle of Wight
 railway was never undertaken.
16 EL to F, 1 Jan. 1870, LLEL, p.
 110.
17 EL to HH, 9 July 1869.
18 EL to F, 27 June 1869.
19 EL to F, 1 Jan. 1870, LLEL, p.
 111.
20 D, 29 Apr. 1868.
21 EL to F, 22 Aug. 1868, LLEL,
 p. 105.

23 Villa Emily

1 EL to Woolner, 1 May 1870.
 Amy Woolner, *Thomas
 Woolner*, 1917, p. 284.
2 F to EL, 30 Dec. 1870.
3 EL to F, 31 July 1870, LLEL,
 p. 123.
4 Chanler, Mrs Winthrop, *Roman
 Spring*, pp. 29–30.
5 D, 21 Nov. 1870.
6 EL to F and Ly. W, 24 Apr.
 1871, LLEL, p. 123.
7 EL to Ly. W, 22 Jan. 1871,
 LLEL, p. 134.
8 EL to F, 31 July 1870, LLEL,
 p. 122.
9 EL to Ly. W, 22 Jan. 1871,
 LLEL, p. 134.
10 Hofer, Philip, *Edward Lear as a*

Landscape Draughtsman, 1968, p. 21.

11 Reade, Brian. Introduction to cat. of Arts Council of Gt Brit. Edward Lear Exhibition, July 1958. Lear in fact had three paintings of the Nile accepted by the Royal Academy in 1871.

12 The meeting took place in 1869, just before Lear bought his San Remo plot (Hubert Congreve, preface to LLEL, p. 18).

13 EL to F, 13 Sept. 1871.

14 RA Cat., p. 71.

15 LLEL, pp. 19–20.

16 EL to F, 26 May 1872, LLEL, p. 150.

17 EL to F, 2 Apr. 1872.

18 EL to F, 26 May 1872, LLEL, p. 150.

19 EL to F, 20 Apr. 1885, LLEL, p. 336.

24 India

1 EL to F, 26 May 1872, LLEL, pp. 147–49.

2 EL to Edward Strachey, 28 Aug. 1872.

3 EL to Drummond, 15 Dec. 1873.

4 D, 22 Oct. 1872.

5 EL to Stanley, 14 Feb. 1838.

6 Congreve, Hubert, preface to LLEL, p. 21.

7 EL to F, 6 July 1873, LLEL, p. 152.

8 EL to Ly W, 2 July 1873, LLEL, pp. 152–53.

9 EL to Ly. W, 6 July 1873.

10 EL to F, 12 Sept. 1873, LLEL, pp. 153–54.

11 EL to F, 12 Sept. 1873, LLEL, pp. 161–64.

12 National Library of Scotland; Lord, p. 24.

13 EL to F, 12 Sept. 1873, LLEL, pp. 156–57.

14 AD, p. 208.

15 IJ. Subsequent quotations in chapter 24 from same source unless otherwise attributed.

16 EL to F, 24 Jan. 1874.

17 EL to F, Winter 1866. Lear's copy of *Alice in Wonderland* is now in the USA.

18 F to EL, 25 Aug. 1869.

19 EL to F, 28 Feb. 1872, LLEL, p. 146.

25 Hubert

1 Congreve, Hubert, preface to LLEL, pp. 23–30. All subsequent quotations about the Italian holiday with Hubert from same source.

2 D, 2 Aug. 1877.

3 D, 25 Aug. 1877.

4 Symonds, J. A., *Memoirs*, 1984. (All Symonds quotations are from the chapter entitled "Norman".)

5 EL to F, 28 Oct. 1878, LLEL, p. 212.

6 EL to F, 16 Apr. 1879.

7 EL to F, 13 Oct. 1879.

8 North, Marianne, *Recollections of a Happy Life*, 1892, vol. II, p. 83.

9 D, 26 Apr. 1879.

10 D, 9 Apr. 1879.

11 EL to F, 31 May 1877.

12 FL to GV, 11 June 1878.

13 FL to GV, 28 May 1878.

14 EL to F, 21 Dec. 1879, LLEL, p. 227.

15 Lady Strachey, introduction to LEL.

16 EL to F, 19 May 1880.
17 Conversation with Jane Lushington, Dec. 1987.
18 D, 22 Apr. 1865.
19 EL to F, 27 June 1880.
20 EL to F, 11 June 1880.
21 Ann, 15 July 1856.
22 F to EL, 22 Dec. 1876, LLEL, p. 198.
23 *A Fourth Book of Nonsense etc.*, 1877.
24 EL to F, 7 June 1880, LLEL, p. 231.
25 Tennyson's "Elsinore".
26 EL to F, 7 June 1880, LLEL, p. 231.
27 EL to F, 6 Aug. 1880.
28 D, 3 July 1880.
29 Congreve, Hubert, preface to LLEL, p. 36.
30 EL to F, 27 June 1880.

26 The End

1 Congreve, Hubert, preface to LLEL, p. 36.
2 EL to Laura Coombe, 22 Oct. 1882.
3 Reproduced in Philip Hofer's *Edward Lear as a Landscape Draughtsman*, 1968.
4 LLEL, p. 379.
5 Tennyson's "Elsinore", RA Cat., p. 155.
6 Diary of fifteenth Earl of Derby, 14 Jan. 1880.
7 Ashmolean Museum, Oxford.
8 Lady Strachey, introduction to LEL, p. xxxiii.
9 EL to F, 10 Apr. 1882.
10 EL to Amelia Edwards, 26 Oct. 1885, at Somerville College, Oxford.
11 EL to F, 31 Aug. 1882, LLEL, pp. 268–9.

12 EL to F, 8 Apr. 1883.
13 EL to F, 2 July 1882, LLEL, p. 263.
14 EL to F, 8 Aug. 1883, LLEL, p. 288.
15 EL to ET, 18 Aug. 1883.
16 EL to F, 21 Jan. 1884, LLEL, p. 300.
17 D, 21 May 1876.
18 EL to Ly. W, 15 Mar. 1863, LEL, p. 276.
19 EL to F, 18 Oct. 1875, LLEL, p. 187.
20 EL to F, 3 May 1885.
21 EL to F, 3 Nov. 1884, LLEL, p. 320.
22 EL to F, 1 Jan. 1885.
23 F to EL, Mar. 1885.
24 F to EL, 21 Dec. 1884, LLEL, p. 325.
25 EL to fifteenth Earl of Derby, n.d. 1884, Liverpool Public Library.
26 EL to Amelia Edwards.
27 EL to F. There are frequent references to the Tennyson drawings in Lear's letters to Fortescue from this point on.
28 Lady Strachey, introduction to LEL.
29 LLEL, facing p. 344.
30 EL to F, 24 Dec. 1885.
31 F to EL, 25 Dec. 1885.
32 See appendix I.
33 EL to F, 17 July 1885.
34 EL to F, 25 July 1885.
35 EL to F, n.d. 1884.
36 FL to Hallam Tennyson, 7 Mar. 1888.
37 EL to F, 1 Apr. 1887.
38 EL to F, 28 Apr. 1887.
39 Mrs Hassall to Lady Strachey, 21 Jan. 1911, LLEL, pp. 360–61.

40 Estes to Hallam Tennyson, 8 May 1887.
41 D, 4 Apr. 1887.
42 Lear had also spent the summers of 1884 and 1885 in Italy, the first at Recoaro (near Milan), the second at Brianza. In 1886 he achieved Mendrisio for the seventh and last time.
43 EL to F, 8 May 1887.
44 EL to F, 1 Aug. 1887, LLEL, p. 355.
45 EL to F, 2 Dec. 1886, LLEL, p. 352.
46 EL to Mrs Hassall, 21 Oct. 1885, LLEL, p. 365.
47 F to FL, 5 Dec. 1887.
48 EL to F, 21 Oct. 1887. The daughter married a Gillies and had nine children. One of these, Mrs Michell, inherited some of Lear's water-colours.
49 EL to F, 10 Dec. 1886.
50 EL to F, 10 Nov. 1887, LLEL, p. 358.
51 LLEL, p. 361.
52 LLEL, p. 362.

Epilogue

1 Giorgio was in fact buried at Mendrisio.
2 EL to HH, 27 Oct. 1880, Huntingdon Library, San Marino.
3 According to Lushington family tradition, passed to me by Jane Lushington, Frank's grand-daughter, it was Frank's widow, Kate Maria, something of a dragon, who destroyed not only the diaries but Frank's entire correspondence with Lear. If Venables had not died the same year, one might have suspected his influence. There are hints that a fragment of a Greek diary was at one time in the possession of Charles Church. It is quoted in Angus Davidson's biography of Lear.
4 FL, *Wagers of Battle*, 1899.
5 Venables eventually became a Queen's Counsel. His tomb can be seen in the churchyard of the church he built in his home village of Newbridge-on-Wye.

Bibliography

WORKS BY EDWARD LEAR

Nonsense Books

LIMERICKS
A Book of Nonsense, by Derry Down Derry (Edward Lear), 1846, Enlarged
edition 1861. The first edition contained 73, the enlarged 130.
More Nonsense, Pictures, Rhymes, Botany &c., 1872. Including 100 new limer-
icks, botany and alphabets, but no Nonsense songs. This was in effect
a second Book of Nonsense.

NONSENSE SONGS
Nonsense Songs, Stories, Botany and Alphabets, 1871. Including such Nonsense
Songs as "The Owl and the Pussy-cat", "The Duck and the Kangaroo"
and "The Daddy Long-legs and the Fly". Reprinted in USA same year.
*Laughable Lyrics, A Fourth Book of Nonsense Poems, Songs, Botany, Music
&c.*, 1877. Including such Nonsense songs as "The Dong with a Lumi-
nous Nose", "The Pelican Chorus", "The Pobble who has no Toes"
and "The Quangle Wangle's Hat".

MODERN COLLECTION
There are dozens of these. Recommended for its completeness:
The Nonsense Verse of Edward Lear, 1984, illustrated by John Vernon Lord.

Natural History Books

Illustrations of the Family of Psittacidae, or Parrots, by R. Ackermann and
Edward Lear, 1832.
Gleanings from the Menagerie and Aviary at Knowsley Hall, ed J. E. Gray,
1846.

Travel Books

Views in Rome and its Environs, 1841.
Illustrated Excursions in Italy, 2 vols., 1846.
Journals of a Landscape Painter in Albania &c., 1851. New edition, 1965.
Journals of a Landscape Painter in Southern Calabria, &c., 1852. New edition, 1964.
Views in the Seven Ionian Islands, 1863.
Journal of a Landscape Painter in Corsica, 1870.

POSTHUMOUSLY PUBLISHED
Poems of Alfred, Lord Tennyson, illustrated by Edward Lear, 1889.
Lear in Sicily. Introduced by Granville Proby, 1938.
Edward Lear's Indian Journal, ed Ray Murphy, 1953.
Edward Lear: The Cretan Journal, ed Rowena Fowler, 1984.
Lear's Corfu: An anthology drawn from the Painter's Letters, with a preface by Lawrence Durrell, 1965.
The Journey to Petra – a Leaf from the Journals of a Landscape Painter, with notes by Franklin Lushington, *Macmillan's Magazine*, April 1897.
Edward Lear's Journals: A selection, ed H. Van Thal, 1952.

Letters

Letters of Edward Lear, ed Lady Strachey, 1907.
Later Letters of Edward Lear, ed Lady Strachey, 1911.

PUBLICATIONS ABOUT EDWARD LEAR

Cormack, M. *How Pleasant . . .* 1982, p. 4.
Croft-Cooke, R., *Feasting with Panthers: a New Consideration of some Late Victorian Writers*, 1967, chap. 7.
Davidson, A., *Edward Lear: Landscape Painter and Nonsense Poet (1812–1888)*, 1938.
Hardie, M., "Edward Lear", *Artwork*, no. 22 (summer 1930), pp. 114–18.
Hewett, O.W. (ed), *. . . and Mr Fortescue*, 1958 (excerpts from the diaries of Chichester Fortescue, Lord Carlingford, 1851–62).
Hofer, P., *Edward Lear as a Landscape Draughtsman*, 1967.
Hyman, S., *Edward Lear's Birds*, 1980.
Kelen, E., *Mr Nonsense: A Life of Edward Lear*, 1973.
Lehmann, J., *Edward Lear and his World*, 1977.
Noakes, V., *Edward Lear: the life of a Wanderer*, 1968.
Edward Lear 1812–88, Cat. of RA exhibition, 1985.

Quennell, P., *Edward Lear, The Singular Preference*, 1952, pp. 95–101.

Sewell, Elizabeth, *The Field of Nonsense*, 1952.

Slade, B. C. (ed), *Edward Lear on my Shelves* (for W. B. Osgood Field), 1933.

Tsigakou, F. M., *Edward Lear in Greece*, 1977, unpublished thesis, University College, London.

　　The Rediscovery of Greece. Travellers and Painters of the Romantic Era, 1981.

MISCELLANEOUS

Hoge, James O. (ed), *Letters of Emily, Lady Tennyson*, 1974.

　　(ed), *Lady Tennyson's Journal*, 1981.

Hunt, W. Holman, *Pre-Raphaelitism and the Pre-Raphaelite Brotherhood*, 1905.

Hyde, H. Montgomery, *The Other Love*, 1970.

Martin, R. B., *Tennyson. The Unquiet Heart*, 1980.

Symonds, J. A., *The Memoirs of John Addington Symonds*, 1984.

Waller, John O., *A Circle of Friendship: The Tennysons and the Lushingtons*, 1986.

Index